Writings on Religion

DAVID HUME

Writings on Religion

Of Superstition and Enthusiasm
A Note on the Profession of Priest
Letter to William Mure of Caldwell
Letter to Gilbert Elliot of Minto
Of the Immortality of the Soul
Of Suicide
Of Miracles
Of a Particular Providence and of a Future State
The Natural History of Religion
Dialogues concerning Natural Religion

INTRODUCTION, NOTES, AND
EDITORIAL ARRANGEMENT BY
ANTONY FLEW

Open Court
La Salle, Illinois

Volume Two in the series: Paul Carus Student Editions

✻

OPEN COURT and the above logo are registered in the U.S. Patent and Trademark Office.

Introduction, notes, and editorial arrangement © 1992 by Open Court Publishing Company.

First printing 1992
Second printing 1993
Third printing 1995

Library of Congress Cataloging-in-Publication Data

Hume, David, 1711–1776.
 Writings on religion / David Hume ; introduction, notes and
editorial arrangement by Antony Flew.
 p. cm. — (Paul Carus student editions ; v. 2)
 Includes bibliographical references and index.
 Contents: Of superstition and enthusiasm — A note on the profession of
priest — Letter to William Mure of Caldwell — Letter to Gilbert Elliot of
Minto — Of the immortality of the soul — Of suicide — Of miracles — Of
a particular providence and of a future state — The natural history of
religion — Dialogues concerning natural religion.
 ISBN 0-8126-9112-1 (paper)
 1. Religion — Philosophy — Early works to 1800. 2. Natural theology —
Early works to 1900. I. Flew, Antony, 1923 – .
II. Title. III. Series.
B1499.R45H85 1992
210—dc20
 92-12729

CONTENTS

INTRODUCTION

David Hume (1711–1776) was a complete unbeliever, the first major thinker of the modern period to be through and through secular, this-worldly, and man-centered. He was always too prudent, too tactful in his concern to preserve smooth relations with his many friends among the Moderate faction of the Scottish clergy, and too much of the principled sceptic, ever to proclaim himself an atheist. Indeed the first openly and explicitly atheist book in the English language did not appear until six years after Hume's death.[1] The most, however, that Hume was prepared positively to affirm was the bare existence of a Deity, about the essential nature of which nothing whatever can be known; and which could, surely, not be identified as an entity separate and distinct from the Universe itself. The *"true* religion", to which Hume professed his devotion, was persuasively defined to exclude all actual religious belief and practice. For he made no bones about his disbeliefs in both human immortality and any kind of Divine interventions, miraculous or otherwise, in the ordinary course of nature.

This unbelief was lifelong: it began early; and, in accord with the family motto of the Humes, he was "True to the End". While composing the posthumously published *Dialogues concerning Natural Religion* (Part VI, below) he revealed that he had recently burnt "an old Manuscript Book, wrote before I was twenty", in which were recorded his first doubts and his struggles to overcome those doubts (II. 2, below). Years later

[1] According to David Berman, this was *An Answer to Dr. Priestley's Letters to a Philosophical Unbeliever,* apparently written by Matthew Turner and William Hammon, published in London in 1782. See Berman's *History of Atheism in Britain: From Hobbes to Russell* (London: Croom Helm, 1988). The late date and obscure authorship of the Turner and Hammon work are hardly surprising given that for centuries an avowal of atheism could easily have led to the death of the atheist.

Hume told Boswell that "he never had entertained any belief in Religion since he began to read Locke and Clarke." Boswell reports too on a deathbed interview: "I had a strong curiosity to be satisfied if he persisted in disbelieving a future state even when he had death before his eyes. I was persuaded from what he now said, and from his manner of saying it, that he did persist."

Unbelieving Hume thus certainly was, but never indifferent. His interest both in the phenomena of religion (its phenomenology) and in the evidencing reasons offered for religious doctrines (their epistemology) was a lifelong as his incredulity. His close friend Adam Smith tells how, even as Hume lay dying, he entertained possible excuses to secure some deferral of his ferrying across the river of death. Hume thought he might say he had been very busily employed in making his countrymen wiser, and if he lived a little longer, might have the satisfaction of seeing the downfall of some of the prevailing systems of superstition. But then the boatman would lose his temper. "You loitering rogue, that will not happen these many hundred years . . . Get into the boat this instant, you lazy, loitering rogue."

Because Hume's interest was thus both comprehensive and lifelong, the main problem for the editor of a collection such as this is what to exclude. Certainly both *The Natural History of Religion* (Part V, below) and the *Dialogues concerning Natural Religion* (VI, below) have to go in: these are Hume's most concentrated and direct contributions to, respectively, the phenomenology and the epistemology. The claims of the two essays 'Of the Immortality of the Soul' and 'Of Suicide' (III, below) are similarly strong. For it is religion which provides the best reasons both for believing in conditional or unconditional human immortality and for proscribing suicide whatever the circumstances; the belief and the proscription which Hume is challenging in these essays. Then the essay 'Of Superstition and Enthusiasm' and the long note about the priestly profession, originally attached to the essay 'Of Natural Characters', both go in as complementary to the *Natural History of Religion* (I.1 and 2, below). Two short letters from Hume are included as illuminating background (Part II).

The difficult question was whether to include the two famous—once notorious—sections from *An Enquiry concern-*

ing Human Understanding, 'Of Miracles' and 'Of a particular Providence and of a Future State'. Extra pages add to the cost of a book, and these sections are easily available in the *Enquiry.* They have often been seriously misunderstood, usually because their relation to the rest of that *Enquiry* has been overlooked, and it is therefore best to read them in the context of that *Enquiry* as a whole. On the other hand, research by Open Court revealed that almost all teachers who might wish to use this collection in the classroom would prefer it to have these sections. I have therefore included them, along with an introduction situating them in the context of Hume's other writings.

Hume's first (anonymous) publication was *A Treatise of Human Nature,* now universally allowed to be one of the greatest works of original philosophy ever written in the English language, and perhaps the greatest. His choice of title suggests that Hume may have seen himself as in some way succeeding Thomas Hobbes (1588–1679),[2] who became notorious in the previous century as an inspirer of necessarily covert and surreptitious atheism. The motto too—"Rare the happiness of times when to think what you like and to say what you think is permitted"—suggests that the contents will be such as to offend the orthodox. From a surviving letter, however, we know that, while preparing the manuscript for the press, Hume systematically excised all passages which he felt that he could not comfortably present to the future Bishop Butler (1692–1752). Joseph Butler, whose opinion of the book Hume intended to solicit, was the contemporary philosopher for whom Hume had the most respect. And, in so far as any of the fictitious characters of the *Dialogues* speak for actual individuals, Butler was to become the model for Cleanthes.[3]

Nevertheless the *Treatise* as published did disturb contemporary readers. Certainly those approaching it with some knowledge of Hume's life and later writings ought to recognize the irony in all his expressions of orthodox belief. What was

[2] See Paul Russell 'Hume's *Treatise* and Hobbes's *The Elements of Law*', in the *Journal of the History of Ideas,* January, 1985.

[3] See E. C. Mossner 'The Enigma of Hume', in *Mind,* 1936, pp. 334–349.

still upsetting to contemporaries was: both what rather conspicuously it did not say about morality; and some of the implications carried by, but not yet drawn from, the main more general theses. Our best evidence is found in *A Letter from a Gentleman*,[4] a defensive pamphlet written by Hume in 1745 while he was applying for a Chair of Philosophy at Edinburgh University. It appears that the author of the *Treatise* was being charged then with not having cast God for an essential part in his system of morality. More generally there were complaints about his principled scepticism; while—for their perceived theological implications—particular exception was taken to his negative contributions about causality.

Fundamental to Hume's critique of natural theology, these contentions were: that we cannot know *a priori,* in advance of experience, that any thing or sort of thing either must be or cannot be the cause of any other thing or sort of thing; or indeed that everything must at least have some cause of its being or occurring. Natural theology aspires to establish, without appealing to any supposed Divine Revelation, the existence and essential characteristics of God; natural religion would be the system of beliefs and practices justified by this achievement. The particular kind of putative proofs of God's existence which Hume's causal contentions were seen to threaten was that favoured by Dr. Samuel Clarke (1675–1729); who must have been, more than any other actual person, the model for the Demea of the *Dialogues*.

If Hume was correct in claiming to Boswell that "he never had entertained any belief in Religion since he began to read Locke and Clarke", then their influence was surely reactive rather than directly active. Presumably it was through studying them that Hume reached his own contrary conclusions. Certainly "Dr. Clarke and others", "Mr. Hobbes", and "Mr. Locke" are the only opponents named in the section of the *Treatise* (I (iii) 3) where Hume concludes: "Since it is not from knowledge or any scientific reasoning, that we derive the opinion of the necessity of a cause to every new production, that opinion must necessarily arise from observation and

[4] Edited by E. C. Mossner and J. V. Price, this was published by Edinburgh University Press in 1967.

experience." However, since the anti-theological implications are not drawn out in the *Treatise,* "that juvenile work"—as Hume was later to dismiss it—contains no candidates for inclusion in the present volume.

A Note on Spelling and Punctuation

English has evolved since Hume to the extent that retaining all of Hume's original spelling and punctuation would make difficult reading today. Yet many of the old usages are comprehensible and give an authentic flavour. This edition therefore maintains a compromise: some archaisms are retained, and sometimes explained in notes; others have been modernized.

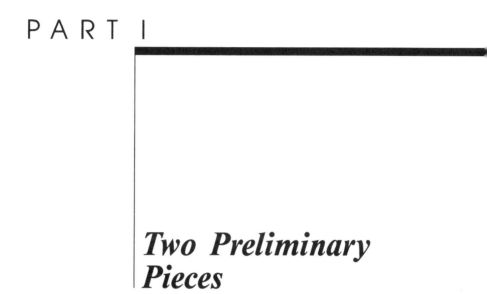

PART I

Two Preliminary Pieces

1. Of Superstition and Enthusiasm

This work was originally one item in a collection of 23 Essays: Moral and Political *(Edinburgh: 1741), the first of Hume's publications to bear the author's name.*

That the corruption of the best things produces the worst, is grown into a maxim, and is commonly proved, among other instances, by the pernicious effects of *superstition* and *enthusiasm,*[1] the corruptions of true religion.

These two species of false religion, though both pernicious, are yet of a very different, and even of a contrary nature. The mind of man is subject to certain unaccountable terrors and apprehensions, proceeding either from the unhappy situation of private or public affairs, from ill health, from a gloomy and melancholy disposition, or from the concurrence of all these circumstances. In such a state of mind, infinite unknown evils are dreaded from unknown agents; and where real objects of terror are wanting, the soul, active to its own prejudice, and fostering its predominant inclination, finds imaginary ones, to whose power and malevolence it sets no limits. As these enemies are entirely invisible and unknown, the methods

[1] This word is not being employed in its familiar contemporary sense. In Hume's day it denoted a form of frenzy. So when eighteenth-century epitaphs in British churches speak of their subjects as having been "religious, but without enthusiasm" this is to be construed not as a sly reproach but as an intended compliment. To understand Hume's contrasting of superstition with enthusiasm, it will perhaps help to note that two of the passages in his *History of England* which gave most offense were one in which he dismissed the distinctive beliefs of Roman Catholics as superstitions and another where all the Protestant sectaries prominent in the Civil War were put down as enthusiasts.

taken to appease them are equally unaccountable, and consist in ceremonies, observances, mortifications, sacrifices, presents, or in any practice, however absurd or frivolous, which either folly or knavery recommends to a blind and terrified credulity. Weakness, fear, melancholy, together with ignorance, are, therefore, the true sources of SUPERSTITION.

But the mind of man is also subject to an unaccountable elevation and presumption, arising from prosperous success, from luxuriant health, from strong spirits, or from a bold and confident disposition. In such a state of mind, the imagination swells with great, but confused conceptions, to which no sublunary[2] beauties or enjoyments can correspond. Every thing mortal and perishable vanishes as unworthy of attention. And a full range is given to the fancy in the invisible regions or world of spirits, where the soul is at liberty to indulge itself in every imagination, which may best suit its present taste and disposition. Hence arise raptures, transports, and surprising flights of fancy; and confidence and presumption still encreasing, these raptures, being altogether unaccountable, and seeming quite beyond the reach of our ordinary faculties, are attributed to the immediate inspiration of that Divine Being, who is the object of devotion. In a little time, the inspired person comes to regard himself as a distinguished favourite of the Divinity; and when this frenzy once takes place, which is the summit of enthusiasm, every whimsy is consecrated: Human reason and even morality are rejected as fallacious guides: And the fanatic madman delivers himself over, blindly, and without reserve, to the supposed incursions of the spirit, and to inspiration from above. Hope, pride, presumption, a warm imagination, together with ignorance, are, therefore, the true sources of ENTHUSIASM.

These two species of false religion might afford occasion to many speculations; but I shall confine myself, at present, to a few reflections concerning their different influence on government and society.

My first reflection is, *That superstition is favourable to*

[2] 'Beneath the Moon', of this world.

priestly power, and enthusiasm not less or rather more contrary to it, than sound reason and philosophy. As superstition is founded on fear, sorrow, and a depression of spirits, it represents the man to himself in such despicable colours, that he appears unworthy, in his own eyes, of approaching the divine presence, and naturally has recourse to any other person, whose sanctity of life, or, perhaps, impudence and cunning, have made him be supposed more favoured by the Divinity. To him the superstitious entrust their devotions: To his care they recommend their prayers, petitions, and sacrifices: And by his means, they hope to render their addresses acceptable to their incensed Deity. Hence the origin of PRIESTS,[3] who may justly be regarded as an invention of a timorous and abject superstition, which, ever diffident of itself, dares not offer up its own devotions, but ignorantly thinks to recommend itself to the Divinity, by the mediation of his supposed friends and servants. As superstition is a considerable ingredient in almost all religions, even the most fanatical; there being nothing but philosophy able entirely to conquer these unaccountable terrors; hence it proceeds, that in almost every sect of religion there are priests to be found: But the stronger mixture there is of superstition, the higher is the authority of the priesthood.

On the other hand, it may be observed, that all enthusiasts have been free from the yoke of ecclesiastics, and have expressed great independence in their devotion; with a contempt of forms, ceremonies, and traditions. The *Quakers*[4] are the most egregious, though, at the same time, the most innocent enthusiasts that have yet been known; and are, perhaps, the only sect, that have never admitted priests amongst them. The

[3] Hume added an eirenic footnote: "By *Priests,* I here mean only the pretenders to power and dominion, and to a superior sanctity of character, distinct from virtue and good morals. These are very different from *clergymen,* who are set apart *by the laws,* to the care of sacred matters, and to the conducting our public devotions with greater decency and order. There is no rank of men more to be respected than the latter."

[4] The Society of Friends, known also as Quakers, was founded in England in the mid-seventeenth century by George Fox. It stands for trust in the 'inner light' in man, the renunciation of violence and war, simplicity of speech and dress, and worship without an ordained ministry.

Independents,[5] of all the ENGLISH sectaries, approach nearest to the *Quakers* in fanaticism, and in their freedom from priestly bondage. The *Presbyterians*[6] follow after, at an equal distance in both particulars. In short this observation is founded in experience; and will also appear to be founded in reason, if we consider, that, as enthusiasm arises from a presumptuous pride and confidence, it thinks itself sufficiently qualified to *approach* the Divinity, without any human mediator. Its rapturous devotions are so fervent, that it even imagines itself *actually* to *approach* him by the way of contemplation and inward converse; which makes it neglect all those outward ceremonies and observances, to which the assistance of the priests appears so requisite in the eyes of their superstitious votaries. The fanatic consecrates himself, and bestows on his own person a sacred character, much superior to what forms and ceremonious institutions can confer on any other.

My *second* reflection with regard to these species of false religion is, *that religions, which partake of enthusiasm are, on their first rise, more furious and violent than those which partake of superstition; but in a little time become more gentle and moderate.* The violence of this species of religion, when excited by novelty, and animated by opposition, appears from numberless instances; of the *Anabaptists*[7] in GERMANY, the

[5] The Independents, or Congregationalists, emerged in England in the sixteenth century but became influential only in the seventeenth. They viewed local congregations of believers as the true church and insisted on the independence of these congregations from all other civil and ecclesiastical organizations.

[6] Presbyterianism grew out of the efforts of John Calvin (1509–64) to return Christianity to its primitive form of church government. Presbyterians in England and Scotland agreed with Congregationalists in rejecting episcopacy, or government of the church by bishops, but they insisted that the election of ministers and elders by local congregations should be subject to confirmation by larger assemblies, or presbyteries.

[7] The Anabaptists broke with Martin Luther (1483–1546) on the issue of infant baptism. But, especially through the Peasants' Revolt of 1528 and the leadership of Thomas Münzer, Anabaptism developed into a revolutionary movement committed to the forcible realization of ideals of a Christian commonwealth. The Mennonites (including the Amish) are one branch of Anabaptism.

Camisars[8] in FRANCE, the *Levellers*[9] and other fanatics in ENGLAND, and the *Covenanters*[10] in SCOTLAND. Enthusiasm being founded on strong spirits, and a presumptuous boldness of character, it naturally begets the most extreme resolutions; especially after it rises to that height as to inspire the deluded fanatic with the opinion of divine illuminations, and with a contempt for the common rules of reason, morality, and prudence.

It is thus enthusiasm produces the most cruel disorders in human society; but its fury is like that of thunder and tempest, which exhaust themselves in a little time, and leave the air more calm and serene than before. When the first fire of enthusiasm is spent, men naturally, in all fanatical sects, sink into the greatest remissness and coolness in sacred matters; there being no body of men among them, endowed with sufficient authority, whose interest is concerned to support the religious spirit: No rites, no ceremonies, no holy observances, which may enter into the common train of life, and preserve the sacred principles from oblivion. Superstition, on the contrary, steals in gradually and insensibly; renders men tame and submissive; is acceptable to the magistrate, and seems inoffensive to the people: Till at last the priest, having firmly established his authority, becomes the tyrant and disturber of human society, by his endless contentions, persecutions, and religious wars. How smoothly did the ROMISH church[11] advance

[8] The Camisards were French Calvinists who rose up in rebellion in 1703 against the revocation in 1685 by Louis XIV of the Edict of Nantes, a law that had permitted Protestants to worship openly and to hold public offices.

[9] The Levellers were a politically radical group which emerged in England after the Parliamentary armies had defeated the Royalists in the Civil War of 1642–46. Hume was later to go on to say in his *History of England* the same sorts of things about these "Levellers and other fanatics" as Edmund Burke in his *Reflections on the Revolution in France* later said about the ultras of 1789.

[10] The Covenanters were those who signed a covenant to defend a presbyterian as opposed to episcopal form of church government. After the re-establishment of episcopacy in 1662 by the restored King Charles II they rose in a revolt, which was savagely suppressed.

[11] The Roman Catholic Church.

in her acquisition of power? But into what dismal convulsions
did she throw all EUROPE, in order to maintain it? On the other
hand, our sectaries,[12] who were formerly such dangerous
bigots, are now become very free reasoners; and the *Quakers*
seem to approach nearly the only regular body of *Deists*[13] in the
universe, the *literati,* or the disciples of CONFUCIUS in CHINA.

My *third* observation on this head is, *that superstition is an
enemy to civil liberty, and enthusiasm a friend to it.* As
superstition groans under the dominion of priests, and enthu-
siasm is destructive of all ecclesiastical power, this sufficiently
accounts for the present observation. Not to mention, that
enthusiasm, being the infirmity of bold and ambitious tem-
pers, is naturally accompanied with a spirit of liberty; as
superstition, on the contrary, renders men tame and abject,
and fits them for slavery. We learn from ENGLISH history, that,
during the civil wars, the *Independents* and *Deists,* though the
most opposite in their religious principles; yet were united in
their political ones, and were alike passionate for a common-
wealth. And since the origin of *Whig* and *Tory,*[14] the leaders of
the *Whigs* have either been *Deists* or professed *Latitudinari-
ans*[15] in their principles; that is, friends to toleration, and

[12] Members of Protestant sects.

[13] The vague term 'Deist' was employed to describe all those who,
whatever their other disagreements among themselves, rejected or were
accused of rejecting the essentials of the Christian Revelation—that is,
the resurrection and the divinity of Jesus bar Joseph—but who still
continued to believe in the existence of a usually somewhat detached and
uninvolved Deity.

The teachings of K'ung fu-tzu or Confucius (551–479 BCE), recorded in
the *Analects,* and traditionally respected by the educated class in China
(the 'lettered people' or *literati*), make much reference to Heaven. But the
Papacy was surely right to reject the attempt by Jesuit missionaries to
equate this Confucian 'Heaven' with the God of Mosaic theism (Judaism,
Christianity, and Islam).

[14] 'Whig' and 'Tory' were the names of the two British political par-
ties in Hume's day. All the British sympathizers with the national aspi-
rations of the American colonists were among the Whigs, whose colours
were adopted by the Continental armies. A personal friend of Franklin,
Hume himself early anticipated and eagerly welcomed the American
Revolution.

[15] Unlike Deists, Latitudinarians were Christians but, as the name
suggests, more tolerant and favouring broader interpretations than many

indifferent to any particular sect of *Christians:* While the sectaries, who have all a strong tincture of enthusiasm, have always, without exception, concurred with that party, in defence of civil liberty. The resemblance in their superstitions long united the high-church *Tories,* and the *Roman catholics,* in support of prerogative[16] and kingly power; though experience of the tolerating spirit of the *Whigs* seems of late to have reconciled the *Catholics* to that party.

The *Molinists* and *Jansenists* in FRANCE have a thousand unintelligible disputes,[17] which are not worthy the reflection of a man of sense: But what principally distinguishes these two sects, and alone merits attention, is the different spirit of their religion. The *Molinists,* conducted by the *Jesuits,* are great friends to superstition, rigid observers of external forms and ceremonies, and devoted to the authority of the priests, and to tradition. The *Jansenists* are enthusiasts, and zealous promoters of the passionate devotion, and of the inward life; little influenced by authority; and, in a word, but half catholics. The consequences are exactly conformable to the foregoing reasoning. The *Jesuits* are the tyrants of the people, and the slaves of the court: And the *Jansenists* preserve alive the small sparks of the love of liberty, which are to be found in the FRENCH nation.

of their contemporary coreligionists. In the Church of Scotland in Hume's own day a similar split developed between the Moderate clergy, among whom he himself numbered many as friends, and the Highflyers.

[16] An exclusive right or privilege held by a person or group.

[17] This party conflict within seventeenth-century Roman Catholicism was largely concerned with freewill and predestination, the Molinists emphasizing the former and the Jansenists the latter. As Hume indicates, the Jesuits backed and enjoyed the backing of the state, while the Jansenist stronghold was the dissident convent of Port-Royal.

2. A Note on the Profession of Priest

This material was originally printed as an incongruous footnote to the Essay 'Of National Characters' in the same volume as the Essay 'Of Superstition and Enthusiasm'.

Though all mankind have a strong propensity to religion at certain times and in certain dispositions; yet are there few or none, who have it to that degree, and with that constancy, which is requisite to support the character of this profession. It must, therefore, happen, that clergymen, being drawn from the common mass of mankind, as people are to other employments, by the views of profit, the greater part, though no atheists or free-thinkers, will find it necessary, on particular occasions, to feign more devotion than they are, at that time, possessed of, and to maintain the appearance of fervor and seriousness, even when jaded with the exercises of their religion, or when they have their minds engaged in the common occupations of life. They must not, like the rest of the world, give scope to their natural movements and sentiments: They must set a guard over their looks and words and actions: And in order to support the veneration paid them by the multitude, they must not only keep a remarkable reserve, but must promote the spirit of superstition, by a continued grimace and hypocrisy. This dissimulation often destroys the candor and ingenuity of their temper, and makes an irreparable breach in their character.

If by chance any of them be possessed of a temper more susceptible of devotion than usual, so that he has but little occasion for hypocrisy to support the character of his profession; it is so natural for him to over-rate this advantage, and to think that it atones for every violation of morality, that

frequently he is not more virtuous than the hypocrite. And though few dare openly avow those exploded opinions, *that every thing is lawful to the saints,* and *that they alone have property in their goods;* yet may we observe, that these principles lurk in every bosom, and represent a zeal for religious observances as so great a merit, that it may compensate for many vices and enormities. This observation is so common, that all prudent men are on their guard, when they meet with any extraordinary appearance of religion; though at the same time, they confess, that there are many exceptions to this general rule, and that probity and superstition, or even probity and fanaticism, are not altogether and in every instance incompatible.

Most men are ambitious; but the ambition of other men may commonly be satisfied, by excelling in their particular profession, and thereby promoting the interests of society. The ambition of the clergy can often be satisfied only by promoting ignorance and superstition and implicit faith and pious frauds. And having got what ARCHIMEDES only wanted,[1] (namely, another world, on which he could fix his engines) no wonder they move this world at their pleasure.

Most men have an overweaning conceit of themselves; but *these* have a peculiar temptation to that vice, who are regarded with such veneration, and are even deemed sacred, by the ignorant multitude.

Most men are apt to bear a particular regard for members of their own profession; but as a lawyer, or physician, or merchant, does, each of them, follow out his business apart, the interests of men of these professions are not so closely united as the interests of clergymen of the same religion; where the whole body gains by the veneration, paid to their common tenets, and by the suppression of antagonists.

Few men can bear contradiction with patience; but the clergy too often proceed even to a degree of fury on this head: Because all their credit and livelihood depend upon the belief which their opinions meet with; and they alone pretend to a

[1] Archimedes (c. 287–212 BCE) was a Syracusan Greek scientist. He is noted, among several other things, for his claim that, thanks to the principle of leverage, he could, given a place to stand, move the Earth.

divine and supernatural authority, or have any colour[2] for representing their antagonists as impious and prophane. The *Odium Theologicum,* or Theological Hatred, is noted even to a proverb, and means that degree of rancour, which is the most furious and implacable.

Revenge is a natural passion to mankind; but seems to reign with the greatest force in priests and women: Because, being deprived of the immediate exertion of anger, in violence and combat, they are apt to fancy themselves despised on that account; and their pride supports their vindictive disposition.

Thus many of the vices of human nature are, by fixed moral causes,[3] inflamed in that profession; and though several individuals escape the contagion, yet all wise governments will be on their guard against the attempts of a society, who will for ever combine into one faction, and while it acts as a society, will for ever be actuated by ambition, pride, revenge, and a persecuting spirit.

The temper of religion is grave and serious; and this is the character required of priests, which confines them to strict rules of decency, and commonly prevents irregularity and intemperance amongst them. The gaiety, much less the excesses of pleasure, is not permitted in that body; and this virtue is, perhaps, the only one which they owe to their profession. In religions, indeed, founded on speculative principles, and where public discourses make a part of religious service, it may also be supposed that the clergy will have a considerable share in the learning of the times; though it is certain that their taste in eloquence will always be greater than their proficiency in reasoning and philosophy. But whoever possesses the other noble virtues of humanity, meekness,

[2] Credibility.

[3] "Moral" causes here are the desires and aspirations which move human agents, by contrast with the physical causes which necessitate the purposeless movements of everything else. In the context of the particular essay to which the present note was attached, Hume's own explanation ran: "By *moral* causes, I mean all circumstances, which are fitted to work on the mind as motives or reasons . . . By *physical* causes I mean those qualities of the air and climate, which are supposed to work insensibly in the temper, by altering the tone and habit of the body . . ."

and moderation, as very many of them, no doubt, do, is beholden for them to nature or reflection, not to the genius of his calling.

It was no bad expedient in the old ROMANS, for preventing the strong effect of the priestly character, to make it a law that no one should be received into the sacerdotal office, till he was past fifty years of age.[4] The living a layman till that age, it is presumed, would be able to fix the character.

[4] Hume here refers to Dionysius of Halicarnassus, *Roman Antiquities,* Book I.

PART II

Two Revealing Letters

These two letters are reprinted here partly as very characteristic specimens of the faintly mischievous tact and charm with which Hume discussed with his friends fundamental disagreements about religion. But the main reason is to make three things clear: that, for better or for worse it was very early in his life that Hume reasoned himself out of all religion; that the 'true religion' to which he continued to profess his total commitment involved the rejection of all actual religious beliefs and practices; and that there should be no doubt that the character in the Dialogues concerning Natural Religion *who comes nearest to expressing the author's own views is Philo.*

1. To William Mure of Caldwell[1] (1743)

Edinburgh, 30 June 1743

Dear Sir,

I have read Mr Leechman's Sermon with a great deal of Pleasure, & think it a very good one; tho' I am sorry to find the Author to be a rank Atheist. You know (or ought to know) that Plato says there are three kinds of Atheists. The first who deny a Deity, the second who deny his Providence, the third who assert, that he is influenced by Prayers or Sacrifices. I find Mr Leechman is an Atheist of the last kind. . . .

As to the Argument I could wish Mr. Leechman would in the second Edition answer this Objection both to Devotion & Prayer, & indeed to every thing we commonly call Religion, except the Practice of Morality, & the Assent of the Understanding to the Proposition *that God exists.*

It must be acknowledged that Nature has given us a strong Passion of Admiration for whatever is excellent, & of Love & Gratitude for whatever is benevolent & beneficial, & that the Deity possesses these Attributes in the highest Perfection & yet I assert he is not the natural Object of any Passion or Affection. He is no Object either of the Senses or Imagination, & very little of the Understanding, without which it is impossible to excite any Affection. A remote Ancestor, who has left us Estates & Honours, acquired with Virtue, is a great Benefac-

[1] The addressee of this letter, one of Hume's lifelong friends, was currently Member of Parliament for Renfrewshire. But it was intended also to be read by Mure's sometime tutor William Leechman, Professor Elect of Divinity in the University of Glasgow and author of *On the Nature, reasonableness, and Advantages of Prayer; with an Attempt to answer the objections against it. A sermon . . .* (Glasgow, 1743). It therefore contained several stylistic suggestions, here omitted.

tor, & yet 'tis impossible to bear him any Affection, because unknown to us; tho in general we know him to be a Man or a human Creature, which brings him vastly nearer our Comprehension than an invisible infinite Spirit. A man, therefore, may have his Heart perfectly well disposed towards every proper & natural Object of Affection, Friends, Benefactors, Country, Children &c, & yet from this Circumstance of the Invisibility & Incomprehensibility of the Deity may feel no Affection towards him. And indeed I am afraid that all Enthusiasts mightily deceive themselves. Hope & Fear perhaps agitate their Breast when they think of the Deity: Or they degrade him into a Resemblance with themselves, & by that means render him more comprehensible. Or they exult with Vanity in esteeming themselves his peculiar Favourites. Or at best they are actuated by a forced & strained Affection, which moves by Starts & Bounds, & with a very irregular disorderly Pace. Such an Affection can not be required of any Man as his Duty. Please to observe, that I not only exclude the turbulent Passions, but the calm Affections. Neither of them can operate without the Assistance of the Senses, & Imagination, or at least a more complete Knowledge of the Object than we have of the Deity. In most Men this is the Case; & a natural Infirmity can never be a Crime. But secondly were Devotion never so much admitted, Prayer must still be excluded. First The Addressing of our virtuous Wishes & Desires to the Deity, since the Address has no Influence on him, is only a kind of rhetorical Figure, in order to render these Wishes more ardent & passionate. This is Mr Leechman's Doctrine. Now the Use of any figure of Speech can never be a Duty. Secondly this Figure, like most Figures of Rhetoric, has an evident Impropriety in it. For we can make use of no Expression or even Thought, in Prayers & Entreaties, which does not imply that these Prayers have an Influence. Thirdly. This Figure is very dangerous & leads directly & even unavoidably to Impiety & Blasphemy. Tis a natural Infirmity of Men to imagine, that their Prayers have a direct Influence, & this Infirmity must be extremely fostered & encouraged by the constant Use of Prayer. Thus all wise Men have excluded the Use of Images & Pictures in Prayer; tho they certainly enliven Devotion; because tis found by Experience, that with the vulgar these visible Representations draw too much towards them, & become the only Objects of Devotion.—

Excuse this Long Letter, make my Compliments to Mr Leechman & all Friends, & believe me to be Yours sincerely

D. H.

I have frequently in Edinburgh enquired for the Dialogues on Devotion[2] published at Glasgow some time ago; but could not find them. If you have a Copy send it me, & I shall restore it with the first Occasion. It may be a means of my Conversion.

[2] Presumably *A Dialogue on Devotion, after the manner of Xenophon; in which the Reasonableness, Pleasure and Advantages of it are considered. To which is prefixed, a Conversation of Socrates on the Being and Providence of God* (Glasgow, 1733).

2. To Gilbert Elliot of Minto[1] (1751)

Ninewells, near Berwick.
March 10, 1751.

Dear Sir

You would perceive by the Sample I have given you, that I make Cleanthes the Hero of the Dialogue.[2] Whatever you can think of, to strengthen that Side of the Argument, will be most acceptable to me. Any Propensity you imagine I have to the other Side, crept in upon me against my Will: And tis not long ago that I burned an old Manuscript Book, wrote before I was twenty; which contained, Page after Page, the gradual Progress of my Thoughts on that head. It begun with an anxious Search after Arguments, to confirm the common Opinion: Doubts stole in, dissipated, returned, were again dissipated, returned again; and it was a perpetual Struggle of a restless Imagination against Inclination, perhaps against Reason.

I have often thought, that the best way of composing a Dialogue, would be for two Persons that are of different Opinions about any Question of Importance, to write alternately the different Parts of the Discourse, & reply to each other. By this Means, that vulgar Error would be avoided, of putting nothing but Nonsense into the Mouth of the Adversary: And at the same time, a Variety of Character & Genius

[1] Sir Gilbert Eliot of Minto, the third Baronet, was another of Hume's lifelong friends, a friendship probably first made when they were students together at Edinburgh University.

[2] Hume had sent Sir Gilbert some partial draft of his *Dialogues concerning Natural Religion*.

being upheld, would make the whole look more natural &
unaffected. Had it been my good Fortune to live near you, I
should have taken on me the Character of Philo, in the
Dialogue, which you'll own I could have supported naturally
enough: And you would not have been averse to that of
Cleanthes. I believe, too, we could both of us have kept our
Temper very well; only, you have not reached an absolute
philosophical Indifference on these Points.[3] What Danger can
ever come from ingenious Reasoning & Enquiry? The worst
speculative Sceptic ever I knew, was a much better Man
than the best superstitious Devotee & Bigot. I must inform
you, too, that this was the way of thinking of the Ancients
on this Subject. If a Man made Profession of Philosophy,
whatever his Sect was, they always expected to find more
Regularity in his Life and Manners, than in those of the ig-
norant & illiterate. There is a remarkable Passage of Appian
to this Purpose. That Historian observes, that notwithstand-
ing the established Prepossession in Favour of Learning,
yet some Philosophers, who have been trusted with absolute
Power, have very much abused it; and he instances in Critias,
the most violent of the Thirty,[4] & Ariston, who governed
Athens in the time of Sulla. But I find, upon Enquiry, that
Critias was a professed Atheist, & Ariston an Epicurean,
which is little or nothing different:[5] And yet Appian wonders
at their Corruption, as much as if they had been Stoics or
Platonists. A modern Zealot would have thought that Corrup-
tion unavoidable.[6]

[3] He never did, remaining a leading Elder of the Kirk, and continu-
ing always to express disapproval of his friend's sceptical and securatiz-
ing philosophy.

[4] Appian of Alexandria lived in the second century of our era and
wrote a *Roman History* in Greek. Sulla was the aristocratic leader in the
Roman Civil War. The cruelties for which he was responsible, especially
to Greeks under Roman rule, were notorious. Critias was one of the
Thirty Tyrants who effected an oligarchic coup against the Athenian
democracy; also apparently the first to suggest that religion was origi-
nally invented by rulers as a means of social control.

[5] This remark, since Hume elsewhere sometimes associates himself
with Epicurean ideas, is perhaps a significant giveaway.

[6] 'Zealot' is Hume's favorite term of abuse for people with strong and

I could wish that Cleanthes's Argument could be so analysed, as to be rendered quite formal & regular. The Propensity of the Mind towards it, unless that Propensity were as strong & universal as that to believe in our Senses & Experience, will still, I am afraid, be esteemed a suspicious Foundation. Tis here I wish for your Assistance. We must endeavour to prove that this Propensity is somewhat different from our Inclination to find our own Figures in the Clouds, our Face in the Moon, our Passions & Sentiments even in inanimate Matter. Such an Inclination may, & ought to be controlled, & can never be a legitimate Ground of Assent.

The Instances I have chosen for Cleanthes are, I hope, tolerably happy, & the Confusion in which I represent the Sceptic seems natural. But *si quid novisti rectius,* &c.[7]

You ask me, If the idea of Cause & Effect is nothing but Vicinity, (you should have said constant Vicinity, or regular Conjunction), I would gladly know *whence is that farther Idea of Causation against which you argue?*[8] This Question is pertinent; but I hope I have answered it. We feel, after the constant Conjunction, an easy Transition from one Idea to the other, or a Connexion in the Imagination. And as it is usual for us to transfer our own Feelings to the Objects on which they are dependent, we attach the internal Sentiment to the external Objects. If no single Instances of Cause & Effect appear to have any Connexion, but only repeated similar ones, you will find yourself obliged to have Recourse to this Theory.

I am sorry our Correspondence should lead us into these abstract Speculations. I have thought, & read, & composed very little on such Questions of late. Morals, Politics, & Literature have employed all my Time; but still the other Topics I must think more curious, important, entertaining, &

intolerant religious convictions.

[7] This is an allusion to Horace *Epistles,* I 11. 678, which translates:
"Well, good luck. If you know anything better,
Be open and share with me. If not make do with this."

[8] Since Hume himself proceeds immediately to argue that there is no such further legitimate idea he must have meant not 'against' but 'for'. He is of course here expounding his own distinctive account of causation.

useful, than any Geometry that is deeper than Euclid.[9] If in order to answer the Doubts started, new Principles of Philosophy must be laid; are not these Doubts themselves very useful? Are they not preferable to blind, & ignorant Assent? I hope I can answer my own Doubts: But if I could not, is it to be wondered at? To give myself Airs, & speak magnificently, might I not observe, that Columbus did not conquer Empires & plant Colonies?

If I have not unravelled the Knot so well, in these last Papers I sent you, as perhaps I did in the former, it has not, I assure you, proceeded from Want of good Will; but some Subjects are easier than others: At some Times one is happier in his Researches & Enquiries than at others. Still I have Recourse to the *si quid novisti rectius*. Not in order to pay you a Compliment, but from a real philosophical Doubt & Curiosity.

After you have done with these Papers, please return them by the same Carrier. But there is no Hurry. On the contrary the longer you keep them, I shall still believe you are thinking the more seriously to execute what I desire of you.[10] I am Dear Sir

<div align="right">

Yours most sincerely
DAVID HUME.

</div>

P.S.

If you'll be persuaded to assist me in supporting Cleanthes, I fancy you need not take Matters any higher than Part 3. He allows, indeed, in Part 2, that all our Inference is founded on the Similitude of the Works of Nature to the usual Effects of Mind. Otherwise they must appear a mere Chaos. The only

[9] Euclid, who flourished around 300 BCE, founded a school of mathematics in Alexandria, Egypt. His systematic treatise *The Elements of Geometry* was for over 2,000 years the pre-eminent textbook. As recently as World War I geometry in British schools was called, simply, 'Euclid'. It is not clear what deeper geometry Hume wished to dismiss, since the non-Euclidean geometries had not yet been introduced, and the co-ordinate geometry of Descartes had already found important application.

[10] Elliot drafted, and probably sent, a long response, which still survives in manuscript. It is said by those who have read it to be— unsurprisingly—"lucid, fluent, superficial, and philosophically worthless."

Difficulty is, why the other Dissimilitudes do not weaken the Argument. And indeed it would seem from Experience & Feeling, that they do not weaken it so much as we might naturally expect. A Theory to solve this would be very acceptable.

I hope you intend to be in this Country this Season. I am sorry to hear Mrs Murray[11] has been ill. But I hope she is now better.

I make no Scruple to push you to write me something regular on this Subject. It will be a kind of Exercise to you; & improve your Style & Invention.

[11] Feminists and others will be interested to learn that this was Elliot's wife. As an heiress in her own right (Lady Agnes Murray Kynnynmond) she could and did retain her own name, and was known either as Mrs. Murray or, sometimes, as Mrs. Elliot-Murray.

PART III

Two Suppressed Essays

Both these essays were to have been included, along with the Natural History of Religion *and essays 'Of Tragedy' and 'Of the Passions', in a volume entitled* Five Dissertations. *But after this had already been set up in print Hume, in response to various threats and warnings, withdrew them both, substituting a fresh piece 'Of the Standard of Taste'. The result was published as* Four Dissertations *in 1757. Shortly before his death, Hume added a codicil to his will, expressing the desire that William Strahan publish his* Dialogues concerning Natural Religion *at any time within two years of that death, to which Strahan "may add, if he thinks proper, the two Essays formerly printed but not published".*

1. Of the Immortality of the Soul

It may well be that what became a draft for this essay was one of the passages excised from the manuscript of A Treatise of Human Nature *while Hume was, as he put it in a letter, "castrating my work, that is, cutting off its noble parts, that is, endeavouring it shall give as little offence as possible . . ." This hypothetical draft could well have been a separate section coming immediately after the section 'Of the Immateriality of the Soul' or, much more likely, it could have formed the concluding pages to that section itself.*

By the mere light of reason it seems difficult to prove the Immortality of the Soul. The arguments for it are commonly derived either from *metaphysical* topics, or *moral*, or *physical*. But in reality, it is the gospel, and the gospel alone, that has brought life and immortality to light.[1]

I. Metaphysical topics are founded on the supposition that the soul is immaterial, and that it is impossible for thought to belong to a material substance.

But just metaphysics[2] teach us that the notion of substance is wholly confused and imperfect, and that we have no other

[1] This sentence, and still more the final paragraph of the whole essay, reminds us of the final sentences of Section X of the first *Enquiry* (Part IV.1 below), something which we can be virtually certain was based upon material excised from the manuscript of the *Treatise*. In both cases Hume is giving fresh, unbelieving employment to the believer's insistence upon the vital need for faith.

[2] That is, sound or correct metaphysics; as happily provided by Hume in the *Treatise*.

idea of any substance than as an aggregate of particular qualities, inhering in an unknown something. Matter, therefore, and spirit are at bottom equally unknown; and we cannot determine what qualities may inhere in the one or in the other.

They likewise teach us, that nothing can be decided *a priori* concerning any cause or effect, and that experience being the only source of our judgements of this nature, we cannot know from any other principle whether matter, by its structure or arrangement, may not be the cause of thought. Abstract reasonings cannot decide any question of fact or existence.[3]

But admitting a spiritual substance to be dispersed throughout the universe, like the ethereal fire of the *Stoics*,[4] and to be the only inherent subject of thought, we have reason to conclude from *analogy* that nature uses it after the same manner she does the other substance, matter. She employs it as a kind of paste or clay; modifies it into a variety of forms and existences; dissolves after a time each modification; and from its substance erects a new form. As the same material substance may successively compose the body of all animals, the same spiritual substance may compose their minds: Their

[3] *A posteriori* and its opposite *a priori* are Latin for from afterwards and from before. An *a priori* proposition is one which can be known to be true, or false, without reference to experience, except in so far as experience is necessary for understanding its terms. An *a posteriori* proposition can be known to be true, or false, only by reference to how, as a matter of contingent fact, things have been, are, or will be. Hume here is insisting once again on his fundamental and revolutionary thesis: that we cannot know *a priori* that any thing or sort of thing either must be or cannot be the cause of any other thing or sort of thing; or indeed even that everything must at least have some cause of its being or occurring.

[4] Stoicism was a philosophical school founded by Zeno of Citium around 300 BCE, and named after the Stoa Poikile, the place where Zeno taught. "Ethereal fire" is thought of as one of two radically different sorts of stuff; spiritual beings being composed of this sort in the way that material things are made of matter.

Paradoxically, there would seem to be little substantial difference between this Stoic view and that of their Epicurean opponents; who maintained that human souls were composed of "exceptionally minute" (material) "particles of very fine texture". Compare Lucretius, *On the Nature of Things,* Book III.

consciousness, or that system of thought, which they formed during life, may be continually dissolved by death; and nothing interest them in the new modification. The most positive asserters of the mortality of the soul, never denied the immortality of its substance. And that an immaterial substance, as well as a material, may lose its memory or consciousness appears, in part, from experience, if the soul be immaterial.

Reasoning from the common course of nature, and without supposing any *new* interposition of the supreme cause, which ought always to be excluded from philosophy; what is incorruptible must also be ingenerable. The soul, therefore, if immortal, existed before our birth: And if the former state of existence no wise concerned us, neither will the latter.

Animals undoubtedly feel, think, love, hate, will, and even reason, tho' in a more imperfect manner than man. Are their souls also immaterial and immortal?

II. Let us now consider the *moral* arguments, chiefly those arguments derived from the justice of God, which is supposed to be further interested in the further punishment of the vicious, and reward of the virtuous.

But these arguments are grounded on the supposition that God has attributes beyond what he has exerted in this universe, with which alone we are acquainted. Whence do we infer the existence of these attributes?[5]

It is very safe for us to affirm that whatever we know the deity to have actually done is best, but it is very dangerous to affirm that he must always do what to us seems best. In how many instances would this reasoning fail us with regard to the present world?

But if any purpose of nature be clear, we may affirm that the whole scope and intention of man's creation, so far as we

[5] It is, Hume is urging, unsound to the point of perversity to argue: from the notorious fact that in the world we know people do not always secure their good or suffer their ill deserts; to the contrary conclusion that in the end we do, simply because the inferred Creator of that same world must surely ensure that ultimately things are not as immediately they seem to be.

can judge by natural reason, is limited to the present life. With how weak a concern, from the original, inherent structure of the mind and passions, does he ever look farther? What comparison either for steadiness or efficacy, between so floating an idea, and the most doubtful persuasion of any matter of fact that occurs in common life.

There arise, indeed, in some minds, some unaccountable terrors with regard to futurity: But these would quickly vanish, were they not artificially fostered by precept and education. And those who foster them; what is their motive? Only to gain a livelihood, and to acquire power and riches in this world. Their very zeal and industry, therefore, are an argument against them.

What cruelty, what iniquity, what injustice in nature, to confine thus all our concern, as well as all our knowledge, to the present life, if there be another scene still awaiting us, of infinitely greater consequence? Ought this barbarous deceit to be ascribed to a beneficent and wise being?

Observe with what exact proportion the task to be performed and the performing powers are adjusted throughout all nature. If the reason of man gives him a great superiority above other animals, his necessities are proportionately multiplied upon him. His whole time, his whole capacity, activity, courage, passion, find sufficient employment in fencing against[6] the miseries of his present condition. And frequently, nay almost always, are too slender for the business assigned them.

A pair of shoes, perhaps, was never yet wrought to the highest degree of perfection which that commodity is capable of attaining. Yet is it necessary, at least very useful, that there should be some politicians and moralists, even some geometers, historians, poets, and philosophers among mankind.

The powers of men are no more superior to their wants, considered merely in this life, than those of foxes and hares are, compared to *their* wants and to *their* period of existence. The inference from parity of reason is therefore obvious.

On the theory of the soul's mortality, the inferiority of women's capacity is easily accounted for: Their domestic life

[6] Erecting a fence against.

requires no higher faculties either of mind or body.[7] This circumstance vanishes and becomes absolutely insignificant, on the religious theory: The one sex has an equal task to perform with the other: Their powers of reason and resolution ought also to have been equal, and both of them infinitely greater than at present.

As every effect implies a cause, and that another, till we reach the first cause of all, which is the *Deity,* everything that happens is ordained by him, and nothing can be the object of his punishment or vengeance.

By what rule are punishments and rewards distributed? What is the divine standard of merit and demerit? Shall we suppose that human sentiments have place in the deity? However bold that hypothesis, we have no conception of any other sentiments.

According to human sentiments, sense, courage, good manners, industry, prudence, genius, &c. are essential parts of personal merit. Shall we therefore erect an Elysium for poets and heroes, like that of the ancient mythology?[8] Why confine all rewards to one species of virtue?

Punishment, without any proper end or purpose, is inconsistent with *our* ideas of goodness and justice; and no end can be served by it after the whole scene is closed.

Punishment, according to *our* conceptions, should bear some proportion to the offence. Why then eternal punishment

[7] Those riled by this throwaway remark will no doubt wish to call into account a note to Hume's Essay 'Of National Characters', which begins: "I am apt to suspect the negroes to be naturally inferior to the whites. There scarcely ever was a civilized nation of that complexion, nor even any individual eminent either in action or speculation. No ingenious manufactures amongst them, no arts, no sciences." But then such cavillers ought to go on to recognize that on both counts, Hume was, if anything, ahead of his time. For, well before the beginnings of any organized movement against slavery, in his essay 'Of the Populousness of Ancient Nations', Hume makes out a most emphatic case against that institution; while in his personal relations he was far indeed from being a 'male chauvinist pig'.

[8] Homer speaks of the Elysian Plain and Hesiod of the Isles of the Blessed as places to which those specially favored by the gods are transported. Later authors depict Elysium as the abode in Hades of the blessed dead.

for the temporary offences of so frail a creature as man? Can any one approve of *Alexander's* rage, who intended to exterminate a whole nation, because they had seized his favourite horse, *Bucephalus?*[9]

Heaven and hell suppose two distinct species of men, the good and the bad. But the greatest part of mankind float between vice and virtue.

Were one to go round the world with an intention of giving a good supper to the righteous and a sound drubbing to the wicked, he would frequently be embarrassed in his choice, and would find, that the merits and demerits of most men and women scarcely amount to the value of either.

To suppose measures of approbation and blame different from the human confounds everything. Whence do we learn, that there is such a thing as moral distinctions but from our own sentiments?

What man, who has not met with personal provocation (or what good natured man who has) could inflict on crimes, from the sense of blame alone, even the common, legal, frivolous punishments? And does anything steel the breast of judges and juries against the sentiments of humanity but reflections on necessity and public interest?

By the Roman law, those who had been guilty of parricide[10] and confessed their crime were put into a sack, along with an ape, a dog, and a serpent, and thrown into the river: Death alone was the punishment of those, who denied their guilt, however fully proved. A criminal was tried before *Augustus,* and condemned after full conviction: But the humane emperor, when he put the last interrogatory, gave it such a turn as to lead the wretch into a denial of his guilt. *You surely,* said the prince, *did not kill your father?*[11] This lenity suits our natural ideas of RIGHT, even towards the greatest of all criminals, and even tho' it prevents so inconsiderable a sufferance. Nay, even

[9] Hume refers readers to Quintus Curtius, *History of Alexander,* VI: 5. This is, of course, Alexander of Macedon, rated 'the Great' (356–323 BCE).

[10] Murder of a close relative. Parricide thus embraces patricide (murder of one's father).

[11] Hume refers readers to Suetonius, *Augustus,* 3. Augustus was the first Roman Emperor.

the most bigotted priest would naturally, without reflection, approve of it, provided the crime was not heresy or infidelity. For as these crimes hurt himself in his *temporal* interests and advantages, perhaps he may not be altogether so indulgent to them.

The chief source of moral ideas is the reflection on the interests of human society. Ought these interests, so short, so frivolous, to be guarded by punishments, eternal and infinite? The damnation of one man is an infinitely greater evil in the universe than the subversion of a thousand million of kingdoms.

Nature has rendered human infancy peculiarly frail and mortal; as it were on purpose to refute the notion of a probationary state. The half of mankind die before they are rational creatures.[12]

III. The *physical* arguments from the analogy of nature are strong for the mortality of the soul; and these are really the only philosophical arguments which ought to be admitted with regard to this question, or indeed any question of fact.

Where any two objects are so closely connected that all alterations which we have ever seen in the one are attended with proportionable alterations in the other, we ought to conclude, by all rules of analogy, that, when there are still greater alterations produced in the former, and it is totally dissolved, there follows a total dissolution of the latter.

Sleep, a very small effect on the body, is attended with a temporary extinction; at least, a great confusion in the soul.

The weakness of the body and that of the mind in infancy are exactly proportioned; their vigor in manhood; their sympathetic disorder in sickness; their common gradual decay in old age. The step further seems unavoidable; their common dissolution in death.

The last symptoms which the mind discovers are disorder, weakness, insensibility, stupidity, the forerunners of its anni-

[12] "Although our information is fragmentary, there is reason to believe that in every part of Europe before the Industrial Revolution, for every 1,000 births, from 150 to 350 died before reaching one year of age, and another 100 to 200 died before reaching ten" (Carlo M. Cipolla, *Before the Industrial Revolution;* New York: Norton, 1976).

hilation. The further progress of the same causes, increasing the same effects, totally extinguish it.

Judging by the usual analogy of nature, no form can continue, when transferred to a condition of life very different from the original one, in which it was placed. Trees perish in the water; fishes in the air; animals in the earth. Even so small a difference as that of climate is often fatal. What reason then to imagine that an immense alteration, such as is made on the soul by the dissolution of its body and all its organs of thought and sensation, can be effected without the dissolution of the whole?

Everything is in common between soul and body. The organs of the one are all of them the organs of the other. The existence therefore of the one must be dependent on that of the other.

The souls of animals are allowed to be mortal; and these bear so near a resemblance to the souls of men, that the analogy from one to the other forms a very strong argument. Their bodies are not more resembling; yet no one rejects the arguments drawn from comparative anatomy. The *Metempsychosis* is therefore the only system of this kind, that philosophy can so much as hearken to.[13]

Nothing in this world is perpetual. Every being, however seemingly firm, is in continual flux and change: The world itself gives symptoms of frailty and dissolution: How contrary to analogy, therefore, to imagine that one single form, seemingly the frailest of any, and from the slightest causes, subject to the greatest disorders, is immortal and indissoluble? What a daring theory is that! How lightly, not to say, how rashly entertained!

How to dispose of the infinite number of posthumous existences ought also to embarrass the religious theory. Every planet, in every solar system, we are at liberty to imagine peopled with intelligent, mortal beings: At least, we can fix on no other supposition. For these, then, a new universe must, every generation, be created, beyond the bounds of the present universe; or one must have been created at first so prodigiously

[13] Metempsychosis is the doctrine of reincarnation, or transmigration of souls.

wide as to admit of this continual influx of beings. Ought such bold suppositions to be received by any philosophy; and that merely on pretence of a bare possibility?[14]

When it is asked whether *Agamemnon, Thersites, Hannibal, Nero,* and every stupid clown that ever existed in *Italy, Scythia, Bactria,* or *Guinea,* are now alive,[15] can any man think, that a scrutiny of nature will furnish arguments strong enough to answer so strange a question in the affirmative? The want of arguments, without revelation, sufficiently establishes the negative.

"How much easier," says *Pliny,* and safer for each to trust in himself, and for us to derive our idea of (future) tranquillity from our experience of it before birth!"[16] Our insensibility,

[14] Against this 'population explosion' objection (which retains some force even though we now believe that few, if any, other planets are inhabited) it is customary to come back with a reminder that souls are supposed to be incorporeal; and that, since they can therefore take up no space, no such accommodation problems could arise. But this counter surely passes Hume by. For he has just now argued that spirits must be composed of a kind of spiritual stuff or substance; which would, presumably, be just as much spatially extended as the Epicurean "exceptionally minute particles of very fine texture". Compare also what Hume has to say about the repugnance to common experience of "mind without body" in Part VI of the *Dialogues* (pp. 233ff, below). This contrasts sharply with his own treatment in the *Treatise* of the problem of personal identity—the problem, that is to say, of what it means to say that this at Time 1 is the same person as that at Time 2. For Hume there took it absolutely for granted that people, or at any rate 'selves' must be either incorporeal subjects of experience, or else some sort of collections of unowned experiences. The modern mortalist is best advised to start by insisting that people are, as we are, creatures of flesh and blood and bone; and then to challenge all comers first to give sense to the idea of incorporeal substances as subjects of experience, and after that to show how the kind of entities thus hypothesized could be identified with creatures such as we. Compare, for instance, Antony Flew, *The Logic of Mortality* (Oxford: Blackwell, 1987).

[15] Agamemnon and Thersites are characters in *The Iliad.* Hannibal (247–183/2 BCE) was the most successful of Carthaginian generals in war against Rome. Nero was Roman Emperor 54–68. Scythia and Bactria were remote territories on or beyond the borders of the Roman Empire.

[16] Hume gives this quotation in the original Latin, adding a footnote reference to Pliny's *Natural History,* II 5.

before the composition of the body, seems to natural reason a proof of a like state after its dissolution.

Were our horror of annihilation an original passion, not the effect of our general love of happiness, it would rather prove the mortality of the soul. For as nature does nothing in vain, she would never give us a horror against an impossible event. She may give us a horror against an unavoidable event, provided our endeavours, as in the present case, may often remove it to some distance. Death is in the end unavoidable; yet the human species could not be preserved, had not nature inspired us with an aversion towards it.

All doctrines are to be suspected which are favoured by our passions. And the hopes and fears which give rise to this doctrine are very obvious.

It is an infinite advantage in every controversy, to defend the negative. If the question be out of the common experienced course of nature, this circumstance is almost, if not altogether, decisive. By what arguments or analogies can we prove any state of existence which no one ever saw, and which no wise resembles any that ever was seen? Who will repose such trust in any pretended philosophy as to admit upon its testimony the reality of so marvellous a scene? Some new species of logic is requisite for that purpose, and some new faculties of the mind, which may enable us to comprehend that logic.

Nothing could set in a fuller light the infinite obligations, which mankind have to divine revelation, since we find that no other medium could ascertain this great and important truth.

2. Of Suicide

One considerable advantage that arises from philosophy consists in the sovereign antidote which it affords to superstition and false religion. All other remedies against that pestilent distemper[1] are vain, or, at least, uncertain. Plain good sense, and the practice of the world, which alone serve most purposes of life, are here found ineffectual: History as well as daily experience affords instances of men, endowed with the strongest capacity for business and affairs, who have all their lives crouched under slavery to the grossest superstition. Even gaiety and sweetness of temper, which infuse a balm into every other wound, afford no remedy to so virulent a poison; as we may particularly observe of the fair sex, who, tho' commonly possessed of these rich presents of nature, feel many of their joys blasted by this importunate intruder. But when sound philosophy has once gained possession of the mind, superstition is effectually excluded; and one may safely affirm that her triumph over this enemy is more complete than over most of the vices and imperfections, incident to human nature. Love or anger, ambition or avarice, have their root in the temper and affections, which the soundest reason is scarce ever able fully to correct. But superstition, being founded on false opinion, must immediately vanish when true philosophy has inspired juster sentiments of superior powers. The contest is here more equal between the distemper and the medicine: And nothing can hinder the latter from proving effectual, but its being false and sophisticated.[2]

It will here be superfluous to magnify the merits of philosophy, by displaying the pernicious tendency of that vice,

[1] Disease.

[2] Corrupted or adulterated.

of which it cures the human mind. The superstitious man, says *Tully*,[3] is miserable in every scene, in every incident of life. Even sleep itself, which banishes all other cares of unhappy mortals, affords to him matter of new terror, while he examines his dreams and finds in those visions of the night prognostications of future calamities. I may add that, tho' death alone can put a full period to his misery, he dares not fly to this refuge, but still prolongs a miserable existence, from a vain fear, lest he offend his maker by using the power with which that beneficent being has endowed him. The presents of God and Nature are ravished from us by this cruel enemy, and notwithstanding that one step would remove us from the regions of pain and sorrow, her menaces still chain us down to a hated being,[4] which she herself chiefly contributes to render miserable.

'Tis observed of such as have been reduced by the calamities of life to the necessity of employing this fatal remedy, that if the unseasonable care of their friends deprive them of that species of death which they proposed to themselves, they seldom venture upon any other, or can summon up so much resolution, a second time, as to execute their purpose. So great is our horror of death that when it presents itself under any form, besides that to which a man has endeavoured to reconcile his imagination, it acquires new terrors, and overcomes his feeble courage. But when the menaces of superstition are joined to this natural timidity, no wonder it quite deprives men of all power over their lives; since even many pleasures and enjoyments, to which we are carried by a strong propensity, are torn from us by this inhuman tyrant. Let us here endeavour to restore men to their native liberty, by examining all the common arguments against Suicide, and shewing that that action may be free from every imputation of guilt or blame; according to the sentiments of all the ancient philosophers.[5]

[3] 'Tully' was in Hume's day the universally accepted nickname for Marcus Tullius Cicero (106–43 BCE). Hume here makes a footnote reference to Cicero's *De Divinatione* (On Divination), II 72.

[4] Existence.

[5] For Hume the ancient world is that of Classical Greece and Rome.

If Suicide be criminal, it must be a transgression of our duty, either to God, our neighbour, or ourselves.

To prove that Suicide is no transgression of our duty to God, the following considerations may perhaps suffice. In order to govern the material world, the almighty creator has established general and immutable laws, by which all bodies, from the greatest planet to the smallest particle of matter, are maintained in their proper sphere and function. To govern the animal world, he has endowed all living creatures with bodily and mental powers, with senses, passions, appetites, memory, and judgement, by which they are impelled or regulated in that course of life to which they are destined. These two distinct principles of the material and animal world continually encroach upon each other, and mutually retard or forward each other's operation. The powers of men and of all other animals are restrained and directed by the nature and qualities of the surrounding bodies; and the modifications and actions of these bodies are incessantly altered by the operation of all animals. Man is stopped by rivers in his passage over the surface of the earth, and rivers, when properly directed, lend their force to the motion of machines, which serve to the use of man. But tho' the provinces of

Recognizing differences between the morality of that world and the morality of the times in which he lived, he was himself inclined to identify with the ancients rather than the moderns, and to see these perceived differences as due to the distorting influence of Christianity.

Perhaps the greatest concern the particular form of suicide or assisted suicide now described as voluntary euthanasia. Writing to his brother, while serving as Secretary to an ill-stared "expedition, which was at first meant against Canada, but ended in an incursion on the coast of France", Hume told of the wretched death of his friend Major Forbes: "I found him with small remains of Life, wallowing in his own Blood, with the Arteries of his Arm cut asunder." Despite surgical assistance, it was clear he would not live. "Never a man expressed a more steady Contempt of Life nor more determined philosophical Principles, suitable to his Exit. He beg'd me to unloosen his Bandage & hasten his Death, as the last Act of Friendship I could show him: But alas! we live not in Greek or Roman times." Which might mean that Hume could not perform this Act, or that he could not report it.

the material and animal powers are not kept entirely separate, there result from thence no discord or disorder in the creation: On the contrary, from the mixture, union, and contrast of all the various powers of inanimate bodies and living creatures, arises that surprising harmony and proportion, which affords the surest argument of supreme wisdom.

The providence of the deity appears not immediately in any operation, but governs everything by those general and immutable laws which have been established from the beginning of time. All events, in one sense, may be pronounced the action of the almighty: They all proceed from those powers with which he has endowed his creatures. A house which falls by its own weight is not brought to ruin by his providence more than one destroyed by the hands of men, nor are the human faculties less his workmanship than the laws of motion and gravitation. When the passions play, when the judgment dictates, when the limbs obey; this is all the operation of God; and upon these animate principles, as well as upon the inanimate, has he established the government of the universe.

Every event is alike important in the eyes of that infinite being, who takes in, at one glance, the most distant regions of space and remotest periods of time. There is no one event, however important to us, which he has exempted from the general laws that govern the universe, or which he has peculiarly reserved for his own immediate action and operation. The revolutions of states and empires depend upon the smallest caprice or passion of single men; and the lives of men are shortened or extended by the smallest accident of air or diet, sunshine or tempest. Nature still continues her progress and operation; and if general laws be ever broke by particular volitions of the deity, 'tis after a manner which entirely escapes human observation.[6] As on

[6] Hume is here taking for granted conclusions for which he had argued in 'Of Miracles' (IV.1 below). His contention is methodological: allowing that such miraculous over-ridings could conceivably occur, he argues that, even if they did, they could not be identified by natural reason and without benefit of revelation.

the one hand, the elements and other inanimate parts of the creation carry on their action without regard to the particular interest and situation of men; so men are entrusted to their own judgement and discretion in the various shocks of matter, and may employ every faculty, with which they are endowed, in order to provide for their ease, happiness, or preservation.

What is the meaning, then, of that principle, that a man, who, tired of life, and hunted by pain and misery, bravely overcomes all the natural terrors of death, and makes his escape from this cruel scene; that such a man, I say, has incurred the indignation of his creator by encroaching on the office of divine providence and disturbing the order of the universe? Shall we assert, that the Almighty has reserved to himself, in any peculiar manner, the disposal of the lives of men, and has not submitted that event, in common with others, to the general laws by which the universe is governed? This is plainly false. The lives of men depend upon the same laws as the lives of all other animals; and these are subjected to the general laws of matter and motion. The fall of a tower or the infusion of a poison will destroy a man equally with the meanest creature: An inundation sweeps away everything without distinction that comes within the reach of its fury. Since therefore the lives of men are for ever dependent on the general laws of matter and motion, is a man's disposing of his life criminal, because, in every case, it is criminal to encroach upon these laws or disturb their operation? But this seems absurd. All animals are entrusted to their own prudence and skill for their conduct in the world, and have full authority, as far as their power extends, to alter all the operations of nature. Without the exercise of this authority, they could not subsist a moment. Every action, every motion of a man innovates in the order of some parts of matter, and diverts, from their ordinary course, the general laws of motion. Putting together, therefore, these conclusions, we find *that* human life depends upon the general laws of matter and motion, and *that* 'tis no encroachment on the office of providence to disturb or alter these general laws. Has not everyone, of consequence, the free disposal of his own life? And may he not

lawfully employ that power with which nature has endowed him?[7]

In order to destroy the evidence of this conclusion, we must shew a reason, why this particular case is excepted. Is it because human life is of so great importance, that it is a presumption for human prudence to dispose of it? But the life of man is of no greater importance to the universe than that of an oyster. And were it of ever so great importance, the order of nature has actually submitted it to human prudence, and reduced us to a necessity, in every incident, of determining concerning it.

Were the disposal of human life so much reserved as the peculiar province of the almighty that it were an encroachment on his right for men to dispose of their own lives; it would be equally criminal to act for the preservation of life as for its destruction. If I turn aside a stone, which is falling upon my head, I disturb the course of nature, and I invade the peculiar province of the almighty, by lengthening out my life, beyond the period, which, by the general laws of matter and motion, he had assigned to it.

A hair, a fly, an insect is able to destroy this mighty being, whose life is of such importance. Is it an absurdity to suppose, that human prudence may lawfully dispose of what depends on such insignificant causes?

It would be no crime in me to divert the *Nile* or *Danube* from its course, were I able to effect such purposes. Where then is the crime of turning a few ounces of blood from their natural channels!

Do you imagine that I repine[8] at providence or curse my creation, because I go out of life, and put a period to a being, which, were it to continue, would render me miserable? Far be such sentiments from me. I am only convinced of a matter of fact, which you yourself acknowledge possible, that human life

[7] Implicit in Hume's challenge here to the idea of a particular Divine proscription of suicide is a general challenge to the then universal assumption that not only are there Divinely ordained and sustained (descriptive) laws of nature; but also there is a Divinely ordained and sustained (prescriptive and proscriptive, moral) Law of Nature.

[8] Complain.

may be unhappy, and that my existence, if further prolonged, would become uneligible. But I thank providence, both for the good which I have already enjoyed and for the power with which I am endowed of escaping the ill that threatens me: "Let us thank God that no man can be kept in life."[9]

To you it belongs to repine at providence, who foolishly imagine that you have no such power, and who must still prolong a hated being, tho' loaded with pain and sickness, with shame and poverty.

Do you not teach that when any ill befalls me, tho' by the malice of my enemies, I ought to be resigned to providence, and that the actions of men are the operations of the almighty as much as the actions of inanimate beings? When I fall upon my own sword, therefore, I receive my death equally from the hands of the deity, as if it had proceeded from a lion, a precipice, or a fever.

The submission which you require to providence in every calamity that befalls me excludes not human skill and industry, if possibly, by their means, I can avoid or escape the calamity. And why may I not employ one remedy as well as another?

If my life be not my own, it were criminal for me to put it in danger, as well as to dispose of it: Nor could one man deserve the appellation of *Hero,* whom glory or friendship transports into the greatest dangers, and another merit the reproach of *Wretch* or *Miscreant,* who puts a period to his life, from the same or like motives.

There is no being which possesses any power or faculty that it receives not from its creator, nor is there any one which, by ever so irregular an action, can encroach upon the plan of his providence, or disorder the universe. Its operations are his work equally with that chain of events, which it invades, and whichever principle prevails, we may, for that very reason, conclude it to be most favoured by him. Be it animate or inanimate, rational or irrational, 'tis all a case: Its power is still derived from the supreme creator, and is alike comprehended in the order of his providence.

[9] Hume gave this quotation from Seneca, *Epistles,* 'On Old Age', XII 10, in Latin, as a footnote.

When the horror of pain prevails over the love of life: When a voluntary action anticipates the effect of blind causes; it is only in consequence of those powers and principles, which he has implanted in his creatures. Divine providence is still inviolate, and placed far beyond the reach of human injuries.

It is impious, says the old *Roman* superstition,[10] to divert rivers from their course, or invade the prerogatives of nature. 'Tis impious, says the *French* superstition, to inoculate for the small-pox, or usurp the business of providence, by voluntarily producing distempers and maladies. 'Tis impious, says the modern *European* superstition, to put a period to our own life, and thereby rebel against our creator. And why not impious, say I, to build houses, cultivate the ground, and sail upon the ocean? In all these actions, we employ our powers of mind and body to produce some innovation in the course of nature, and in none of them do we any more. They are all of them, therefore, equally innocent or equally criminal.

But you are placed by providence, like a sentinel, in a particular station, and when you desert it, without being recalled, you are guilty of rebellion against your almighty sovereign, and have incurred his displeasure. I ask, why do you conclude that Providence has placed me in this station? For my part I find that I owe my birth to a long chain of causes, of which many and even the principal, depended upon voluntary actions of men. *But Providence guided all these causes, and nothing happens in the universe without its consent and co-operation.* If so, then neither does my death, however voluntary, happen without its consent, and whenever pain and sorrow so far overcome my patience as to make me tired of life, I may conclude that I am recalled from my station in the clearest and most express terms.

It is providence, surely, that has placed me at present in this chamber: But may I not leave it, when I think proper,

[10] Hume refers in a note to Tacitus *Annals,* I 79, a chapter which recounts a debate in the Roman senate over whether or not the tributaries of the Tiber should be altered. Tacitus observes that whatever the deciding factor—the protests from sections of the public, the difficulty of the work, or a superstitious reluctance to alter the course assigned to rivers by nature—Piso's motion "that nothing be changed" was agreed to.

without being liable to the imputation of having deserted my post or station? When I shall be dead, the principles of which I am composed will still perform their part in the universe, and will be equally useful in the grand fabric as when they composed this individual creature. The difference to the whole will be no greater than between my being in a chamber and in the open air. The one change is of more importance to me than the other, but not more so to the universe.

It is a kind of blasphemy to imagine that any created being can disturb the order of the world, or invade the business of providence. It supposes, that that being possesses powers and faculties, which it received not from its creator, and which are not subordinate to his government and authority.[11] A man may disturb society, no doubt, and thereby incur the displeasure of the almighty: But the government of the world is placed far beyond his reach and violence. And how does it appear that the almighty is displeased with those actions that disturb society? By the principles which he has implanted in human nature, and which inspire us with a sentiment of remorse, if we ourselves have been guilty of such actions, and with that of blame and disapprobation, if we ever observe them in others. Let us now examine, according to the method proposed, whether Suicide be of this kind of actions, and be a breach of our duty to our *neighbour* and to society.

A man who retires from life does no harm to society. He only ceases to do good, which, if it be an injury, is of the lowest kind.

All our obligations to do good to society seem to imply something reciprocal. I receive the benefits of society, and therefore ought to promote its interest. But when I withdraw myself altogether from society, can I be bound any longer?

But allowing, that our obligations to do good were perpetual, they have certainly some bounds. I am not obliged to do a

[11] To appreciate the full force of Hume's argument, it is essential to appreciate that theists conceive their Creator not only or even primarily as a First Cause setting everything off 'in the beginning', but also thereafter and for ever as the sustaining and controlling cause of everything within the thus created Universe.

small good to society, at the expense of a great harm to myself.
Why then should I prolong a miserable existence, because of
some frivolous advantage which the public may, perhaps,
receive from me? If upon account of age and infirmities, I may
lawfully resign any office, and employ my time altogether in
fencing against these calamities, and alleviating, as much as
possible, the miseries of my future life: Why may I not cut
short these miseries at once by an action, which is no more
prejudicial to society?

But suppose that it is no longer in my power to promote the
interest of the public: Suppose that I am a burden to it:
Suppose that my life hinders some person from being much
more useful to the public. In such cases my resignation of life
must not only be innocent but laudable. And most people who
lie under any temptation to abandon existence are in some
such situation. Those who have health, or power, or author-
ity, have commonly better reason to be in humour with the
world.

A man is engaged in a conspiracy for the public interest, is
seized upon suspicion, is threatened with the rack, and knows,
from his own weakness, that the secret will be extorted from
him: Could such a one consult the public interest better than
by putting a quick period to a miserable life? This was the case
of the famous and brave *Strozzi* of *Florence*.[12]

Again, suppose a malefactor justly condemned to a shame-
ful death; can any reason be imagined, why he may not
anticipate his punishment, and save himself all the anguish of
thinking on its dreadful approaches? He invades the business
of providence no more than the magistrate did, who ordered
his execution, and his voluntary death is equally advantageous
to society, by ridding it of a pernicious member.

That Suicide may often be consistent with interest and

[12] Filippo Strozzi (1489–1538), a leading Florentine banker and for
most of this life a supporter of the Medici in Florence and at the papal
court in Rome, was best remembered by later generations for his opposi-
tion to the Medici dukes of Florence, Alessandro, and Cosimo. In our
time there are, of course, all too abundant examples of members of
resistance movements needing to take quick-acting poisons lest captured
they should under torture reveal the names and activities of their associ-
ates.

with our duty to *ourselves,* no one can question, who allows, that age, sickness, or misfortune may render life a burden, and make it worse even than annihilation. I believe that no man ever threw away life while it was worth keeping. For such is our natural horror of death that small motives will never be able to reconcile us to it. And tho' perhaps the situation of a man's health or fortune did not seem to require this remedy, we may at least be assured, that anyone who, without apparent reason, has had recourse to it, was cursed with such an incurable depravity or gloominess of temper as must poison all enjoyment, and render him equally miserable as if he had been loaded with the most grievous misfortunes.

If Suicide be supposed a crime, 'tis only cowardice can impel us to it. If it be no crime, both prudence and courage should engage us to rid ourselves at once of existence, when it becomes a burden. It is the only way that we can then be useful to society, by setting an example which, if imitated, would preserve to everyone his chance for happiness in life, and would effectually free him from all danger of misery.[13]

It would be easy to prove that Suicide is as lawful under the *Christian* dispensation as it was to the heathens. There is not a single text of Scripture which prohibits it. That great and infallible rule of faith and practice, which must control all philosophy and human reasoning, has left us, in this particular, to our natural liberty. Resignation to providence is, indeed, recommended in Scripture; but that implies only submission to ills which are unavoidable, not to such as may be remedied by prudence or courage. *Thou shalt not kill* is evidently meant to exclude only the killing of others, over whose life we have no authority.[14] That this precept like most of the Scripture precepts must be modified by reason and common sense, is plain from the practice of magistrates, who

[13] In Hume's original the following, final paragraph is a footnote.

[14] The alternative and surely superior translation of this Commandment is 'Thou shalt do no murder'. This was clearly the interpretation followed by St. Augustine in his contention—thereafter for several centuries accepted as authoritative by all Christians—that suicide is to be categorically and unreservedly condemned as 'self-murder'. (Opponents have proposed and ridiculed a parallel proscription of intra-marital sexual relations as 'own-spouse adultery'.)

punish criminals capitally, notwithstanding the letter of this law.[15] But were this commandment ever so express against Suicide, it could now have no authority. For all the law of *Moses* is abolished, except so far as it is established by the Law of Nature, and we have already endeavoured to prove that Suicide is not prohibited by that law. In all cases, *Christians* and *Heathens* are precisely upon the same footing, and if *Cato* and *Brutus, Arria* and *Portia* acted heroically, those who now imitate their example ought to receive the same praise from posterity. The power of committing Suicide is regarded by *Pliny* as an advantage which men possess even above the Deity himself. "God cannot even if he wishes, commit suicide, the supreme boon that he has bestowed on man among all the afflictions of life."[16]

[15] Hume is arguing that "Thou shalt not kill" cannot be taken literally, for this would prohibit capital punishment, which was extremely common for a great many offences in Hume's time.

[16] This quotation from Pliny, *Natural History,* II 7, was given by Hume in the original Latin. Cato and Brutus, Arria and Portia were all 'ancients', the stories of whose suicides would have been known to all Hume's contemporary, Classically educated readers.

PART IV

Two Scandalous Sections

An Introduction to 'Two Scandalous Sections'

Like so many young authors before and since, Hume was disappointed with the reception of his first book. *A Treatise of Human Nature* "fell dead-born from the press," he was to write in an autobiographical fragment,[1] adding, significantly, "without reaching such distinction as even to excite a murmur among the zealots." ('Zealot' was his favourite term of abuse for enthusiastic and intolerant religious believers.) Several years later, because "I had always entertained a notion, that my want of success in publishing the *Treatise of Human Nature,* had proceeded more from the manner than the matter, . . . I . . . cast the first part of that work anew in the *Enquiry concerning Human Understanding . . .*"

This first *Enquiry*—it was to be followed by *An Enquiry concerning the Principles of Morals*—is very far from being simply a revised edition of Book I of the *Treatise.* Much that posterity has learnt to value in the *Treatise* has no successor here, while of its twelve sections (chapters) two have no predecessors in the *Treatise* as published. Section X 'Of Miracles' was surely based on something excised from the manuscript as not fit to be seen by "the good Doctor" (Joseph Butler). Although we have no direct evidence the same is probably true of Section XI. But, whereas in Section X the argument is presented in a way calculated to infuriate "the zealots", in Section XI Hume employed several artifices to ensure that,

[1] Reprinted in Antony Flew (ed.), *David Hume: An Enquiry concerning Human Understanding* (Open Court, 1988).

though stated clearly, its full significance might escape the careless reader; as it often has done, and still does.[2]

To appreciate the force of Hume's argument, it is helpful to consider Section XI *before* Section X. The original title of Section XI was 'Of the Practical Consequences of Natural Religion.' Certainly it does treat that subject, arguing that no such consequences can validly be drawn. But in fact it goes much further, launching an all-out attack upon the one sort of argument for which Hume always retained some respect. It was, presumably, in order to avert zealot attention from this wider assault that, when later he decided to alter that original title, Hume changed it to 'Of a Particular Providence and Of a Future State' rather than to 'The Religious Hypothesis'.

Sections XI and X form a complementary pair, designed to discredit the two successive stages of the traditional rational apologetic; an apologetic the acceptance of the validity of which became defined dogma of Roman Catholicism by decrees of the First Vatican Council of 1870–71.[3]

Stage One consisted in an attempt to establish the existence of God by appealing only to natural reason. In Stage Two the resulting, somewhat sketchy, religion of nature was to be supplemented by a more abundant revelation. The validity of the revelation claims was to be itself established by reference to supposedly sufficient evidence for the actual historical occurrence of endorsing or constitutive miracles. (By supernaturally overriding the ordinary laws of nature God himself authorizes and *endorses* the claims of one particular candidate revelation; whereas the alleged physical resurrection of Jesus bar Joseph surely *constitutes* part of the very essence of the Christian revelation.)

Having disposed (earlier in the *Enquiry*) of all arguments presupposing *a priori* knowledge about causation, Hume proceeds to address himself to arguments which, while still concerned with causes, are nevertheless arguments from expe-

[2] See Antony Flew, *God, Freedom, and Immortality* (Buffalo: Prometheus, 1984), Chapter 3.

[3] See H. Denzinger (ed.) *Enchiridion Symbolorum* (Freiberg in Breisgau: Herder, Twenty-ninth Revised Edition, 1953), 1806 and 1813.

rience. He proceeds, that is, to assail what he calls "the religious hypothesis". To appreciate the flavour of this phrase we need to remember that Hume wrote under the enormous shadow of "the incomparable Mr. Newton", and that he is throughout following most faithfully the 'Rules of Reasoning in Philosophy' given in Newton's *Principia*.

Newton had ruled that "We are to admit no more causes of natural things than such as are both true and sufficient to explain their appearances."[4] So Hume insisted: "When we infer any particular cause from an effect, we must proportion the one to the other, and can never be allowed to ascribe to the cause any qualities, but what are exactly sufficient to produce the effect."

Again, for Newton, and hence for Hume too, 'hypothesis' could be a bad word. Thus Newton rules that "Whatever is not deduced from the phenomena is to be called an hypothesis; and hypotheses, whether metaphysical or physical, whether of occult qualities or mechanical, have no place in experimental philosophy."[5] So Hume had subtitled the *Treatise* "An Attempt to introduce the Experimental Method of Reasoning into Moral Subjects".[6]

When Hume speaks of "the religious hypothesis", therefore, this phrase for his contemporaries did not have only the piquancy which it still possesses for the modern reader. Religious propositions are, after all, normally put forward, not as corrigible suggestions for further investigation, but as categorically certain truths demanding total personal commitment. The same phrase in Hume also carries important allusive overtones of offence. The suggestion is of arbitrary, gratuitous, unwarranted and—worst of all—un-Newtonian speculation.

[4] F. Cajori (ed.) *Newton's Principia* (Berkeley: University of California Press, 1946), p. 398.

[5] *Ibid.*, p. 547.

[6] By "moral subjects" Hume understands human studies and, in his Introduction Hume makes it clear that by "experimental" he means 'appealing to experience'. The verbal distinction between 'experience' and 'experiment' wasn't clearly established in the eighteenth century. To this day French uses the same word (*expérience*) for both.

Putting his words into the mouth of an 'Epicurus' defending himself against charges of antisocial unbelief, Hume begins by, in effect, defining "the religious hypothesis". It presupposes:

> that the chief or sole argument for a divine existence (which I never questioned) is derived from the order of nature; where there appear such marks of intelligence and design, that you think it extravagant to assign for its cause, either chance, or the blind and unguided force of matter. You allow, that this is an argument drawn from effects to causes. From the order of the work, you infer, that there must have been project and forethought in the workman. (Below, p. 92)

Hume's first strike here is to insist that no argument of this sort can enable us validly to conclude to the existence and operation of a First Cause in any way greater than is or was minimally necessary to produce the Universe as it actually is. At one blow this invalidates every practically interesting conclusion which anyone could wish to draw. The God of "the religious hypothesis" cannot satisfy the seeker after—in Matthew Arnold's famous phrase—"something, not ourselves, which makes for righteousness". It is impossible validly to argue that the God thus hypothesized is perfectly good, or in any way better or worse than the Universe the existence and characteristics of which that God is postulated to explain.

But Hume is still not done with "the religious hypothesis". After labouring the implications of that first strike he launches a second, this time in his own name:

> It is only when two *species* of objects are found to be constantly conjoined, that we can infer the one from the other If experience and observation and analogy be, indeed, the only guides which we can reasonably follow in inferences of this nature; both the effect and cause must bear a similarity . . . to other effects and causes, which we know, and which we have found, in many instances, to be conjoined with each other. I leave it to your own reflection to pursue the consequences of this principle the antagonists of Epicurus always suppose the Universe, an effect quite singular and unparalleled, to be a proof of a Deity, a cause no less singular and unparalleled . . . (p. 103)

The upshot, clearly, is that we cannot legitimately apply the ideas of cause and effect outside the Universe; not, that is, employ them, as in "the religious hypothesis" to ask and answer the question: 'What is its cause?' Not only is the hypothetical Cause unique, by definition; but the supposed Effect is also unique, again by definition. For, although there is a regrettable sense in which the Andromeda Nebula might be spoken of as 'an island universe', the Universe whose existence and regularities "the religious hypothesis" might be thought to explain is specified as including everything there is (with the exception of its possible Creator). One devastating consequence is that, however far back we may be able to trace the internal history of the Universe, there can be no question of arguing that this or that external origin is either probable or improbable. We do not have, and we necessarily could not have, experience of other Universes to tell us that Universes, or Universes with these particular features, are the work of Gods, or of Gods of this or that particular sort. To improve slightly on a famous remark by C. S. Peirce: "Universes, unlike universes, are not as plentiful as blackberries."

The conclusion, which I believe that Hume eventually drew, is that we must take the Universe itself and its most fundamental laws as being themselves the ultimates in terms of which everything which is explicable necessarily has to be explained. This is the position which Hume, following Bayle, identified as "the Stratonician atheism". (Strato of Lampsacus [died 269 BCE] was the next but one in succession to Aristotle as president of his university foundation, the Lyceum.) For the theist the explanatory ultimates are the existence and the will of God. For the Stratonician they have to be the existence of the Universe itself, and whatever scientists discover to be its most fundamental laws.

Since Hume, in the first *Enquiry,* is on the offensive, he engages with what logically is the second stage of the most traditional and rational apologetic first: Section XI is preceded by Section X. There Hume's first presentation of an argument which, he hopes, "will, with the wise and learned, be an everlasting check to all kinds of superstitions delusion", is made in terms of a crudely mechanical theory of the psychology of belief. Adequately to appreciate the force of his core argument it is necessary first to discount this mechanical

psychologizing and then to go on to grasp that—though he himself, of course, believes that miracles never do in fact occur—his contention here is methodological and epistemological rather than ontological. Hume's point, put with fewer polysyllables, is that, even if miracles had occurred, we could never, without benefit of some prior religious revelation, know that they had. Hence it is out of the question to employ the known occurrence of endorsing or constitutive miracles as our means for identifying the authentic revelation.

The heart of the matter is that the critical historian, both in identifying elements in the detritus of the past as evidence, and in employing and assessing that evidence in order to construct an account of what actually happened, has to be guided always by all that he knows, or believes that he knows, about what is probable or improbable, possible or impossible.[7] But, if an occurrence is to be accounted a miracle we must have the very best of experiential reasons for dismissing it as practically impossible. There is, therefore, bound to be a conflict between the evidence that the miracle occurred and the reasons why, had it occurred, it would have to be accounted miraculous. So it would seem that the most favourable verdict open to the critical historian, to whom a prior revelation has not been vouchsafed, is the appropriately and peculiarly Scottish, 'Not proven'.

Taken out of context, Sections X and XI may easily be misunderstood. They have indeed often been so taken, and mistaken. For instance: during the nineteenth century, in the edition in Sir John Lubbock's famous Hundred Books series, they were excised from the first *Enquiry* and printed as a supplement, under a remarkable note beginning: "These essays are generally omitted in popular editions of the writings of Hume." Again, in the original nineteenth-century 'Introduction' to what is still the standard edition of the two *Enquiries* together, the editor mistook these scandalous sections to be "quite superfluous" and irrelevant to the purposes of the first *Enquiry*.[8]

[7] For a fuller account, see the introduction to my edition of Hume's *Of Miracles* (Open Court, 1987).

[8] *Hume's Enquiries*, edited by L. A. Selby-Bigge, revised by P. H. Nidditch (Oxford: Clarendon, Third Edition 1975) p. viii.

But now, if we turn to Section I and learn from Hume himself what his project actually was, then it at once becomes obvious that their inclusion was crucial. For his stated aim was to draw the limits of the understanding "and discover the proper province of human reason." Distinguishing two "species of philosophy" he tries to justify his own presently preferred "profound and abstract" kind. Such philosophy:

> is objected to, not only as painful and fatiguing, but as the inevitable source of uncertainty and error. Here indeed lies the justest and most plausible objection against a considerable part of metaphysics, that they are not properly a science, but arise either from the fruitless efforts of human vanity, which would penetrate into subjects utterly inaccessible to the understanding, or from the craft of popular superstitions, which, being unable to defend themselves on fair ground, raise these entangling brambles to cover and protect their weakness. Chased from the open country, these robbers fly into the forest and lie in wait to break in upon every unguarded avenue of the mind, and overwhelm it with religious fears and prejudices.

What Hume surely had in mind in speaking of "the craft of popular superstitions" raising "entangling brambles" was, not only the Scholasticism so rollickingly abused by Hobbes in Chapter XLVI of his *Leviathan,* but also the philosophical theology of Locke and Clarke and Newton. "But is this", Hume goes on to ask, "a sufficient reason, why philosophers should desist from such researches, and leave superstition still in possession of her retreat? Is it not proper to draw an opposite conclusion, and perceive the necessity of carrying the war into the most secret recesses of the enemy?"

The purpose of the first *Enquiry* thus precisely is to carry this offensive through to total victory. Hume's strategy, as he explains, "is to enquire seriously into the nature of human understanding, and show, from an exact analysis of its powers and capacity, that it is by no means fitted for such remote and abstruse subjects." And, if we are to be so emancipated from religious fears and prejudices, then the biggest battle has to be the struggle to collapse the traditional two-stage rational apologetic.

In addressing himself to "the religious hypothesis" Hume assumed that all arguments presupposing any *a priori* knowl-

edge about causation had already been seen off. Certainly Sections IV–VII are devoted to expounding and defending all Hume's crucial conclusions about causality. But it is only in the last part of the final Section XII that he applies these conclusions to arguments about God. The notorious Ontological Argument, which contends that the statement that God exists is a logically necessary truth is put down in two peremptory sentences: "That the cube root of 64 is equal to the half of 10, is a false proposition, and can never be distinctly conceived. But that Caesar, or the angel Gabriel, or any being never existed, may be a false proposition, but still is perfectly conceivable, and implies no contradiction."

So there is room only for "the religious hypothesis"; which has been disposed of already. For:

> The existence . . . of any being can only be proved by arguments from its cause or its effect; and these arguments are founded entirely on experience. If we reason *a priori*, anything may appear able to produce anything. The falling of a pebble may, for aught we know, extinguish the sun; or the wish of a man control the planets in their orbits. It is only experience, which teaches us the nature and bounds of cause and effect, and enables us to infer the existence of one object from that of another.

But even that is not the whole of it. For there is also the second part of Section VIII 'Of Liberty and Necessity', the relevance of which is usually overlooked. It is overlooked mainly because Hume chooses to present what is in truth an emphatic enforcement of the central contention of the whole book as if he were attempting, rather awkwardly, to deal with an embarrassing objection. The 'objection' is that, on his principles:

> The ultimate Author of all our volitions is the Creator of the world, who first bestowed motion on this immense machine, and placed all beings in that particular position, whence every subsequent event, by an inevitable necessity, must result. Human actions, therefore, either can have no moral turpitude at all, as proceeding from so good a cause; or if they have any turpitude, they must involve our Creator in the same guilt, while he is acknowledged to be their ultimate cause and author.

Hume forebears to point out that everything here follows necessarily from the most fundamental assertion of all theism —as has indeed been admitted with greater or lesser degrees of frankness by every classical theologian, not only those customarily condemned as predestinarians but also those usually reckoned to be on this issue their opponents.[9] Hume instead pretends to be confronted with a dilemma:

> if human actions can be traced up, by a necessary chain, to the Deity, they can never be criminal; on account of the infinite perfection of that Being from whom they are derived, and who can intend nothing but what is altogether good and laudable. Or, . . . if they be criminal, we must retract the attribute of perfection, which we ascribe to the Deity, and must acknowledge him to be the ultimate author of guilt and moral turpitude in all his creatures.

This pretended dilemma is then employed as the means for establishing two of Hume's own most cherished theses. He categorically, and very elegantly, refuses to admit any theological invalidation of fundamental value distinctions. For "these distinctions are founded in the natural sentiments of the human mind: And these sentiments are not to be controlled or altered by any philosophical theory or speculation whatsoever."

The second horn is turned round similarly, to become a powerful support for Hume's aggressive agnosticism. It is not that, because of the shortage or the conflict of evidence, he cannot make up his mind. Instead, he contends, positively and without hesitations, that this is an area where knowledge is humanly impossible:

> These are mysteries, which mere natural and unassisted reason is very unfit to handle . . . To reconcile the indifference and contingency of human actions with prescience; or to defend absolute decrees, and yet free the Deity from being the author of sin, has been found hitherto to exceed all the power of philosophy. Happy, if she be thence sensible of her temerity, when she pries into these sublime

[9] For supporting texts from Aquinas, Luther, and of course the *Bible* compare Antony Flew and Godfrey Vesey *Agency and Necessity* (Oxford: Blackwell, 1987), pp. 84–89.

mysteries; and, leaving a scene so full of obscurities and perplexities, return, with suitable modesty, to her true and proper province, the examination of common life; where she will find difficulties enough to employ her enquiries, without launching into so boundless an ocean of doubt, uncertainty, and contradiction!

1. Of Miracles

PART I

There is, in Dr. TILLOTSON'S writings, an argument against the *real presence*, which is as concise, and elegant, and strong as any argument can possibly be supposed against a doctrine, so little worthy of a serious refutation.[1] It is acknowledged on all hands, says that learned prelate, that the authority, either of the scripture or of tradition, is founded merely in the testimony of the apostles, who were eye-witnesses to those miracles of our Saviour, by which he proved his divine mission. Our evidence, then, for the truth of the *Christian* religion is less than the evidence for the truth of our senses; because, even in the first authors of our religion, it was no greater; and it is evident it must diminish in passing from them to their disciples; nor can any one rest such confidence in their

[1] John Tillotson (1630–94) put forward this argument, which Hume summarizes, in his *Discourse against Transubstantiation,* published in 1684, seven years before he was appointed Archbishop of Canterbury. For Tillotson to have urged such an argument in that context is surprising. For it suggests that he failed to appreciate what the nub of the doctrine of transubstantiation actually is. Tillotson is apparently mistaking it to assert that at the Mass Christ is really present in a sense which is flagrantly contrary to all experience. The dogma in fact is less straightforward, and less easily intelligible. It does indeed begin by asserting a real presence, but this is immediately qualified in a way which should forestall any unsophisticated objections. The point comes out well in the second Canon adopted by the Council of Trent 'On the sacrament of the most holy Eucharist'. This Canon anathematizes anyone who "shall say that in the most holy sacrament of the Eucharist the substance of bread and wine remains . . . and shall deny that marvellous and singular conversion of the whole substance of the bread into the body, and of the whole substance of the wine into the blood, with the appearances of bread and wine remaining; which conversion the Catholic Church most aptly calls transubstantiation".

testimony, as in the immediate object of his senses. But a weaker evidence can never destroy a stronger, and therefore, were the doctrine of the real presence ever so clearly revealed in scripture, it were directly contrary to the rules of just reasoning to give our assent to it. It contradicts sense, though both the scripture and tradition on which it is supposed to be built carry not such evidence with them as sense; when they are considered merely as external evidences, and are not brought home to every one's breast by the immediate operation of the Holy Spirit.

Nothing is so convenient as a decisive argument of this kind, which must at least *silence* the most arrogant bigotry and superstition, and free us from their impertinent solicitations. I flatter myself that I have discovered an argument of a like nature, which, if just, will, with the wise and learned, be an everlasting check to all kinds of superstitious delusion, and consequently, will be useful as long as the world endures. For so long, I presume, will the accounts of miracles and prodigies be found in all history, sacred and profane.

Though experience be our only guide in reasoning concerning matters of fact; it must be acknowledged, that this guide is not altogether infallible, but in some cases is apt to lead us into errors. One who in our climate should expect better weather in any week of June than in one of December would reason justly, and conformably to experience, but it is certain that he may happen, in the event, to find himself mistaken. However, we may observe that in such a case he would have no cause to complain of experience, because it commonly informs us beforehand of the uncertainty, by that contrariety of events, which we may learn from a diligent observation. All effects follow not with like certainty from their supposed causes. Some events are found, in all countries and all ages, to have been constantly conjoined together: Others are found to have been more variable, and sometimes to disappoint our expectations; so that, in our reasonings concerning matter of fact, there are all imaginable degrees of assurance, from the highest certainty to the lowest species of moral evidence.[2]

[2] "Moral evidence" here means evidence from and about matters of fact. The contrast is with matters which can be demonstrated as deduci-

A wise man, therefore, proportions his belief to the evidence. In such conclusions as are founded on an infallible experience, he expects the event with the last degree of assurance, and regards his past experience as a full *proof* of the future existence of that event. In other cases, he proceeds with more caution: He weighs the opposite experiments:[3] He considers which side is supported by the greater number of experiments: to that side he inclines, with doubt and hesitation; and when at last he fixes his judgement, the evidence exceeds not what we properly call *probability*. All probability, then, supposes an opposition of experiments and observations, where the one side is found to overbalance the other, and to produce a degree of evidence, proportioned to the superiority. A hundred instances or experiments on one side and fifty on another afford a doubtful expectation of any event, though a hundred uniform experiments, with only one that is contradictory, reasonably beget a pretty strong degree of assurance. In all cases, we must balance the opposite experiments, where they are opposite, and deduct the smaller number from the greater, in order to know the exact force of the superior evidence.

To apply these principles to a particular instance; we may observe that there is no species of reasoning more common, more useful, and even necessary to human life, than that which is derived from the testimony of men, and the reports of eye-witnesses and spectators. This species of reasoning, perhaps, one may deny to be founded on the relation of cause and effect. I shall not dispute about a word. It will be sufficient to observe that our assurance in any argument of this kind is derived from no other principle than our observation of the veracity of human testimony, and of the usual conformity of facts to the reports of witnesses. It being a general maxim that no objects have any discoverable connexion together, and that

ble from logically necessary truths. It is the same use of the word 'moral' as in the fossil phrase 'moral certainty'.

[3] Although he sometimes draws conclusions which only actively experimental evidence would warrant, Hume, in a way which perhaps confused him as much as it does us, used the words 'experiment' and 'experimental' as if they were synonymous with 'experience' and 'experiential'.

all the inferences, which we can draw from one to another are founded merely on our experience of their constant and regular conjunction, it is evident that we ought not to make an exception to this maxim in favour of human testimony, whose connexion with any event seems, in itself, as little necessary as any other. Were not the memory tenacious to a certain degree; had not men commonly an inclination to truth and a principle of probity; were they not sensible to shame, when detected in a falsehood: Were not these, I say, discovered by *experience* to be qualities, inherent in human nature, we should never repose the least confidence in human testimony. A man delirious, or noted for falsehood and villany, has no manner of authority with us.

And as the evidence derived from witnesses and human testimony is founded on past experience, so it varies with the experience, and is regarded either as a *proof* or a *probability,* according as the conjunction between any particular kind of report and any kind of object has been found to be constant or variable. There are a number of circumstances to be taken into consideration in all judgements of this kind; and the ultimate standard, by which we determine all disputes that may arise concerning them, is always derived from experience and observation. Where this experience is not entirely uniform on any side, it is attended with an unavoidable contrariety in our judgements, and with the same opposition and mutual destruction of argument as in every other kind of evidence. We frequently hesitate concerning the reports of others. We balance the opposite circumstances, which cause any doubt or uncertainty; and when we discover a superiority on any side, we incline to it; but still with a diminution of assurance, in proportion to the force of its antagonist.

This contrariety of evidence, in the present case, may be derived from several different causes; from the opposition of contrary testimony; from the character or number of the witnesses; from the manner of their delivering their testimony; or from the union of all these circumstances. We entertain a suspicion concerning any matter of fact, when the witnesses contradict each other; when they are but few, or of a doubtful character; when they have an interest in what they affirm; when they deliver their testimony with hesitation, or on the contrary, with too violent asseverations. There are many other

particulars of the same kind, which may diminish or destroy the force of any argument derived from human testimony.

Suppose, for instance, that the fact which the testimony endeavours to establish, partakes of the extraordinary and the marvellous; in that case, the evidence, resulting from the testimony, admits of a diminution, greater or less, in proportion as the fact is more or less unusual. The reason why we place any credit in witnesses and historians, is not derived from any *connexion* which we perceive *a priori* between testimony and reality, but because we are accustomed to find a conformity between them. But when the fact attested is such a one as has seldom fallen under our observation, here is a contest of two opposite experiences; of which the one destroys the other, as far as its force goes, and the superior can only operate on the mind by the force, which remains. The very same principle of experience, which gives us a certain degree of assurance in the testimony of witnesses, gives us also, in this case, another degree of assurance against the fact, which they endeavour to establish; from which contradiction there necessarily arises a counterpoise, and mutual destruction of belief and authority.

I should not believe such a story were it told me by Cato, was a proverbial saying in Rome, even during the lifetime of that philosophical patriot (Plutarch, *Life of Cato*)[4]. The incredibility of a fact, it was allowed, might invalidate so great an authority.

The Indian prince who refused to believe the first relations concerning the effects of frost, reasoned justly; and it naturally required very strong testimony to engage his assent to facts, that arose from a state of nature, with which he was unacquainted, and which bore so little analogy to those events of which he had had constant and uniform experience. Though they were not contrary to his experience, they were not conformable to it.[5]

No Indian, it is evident, could have experience that water

[4] Cato the Younger (95–46 BCE) was a Roman politician and a Stoic, hence 'philosophical'.

[5] The following paragraph was originally printed as a footnote.

did not freeze in cold climates. This is placing nature in a situation quite unknown to him; and it is impossible for him to tell *a priori* what will result from it. It is making a new experiment, the consequence of which is always uncertain. One may sometimes conjecture from analogy what will follow; but still this is but conjecture. And it must be confessed that in the present case of freezing, the event follows contrary to the rules of analogy, and is such as a rational Indian would not look for. The operations of cold upon water are not gradual, according to the degrees of cold; but whenever it comes to the freezing point, the water passes in a moment, from the utmost liquidity to perfect hardness. Such an event, therefore, may be denominated *extraordinary,* and requires a pretty strong testimony, to render it credible to people in a warm climate: But still it is not *miraculous,* nor contrary to uniform experience of the course of nature in cases where all the circumstances are the same. The inhabitants of Sumatra have always seen water fluid in their own climate, and the freezing of their rivers ought to be deemed a prodigy: But they never saw water in Muscovy during the winter; and therefore they cannot reasonably be positive what would there be the consequence.

But in order to increase the probability against the testimony of witnesses, let us suppose that the fact which they affirm, instead of being only marvellous, is really miraculous; and suppose also that the testimony considered apart and in itself amounts to an entire proof; in that case, there is proof against proof, of which the strongest must prevail, but still with a diminution of its force, in proportion to that of its antagonist.

A miracle is a violation of the laws of nature; and as a firm and unalterable experience has established these laws, the proof against a miracle, from the very nature of the fact, is as entire as any argument from experience can possibly be imagined. Why is it more than probable that all men must die; that lead cannot, of itself, remain suspended in the air; that fire consumes wood, and is extinguished by water; unless it be that these events are found agreeable to the laws of nature, and there is required a violation of these laws, or in other words, a miracle to prevent them? Nothing is esteemed a miracle, if it ever happen in the common course of nature. It is no miracle that a man, seemingly in good health, should die on

a sudden: because such a kind of death, though more unusual than any other, has yet been frequently observed to happen. But it is a miracle, that a dead man should come to life; because that has never been observed in any age or country. There must, therefore, be a uniform experience against every miraculous event, otherwise the event would not merit that appellation. And as a uniform experience amounts to a proof, there is here a direct and full *proof,* from the nature of the fact, against the existence of any miracle; nor can such a proof be destroyed, or the miracle rendered credible, but by an opposite proof, which is superior.[6]

Sometimes an event may not, *in itself, seem* to be contrary to the laws of nature, and yet, if it were real, it might, by reason of some circumstances, be denominated a miracle; because, in *fact,* it is contrary to these laws. Thus if a person, claiming a divine authority, should command a sick person to be well, a healthful man to fall down dead, the clouds to pour rain, the winds to blow, in short, should order many natural events which immediately follow upon his command, these might justly be esteemed miracles, because they are really, in this case, contrary to the laws of nature. For if any suspicion remain that the event and command concurred by accident, there is no miracle and no transgression of the laws of nature. If this suspicion be removed, there is evidently a miracle, and a transgression of these laws; because nothing can be more contrary to nature than that the voice or command of a man should have such an influence. A miracle may be accurately defined, *a transgression of a law of nature by a particular volition of the Deity, or by the interposition of some invisible agent.* A miracle may either be discoverable by men or not. This alters not its nature and essence. The raising of a house or ship into the air is a visible miracle. The raising of a feather, when the wind wants ever so little of a force requisite for that purpose, is as real a miracle, though not so sensible with regard to us.[7]

[6] Hume's argument is that the evidence in favor of a law of nature is always at least as strong as the testimonial evidence for the occurrence of an event inconsistent with that law.

[7] This paragraph was originally printed as a footnote.

The plain consequence is (and it is a general maxim worthy of our attention), 'That no testimony is sufficient to establish a miracle, unless the testimony be of such a kind that its falsehood would be more miraculous than the fact which it endeavours to establish; and even in that case there is a mutual destruction of arguments, and the superior only gives us an assurance suitable to that degree of force which remains after deducting the inferior.' When anyone tells me, that he saw a dead man restored to life, I immediately consider with myself, whether it be more probable, that this person should either deceive or be deceived, or that the fact which he relates should really have happened. I weigh the one miracle against the other; and according to the superiority, which I discover, I pronounce my decision, and always reject the greater miracle. If the falsehood of his testimony would be more miraculous than the event which he relates; then, and not till then, can he pretend to command my belief or opinion.[8]

[8] A problem for Hume is to account for some people's belief in miracles based on testimony. He is not only arguing that we have no reasonable grounds to accept the occurrence of a miracle based on testimony but also that the mind *in fact* operates in the way he describes. This problem he attempts to solve in the next few pages.

PART II

In the foregoing reasoning we have supposed, that the testimony upon which a miracle is founded may possibly amount to an entire proof, and that the falsehood of that testimony would be a real prodigy: But it is easy to shew that we have been a great deal too liberal in our concession, and that there never was a miraculous event established on so full an evidence.

For *first,* there is not to be found, in all history, any miracle attested by a sufficient number of men, of such unquestioned good-sense, education, and learning, as to secure us against all delusion in themselves; of such undoubted integrity, as to place them beyond all suspicion of any design to deceive others; of such credit and reputation in the eyes of mankind, as to have a great deal to lose in case of their being detected in any falsehood; and at the same time, attesting facts performed in such a public manner and in so celebrated a part of the world, as to render the detection unavoidable: All which circumstances are requisite to give us a full assurance in the testimony of men.

Secondly. We may observe in human nature a principle which, if strictly examined, will be found to diminish extremely the assurance, which we might, from human testimony, have in any kind of prodigy. The maxim, by which we commonly conduct ourselves in our reasonings, is that the objects of which we have no experience resemble those of which we have; that what we have found to be most usual is always most probable; and that where there is an opposition of arguments, we ought to give the preference to such as are founded on the greatest number of past observations. But though, in proceeding by this rule, we readily reject any fact which is unusual and incredible in an ordinary degree; yet in advancing farther, the mind observes not always the same rule; but when anything is affirmed utterly absurd and miraculous, it rather the more readily admits of such a fact, upon account of that very circumstance, which ought to destroy all its authority. The passion of *surprise* and *wonder,* arising from miracles, being an agreeable emotion, gives a sensible tendency towards the belief of those events, from which it is derived. And this goes so far that even those who cannot enjoy this pleasure immediately, nor can believe those miraculous events of which they are informed, yet love to partake of the satisfaction at second-hand

or by rebound, and place a pride and delight in exciting the admiration of others.

With what greediness are the miraculous accounts of travellers received, their descriptions of sea and land monsters, their relations of wonderful adventures, strange men, and uncouth manners? But if the spirit of religion join itself to the love of wonder, there is an end of common sense; and human testimony, in these circumstances, loses all pretensions to authority. A religionist may be an enthusiast[9] and imagine he sees what has no reality: he may know his narrative to be false, and yet persevere in it, with the best intentions in the world, for the sake of promoting so holy a cause: or even where this delusion has not place, vanity, excited by so strong a temptation, operates on him more powerfully than on the rest of mankind in any other circumstances; and self-interest with equal force. His auditors may not have, and commonly have not, sufficient judgement to canvass his evidence: what judgement they have, they renounce by principle, in these sublime and mysterious subjects: or if they were ever so willing to employ it, passion and a heated imagination disturb the regularity of its operations. Their credulity increases his impudence, and his impudence overpowers their credulity.

Eloquence, when at its highest pitch, leaves little room for reason or reflection, but addressing itself entirely to the fancy or the affections, captivates the willing hearers, and subdues their understanding. Happily, this pitch it seldom attains. But what a TULLY or a DEMOSTHENES could scarcely effect over a Roman or Athenian audience, every CAPUCHIN, every itinerant or stationary teacher can perform over the generality of mankind, and in a higher degree, by touching such gross and vulgar passions.[10]

The many instances of forged miracles, and prophecies,

[9] "Enthusiast" in the eighteenth century meant 'fanatic'. Bishop Joseph Butler said to John Wesley that "enthusiasm is a very horrid thing", a typical eighteenth-century English attitude.

[10] 'Tully' was a nickname for Marcus Tullius Cicero. Demosthenes (384–322 BCE) was an Athenian orator and politician, a leader in resistance to the conquests of Philip of Macedon.

and supernatural events, which, in all ages, have either been detected by contrary evidence, or which detect themselves by their absurdity, prove sufficiently the strong propensity of mankind to the extraordinary and the marvellous, and ought reasonably to beget a suspicion against all relations of this kind. This is our natural way of thinking, even with regard to the most common and most credible events. For instance: There is no kind of report which rises so easily, and spreads so quickly, especially in country places and provincial towns, as those concerning marriages; insomuch that two young persons of equal condition never see each other twice, but the whole neighbourhood immediately join them together. The pleasure of telling a piece of news so interesting, of propagating it, and of being the first reporters of it, spreads the intelligence. And this is so well known, that no man of sense gives attention to these reports, till he find them confirmed by some greater evidence. Do not the same passions, and others still stronger, incline the generality of mankind to believe and report, with the greatest vehemence and assurance, all religious miracles?

Thirdly. It forms a strong presumption against all super-natural and miraculous relations that they are observed chiefly to abound among ignorant and barbarous nations, or if a civilized people has ever given admission to any of them, that people will be found to have received them from ignorant and barbarous ancestors, who transmitted them with that inviolable sanction and authority, which always attend received opinions. When we peruse the first histories of all nations, we are apt to imagine ourselves transported into some new world, where the whole frame of nature is disjointed and every element performs its operations in a different manner from what it does at present. Battles, revolutions, pestilence, famine and death are never the effect of those natural causes which we experience. Prodigies, omens, oracles, judgements, quite obscure the few natural events that are intermingled with them. But as the former grow thinner every page, in proportion as we advance nearer the enlightened ages, we soon learn that there is nothing mysterious or supernatural in the case, but that all proceeds from the usual propensity of mankind towards the marvellous, and that, though this inclination may at intervals receive a check from sense and learning, it can never be thoroughly extirpated from human nature.

It is strange, a judicious reader is apt to say, upon the perusal of these wonderful historians, *that such prodigious events never happen in our days.* But it is nothing strange, I hope, that men should lie in all ages. You must surely have seen instances enough of that frailty. You have yourself heard many such marvellous relations[11] started which, being treated with scorn by all the wise and judicious, have at last been abandoned even by the vulgar. Be assured that those renowned lies, which have spread and flourished to such a monstrous height, arose from like beginnings, but being sown in a more proper soil, shot up at last into prodigies almost equal to those which they relate.

It was a wise policy in that false prophet, ALEXANDER, who though now forgotten, was once so famous, to lay the first scene of his impostures in Paphlagonia, where, as LUCIAN tells us, the people were extremely ignorant and stupid, and ready to swallow even the grossest delusion.[12] People at a distance, who are weak enough to think the matter at all worth enquiry, have no opportunity of receiving better information. The stories come magnified to them by a hundred circumstances. Fools are industrious in propagating the imposture, while the wise and learned are contented, in general, to deride its absurdity, without informing themselves of the particular facts by which it may be distinctly refuted. And thus the impostor above mentioned was enabled to proceed, from his ignorant Paphlagonians, to the enlisting of votaries, even among the Grecian philosophers, and men of the most eminent rank and distinction in Rome: nay, could engage the attention of that sage emperor MARCUS AURELIUS,[13] so far as to make him trust the success of a military expedition to his delusive prophecies.

[11] Reports.

[12] Lucian (second century CE) was a Greek author, who wrote *Alexander, or The False Prophet,* a rollicking exposure of that otherwise unmemorable worker of fraudulent miracles, Alexander of Abonoteichos. Paphlagonia was an area of Northern Asia Minor, now part of Turkey.

[13] Marcus Aurelius (121–180 CE) was a Stoic philosopher and author of the famous *Meditations.* At the time referred to he was Roman emperor and thus ruler of Paphlagonia.

The advantages are so great of starting an imposture among an ignorant people, that, even though the delusion should be too gross to impose on the generality of them (*which, though seldom, is sometimes the case*) it has a much better chance for succeeding in remote countries, than if the first scene had been laid in a city renowned for arts and knowledge. The most ignorant and barbarous of these barbarians carry the report abroad. None of their countrymen have a large correspondence or sufficient credit and authority to contradict and beat down the delusion. Men's inclination to the marvellous has full opportunity to display itself. And thus a story, which is universally exploded in the place where it was first started, shall pass for certain at a thousand miles distance. But had Alexander fixed his residence at Athens, the philosophers of that renowned mart of learning had immediately spread, throughout the whole Roman empire, their sense of the matter; which, being supported by so great authority, and displayed by all the force of reason and eloquence, had entirely opened the eyes of mankind. It is true; Lucian, passing by chance through Paphlagonia, had an opportunity of performing this good office. But, though much to be wished, it does not always happen, that every Alexander meets with a Lucian, ready to expose and detect his impostures.

I may add as a *fourth* reason, which diminishes the authority of prodigies, that there is no testimony for any, even those which have not been expressly detected, that is not opposed by an infinite number of witnesses; so that not only the miracle destroys the credit of testimony, but the testimony destroys itself. To make this the better understood, let us consider, that, in matters of religion, whatever is different is contrary; and that it is impossible the religions of ancient Rome, of Turkey, of Siam, and of China should, all of them, be established on any solid foundation. Every miracle, therefore pretended to have been wrought in any of these religions (and all of them abound in miracles), as its direct scope is to establish the particular system to which it is attributed; so has it the same force, though more indirectly, to overthrow every other system. In destroying a rival system, it likewise destroys the credit of those miracles, on which that system was established; so that all the prodigies of different religions are to be regarded as contrary facts, and the evidences of these prodi-

gies, whether weak or strong, as opposite to each other. According to this method of reasoning, when we believe any miracle of MAHOMET[14] or his successors, we have for our warrant the testimony of a few barbarous Arabians: And on the other hand, we are to regard the authority of TITUS LIVIUS, PLUTARCH,[15] TACITUS, and, in short, of all the authors and witnesses, Grecian, Chinese, and Roman Catholic, who have related any miracle in their particular religion; I say, we are to regard their testimony in the same light as if they had mentioned that Mahometan miracle, and had in express terms contradicted it, with the same certainty as they have for the miracle they relate. This argument may appear over subtile and refined; but is not in reality different from the reasoning of a judge who supposes that the credit of two witnesses, maintaining a crime against anyone, is destroyed by the testimony of two others who affirm him to have been two hundred leagues distant at the same instant when the crime is said to have been committed.

One of the best attested miracles in all profane history, is that which Tacitus reports of VESPASIAN,[16] who cured a blind man in Alexandria, by means of his spittle, and a lame man by the mere touch of his foot; in obedience to a vision of the god SERAPIS,[17] who had enjoined them to have recourse to the Emperor, for these miraculous cures. The story may be seen in that fine historian;[18] where every circumstance seems to add

[14] Mahomet, or Mohammed (c. 570–632), born in Mecca, was the Prophet of Islam.

[15] Titus Livius, or Livy (59 BCE–17 CE), was a Roman historian of Rome. Plutarch (c. 46–120 CE) was a Greek writer, best known as the author of a series of comparative, parallel biographies.

[16] Vespasian (9–79 CE) was a soldier and a Roman emperor.

[17] Serapis, or Sarapis, was a god worshipped in Ptolemaic Egypt from the late fourth century BCE onwards.

[18] Hume here has a footnote giving a reference to the *Histories* of Tacitus, adding that Suetonius (c. 69–c. 140 CE) "gives nearly the same account" in his *Life of Vespasian*. But the reference given in the first printing of Hume's first *Enquiry* was incorrect, and a further error was introduced in the edition of 1756. It should have been *Histories* IV, 81. It appears that for over two hundred years—indeed until the present editor was working on his *Hume's Philosophy of Belief*—no one ever tried to check what the two passages actually said. The reward of scholarly

weight to the testimony, and might be displayed at large with all the force of argument and eloquence, if anyone were now concerned to enforce the evidence of that exploded and idolatrous superstition. The gravity, solidity, age, and probity of so great an emperor, who, through the whole course of his life, conversed in a familiar manner with his friends and courtiers, and never affected those extraordinary airs of divinity assumed by ALEXANDER and DEMETRIUS.[19] The historian, a contemporary writer, noted for candour and veracity, and withal, the greatest and most penetrating genius, perhaps, of all antiquity; and so free from any tendency to credulity, that he even lies under the contrary imputation, of atheism and profaneness: The persons, from whose authority he related the miracle, of established character for judgement and veracity, as we may well presume; eye-witnesses of the fact, and confirming their testimony, after the Flavian family was despoiled of the empire, and could no longer give any reward, as the price of a lie. *Utrumque, qui interfuere, nunc quoque memorant, postquam nullum mendacio pretium.*[20] To which if we add the public nature of the facts, as related, it will appear that no evidence can well be supposed stronger for so gross and so palpable a falsehood.

There is also a memorable story related by Cardinal DE RETZ, which may well deserve our consideration.[21] When that intriguing politician fled into Spain, to avoid the persecution of

virtue was then to discover that the better of our two authorities recorded that Vespasian's army surgeons had reported that there were—to put it in modern terms—no organic lesions; which suggests that the alleged cures would have been within the limits of psychosomatic possibility.

[19] "Alexander" here is Alexander the Great. Demetrius is Demetrius I of Macedonia (336–283 BCE). After his Eastern conquests, Alexander took over the quasi-divine attributes ascribed to the Persian Emperor.

[20] The Flavian family were, here, Vespasian and his two emperor sons, Titus (c. 40–81 CE) and Domitian (51–96 CE). The Latin, which is a characteristic comment made by Tacitus, translates: 'Those who were present mention both incidents even now, when there is no reward for telling a lie'.

[21] Cardinal de Retz (1614–79) was an Archbishop of Paris, author of some once widely-read *Mémoires*.

his enemies, he passed through Saragossa, the capital of Arragon, where he was shewn, in the cathedral, a man who had served seven years as a doorkeeper and was well known to everybody in town, that had ever paid his devotions at that church. He had been seen, for so long a time, wanting a leg, but recovered that limb by the rubbing of holy oil upon the stump, and the cardinal assures us that he saw him with two legs. This miracle was vouched by all the canons of the church; and the whole company in town were appealed to for a confirmation of the fact; whom the cardinal found, by their zealous devotion, to be thorough believers of the miracle. Here the relater was also contemporary to the supposed prodigy, of an incredulous and libertine character, as well as of great genius; the miracle of so *singular* a nature as could scarcely admit of a counterfeit, and the witnesses very numerous, and all of them, in a manner, spectators of the fact to which they gave their testimony. And what adds mightily to the force of the evidence, and may double our surprise on this occasion, is that the cardinal himself who relates the story seems not to give any credit to it, and consequently cannot be suspected of any concurrence in the holy fraud. He considered justly that it was not requisite, in order to reject a fact of this nature, to be able accurately to disprove the testimony, and to trace its falsehood, through all the circumstances of knavery and credulity which produced it. He knew, that, as this was commonly altogether impossible at any small distance of time and place; so was it extremely difficult, even where one was immediately present, by reason of the bigotry, ignorance, cunning, and roguery of a great part of mankind. He therefore concluded, like a just reasoner, that such an evidence carried falsehood upon the very face of it, and that a miracle, supported by any human testimony, was more properly a subject of derision than of argument.

There surely never was a greater number of miracles ascribed to one person than those which were lately said to have been wrought in France upon the tomb of Abbé PARIS, the famous JANSENIST, with whose sanctity the people were so long deluded.[22] The curing of the sick, giving hearing to the

[22] The Abbé Paris was François de Paris (1690–1727), a follower of

deaf, and sight to the blind, were everywhere talked of as the usual effects of that holy sepulchre. But what is more extraordinary; many of the miracles were immediately proved upon the spot, before judges of unquestioned integrity, attested by witnesses of credit and distinction, in a learned age, and on the most eminent theatre that is now in the world. Nor is this all: a relation of them was published and dispersed everywhere; nor were the *JESUITS,* though a learned body, supported by the civil magistrate, and determined enemies to those opinions,[23] in whose favour the miracles were said to have been wrought, ever able distinctly to refute or detect them. Where shall we find such a number of circumstances, agreeing to the corroboration of one fact? And what have we to oppose to such a cloud of witnesses, but the absolute impossibility or miraculous nature of the events, which they relate? And this surely, in the eyes of all reasonable people, will alone be regarded as a sufficient refutation.[24]

This book was writ by Mons. MONTGERON counsellor or judge of the parliament of Paris, a man of figure and character, who was also a martyr to the cause, and is now said to be somewhere in a dungeon on account of his book.

There is another book in three volumes (called *Recueil des Miracles de l' Abbé Paris*) giving an account of many of these miracles, and accompanied with prefatory discourses which are very well written. There runs, however, through the whole

Cornelius Jansen (1585–1638), a Bishop of Ypres in Flanders. In his 1640 *Augustinus* Jansen propounded doctrines of moral austerity and of the dependence of human virtue upon Divine grace, doctrines adopted by the convent of Port-Royal and by all those, such as Blaise Pascal and the authors of the *Port-Royal Logic,* who associated with it. Jesuits are members of the Society of Jesus; an order originally founded for the purpose of promoting the Counter-Reformation, and an order owing (and until very recently yielding) a special obedience to the Popes.

[23] The Jesuits strongly opposed the Jansenists, who accused them of moral laxity. Pascal's *Lettres provinciales* (1656–1657), a series of 18 letters, is devoted to an attack on Jesuit casuistry, i.e., application of moral principles to particular cases.

[24] The next twelve paragraphs were originally printed as a monster footnote. At the height of the whole affair Hume was himself in France, living at La Flèche in Touraine, site of the crack Jesuit school which had educated Descartes, and working on the composition of his own *Treatise.*

of these a ridiculous comparison between the miracles of our
Saviour and those of the Abbé, wherein it is asserted that the
evidence for the latter is equal to that for the former: As if the
testimony of men could ever be put in the balance with that of
God himself, who conducted the pen of the inspired writers. If
these writers, indeed, were to be considered merely as human
testimony, the French author is very moderate in his compari-
son; since he might, with some appearance of reason, pretend
that the Jansenist miracles much surpass the other in evi-
dence and authority. The following circumstances are drawn
from authentic papers, inserted in the above-mentioned book.

Many of the miracles of Abbé Paris were proved immedi-
ately by witnesses before the officiality or bishop's court at
Paris, under the eye of cardinal Noailles, whose character for
integrity and capacity was never contested even by his ene-
mies.

His successor in the archbishopric was an enemy to the
Jansenists, and for that reason promoted to the see by the
court. Yet 22 rectors or *curés* of Paris, with infinite earnest-
ness, pressed him to examine those miracles, which they
assert to be known to the whole world, and undisputably
certain: But he wisely forbore.

The MOLINIST party[25] had tried to discredit these miracles
in one instance, that of Mademoiselle le Franc. But, besides
that their proceedings were in many respects the most irregu-
lar in the world, particularly in citing only a few of the
Jansenist witnesses, whom they tampered with: Besides this, I
say, they soon found themselves overwhelmed by a cloud of
new witnesses, one hundred and twenty in number, most of
them persons of credit and substance in Paris, who gave oath
for the miracle. This was accompanied with a solemn and
earnest appeal to the parliament. But the parliament were
forbidden by authority to meddle in the affair. It was at last
observed that where men are heated by zeal and enthusiasm
there is no degree of human testimony so strong as may not be
procured for the greatest absurdity: And those who will be so
silly as to examine the affair by that medium, and seek

[25] Followers of Luis de Molina (1535–1600), believers in free will, and
hence anti-Jansenists. They were usually Jesuits.

particular flaws in the testimony, are almost sure to be confounded. It must be a miserable imposture, indeed, that does not prevail in that contest.

All who have been in France about that time have heard of the reputation of Mons. HERAUT, the *lieutenant de Police,* whose vigilance, penetration, activity, and extensive intelligence have been much talked of. This magistrate, who by the nature of his office is almost absolute, was invested with full powers, on purpose to suppress or discredit these miracles; and he frequently seized immediately, and examined the witnesses and subjects of them: But never could reach anything satisfactory against them.

In the case of Mademoiselle THIBAUT he sent the famous DE SYLVA to examine her; whose evidence is very curious. The physician declares that it was impossible she could have been so ill as was proved by witnesses; because it was impossible she could, in so short a time, have recovered so perfectly as he found her. He reasoned, like a man of sense, from natural causes, but the opposite party told him that the whole was a miracle, and that his evidence was the very best proof of it.

The Molinists were in a sad dilemma. They durst not assert the absolute insufficiency of human evidence to prove a miracle. They were obliged to say that these miracles were wrought by witchcraft and the devil. But they were told, that this was the resource of the Jews of old.[26]

No Jansenist was ever embarrassed to account for the cessation of the miracles, when the church-yard was shut up by the king's edict. It was the touch of the tomb which produced these extraordinary effects; and when no one could approach the tomb, no effects could be expected. God, indeed, could have thrown down the walls in a moment; but he is master of his own graces and works, and it belongs not to us to account for them. He did not throw down the walls of every city like those of Jericho, on the sounding of the rams horns, nor break up the prison of every apostle, like that of St. Paul.

No less a man, than the Duc DE CHATILLON, a duke and peer of France, of the highest rank and family, gives evidence of a miraculous cure, performed upon a servant of his, who had

[26] In questioning the miracles of Christ.

lived several years in his house with a visible and palpable infirmity.

I shall conclude with observing, that no clergy are more celebrated for strictness of life and manners than the secular clergy of France, particularly the rectors or curés of Paris who bear testimony to these impostures.

The learning, genius, and probity of the gentlemen, and the austerity of the nuns of Port-Royal, have been much celebrated all over Europe. Yet they all give evidence for a miracle, wrought on the niece of the famous Pascal, whose sanctity of life, as well as extraordinary capacity, is well known. The famous RACINE[27] gives an account of this miracle in his famous history of Port-Royal, and fortifies it with all the proofs which a multitude of nuns, priests, physicians, and men of the world, all of them of undoubted credit, could bestow upon it. Several men of letters, particularly the bishop of Tournay, thought this miracle so certain as to employ it in the refutation of atheists and free-thinkers. The queen-regent of France, who was extremely prejudiced against the Port-Royal, sent her own physician to examine the miracle, who returned an absolute convert. In short, the supernatural cure was so uncontestable, that it saved, for a time, that famous monastery from the ruin with which it was threatened by the Jesuits. Had it been a cheat, it had certainly been detected by such sagacious and powerful antagonists, and must have hastened the ruin of the contrivers. Our divines, who can build up a formidable castle from such despicable materials; what a prodigious fabric could they have reared from these and many other circumstances which I have not mentioned! How often would the great names of Pascal, Racine, Arnauld, Nicole, have resounded in our ears? But if they be wise, they had better adopt the miracle, as being more worth, a thousand times, than all the rest of their collection. Besides, it may serve very much to their purpose. For that miracle was really performed

[27] Jean Racine (1639–1699), author of *Andromaque, Phèdre, Athalie,* and other plays. He was educated at the Jansenist school at Port Royal, and buried in the Port Royal abbey, ten years before it was destroyed by the French king following the Pope's condemnation of Jansenism.

by the touch of an authentic holy prickle of the holy thorn, which composed the holy crown, which, &c.

Is the consequence just, because some human testimony has the utmost force and authority in some cases, when it relates the battle of PHILIPPI or PHARSALIA for instance; that therefore all kinds of testimony must, in all cases, have equal force and authority?[28] Suppose that the Cæsarean and Pompeian factions had, each of them, claimed the victory in these battles, and that the historians of each party had uniformly ascribed the advantage to their own side; how could mankind, at this distance, have been able to determine between them? The contrariety is equally strong between the miracles related by Herodotus or Plutarch, and those delivered by Mariana, Bede, or any monkish historian.[29]

The wise lend a very academic[30] faith to every report which favours the passion of the reporter; whether it magnifies his country, his family, or himself, or in any other way strikes in with his natural inclinations and propensities. But what greater temptation than to appear a missionary, a prophet, an ambassador from heaven? Who would not encounter many dangers and difficulties, in order to attain so sublime a character? Or if, by the help of vanity and a heated imagination, a man has first made a convert of himself, and entered seriously into the delusion; who ever scruples to make use of pious frauds, in support of so holy and meritorious a cause?

[28] After the long digression about the evidence in the case of the alleged miracles at the tomb of the Abbé Paris, Hume is resuming his main argument. Philippi was a city in Macedonia near which in 42 BCE the armies of Octavian, the future first Emperor Augustus, and Mark Antony defeated the republican forces under Brutus and Cassius. See Shakespeare's *Julius Caesar,* Act V. Pharsalia was a city in Thessaly where in 48 BCE Julius Caesar himself defeated Pompey, his rival for dominion over the Roman world.

[29] Herodotus, who flourished in the earlier part of the fifth century BCE, was a Greek from Halicarnassus in Asia Minor, often hailed as the Father of History. Juan Mariana (1536–1623) was a Spanish Jesuit. Bede (c. 673–735) is sometimes spoken of as the father of English history.

[30] "Academic" = 'sceptical', after the sceptics who took over the Academy founded by Plato. The most important of these was Carneades.

The smallest spark may here kindle into the greatest flame; because the materials are always prepared for it. The *avidum genus auricularum*,[31] the gazing populace, receive greedily, without examination, whatever sooths superstition, and promotes wonder.

How many stories of this nature have, in all ages, been detected and exploded in their infancy? How many more have been celebrated for a time, and have afterwards sunk into neglect and oblivion? Where such reports, therefore, fly about, the solution of the phenomenon is obvious; and we judge in conformity to regular experience and observation, when we account for it by the known and natural principles of credulity and delusion. And shall we, rather than have a recourse to so natural a solution, allow of a miraculous violation of the most established laws of nature?

I need not mention the difficulty of detecting a falsehood in any private or even public history, at the place, where it is said to happen; much more when the scene is removed to ever so small a distance. Even a court of judicature, with all the authority, accuracy, and judgement, which they can employ, find themselves often at a loss to distinguish between truth and falsehood in the most recent actions. But the matter never comes to any issue, if trusted to the common method of altercation and debate and flying rumours; especially when men's passions have taken part on either side.

In the infancy of new religions, the wise and learned commonly esteem the matter too inconsiderable to deserve their attention or regard. And when afterwards they would willingly detect the cheat, in order to undeceive the deluded multitude, the season is now past, and the records and witnesses, which might clear up the matter, have perished beyond recovery.

No means of detection remain, but those which must be drawn from the very testimony itself of the reporters: and

[31] Titus Lucretius Carus (99/96–55/51 BCE) wrote a Latin didactic poem expounding Epicurean philosophy, *De Rerum Natura (On the Nature of Things)*. Book IV lines 593–94 read:
. . . ut omne humanum genus est avidum nimis auricularum (As all mankind is too eager for hearsay).

these, though always sufficient with the judicious and know-
ing, are commonly too fine to fall under the comprehension of
the vulgar.

Upon the whole, then, it appears that no testimony for any
kind of miracle has ever amounted to a probability, much less
to a proof; and that, even supposing it amounted to a proof, it
would be opposed by another proof; derived from the very
nature of the fact, which it would endeavour to establish. It is
experience only, which gives authority to human testimony;
and it is the same experience, which assures us of the laws of
nature. When, therefore, these two kinds of experience are
contrary, we have nothing to do but substract the one from the
other, and embrace an opinion, either on one side or the other,
with that assurance which arises from the remainder. But
according to the principle here explained, this substraction,
with regard to all popular religions, amounts to an entire
annihilation; and therefore we may establish it as a maxim,
that no human testimony can have such force as to prove a
miracle, and make it a just foundation for any such system of
religion.

I beg the limitations here made may be remarked, when I
say, that a miracle can never be proved, so as to be the
foundation of a system of religion. For I own, that otherwise,
there may possibly be miracles, or violations of the usual
course of nature, of such a kind as to admit of proof from
human testimony; though, perhaps, it will be impossible to
find any such in all the records of history. Thus, suppose, all
authors, in all languages, agree that, from the first of January
1600, there was a total darkness over the whole earth for eight
days: suppose that the tradition of this extraordinary event is
still strong and lively among the people: that all travellers,
who return from foreign countries, bring us accounts of the
same tradition, without the least variation or contradiction: it
is evident, that our present philosophers, instead of doubting
the fact, ought to receive it as certain, and ought to search for
the causes whence it might be derived. The decay, corruption,
and dissolution of nature, is an event rendered probable by so
many analogies, that any phenomenon, which seems to have a
tendency towards that catastrophe, comes within the reach of
human testimony, if that testimony be very extensive and
uniform.

But suppose, that all the historians who treat of England, should agree, that, on the first of January 1600, Queen Elizabeth died; that both before and after her death she was seen by her physicians and the whole court, as is usual with persons of her rank; that her successor was acknowledged and proclaimed by the parliament; and that, after being interred a month, she again appeared, resumed the throne, and governed England for three years: I must confess that I should be surprised at the concurrence of so many odd circumstances, but should not have the least inclination to believe so miraculous an event. I should not doubt of her pretended death, and of those other public circumstances that followed it: I should only assert it to have been pretended, and that it neither was, nor possibly could be real. You would in vain object to me the difficulty, and almost impossibility of deceiving the world in an affair of such consequence; the wisdom and solid judgement of that renowned queen; with the little or no advantage which she could reap from so poor an artifice: All this might astonish me; but I would still reply, that the knavery and folly of men are such common phenomena, that I should rather believe the most extraordinary events to arise from their concurrence, than admit of so signal a violation of the laws of nature.

But should this miracle be ascribed to any new system of religion; men, in all ages, have been so much imposed on by ridiculous stories of that kind, that this very circumstance would be a full proof of a cheat, and sufficient, with all men of sense, not only to make them reject the fact, but even reject it without farther examination. Though the Being to whom the miracle is ascribed, be, in this case, Almighty, it does not, upon that account, become a whit more probable; since it is impossible for us to know the attributes or actions of such a Being, otherwise than from the experience which we have of his productions, in the usual course of nature. This still reduces us to past observation, and obliges us to compare the instances of the violation of truth in the testimony of men, with those of the violation of the laws of nature by miracles, in order to judge which of them is most likely and probable. As the violations of truth are more common in the testimony concerning religious miracles, than in that concerning any other matter of fact; this must diminish very much the authority of the former testimony, and make us form a general resolution, never to lend any

attention to it, with whatever specious pretence it may be covered.

Lord BACON[32] seems to have embraced the same principles of reasoning. "We ought," says he, "to make a collection or particular history of all monsters and prodigious births or productions, and in a word of every thing new, rare, and extraordinary in nature. But this must be done with the most severe scrutiny, lest we depart from truth. Above all, every relation must be considered as suspicious, which depends in any degree upon religion, as the prodigies of Livy:[33] And no less so, every thing that is to be found in the writers of natural magic or alchimy, or such authors, who seem, all of them, to have an unconquerable appetite for falsehood and fable" (*Novum Organum*, II, aph. 29).

I am the better pleased with the method of reasoning here delivered, as I think it may serve to confound those dangerous friends or disguised enemies to the *Christian Religion,* who have undertaken to defend it by the principles of human reason. Our most holy religion is founded on *Faith,* not on reason; and it is a sure method of exposing it to put it to such a trial as it is, by no means, fitted to endure. To make this more evident, let us examine those miracles, related in scripture; and not to lose ourselves in too wide a field, let us confine ourselves to such as we find in the PENTATEUCH,[34] which we shall examine, according to the principles of these pretended Christians,[35] not as the word or testimony of God himself, but as the production of a mere human writer and historian. Here

[32] Francis Bacon (1561–1626) is often rated the first in the long line of British empiricist philosophers. The passage quoted is Aphorism 29 from Book II of Bacon's *Novum Organum,* in which he tried to improve upon previous conceptions of scientific method.

[33] The Roman historian Livy's *Histories* frequently record what Hume terms "marvellous events" or "prodigies" accompanying the growth of Roman power.

[34] 'Pentateuch' is the collective name for the first five books of the Bible (*Genesis, Exodus, Leviticus, Numbers,* and *Deuteronomy*), also known as 'the five books of Moses', 'the Book of the Law', or 'Torah'.

[35] "Pretended Christians"—because Hume wants to suggest that such rationalizing forfeits their claim to be true adherents of the Christian Faith.

then we are first to consider a book, presented to us by a barbarous and ignorant people, written in an age when they were still more barbarous, and in all probability long after the facts which it relates, corroborated by no concurring testimony, and resembling those fabulous accounts, which every nation gives of its origin. Upon reading this book, we find it full of prodigies and miracles. It gives an account of a state of the world and of human nature entirely different from the present: Of our fall from that state: Of the age of man, extended to near a thousand years: Of the destruction of the world by a deluge: Of the arbitrary choice of one people, as the favourites of heaven; and that people the countrymen of the author: Of their deliverance from bondage by prodigies the most astonishing imaginable: I desire any one to lay his hand upon his heart, and after a serious consideration declare, whether he thinks that the falsehood of such a book, supported by such a testimony, would be more extraordinary and miraculous than all the miracles it relates; which is, however, necessary to make it be received, according to the measures of probability above established.

What we have said of miracles may be applied, without any variation, to prophecies; and indeed, all prophecies are real miracles, and as such only, can be admitted as proofs of any revelation. If it did not exceed the capacity of human nature to foretell future events, it would be absurd to employ any prophecy as an argument for a divine mission or authority from heaven. So that, upon the whole, we may conclude, that the *Christian Religion* not only was at first attended with miracles, but even at this day cannot be believed by any reasonable person without one. Mere reason is insufficient to convince us of its veracity: And whoever is moved by *Faith* to assent to it, is conscious of a continued miracle in his own person, which subverts all the principles of his understanding, and gives him a determination to believe what is most contrary to custom and experience.

2. Of a particular Providence and of a future State

I was lately engaged in conversation with a friend who loves sceptical paradoxes; where, though he advanced many principles, of which I can by no means approve, yet as they seem to be curious, and to bear some relation to the chain of reasoning carried on throughout this enquiry, I shall here copy them from my memory as accurately as I can, in order to submit them to the judgement of the reader.

Our conversation began with my admiring the singular good fortune of philosophy, which, as it requires entire liberty above all other privileges, and chiefly flourishes from the free opposition of sentiments and argumentation, received its first birth in an age and country of freedom and toleration, and was never cramped, even in its most extravagant principles, by any creeds, confessions, or penal statutes. For, except the banishment of PROTAGORAS,[1] and the death of SOCRATES, which last event proceeded partly from other motives, there are scarcely any instances to be met with, in ancient history, of this bigotted jealousy, with which the present age is so much infested. EPICURUS[2] lived at ATHENS to an advanced age, in peace and tranquillity: Epicureans[3] were even admitted to receive the sacerdotal character, and to officiate at the altar, in

[1] Protagoras (fifth century BCE) was one of the earliest and most successfully influential of the set of Greek educationist-philosophers known as the Sophists. His relativism—"man is the measure of all things"—is discussed in Plato's *Theaetetus*.

[2] Epicurus (341–270 BCE) founded his school in 307 BCE. His main debt was to the atomism of Democritus of Abdera (c. 460–c. 370 BCE). By far the most agreeable sourcebook for the ideas of Epicurus is the *De Rerum Natura* by his Roman convert Lucretius.

[3] Hume here refers, by its Greek title, in a footnote, to Lucian's *The Carousal, or the Lapiths*.

the most sacred rites of the established religion: And the public encouragement[4] of pensions and salaries was afforded equally, by the wisest of all the Roman emperors[5] to the professors of every sect of philosophy. How requisite such kind of treatment was to philosophy, in her early youth, will easily be conceived, if we reflect, that, even at present, when she may be supposed more hardy and robust, she bears with much difficulty the inclemency of the seasons, and those harsh winds of calumny and persecution, which blow upon her.

You admire, says my friend, as the singular good fortune of philosophy, what seems to result from the natural course of things, and to be unavoidable in every age and nation. This pertinacious bigotry, of which you complain, as so fatal to philosophy, is really her offspring, who, after allying with superstition, separates himself entirely from the interest of his parent, and becomes her most inveterate enemy and persecutor. Speculative dogmas of religion, the present occasions of such furious dispute, could not possibly be conceived or admitted in the early ages of the world; when mankind, being wholly illiterate, formed an idea of religion more suitable to their weak apprehension, and composed their sacred tenets of such tales chiefly as were the objects of traditional belief, more than of argument or disputation. After the first alarm, therefore, was over, which arose from the new paradoxes and principles of the philosophers; these teachers seem ever after, during the ages of antiquity, to have lived in great harmony with the established superstition, and to have made a fair partition of mankind between them; the former claiming all the learned and wise, the latter possessing all the vulgar and illiterate.

It seems then, say I, that you leave politics entirely out of the question, and never suppose that a wise magistrate can

[4] Hume here refers, by its Greek title, in a footnote, to Lucian's *Eunuch*.

[5] Marcus Aurelius. Hume in a footnote mentions as his authorities Lucian and Dio Cassius, but without providing any more precise reference.

justly be jealous of certain tenets of philosophy, such as those of Epicurus, which, denying a divine existence, and consequently a providence and a future state, seem to loosen, in a great measure, the ties of morality, and may be supposed, for that reason, pernicious to the peace of civil society.

I know, replied he, that in fact these persecutions never, in any age, proceeded from calm reason, or from experience of the pernicious consequences of philosophy; but arose entirely from passion and prejudice. But what if I should advance farther, and assert, that if Epicurus had been accused before the people, by any of the *sycophants* or informers of those days, he could easily have defended his cause, and proved his principles of philosophy to be as salutary as those of his adversaries, who endeavoured, with such zeal, to expose him to the public hatred and jealousy?

I wish, said I, you would try your eloquence upon so extraordinary a topic, and make a speech for Epicurus, which might satisfy, not the mob of Athens, if you will allow that ancient and polite city to have contained any mob, but the more philosophical part of his audience, such as might be supposed capable of comprehending his arguments.

The matter would not be difficult, upon such conditions, replied he: And if you please, I shall suppose myself Epicurus for a moment, and make you stand for the Athenian people, and shall deliver you such an harangue as will fill all the urn with white beans, and leave not a black one to gratify the malice of my adversaries.[6]

Very well: Pray proceed upon these suppositions.

I come hither, O ye Athenians, to justify in your assembly what I maintained in my school, and I find myself impeached by furious antagonists, instead of reasoning with calm and dispassionate enquirers. Your deliberations, which of right should be directed to questions of public good, and the interest of the commonwealth, are diverted to the disquisitions of speculative philosophy; and these magnificent, but perhaps fruitless enquiries, take place of your more familiar but more

[6] Voting in Athenian trials was conducted by each juror placing a bean in a jar: white for innocent, black for guilty.

useful occupations. But so far as in me lies, I will prevent this abuse. We shall not here dispute concerning the origin and government of worlds. We shall only enquire how far such questions concern the public interest. And if I can persuade you, that they are entirely indifferent to the peace of society and security of government, I hope that you will presently send us back to our schools, there to examine, at leisure, the question the most sublime, but at the same time, the most speculative of all philosophy.

The religious philosophers, not satisfied with the tradition of your forefathers, and doctrine of your priests (in which I willingly acquiesce), indulge a rash curiosity, in trying how far they can establish religion upon the principles of reason; and they thereby excite, instead of satisfying, the doubts, which naturally arise from a diligent and scrutinous enquiry. They paint, in the most magnificent colours, the order, beauty, and wise arrangement of the universe; and then ask, if such a glorious display of intelligence could proceed from the fortuitous concourse of atoms, or if chance could produce what the greatest genius can never sufficiently admire. I shall not examine the justness of this argument.[7] I shall allow it to be as solid as my antagonists and accusers can desire. It is sufficient, if I can prove, from this very reasoning, that the question is entirely speculative, and that, when, in my philosophical disquisitions, I deny a providence and a future state, I undermine not the foundations of society, but advance principles, which they themselves, upon their own topics, if they argue consistently, must allow to be solid and satisfactory.

You then, who are my accusers, have acknowledged, that the chief or sole argument for a divine existence (which I never questioned) is derived from the order of nature; where there appear such marks of intelligence and design that you think it extravagant to assign for its cause, either chance, or the blind and unguided force of matter. You allow, that this is an argument drawn from effects to causes. From the order of the work, you infer, that there must have been project and forethought in the workman. If you cannot make out this point, you allow, that your conclusion fails; and you pretend not to

[7] Hume did so in his *Dialogues concerning Natural Religion*.

establish the conclusion in a greater latitude than the phenomena of nature will justify. These are your concessions. I desire you to mark the consequences.

When we infer any particular cause from an effect, we must proportion the one to the other, and can never be allowed to ascribe to the cause any qualities, but what are exactly sufficient to produce the effect. A body of ten ounces raised in any scale may serve as a proof, that the counterbalancing weight exceeds ten ounces; but can never afford a reason that it exceeds a hundred. If the cause, assigned for any effect, be not sufficient to produce it, we must either reject that cause, or add to it such qualities as will give it a just proportion to the effect. But if we ascribe to it farther qualities, or affirm it capable of producing other effects, we can only indulge the licence of conjecture, and arbitrarily suppose the existence of qualities and energies, without reason or authority.

The same rule holds, whether the cause assigned be brute unconscious matter, or a rational intelligent being. If the cause be known only by the effect, we never ought to ascribe to it any qualities, beyond what are precisely requisite to produce the effect: Nor can we, by any rules of just reasoning, return back from the cause, and infer other effects from it, beyond those by which alone it is known to us. No one, merely from the sight of one of ZEUXIS's pictures[8] could know that he was also a statuary or architect, and was an artist no less skilful in stone and marble than in colours. The talents and taste, displayed in the particular work before us; these we may safely conclude the workman to be possessed of. The cause must be proportioned to the effect; and if we exactly and precisely proportion it, we shall never find in it any qualities, that point farther, or afford an inference concerning any other design or performance. Such qualities must be somewhat beyond what is merely requisite for producing the effect, which we examine.

Allowing, therefore, the gods to be the authors of the existence or order of the universe; it follows, that they possess that precise degree of power, intelligence, and benevolence, which appears in their workmanship; but nothing farther can

[8] Zeuxis (fifth century BCE) was a Greek painter, born in Heraclea in Southern Italy.

ever be proved, except we call in the assistance of exaggeration and flattery to supply the defects of argument and reasoning. So far as the traces of any attributes, at present, appear, so far may we conclude these attributes to exist. The supposition of farther attributes is mere hypothesis; much more the supposition, that, in distant regions of space or periods of time, there has been, or will be, a more magnificent display of these attributes, and a scheme of administration more suitable to such imaginary virtues. We can never be allowed to mount up from the universe, the effect, to JUPITER, the cause;[9] and then descend downwards, to infer any new effect from that cause; as if the present effects alone were not entirely worthy of the glorious attributes, which we ascribe to that deity. The knowledge of the cause being derived solely from the effect, they must be exactly adjusted to each other; and the one can never refer to anything farther, or be the foundation of any new inference and conclusion.

You find certain phenomena in nature. You seek a cause or author. You imagine that you have found him. You afterwards become so enamoured of this offspring of your brain, that you imagine it impossible but he must produce something greater and more perfect than the present scene of things, which is so full of ill and disorder. You forget, that this superlative intelligence and benevolence are entirely imaginary, or, at least, without any foundation in reason; and that you have no ground to ascribe to him any qualities, but what you see he has actually exerted and displayed in his productions. Let your gods, therefore, O philosophers, be suited to the present appearances of nature: and presume not to alter these appearances by arbitrary suppositions, in order to suit them to the attributes, which you so fondly ascribe to your deities.

When priests and poets, supported by your authority, O Athenians, talk of a golden or silver age, which preceded the present state of vice and misery, I hear them with attention and with reverence. But when philosophers, who pretend to neglect authority, and to cultivate reason, hold the same discourse, I pay them not, I own, the same obsequious submission and pious deference. I ask; who carried them into the

[9] Jupiter, identified with the Greek Zeus, was the chief Roman god.

celestial regions, who admitted them into the councils of the gods, who opened to them the book of fate, that they thus rashly affirm, that their deities have executed, or will execute, any purpose beyond what has actually appeared? If they tell me, that they have mounted on the steps or by the gradual ascent of reason, and by drawing inferences from effects to causes, I still insist, that they have aided the ascent of reason by the wings of imagination; otherwise they could not thus change their manner of inference, and argue from causes to effects; presuming, that a more perfect production than the present world would be more suitable to such perfect beings as the gods, and forgetting that they have no reason to ascribe to these celestial beings any perfection or any attribute, but what can be found in the present world.

Hence all the fruitless industry to account for the ill appearances of nature, and save the honour of the gods; while we must acknowledge the reality of that evil and disorder, with which the world so much abounds. The obstinate and intractable qualities of matter, we are told, or the observance of general laws, or some such reason, is the sole cause, which controlled the power and benevolence of *Jupiter,* and obliged him to create mankind and every sensible creature so imperfect and so unhappy. These attributes then, are, it seems, beforehand, taken for granted, in their greatest latitude. And upon that supposition, I own that such conjectures may, perhaps, be admitted as plausible solutions of the ill phenomena. But still I ask; Why take these attributes for granted, or why ascribe to the cause any qualities but what actually appear in the effect? Why torture your brain to justify the course of nature upon suppositions, which, for aught you know, may be entirely imaginary, and of which there are to be found no traces in the course of nature?

The religious hypothesis, therefore, must be considered only as a particular method of accounting for the visible phenomena of the universe: but no just reasoner will ever presume to infer from it any single fact, and alter or add to the phenomena, in any single particular. If you think that the appearances of things prove such causes, it is allowable for you to draw an inference concerning the existence of these causes. In such complicated and sublime subjects, every one should be indulged in the liberty of conjecture and argument. But here

you ought to rest. If you come backward, and arguing from your inferred causes, conclude, that any other fact has existed, or will exist, in the course of nature, which may serve as a fuller display of particular attributes; I must admonish you, that you have departed from the method of reasoning, attached to the present subject, and have certainly added something to the attributes of the cause, beyond what appears in the effect; otherwise you could never, with tolerable sense or propriety, add anything to the effect, in order to render it more worthy of the cause.

Where, then, is the odiousness of that doctrine, which I teach in my school, or rather, which I examine in my gardens? Or what do you find in this whole question, wherein the security of good morals, or the peace and order of society, is in the least concerned?

I deny a providence, you say, and supreme governor of the world, who guides the course of events, and punishes the vicious with infamy and disappointment, and rewards the virtuous with honour and success, in all their undertakings. But surely, I deny not the course itself of events, which lies open to every one's inquiry and examination. I acknowledge, that, in the present order of things, virtue is attended with more peace of mind than vice, and meets with a more favourable reception from the world. I am sensible, that, according to the past experience of mankind, friendship is the chief joy of human life, and moderation the only source of tranquillity and happiness. I never balance between the virtuous and the vicious course of life; but am sensible that, to a well-disposed mind, every advantage is on the side of the former. And what can you say more, allowing all your suppositions and reasonings? You tell me, indeed, that this disposition of things proceeds from intelligence and design. But whatever it proceeds from, the disposition itself, on which depends our happiness or misery, and consequently our conduct and deportment in life is still the same. It is still open for me, as well as you, to regulate my behaviour, by my experience of past events. And if you affirm, that, while a divine providence is allowed, and a supreme distributive justice in the universe, I ought to expect some more particular reward of the good, and punishment of the bad, beyond the ordinary course of events, I here find the same fallacy which I have before endeavoured to detect. You

persist in imagining, that, if we grant that divine existence, for which you so earnestly contend, you may safely infer consequences from it, and add something to the experienced order of nature, by arguing from the attributes which you ascribe to your gods. You seem not to remember, that all your reasonings on this subject can only be drawn from effects to causes; and that every argument, deduced from causes to effects, must of necessity be a gross sophism; since it is impossible for you to know anything of the cause, but what you have antecedently, not inferred, but discovered to the full, in the effect.

But what must a philosopher think of those vain reasoners, who, instead of regarding the present scene of things as the sole object of their contemplation, so far reverse the whole course of nature, as to render this life merely a passage to something farther; a porch, which leads to a greater, and vastly different building; a prologue, which serves only to introduce the piece, and give it more grace and propriety? Whence, do you think, can such philosophers derive their idea of the gods? From their own conceit and imagination surely. For if they derived it from the present phenomena, it would never point to anything farther, but must be exactly adjusted to them. That the divinity may *possibly* be endowed with attributes, which we have never seen exerted; may be governed by principles of action, which we cannot discover to be satisfied: all this will freely be allowed. But still this is mere *possibility* and hypothesis. We never can have reason to *infer* any attributes, or any principles of action in him, but so far as we know them to have been exerted and satisfied.

Are there any marks of a distributive justice in the world? If you answer in the affirmative, I conclude, that, since justice here exerts itself, it is satisfied. If you reply in the negative, I conclude, that you have then no reason to ascribe justice, in our sense of it, to the gods. If you hold a medium between affirmation and negation, by saying, that the justice of the gods, at present, exerts itself in part, but not in its full extent; I answer, that you have no reason to give it any particular extent, but only so far as you see it, *at present,* exert itself.

Thus I bring the dispute, O Athenians, to a short issue with my antagonists. The course of nature lies open to my contemplation as well as to theirs. The experienced train of events is the great standard, by which we all regulate our

conduct. Nothing else can be appealed to in the field, or in the senate. Nothing else ought ever to be heard of in the school, or in the closet.[10] In vain would our limited understanding break through those boundaries, which are too narrow for our fond imagination. While we argue from the course of nature, and infer a particular intelligent cause, which first bestowed, and still preserves order in the universe, we embrace a principle, which is both uncertain and useless. It is uncertain; because the subject lies entirely beyond the reach of human experience. It is useless; because our knowledge of this cause being derived entirely from the course of nature, we can never, according to the rules of just reasoning, return back from the cause with any new inference, or making additions to the common and experienced course of nature, establish any new principles of conduct and behavior.

I observe (said I, finding he had finished his harangue) that you neglect not the artifice of the demagogues of old; and as you were pleased to make me stand for the people, you insinuate yourself into my favour by embracing those principles, to which, you know, I have always expressed particular attachment. But allowing you to make experience (as indeed I think you ought) the only standard of our judgment concerning this, and all other questions of fact; I doubt not but, from the very same experience to which you appeal, it may be possible to refute this reasoning, which you have put into the mouth of Epicurus. If you saw, for instance, a half-finished building, surrounded with heaps of brick and stone and mortar, and all the instruments of masonry; could you not *infer* from the effect, that it was a work of design and contrivance? And could you not return again, from this inferred cause, to infer new additions to the effect, and conclude, that the building would soon be finished, and receive all the further improvements, which art could bestow upon it? If you saw upon the sea-shore the print of one human foot, you would conclude that a man had passed that way, and that he had also left the traces of the other foot, though effaced by the rolling of the sands or inundation of the waters. Why then do you refuse to admit the same method of reasoning with regard to the order of nature?

[10] "Closet" = 'private quarters' in present-day usage.

Consider the world and the present life only as an imperfect building, from which you can infer a superior intelligence; and arguing from that superior intelligence, which can leave nothing imperfect; why may you not infer a more finished scheme or plan, which will receive its completion in some distant point of space or time? Are not these methods of reasoning exactly similar? And under what pretence can you embrace the one, while you reject the other?

The infinite difference of the subjects, replied he, is a sufficient foundation for this difference in my conclusions. In works of *human* art and contrivance, it is allowable to advance from the effect to the cause, and returning back from the cause, to form new inferences concerning the effect, and examine the alterations, which it has probably undergone, or may still undergo. But what is the foundation of this method of reasoning? Plainly this; that man is a being, whom we know by experience, whose motives and designs we are acquainted with, and whose projects and inclinations have a certain connexion and coherence, according to the laws which nature has established for the government of such a creature. When, therefore, we find, that any work has proceeded from the skill and industry of man; as we are otherwise acquainted with the nature of the animal, we can draw a hundred inferences concerning what may be expected from him; and these inferences will all be founded in experience and observation. But did we know man only from the single work or production which we examine, it were impossible for us to argue in this manner; because our knowledge of all the qualities which we ascribe to him, being in that case derived from the production, it is impossible they could point to anything farther, or be the foundation of any new inference. The print of a foot in the sand can only prove, when considered alone, that there was some figure adapted to it, by which it was produced: but the print of a human foot proves likewise, from our other experience, that there was probably another foot, which also left its impression, though effaced by time or other accidents. Here we mount from the effect to the cause; and descending again from the cause, infer alterations in the effect; but this is not a continuation of the same simple chain of reasoning. We comprehend in this case a hundred other experiences and observations, concerning the *usual* figure and members of that species of animal,

without which this method of argument must be considered as fallacious and sophistical.

The case is not the same with our reasonings from the works of nature. The Deity is known to us only by his productions, and is a single being in the universe, not comprehended under any species or genus, from whose experienced attributes or qualities, we can, by analogy, infer any attribute or quality in him. As the universe shews wisdom and goodness, we infer wisdom and goodness. As it shews a particular degree of these perfections, we infer a particular degree of them, precisely adapted to the effect which we examine. But farther attributes or farther degrees of the same attributes, we can never be authorised to infer or suppose, by any rules of just reasoning. Now, without some such licence of supposition, it is impossible for us to argue from the cause, or infer any alteration in the effect, beyond what has immediately fallen under our observation. Greater good produced by this Being must still prove a greater degree of goodness: a more impartial distribution of rewards and punishments must proceed from a greater regard to justice and equity. Every supposed addition to the works of nature makes an addition to the attributes of the Author of nature; and consequently, being entirely unsupported by any reason or argument, can never be admitted but as mere conjecture and hypothesis.[11]

In general, it may, I think, be established as a maxim, that where any cause is known only by its particular effects, it must be impossible to infer any new effects from that cause; since the qualities, which are requisite to produce these new effects along with the former, must either be different, or superior, or of more extensive operation, than those which simply produced the effect, whence alone the cause is supposed to be known to us. We can never, therefore, have any reason to suppose the existence of these qualities. To say that the new effects proceed only from a continuation of the same energy, which is already known from the first effects, will not remove the difficulty. For even granting this to be the case (which can seldom be supposed), the very continuation and exertion of a like energy (for it is impossible it can be absolutely the same), I say, this

[11] The following paragraph is a promoted footnote.

exertion of a like energy, in a different period of space and time, is a very arbitrary supposition, and what there cannot possibly be any traces of in the effects, from which all our knowledge of the cause is originally derived. Let the *inferred* cause be exactly proportioned (as it should be) to the known effect; and it is impossible that it can possess any qualities, from which new or different effects can be *inferred*.

The great source of our mistake in this subject, and of the unbounded license of conjecture, which we indulge, is, that we tacitly consider ourselves, as in the place of the Supreme Being, and conclude, that he will, on every occasion, observe the same conduct, which we ourselves, in his situation, would have embraced as reasonable and eligible. But, besides that the ordinary course of nature may convince us, that almost everything is regulated by principles and maxims very different from ours; besides this, I say, it must evidently appear contrary to all rules of analogy to reason, from the intentions and projects of men, to those of a Being so different, and so much superior. In human nature, there is a certain experienced coherence of designs and inclinations; so that when, from any fact, we have discovered one intention of any man, it may often be reasonable, from experience, to infer another, and draw a long chain of conclusions concerning his past or future conduct. But this method of reasoning can never have place with regard to a Being, so remote and incomprehensible, who bears much less analogy to any other being in the universe than the sun to a waxen taper, and who discovers himself[12] only by some faint traces or outlines, beyond which we have no authority to ascribe to him any attribute or perfection. What we imagine to be a superior perfection may really be a defect. Or were it ever so much a perfection, the ascribing of it to the Supreme Being, where it appears not to have been really exerted, to the full, in his works, savours more of flattery and panegyric, than of just reasoning and sound philosophy. All the philosophy, therefore, in the world, and all the religion, which is nothing but a species of philosophy, will

[12] The old sense of 'discover' was 'uncover', as in the chess term 'discovered check'. Hence "discovers himself" here means 'reveals himself' or 'makes himself evident'.

never be able to carry us beyond the usual course of experience, or give us measures of conduct and behaviour different from those which are furnished by reflections on common life. No new fact can ever be inferred from the religious hypothesis; no event foreseen or foretold; no reward or punishment expected or dreaded, beyond what is already known by practice and observation. So that my apology for Epicurus will still appear solid and satisfactory; nor have the political interest of society any connexion with the philosophical disputes concerning metaphysics and religion.

There is still one circumstance, replied I, which you seem to have overlooked. Though I should allow your premises, I must deny your conclusion. You conclude, that religious doctrines and reasonings *can* have no influence on life, because they *ought* to have no influence; never considering, that men reason not in the same manner you do, but draw many consequences from the belief of a divine Existence, and suppose that the Deity will inflict punishments on vice, and bestow rewards on virtue, beyond what appear in the ordinary course of nature. Whether this reasoning of theirs be just or not, is no matter. Its influence on their life and conduct must still be the same. And, those, who attempt to disabuse them of such prejudices, may, for aught I know, be good reasoners, but I cannot allow them to be good citizens and politicians; since they free men from one restraint upon their passions, and make the infringement of the laws of society, in one respect, more easy and secure.

After all, I may, perhaps, agree to your general conclusion in favour of liberty, though upon different premises from those on which you endeavour to found it. I think, that the state ought to tolerate every principle of philosophy; nor is there an instance, that any government has suffered in its political interests by such indulgence. There is no enthusiasm among philosophers; their doctrines are not very alluring to the people; and no restraint can be put upon their reasonings, but what must be of dangerous consequence to the sciences, and even to the state, by paving the way for persecution and oppression in points, where the generality of mankind are more deeply interested and concerned.

But there occurs to me (continued I) with regard to your main topic, a difficulty, which I shall just propose to you

without insisting on it; lest it lead into reasonings of too nice and delicate a nature. In a word, I much doubt whether it be possible for a cause to be known only by its effect (as you have all along supposed) or to be of so singular and particular a nature as to have no parallel and no similarity with any other cause or object, that has ever fallen under our observation. It is only when two *species* of objects are found to be constantly conjoined, that we can infer the one from the other; and were an effect presented, which was entirely singular, and could not be comprehended under any known *species,* I do not see that we could form any conjecture or inference at all concerning its cause. If experience and observation and analogy be, indeed, the only guides which we can reasonably follow in inferences of this nature; both the effect and cause must bear a similarity and resemblance to other effects and causes, which we know, and which we have found, in many instances, to be conjoined with each other. I leave it to your own reflection to pursue the consequences of this principle.[13] I shall just observe, that, as the antagonists of Epicurus always suppose the Universe, an effect quite singular and unparalleled, to be the proof of a Deity, a cause no less singular and unparalleled; your reasonings, upon that supposition, seem, at least, to merit our attention. There is, I own, some difficulty, how we can ever return from the cause to the effect, and, reasoning from our ideas of the former, infer any alteration on the latter, or any addition to it.

[13] Hume is here questioning whether experience allows the inference to any deity at all, even one with no greater attributes than whatever is required to produce the existing world. He is thus hinting at what—after Strato of Lampsacus, second in succession after Aristotle as Head of the Lyceum—had come to be called Stratonician atheism. This maintains that, since every system of explanation has to end in some fundamentals which are not and cannot be themselves explained, all our explanations should end with the existence of the Universe and the subsistence of whatever science discovers to be its most fundamental laws.

PART V

The Natural History of Religion

3. *The Natural History of Religion*

INTRODUCTION

As every enquiry, which regards religion, is of the utmost importance, there are two questions in particular, which challenge our attention, to wit, that concerning its foundation in reason, and that concerning its origin in human nature. Happily, the first question, which is the most important, admits of the most obvious, at least, the clearest, solution. The whole frame of nature bespeaks an intelligent author; and no rational enquirer can, after serious reflection, suspend his belief a moment with regard to the primary principles of genuine Theism and Religion. But the other question, concerning the origin of religion in human nature, is exposed to some more difficulty. The belief of invisible, intelligent power has been very generally diffused over the human race, in all places and in all ages; but it has neither perhaps been so universal as to admit of no exception, nor has it been, in any degree, uniform in the ideas, which it has suggested. Some nations have been discovered, who entertained no sentiments of Religion, if travellers and historians may be credited; and no two nations, and scarce any two men, have ever agreed precisely in the same sentiments. It would appear, therefore, that this preconception springs not from an original instinct or primary impression of nature, such as gives rise to self-love, affection between the sexes, love of progeny, gratitude, resentment; since every instinct of this kind has been found absolutely universal in all nations and ages, and has always a precise determinate object, which it inflexibly pursues. The first religious principles must be secondary; such as may easily be perverted by various accidents and causes, and whose operation too, in some cases, may, by an

extraordinary concurrence of circumstances, be altogether prevented. What those principles are, which give rise to the original belief, and what those accidents and causes are, which direct its operation, is the subject of our present enquiry.

I—THAT POLYTHEISM WAS THE PRIMARY RELIGION OF MEN

It appears to me, that, if we consider the improvement of human society, from rude beginnings to a state of greater perfection, polytheism or idolatry was, and necessarily must have been, the first and most ancient religion of mankind. This opinion I shall endeavour to confirm by the following arguments.

It is a matter of fact incontestable, that about 1,700 years ago all mankind were polytheists. The doubtful and sceptical principles of a few philosophers, or the theism, and that too not entirely pure, of one or two nations, form no objection worth regarding.[1] Behold then the clear testimony of history. The farther we mount up into antiquity, the more do we find mankind plunged into polytheism. No marks, no symptoms of any more perfect religion. The most ancient records of the human race still present us with that system as the popular and established creed. The north, the south, the east, the west, give their unanimous testimony to the same fact. What can be opposed to so full an evidence?

As far as writing or history reaches, mankind, in ancient times, appear universally to have been polytheists. Shall we assert, that, in more ancient times, before the knowledge of letters, or the discovery of any art or science, men entertained the principles of pure theism? That is, while they were ignorant and barbarous, they discovered truth: But fell into error, as soon as they acquired learning and politeness.

But in this assertion you not only contradict all appearance of probability, but also our present experience concerning the principles and opinions of barbarous nations. The savage

[1] Certainly the religion of Israel was exceptional. So we have here, it appears, an appeal to the rarely thought through maxim that the exception proves the rule. However, at least parts of the Old Testament seem to imply that non-Jewish gods do really exist and have some power. At any rate, Hume's main point seems to be that the modern predominance of monotheism arises from the comparatively recent spread of Christianity. (This and all the notes to the present edition of the *Natural History of Religion* are my editorial additions replacing those which Hume himself directed to be printed. Those were, with exceptions to be mentioned below, only much abbreviated references quite inadequate for the twentieth-century reader.)

tribes of AMERICA, AFRICA, and ASIA are all idolaters. Not a single exception to this rule. Insomuch, that, were a traveller to transport himself into any unknown region; if he found inhabitants cultivated with arts and science, though even upon that supposition there are odds against their being theists, yet could he not safely, till farther inquiry, pronounce any thing on that head: But if he found them ignorant and barbarous, he might beforehand declare them idolaters; and there scarcely is a possibility of his being mistaken.

It seems certain, that, according to the natural progress of human thought, the ignorant multitude must first entertain some grovelling and familiar notion of superior powers, before they stretch their conception to that perfect Being, who bestowed order on the whole frame of nature. We may as reasonably imagine, that men inhabited palaces before huts and cottages, or studied geometry before agriculture; as assert that the Deity appeared to them a pure spirit, omniscient, omnipotent, and omnipresent, before he was apprehended to be a powerful, though limited being, with human passions and appetites, limbs and organs. The mind rises gradually, from inferior to superior: By abstracting from what is imperfect, it forms an idea of perfection: And slowly distinguishing the nobler parts of its own frame from the grosser, it learns to transfer only the former, much elevated and refined, to its divinity. Nothing could disturb this natural progress of thought, but some obvious and invincible argument, which might immediately lead the mind into the pure principles of theism, and make it overleap, at one bound, the vast interval which is interposed between the human and the divine nature. But though I allow, that the order and frame of the universe, when accurately examined, affords such an argument; yet I can never think, that this consideration could have an influence on mankind, when they formed their first rude notions of religion.

The causes of such objects, as are quite familiar to us, never strike our attention or curiosity; and however extraordinary or surprising these objects in themselves, they are passed over, by the raw and ignorant multitude, without much examination or enquiry. ADAM, rising at once, in paradise, and in the full perfection of his faculties, would naturally, as represented by MILTON, be astonished at the glorious appearances of

nature, the heavens, the air, the earth, his own organs and members; and would be led to ask, whence this wonderful scene arose.[2] But a barbarous, necessitous animal (such as a man is on the first origin of society), pressed by such numerous wants and passions, has no leisure to admire the regular face of nature, or make enquiries concerning the cause of those objects, to which from his infancy he has been gradually accustomed. On the contrary, the more regular and uniform, that is, the more perfect nature appears, the more is he familiarized to it, and the less inclined to scrutinize and examine it. A monstrous birth excites his curiosity, and is deemed a prodigy.[3] It alarms him from its novelty; and immediately sets him a-trembling, and sacrificing, and praying. But an animal, complete in all its limbs and organs, is to him an ordinary spectacle, and produces no religious opinion or affection. Ask him, whence that animal arose; he will tell you, from the copulation of its parents. And these, whence? From the copulation of theirs. A few removes satisfy his curiosity, and set the objects at such a distance, that he entirely loses sight of them. Imagine not, that he will so much as start the question, whence the first animal; much less, whence the whole system, or united fabric of the universe arose. Or, if you start such a question to him, expect not, that he will employ his mind with any anxiety about a subject, so remote, so uninteresting, and which so much exceeds the bounds of his capacity.

But farther, if men were at first led into the belief of one Supreme Being, by reasoning from the frame of nature, they could never possibly leave that belief, in order to embrace polytheism; but the same principles of reason, which at first produced and diffused over mankind, so magnificent an opinion, must be able, with greater facility, to preserve it. The first invention and proof of any doctrine is much more difficult than the supporting and retaining of it.

There is a great difference between historical facts and

[2] The reference is to John Milton's Christian epic, *Paradise Lost.*

[3] 'Miracle' and 'prodigy' are by Hume employed as near-synonyms, both terms suggesting not only the extraordinary and the marvellous but also the religiously significant.

speculative opinions; nor is the knowledge of the one propagated in the same manner with that of the other. An historical fact, while it passes by oral tradition from eyewitnesses and contemporaries, is disguised in every successive narration, and may at last retain but very small, if any, resemblance of the original truth on which it was founded. The frail memories of men, their love of exaggeration, their supine carelessness; these principles, if not corrected by books and writing, soon pervert the account of historical events; where argument or reasoning has little or no place, nor can ever recall the truth, which has once escaped those narrations. It is thus the fables of HERCULES, THESEUS, BACCHUS are supposed to have been originally founded in true history, corrupted by tradition.[4] But with regard to speculative opinions, the case is far otherwise. If these opinions be founded on arguments so clear and obvious as to carry conviction with the generality of mankind, the same arguments, which at first diffused the opinions, will still preserve them in their original purity. If the arguments be more abstruse, and more remote from vulgar apprehension, the opinions will always be confined to a few persons; and as soon as men leave the contemplation of the arguments, the opinions will immediately be lost and be buried in oblivion. Whichever side of this dilemma we take, it must appear impossible, that theism could, from reasoning, have been the primary religion of human race, and have afterwards, by its corruption, given birth to polytheism and to all the various superstitions of the heathen world. Reason, when obvious, prevents these corruptions: When abstruse, it keeps the principles entirely from the knowledge of the vulgar, who are alone liable to corrupt any principle or opinion.

[4] The three cases are not exactly the same. 'Bacchus' was a name for the Greek god of wine. But neither of the two heroes, Hercules and Theseus, was supposed to have been more than a demigod by birth.

II—ORIGIN OF POLYTHEISM

If we would, therefore, indulge our curiosity, in enquiring concerning the origin of religion, we must turn our thoughts towards polytheism, the primitive religion of uninstructed mankind.

Were men led into the apprehension of invisible, intelligent power by a contemplation of the works of nature, they could never possibly entertain any conception but of one single being, who bestowed existence and order on this vast machine, and adjusted all its parts, according to one regular plan or connected system. For though, to persons of a certain turn of mind, it may not appear altogether absurd, that several independent beings, endowed with superior wisdom, might conspire in the contrivance and execution of one regular plan; yet is this a merely arbitrary supposition, which, even if allowed possible, must be confessed neither to be supported by probability nor necessity. All things in the universe are evidently of a piece. Every thing is adjusted to every thing. One design prevails throughout the whole. And this uniformity leads the mind to acknowledge one author; because the conception of different authors, without any distinction of attributes or operations, serves only to give perplexity to the imagination, without bestowing any satisfaction on the understanding. The statue of LAOCOON,[5] as we learn from PLINY, was the work of three artists: But it is certain, that, were we not told so, we should never have imagined, that a group of figures, cut from one stone, and united in one plan, was not the work and contrivance of one statuary. To ascribe any single effect to the combination of several causes, is not surely a natural and obvious supposition.

On the other hand, if, leaving the works of nature, we trace the footsteps of invisible power in the various and contrary events of human life, we are necessarily led into polytheism

[5] The famous group of statues of Laocoon and his two sons being strangled to death by sea serpents has since 1506 been one of the glories of the Vatican Museum. The Elder Pliny was a Roman administrator and encyclopedic writer who died in the eruption of Vesuvius which destroyed the ancient city of Pompeii. The reference to the Laocoon group is in his *Natural History*, XXXVI (iv) 37.

and to the acknowledgment of several limited and imperfect deities. Storms and tempests ruin what is nourished by the sun. The sun destroys what is fostered by the moisture of dews and rains. War may be favourable to a nation, whom the inclemency of the seasons afflicts with famine. Sickness and pestilence may depopulate a kingdom, amidst the most profuse plenty. The same nation is not, at the same time, equally successful by sea and by land. And a nation, which now triumphs over its enemies, may anon submit to their more prosperous arms. In short, the conduct of events, or what we call the plan of a particular providence, is so full of variety and uncertainty, that, if we suppose it immediately ordered by any intelligent beings, we must acknowledge a contrariety in their designs and intentions, a constant combat of opposite powers, and a repentance or change of intention in the same power, from impotence or levity. Each nation has its tutelar deity. Each element is subjected to its invisible power or agent. The province of each god is separate from that of another. Nor are the operations of the same god always certain and invariable. To-day he protects: To-morrow he abandons us. Prayers and sacrifices, rites and ceremonies, well or ill performed, are the sources of his favour or enmity, and produce all the good or ill fortune, which are to be found amongst mankind.

We may conclude, therefore, that, in all nations, which have embraced polytheism, the first ideas of religion arose not from a contemplation of the works of nature, but from a concern with regard to the events of life, and from the incessant hopes and fears, which actuate the human mind. Accordingly, we find, that all idolaters, having separated the provinces of their deities, have recourse to that invisible agent, to whose authority they are immediately subjected, and whose province it is to superintend that course of actions, in which they are, at any time, engaged. JUNO is invoked at marriages; LUCINA at births. NEPTUNE receives the prayers of seamen; and MARS of warriors.[6] The husbandman cultivates his field

[6] The Roman Juno was identified with the Greek Hera, sister and wife of Zeus (Jupiter). The Roman Neptune was identified with the Greek Poseidon, and the Roman Mars with the Greek Ares.

under the protection of CERES: and the merchant acknowl-
edges the authority of MERCURY.[7] Each natural event is sup-
posed to be governed by some intelligent agent; and nothing
prosperous or adverse can happen in life, which may not be the
subject of peculiar prayers or thanksgiving.

"Frail, toiling mortality, remembering its own weakness,
has divided such deities into groups, so as to worship in
sections, each the deity he is most in need of" (Pliny *Natural
History*, III (v) 15). So early as Hesiod's time there were 30,000
deities.[8] But the task to be performed by these seems still too
great for their number. The provinces of the deities were so
subdivided, that there was even a God of Sneezing. (See
Aristotle *Problems* XXXIII 7.) The providence of copulation,
suitably to the importance and dignity of it, was divided
among several deities.[9]

It must necessarily, indeed, be allowed, that, in order to
carry men's intention beyond the present course of things, or
lead them into any inference concerning invisible intelligent
power, they must be actuated by some passion, which prompts
their thought and reflection; some motive, which urges their
first enquiry. But what passion shall we here have recourse to,
for explaining an effect of such mighty consequences? Not
speculative curiosity, surely, or the pure love of truth. That
motive is too refined for such gross apprehensions; and would
lead men into enquiries concerning the frame of nature, a
subject too large and comprehensive for their narrow capaci-
ties. No passions, therefore, can be supposed to work upon such
barbarians, but the ordinary affections of human life; the
anxious concern for happiness, the dread of future misery, the
terror of death, the thirst of revenge, the appetite for food and

[7] The Italian corn-goddess Ceres was identified with the Greek
Demeter, the Roman Mercury with the Greek Hermes.

[8] Hesiod is the earliest known Greek poet after the author or authors
of the *Iliad* and the *Odyssey*. His *Works and Days* is a treasury of
peasant lore and folk wisdom. The reference is to lines 252–55.

[9] This paragraph, which Hume printed as a footnote, has been pro-
moted into the text. Two references have been modernized and placed in
parentheses, while the original Latin of Hume's first sentence has been
translated.

other necessaries. Agitated by hopes and fears of this nature, especially the latter, men scrutinize, with a trembling curiosity, the course of future causes, and examine the various and contrary events of human life. And in this disordered scene, with eyes still more disordered and astonished, they see the first obscure traces of divinity.

III — THE SAME SUBJECT CONTINUED

We are placed in this world, as in a great theatre, where the true springs and causes of every event are entirely concealed from us; nor have we either sufficient wisdom to foresee, or power to prevent those ills, with which we are continually threatened. We hang in perpetual suspense between life and death, health and sickness, plenty and want; which are distributed amongst the human species by secret and unknown causes, whose operation is oft unexpected, and always unaccountable. These *unknown causes,* then, become the constant object of our hope and fear; and while the passions are kept in perpetual alarm by an anxious expectation of the events, the imagination is equally employed in forming ideas of those powers, on which we have so entire a dependence. Could men anatomize nature, according to the most probable, at least the most intelligible philosophy, they would find, that these causes are nothing but the particular fabric and structure of the minute parts of their own bodies and of external objects; and that, by a regular and constant machinery, all the events are produced, about which they are so much concerned. But this philosophy exceeds the comprehension of the ignorant multitude, who can only conceive the *unknown causes* in a general and confused manner; though their imagination, perpetually employed on the same subject, must labour to form some particular and distinct idea of them. The more they consider these causes themselves, and the uncertainty of their operation, the less satisfaction do they meet with in their researches; and, however unwilling, they must at last have abandoned so arduous an attempt, were it not for a propensity in human nature, which leads into a system, that gives them some satisfaction.

There is an universal tendency among mankind to conceive all beings like themselves, and to transfer to every object, those qualities, with which they are familiarly acquainted, and of which they are intimately conscious. We find human faces in the moon, armies in the clouds; and by a natural propensity, if not corrected by experience and reflection, ascribe malice or good-will to every thing, that hurts or pleases us. Hence the frequency and beauty of the *prosopopœia* in poetry; where trees, mountains and streams are personified,

and the inanimate parts of nature acquire sentiment and passion.[10] And though these poetical figures and expressions gain not on the belief, they may serve, at least, to prove a certain tendency in the imagination, without which they could neither be beautiful nor natural. Nor is a river-god or hamadryad[11] always taken for a mere poetical or imaginary personage; but may sometimes enter into the real creed of the ignorant vulgar; while each grove or field is represented as possessed of a particular *genius* or invisible power,[12] which inhabits and protects it. Nay, philosophers cannot entirely exempt themselves from this natural frailty; but have oft ascribed to inanimate matter the horror of a *vacuum,* sympathies, antipathies, and other affections of human nature.[13] The absurdity is not less, while we cast our eyes upwards; and transferring, as is too usual, human passions and infirmities to the deity, represent him as jealous and revengeful, capricious and partial, and, in short, a wicked and foolish man, in every respect but his superior power and authority. No wonder, then, that mankind, being placed in such an absolute ignorance of causes, and being at the same time so anxious concerning their future fortune, should immediately acknowledge a dependence on invisible powers, possessed of sentiment and intelligence. The *unknown causes* which continually employ their thought, appearing always in the same aspect, are all apprehended to be of the same kind or species. Nor is it long before we ascribe to them thought and reason and passion, and sometimes even the limbs and figures of men, in order to bring them nearer to a resemblance with ourselves.

In proportion as any man's course of life is governed by accident, we always find, that he encreases in superstition; as

[10] To Hume's sufficient explanation of the meaning of *'prosopopoeia'* it is worth adding that 'pathetic fallacy' is now the accepted name for the mistake—not strictly a fallacy—of attributing to inanimate objects the feelings, dispositions, and reactions which could only characterize animate creatures, and in particular people.

[11] A wood nymph.

[12] Hence *genius loci* [spirit of the place].

[13] In Hume's day and for a century or more thereafter what we call physics was known as natural philosophy.

may particularly be observed of gamesters and sailors, who, though, of all mankind, the least capable of serious reflection, abound most in frivolous and superstitious apprehensions. The gods, says CORIOLANUS in DIONYSIUS[14] have an influence in every affair; but above all, in war; where the event is so uncertain. All human life, especially before the institution of order and good government, being subject to fortuitous accidents; it is natural, that superstition should prevail every where in barbarous ages, and put men on the most earnest enquiry concerning those invisible powers, who dispose of their happiness or misery. Ignorant of astronomy and the anatomy of plants and animals, and too little curious to observe the admirable adjustment of final causes; they remain still unacquainted with a first and supreme creator, and with that infinitely perfect spirit, who alone, by his almighty will, bestowed order on the whole frame of nature. Such a magnificent idea is too big for their narrow conceptions, which can neither observe the beauty of the work, nor comprehend the grandeur of its author. They suppose their deities, however potent and invisible, to be nothing but a species of human creatures, perhaps raised from among mankind, and retaining all human passions and appetites, together with corporeal limbs and organs. Such limited beings, though masters of human fate, being, each of them, incapable of extending his influence every where, must be vastly multiplied, in order to answer that variety of events, which happen over the whole face of nature. Thus every place is stored with a crowd of local deities; and thus polytheism has prevailed, and still prevails, among the greatest part of uninstructed mankind.[15]

Any of the human affections may lead us into the notion of

[14] The reference is to Dionysius of Halicarnassus, *Roman Antiquities,* Vii(ii) 2. This Dionysius was an historian and rhetorician flourishing in Rome from 30 BCE; and this book was, presumably, the ultimate source for the plot of Shakespeare's *Coriolanus.*

[15] Hume here added a note, since he could not "forbear quoting" Euripides, *Hecuba* (lines 956–960), which translates: "There is nothing secure in the world; no glory, no prosperity. The gods themselves toss all life into confusion; mix every thing with its reverse; that all of us, from our ignorance and uncertainty, may pay them the more worship and reverence."

invisible, intelligent power; hope as well as fear, gratitude as well as affliction: But if we examine our own hearts, or observe what passes around us, we shall find that men are much oftener thrown on their knees by the melancholy than by the agreeable passions. Prosperity is easily received as our due, and few questions are asked concerning its cause or author. It begets cheerfulness and activity and alacrity and a lively enjoyment of every social and sensual pleasure: And during this state of mind, men have little leisure or inclination to think of the unknown invisible regions. On the other hand, every disastrous accident alarms us, and sets us on enquiries concerning the principles whence it arose: Apprehensions spring up with regard to futurity: And the mind, sunk into diffidence, terror, and melancholy, has recourse to every method of appeasing those secret intelligent powers, on whom our fortune is supposed entirely to depend.

No topic is more usual with all popular divines than to display the advantages of affliction, in bringing men to a due sense of religion; by subduing their confidence and sensuality, which, in times of prosperity, make them forgetful of a divine providence. Nor is this topic confined merely to modern religions. The ancients have also employed it. *Fortune has never liberally, without envy,* says a GREEK historian, *bestowed an unmixed happiness on mankind; but with all her gifts has ever conjoined some disastrous circumstance, in order to chastize men into a reverence for the gods, whom, in a continued course of prosperity, they are apt to neglect and forget.*[16]

What age or period of life is the most addicted to superstition? The weakest and most timid. What sex? The same answer must be given. *The leaders and examples of every kind of superstition,* says STRABO, *are the women. These excite the men to devotion and supplications, and the observance of religious days. It is rare to meet with one that lives apart from the females, and yet is addicted to such practices. And nothing can, for this reason, be more improbable, than the account given*

[16] The reference is to Book III, Chapter 47, of the *Library of World History* compiled by Diodorus Siculus, who flourished under Julius Caesar and lived on into the first part of the reign of Augustus. Diodorus applied his remarks not to mankind in general but to one specific Arabian tribe, the Sabaeans.

of an order of men among the GETES, *who practised celibacy, and were notwithstanding the most religious fanatics.*[17] A method of reasoning, which would lead us to entertain a bad idea of the devotion of monks; did we not know by an experience, not so common, perhaps, in STRABO'S days, that one may practise celibacy, and profess chastity; and yet maintain the closest connexions and most entire sympathy with that timorous and pious sex.

[17] The reference is to Book VII, Chapter 4, of the *Geography* of Strabo (c. 63 BCE–c. 21 CE).

IV — DEITIES NOT CONSIDERED AS CREATORS OR FORMERS OF THE WORLD

The only point of theology, in which we shall find a consent of mankind almost universal, is, that there is invisible, intelligent power in the world: But whether this power be supreme or subordinate, whether confined to one being, or distributed among several, what attributes, qualities, connexions, or principles of action ought to be ascribed to those beings; concerning all these points, there is the widest difference in the popular systems of theology. Our ancestors in EUROPE, before the revival of letters, believed, as we do at present, that there was one supreme God, the author of nature, whose power, though in itself uncontroulable, was yet often exerted by the interposition of his angels and subordinate ministers, who executed his sacred purposes. But they also believed, that all nature was full of other invisible powers; fairies, goblins, elves, sprights; beings, stronger and mightier than men, but much inferior to the celestial natures, who surround the throne of God. Now, suppose, that any one, in those ages, had denied the existence of God and of his angels; would not his impiety justly have deserved the appellation of atheism, even though he had still allowed, by some odd capricious reasoning, that the popular stories of elves and fairies were just and well-grounded? The difference, on the one hand, between such a person and a genuine theist is infinitely greater than that, on the other, between him and one that absolutely excludes all invisible intelligent power. And it is a fallacy, merely from the casual resemblance of names, without any conformity of meaning, to rank such opposite opinions under the same denomination.[18]

To any one, who considers justly of the matter, it will appear, that the gods of all polytheists are not better than the elves or fairies of our ancestors, and merit as little any pious worship or veneration. These pretended religionists are really a kind of superstitious atheists, and acknowledge no being, that corresponds to our idea of a deity. No first principle of

[18] Hume here is presumably recalling that the early Christians were sometimes denounced as atheists because they refused to worship any "invisible intelligent power" other than the unique God of Mosaic theism (that of Judaism, Christianity, and Islam).

mind or thought: No supreme government and administration: No divine contrivance or intention in the fabric of the world.

The CHINESE, when their prayers are not answered, beat their idols.[19] The deities of the LAPLANDERS are any large stone which they meet with of an extraordinary shape.[20] The EGYPTIAN mythologists, in order to account for animal worship, said, that the gods, pursued by the violence of earthborn men, who were their enemies, had formerly been obliged to disguise themselves under the semblance of beasts.[21] The CAUNII, a nation in the Lesser ASIA,[22] resolving to admit no strange gods among them, regularly, at certain seasons assembled themselves compleatly armed, beat the air with their lances, and proceeded in that manner to their frontiers; in order, as they said, to expel the foreign deities.[23] *Not even the immortal gods,* said some GERMAN nations to CÆSAR,[24] *are a match for the* SUEVI.

[19] Hume here refers to Père Le Comte, *Nouveaux Memoires sur l'état present de la Chine* [Fresh Notes on the Present Condition of China] (Amsterdam, 1698), II 104. This Jesuit Father was one of a team sent to China in 1685. His book, eventually translated into all the main languages of Western Europe, was enormously popular. Because of its extremely sympathetic account of contemporary Chinese religion and morals it offended ecclesiastical authority, and was several times officially condemned.

[20] Hume's in truth unreliable authority was Jean-François Regnard, *Voiage de Lapponie* [Journey to Lapland]. His collected works were published in Paris in 1731, and Hume probably came upon this one while working on *A Treatise of Human Nature* at La Flèche in Touraine.

[21] Diodorus Siculus, *Op. Cit.,* I.86; Lucian, *De Sacrificiis* [On Sacrifices], 14; Ovid, *Metamorphoses,* V.321; also Manilius, *Astronomica* [Astronomy], IV.

[22] Asia Minor, or Anatolia, the peninsula between the Black and Mediterranean seas, now constitutes most of Turkey. Hume uses the word "nation" where we would say 'tribe'.

[23] Herodotus, *History,* I.172. Herodotus, who flourished in the earlier part of the fifth century BCE, was a Greek from Halicarnassus in Asia Minor, often hailed as the Father of History.

[24] Caesar, *De Bello Gallico* [On The Gallic War], IV. 7. This is, of course, Julius Caesar, subject of Shakespeare's play, *Julius Caesar,* and of Phyllis Bentley's novel, *Freedom, Farewell!* He conquered Gaul (now France), and then used his army to become ruler of Rome in 46 BCE. He

Many ills, says DIONE in HOMER to VENUS wounded by
DIOMEDE, many ills, my daughter, have the gods inflicted on
men: And many ills, in return, have men inflicted on the
gods.[25] We need but open any classic author to meet with these
gross representations of the deities; and LONGINUS with rea-
son observes, that such ideas of the divine nature, if literally
taken, contain a true atheism.[26]

Some writers[27] have been surprised, that the impieties of
ARISTOPHANES should have been tolerated, nay publicly acted
and applauded by the ATHENIANS; a people so superstitious
and so jealous of the public religion, that, at that very time,
they put SOCRATES to death for his imagined incredulity. But
these writers do not consider that the ludicrous, familiar
images, under which the gods are represented by that comic
poet, instead of appearing impious, were the genuine lights in
which the ancients conceived their divinities. What conduct
can be more criminal or mean, than that of JUPITER in the
AMPHITRION? Yet that play, which represented his gallante
exploits, was supposed so agreeable to him, that it was always
acted in ROME by public authority, when the state was threat-
ened with pestilence, famine, or any general calamity.[28] The
ROMANS supposed, that, like all old letchers, he would be
highly pleased with the recital of his former feats of prowess
and vigour, and that no topic was so proper, upon which to
flatter his vanity.

The LACEDEMONIANS, says XENOPHON,[29] always, during
war, put up their petitions very early in the morning, in order

was assassinated in 44 BCE, and in due course became a god. His
adopted son Octavian (Augustus Caesar) took power, and is usually
regarded as the first Roman emperor.

[25] *Iliad,* V.381–84.

[26] Longinus, *On the Sublime,* IX.7.

[27] Pierre Brimoy, *Théâtre des Grecs* [Greek Drama] (Paris, 1730) and
Fontanelle, *Histoire des Oracles* (Paris, 1687). The latter was a very
popular work, which reappeared almost immediately in an English trans-
lation as *The History of Oracles, and the Cheats of the Pagan Priests*
(London, 1688).

[28] Arnobius, *Seven Books against the Heathen,* VII.33.

[29] *The Constitution of the Lacedaimonians,* 13. 'Lacedaimonian' is an
older synonym for 'Spartan'.

to be beforehand with their enemies, and, by being the first solicitors, pre-engage the gods in their favour. We may gather from SENECA,[30] that it was usual, for the votaries in the temples, to make interest with the beadle or sexton, that they might have a seat near the image of the deity, in order to be the best heard in their prayers and applications to him. The TYRIANS, when besieged by ALEXANDER, threw chains on the statue of HERCULES, to prevent that deity from deserting to the enemy.[31] AUGUSTUS, having twice lost his fleet by storms, forbad NEPTUNE to be carried in procession along with the other gods; and fancied, that he had sufficiently revenged himself by that expedient.[32] After GERMANICUS's death, the people were so enraged at their gods, that they stoned them in their temples; and openly renounced all allegiance to them.[33]

To ascribe the origin and fabric of the universe to these imperfect beings never enters into the imagination of any polytheist or idolater. HESIOD, whose writings, with those of HOMER, contained the canonical system of the heavens;[34] HESIOD, I say, supposes gods and men to have sprung equally from the unknown powers of nature.[35] And throughout the whole theogony of that author, PANDORA is the only instance of creation or a voluntary production; and she too was formed by the gods merely from despight to PROMETHEUS, who had furnished men with stolen fire from the celestial regions.[36] The ancient mythologists, indeed, seem throughout to have rather embraced the idea of generation than that of creation or formation; and to have thence accounted for the origin of this universe.

OVID, who lived in a learned age, and had been instructed

[30] *Moral Letters,* 41.

[31] Curtius Rufus, *History of Alexander,* IV (iii) 21–22; and Diodorus Siculus, *Op. Cit.,* XVII (xli) 8.

[32] Suetonius, *Life of Augustus,* 16.

[33] Suetonius, *Gaius Caligula,* 5.

[34] Herodotus, *Op. Cit.,* II.53; and Lucian, *Some Questions for Zeus, On Funerals, Saturn,* etc. The writings of Lucian constitute a treasury of ancient scepticism.

[35] Hume quotes in a note line 108 of *Works and Days,* which translates: "How the gods and mortal men sprang from one source."

[36] Hesiod, *Theogony,* 570ff.

by philosophers in the principles of a divine creation or formation of the world; finding, that such an idea would not agree with the popular mythology, which he delivers, leaves it, in a manner, loose and detached from his system. *Quisquis fuit ille Deorum?*[37] Whichever of the gods it was, says he, that dissipated the chaos, and introduced order into the universe. It could neither be SATURN, he knew, nor JUPITER, nor NEPTUNE, nor any of the received deities of paganism. His theological system had taught him nothing upon that head; and he leaves the matter equally undetermined.

DIODORUS SICULUS,[38] beginning his work with an enumeration of the most reasonable opinions concerning the origin of the world, makes no mention of a deity or intelligent mind; though it is evident from his history, that he was much more prone to superstition than to irreligion. And in another passage,[39] talking of the ICHTHYOPHAGI, a nation in INDIA, he says, that, there being so great difficulty in accounting for their descent, we must conclude them to be *aborigines,* without any beginning of their generation, propagating their race from all eternity, as some of the physiologers,[40] in treating of the origin of nature, have justly observed. "But in such subjects as these," adds the historian, "which exceed all human capacity, it may well happen, that those, who discourse the most, know the least; reaching a specious appearance of truth in their reasonings, while extremely wide of the real truth and matter of fact."

A strange sentiment in our eyes, to be embraced by a professed and zealous religionist! The same author, who can thus account for the origin of the world without a Deity, esteems it impious to explain from physical causes, the common accidents of life, earthquakes, inundations, and tempests; and devoutly ascribes these to the anger of JUPITER or NEPTUNE. A plain proof, whence he derived his ideas of religion.[41]

[37] Ovid, *Metamorphoses,* I 32. The immediate following words translate his Latin.

[38] *Op. Cit.,* I.6–7.

[39] *Ibid.,* III.20.

[40] Physiologists.

[41] Hume printed the previous two sentences as a footnote, referring readers to Diodorus Siculus, *Op. Cit.,* XV.48.

But it was merely by accident that the question concerning the origin of the world did ever in ancient times enter into religious systems, or was treated of by theologers. The philosophers alone made profession of delivering systems of this kind; and it was pretty late too before these bethought themselves of having recourse to a mind of supreme intelligence, as the first cause of all. So far was it from being esteemed profane in those days to account for the origin of things without a deity, that THALES, ANAXIMENES, HERACLITUS,[42] and others, who embraced that system of cosmogony, past unquestioned; while ANAXAGORAS, the first undoubted theist, among the philosophers, was perhaps the first that ever was accused of atheism.[43]

It will be easy to give a reason, why THALES, ANAXIMANDER, and those early philosophers, who really were atheists, might be very orthodox in the pagan creed; and why ANAXAGORAS and SOCRATES, though real theists, must naturally, in ancient times, be esteemed impious. The blind, unguided powers of nature, if they could produce men, might also produce such beings as JUPITER and NEPTUNE, who being the most powerful, intelligent existences in the world, would be proper objects of worship. But where a supreme intelligence, the first cause of all, is admitted, these capricious beings, if they exist at all, must appear very subordinate and dependent, and consequently be excluded from the rank of deities. PLATO assigns this reason for the imputation thrown on ANAXAGORAS, namely, his denying the divinity of the stars, planets, and other created objects.[44]

[42] Thales who, drawing on the work of Babylonian astronomers, predicted the eclipse of 585 BCE, Anaximander who died c. 547/6 BCE, and his younger contemporary Anaximines were the first three Greek speculators in what later came to be called 'natural philosophy' and subsequently 'physics'. All three were citizens of Miletus on the coast of Asia Minor. Heraclitus of Ephesus, about whose life nothing is known save that it must have been lived a full century later than that of Anaximines, became, mainly by reaction, a major influence on Plato (c. 428–c. 348 BCE).

[43] About Anaxagoras of Clazomenae (c. 500/499–c. 428/7 BCE) almost everything else which is known is stated in the paragraph which, in the text above, follows. Hume printed that paragraph as a footnote.

[44] Plato, *The Laws*, X.886 A–E.

We are told by SEXTUS EMPIRICUS,[45] that EPICURUS, when a boy, reading with his preceptor these verses of HESIOD,

> Eldest of beings, *chaos* first arose;
> Next *earth*, wide-stretch'd, the SEAT of all.

the young scholar first betrayed his inquisitive genius, by asking, *And chaos whence?* But was told by his preceptor, that he must have recourse to the philosophers for a solution of such questions. And from this hint EPICURUS left philology and all other studies, in order to betake himself to that science, whence alone he expected satisfaction with regard to these sublime subjects.

The common people were never likely to push their researches so far, or derive from reasoning their systems of religion; when philologers and mythologists, we see, scarcely ever discovered[46] so much penetration. And even the philosophers, who discourse of such topics, readily assented to the grossest theory, and admitted the joint origin of gods and men from night and chaos: from fire, water, air, or whatever they established to be the ruling element.

Nor was it only on their first origin, that the gods were supposed dependent on the powers of nature. Throughout the whole period of their existence they were subjected to the dominion of fate or destiny. *Think of the force of necessity,* says AGRIPPA to the ROMAN people, that force, *to which even the gods must submit.*[47] And the Younger PLINY,[48] agreeably to this way of thinking, tells us, that amidst the darkness, horror, and confusion, which ensued upon the first eruption of VESUVIUS, several concluded, that all nature was going to wrack, and that gods and men were perishing in one common ruin.

[45] *Against the Physicists,* II 18–19. Epicurus (341–270 BCE), who founded the Epicurean school in Athens in about 307 BCE, drew most of his ideas in natural philosophy from the original atomists Leucippus and Democritus.

[46] In Hume's day, the word 'discover' meant 'uncover', and hence 'reveal'. Hume is saying that we can't expect ordinary people in ancient times to have erected their religious beliefs on a rational foundation, when scholars and poets failed to do so.

[47] Dionysius of Halicarnassus, *Op. Cit.,* VI.54.

[48] *Letters* VI (xx) 15.

It is great complaisance, indeed, if we dignify with the name of religion such an imperfect system of theology, and put it on a level with later systems, which are founded on principles more just and more sublime. For my part, I can scarcely allow the principles even of MARCUS AURELIUS, PLUTARCH, and some other *Stoics* and *Academics,* though much more refined than the pagan superstition, to be worthy of the honourable appellation of theism.[49] For if the mythology of the heathens resemble the ancient EUROPEAN system of spiritual beings, excluding God and angels, and leaving only fairies and sprights,[50] the creed of these philosophers may justly be said to exclude a deity, and to leave only angels and fairies.

[49] Marcus Aurelius Antoninus was Roman emperor from 161 till 180, and his Stoic *Meditations* have traditionally been respected as an expression of Classical paganism at its best. Plutarch (46–126) is mentioned here as the author of *Moralia* [moral essays] and the much read *Parallel Lives*. Stocism was a philosophy and world outlook named after the Stoa Poikile, the building in Athens where it was first propounded by Zeno of Citium (c. 334–262 BCE); not to be confounded with Zeno of Elea, the Zeno of the Paradoxes. Academics are those accepting what was from time to time taught in the Academy, the first university institution, founded by Plato in Athens in about 385 BCE.

[50] Some sort of, or any sort of, bodiless spirit.

V — VARIOUS FORMS OF POLYTHEISM: ALLEGORY, HERO-WORSHIP

But it is chiefly our present business to consider the gross polytheism of the vulgar, and to trace all its various appearances, in the principles of human nature, whence they are derived.

Whoever learns by argument the existence of invisible intelligent power, must reason from the admirable contrivance of natural objects, and must suppose the world to be the workmanship of that divine being, the original cause of all things. But the vulgar polytheist, so far from admitting that idea, deifies every part of the universe, and conceives all the conspicuous productions of nature to be themselves so many real divinities. The sun, moon, and stars, are all gods according to his system: Fountains are inhabited by nymphs, and trees by hamadryads: Even monkeys, dogs, cats, and other animals often become sacred in his eyes, and strike him with a religious veneration. And thus, however strong men's propensity to believe invisible, intelligent power in nature, their propensity is equally strong to rest their attention on sensible, visible objects; and in order to reconcile these opposite inclinations, they are led to unite the invisible power with some visible object.

The distribution also of distinct provinces to the several deities is apt to cause some allegory,[51] both physical and moral, to enter into the vulgar systems of polytheism. The god of war will naturally be represented as furious, cruel, and impetuous: The god of poetry as elegant, polite, and amiable: The god of merchandise, especially in early times, as thievish and deceitful. The allegories, supposed in HOMER and other mythologists, I allow, have often been so strained, that men of sense are apt entirely to reject them, and to consider them as the

[51] 'Allegory' is standardly defined as the description of one thing under the image of another. In *De Rerum Natura* [On the Nature of Things], II.655–60, Lucretius, the poet of Epicurean philosophy, insisted that talk of the Olympian gods was acceptable only if construed allegorically: "If anyone elects to call the sea Neptune and the crops Ceres and would rather take Bacchus's name in vain than denote grape juice by its proper title, we may let it pass . . . provided that he genuinely refrains from polluting his mind with the foul taint of superstition."

production merely of the fancy and conceit of critics and commentators. But that allegory really has place in the heathen mythology is undeniable even on the least reflection. CUPID the son of VENUS; the Muses the daughters of Memory; PROMETHEUS, the wise brother, and EPIMETHEUS the foolish; HYGIEIA or the goddess of health descended from ÆSCULAPIUS or the god of Physic: Who sees not, in these, and in many other instances, the plain traces of allegory?[52] When a god is supposed to preside over any passion, event, or system of actions, it is almost unavoidable to give him a genealogy, attributes, and adventures, suitable to his supposed powers and influence; and to carry on that similitude and comparison, which is naturally so agreeable to the mind of man.

Allegories, indeed, entirely perfect, we ought not to expect as the productions of ignorance and superstition; there being no work of genius that requires a nicer hand, or has been more rarely executed with success. That *Fear* and *Terror* are the sons of MARS is just; but why by VENUS?[53] That *Harmony* is the daughter of VENUS is regular; but why by MARS?[54] That *Sleep* is the brother of *Death* is suitable; but why describe him as enamoured of one of the Graces?[55] And since the ancient mythologists fall into mistakes so gross and palpable, we have no reason surely to expect such refined and long-spun allegories, as some have endeavoured to deduce from their fictions.

LUCRETIUS was plainly seduced by the strong appearance of allegory, which is observable in the pagan fictions. He first addresses himself to VENUS as to that generating power, which animates, renews, and beautifies the universe: But is soon betrayed by the mythology into incoherencies, while he prays to that allegorical personage to appease the furies of her lover MARS: An idea not drawn from allegory, but from the popular

[52] 'Prometheus' and 'Epimetheus' are derivations from Greek words for, respectively, forethought and afterthought. English 'hygiene' and 'venereal' derive from the names of the goddesses Hygieia (Greek) and Venus (Roman). The Romans identified their Venus with the Greek Aphrodite, from whom we derive 'aphrodisiac'.

[53] Hesiod *Theogony*, 933–35.

[54] *Ibid.*, 936–37; and Plutarch *Life of Pelopidas*, 19.

[55] Homer *The Iliad*, XIV. 267.

religion, and which LUCRETIUS, as an EPICUREAN, could not consistently admit of.[56]

The deities of the vulgar are so little superior to human creatures, that, where men are affected with strong sentiments of veneration or gratitude for any hero or public benefactor, nothing can be more natural than to convert him into a god, and fill the heavens, after this manner, with continual recruits from among mankind. Most of the divinities of the ancient world are supposed to have once been men, and to have been beholden for their *apotheosis*[57] to the admiration and affection of the people. The real history of their adventures, corrupted by tradition, and elevated by the marvellous, became a plentiful source of fable; especially in passing through the hands of poets, allegorists, and priests, who successively improved upon the wonder and astonishment of the ignorant multitude.

Painters too and sculptors came in for their share of profit in the sacred mysteries; and furnishing men with sensible representations of their divinities, whom they clothed in human figures, gave great encrease to the public devotion, and determined its object. It was probably for want of these arts in rude and barbarous ages, that men deified plants, animals, and even brute, unorganized matter; and rather than be without a sensible object of worship, affixed divinity to such ungainly forms. Could any statuary of SYRIA, in early times, have formed a just figure of APOLLO, the conic stone, HELIO-GABALUS, had never become the object of such profound adoration, and been received as a representation of the solar deity[58] JUPITER AMMON is represented by CURTIUS as a deity of

[56] *Op. Cit.*, I.1–40.

[57] Turning into a god, deification. It was on the model of this word that Seneca formed the title *Apocolocyntosis* [Pumpkinification] for his satire on the reign of the Emperor Claudius (41–50). See Robert Graves's *Claudius the God,* sequel to his *I, Claudius* (both of them modern novels based on the Life of Claudius).

[58] As an Olympian god of light Apollo was always presented as a young and handsome man. The name of the Roman Emperor Heliogabalus or Elagabalus (218–222) was derived from that of this local Syrian sun god, whose priest he had been. Hume refers here to Herodian, a Greek grammarian compiling enormous otherwise unread works at Rome in the time of Marcus Aurelius.

the same kind.[59] The ARABIANS and PESSINUNTIANS adored also shapeless unformed stones as their deity.[60] So much did their folly exceed that of the EGYPTIANS.[61]

STILPO was banished by the council of AREOPAGUS, for affirming that the MINERVA in the citadel was no divinity; but the workmanship of PHIDIAS, the sculptor.[62] What degree of reason must we expect in the religious belief of the vulgar in other nations; when ATHENIANS and AREOPAGITES could entertain such gross misconceptions?

These then are the general principles of polytheism, founded in human nature, and little or nothing dependent on caprice and accident. As the *causes,* which bestow happiness or misery, are, in general, very little known and very uncertain, our anxious concern endeavours to attain a determinate idea of them; and finds no better expedient than to represent them as intelligent voluntary agents, like ourselves; only somewhat superior in power and wisdom. The limited influence of these agents, and their great proximity to human weakness, introduce the various distribution and division of their authority; and thereby give rise to allegory. The same principles naturally deify mortals, superior in power, courage, or understanding, and produce hero-worship; together with fabulous history and mythological tradition, in all its wild and unaccountable forms. And as an invisible spiritual intelligence is an object too refined for vulgar apprehension, men naturally affix it to some sensible representation; such as either the more conspicuous parts of nature, or the statues, images, and pictures, which a more refined age forms of its divinities.

Almost all idolaters, of whatever age or country, concur in these general principles and conceptions; and even the partic-

[59] *History of Alexander,* I.233.

[60] Arnobius, *Seven Books against the Heathen,* VI.ii (510B).

[61] This and the two preceding sentences were printed by Hume as a footnote.

[62] Diogenes Laertius, *Lives of the Eminent Philosophers,* II (xi) 116. Minerva was the Roman goddess identified with Athena, patron of Athens. 'Athena Parthenos' was the name of the statue by Phidias (or Pheidias) which used to stand in her temple, the Parthenon. The ancient Council of the Areopagus (the hill of Ares) was still in existence as late as the fourth century CE.

ular characters and provinces, which they assign to their deities, are not extremely different.[63] The GREEK and ROMAN travellers and conquerors, without much difficulty, found their own deities every where; and said, This is MERCURY, that VENUS; this MARS, that NEPTUNE; by whatever title the strange gods might be denominated. The goddess HERTHA of our SAXON ancestors seems to be no other, according to TACITUS than[64] the *Mater Tellus* of the ROMANS; and his conjecture was evidently just.

[63] Caesar, *De Bello Gallico* [On the Gallic War], VI.16–17.

[64] Tacitus, *Germania*, 40. *Mater Tellus* is Earth Mother. The modern phrase 'Mother Earth' derives from very ancient cultic roots!

VI—ORIGIN OF THEISM FROM POLYTHEISM

The doctrine of one supreme deity, the author of nature, is very ancient, has spread itself over great and populous nations, and among them has been embraced by all ranks and conditions of men: But whoever thinks that it has owed its success to the prevalent force of those invincible reasons, on which it is undoubtedly founded, would show himself little acquainted with the ignorance and stupidity of the people, and their incurable prejudices in favour of their particular superstitions. Even at this day, and in EUROPE, ask any of the vulgar, why he believes in an omnipotent creator of the world; he will never mention the beauty of final causes, of which he is wholly ignorant: He will not hold out his hand, and bid you contemplate the suppleness and variety of joints in his fingers, their bending all one way, the counterpoise which they receive from the thumb, the softness and fleshy parts of the inside of his hand, with all the other circumstances, which render that member fit for the use, to which it was destined. To these he has been long accustomed; and he beholds them with listlessness and unconcern. He will tell you of the sudden and unexpected death of such a one: The fall and bruise of such another: The excessive drought of this season: The cold and rains of another. These he ascribes to the immediate operation of providence: And such events, as, with good reasoners, are the chief difficulties in admitting a supreme intelligence, are with him the sole arguments for it.

Many theists, even the most zealous and refined, have denied a *particular* providence, and have asserted, that the Sovereign mind or first principle of all things, having fixed general laws, by which nature is governed, gives free and uninterrupted course to these laws, and disturbs not, at every turn, the settled order of events by particular volitions. From the beautiful connexion, say they, and rigid observance of established rules, we draw the chief argument for theism; and from the same principles are enabled to answer the principal objections against it. But so little is this understood by the generality of mankind, that, wherever they observe any one to ascribe all events to natural causes, and to remove the particular interposition of a deity, they are apt to suspect him of the

grossest infidelity. *A little philosophy,* says LORD BACON, *makes men atheists: A great deal reconciles them to religion.*[65] For men, being taught, by superstitious prejudices, to lay the stress on a wrong place; when that fails them, and they discover, by a little reflection, that the course of nature is regular and uniform, their whole faith totters, and falls to ruin. But being taught, by more reflection, that this very regularity and uniformity is the strongest proof of design and of a supreme intelligence, they return to that belief, which they had deserted; and they are now able to establish it on a firmer and more durable foundation.

Convulsions in nature, disorders, prodigies, miracles, though the most opposite to the plan of a wise superintendent, impress mankind with the strongest sentiments of religion; the causes of events seeming then the most unknown and unaccountable. Madness, fury, rage, and an inflamed imagination, though they sink men nearest to the level of beasts, are, for a like reason, often supposed to be the only dispositions, in which we can have any immediate communication with the Deity.

We may conclude, therefore, upon the whole, that, since the vulgar, in nations which have embraced the doctrine of theism, still build it upon irrational and superstitious principles, they are never led into that opinion by any process of argument, but by a certain train of thinking, more suitable to their genius and capacity.

It may readily happen, in an idolatrous nation, that though men admit the existence of several limited deities, yet is there some one God, whom, in a particular manner, they make the object of their worship and adoration. They may either suppose, that, in the distribution of power and territory among the gods, their nation was subjected to the jurisdiction of that particular deity; or reducing heavenly objects to the model of

[65] Lord Bacon was Francis Bacon, first Lord Verulam (1561–1626), author of *Essays, The Advancement of Learning, Novum Organum,* and *New Atlantis.* In his essay 'Of Atheism' he wrote: "Certainly a little philosophy inclineth a man's mind to atheism, but depth in philosophy bringeth men about to religion."

things below, they may represent one god as the prince or supreme magistrate of the rest, who, though of the same nature, rules them with an authority, like that which an earthly sovereign exercises over his subjects and vassals. Whether this god, therefore, be considered as their peculiar patron, or as the general sovereign of heaven, his votaries will endeavour, by every art, to insinuate themselves into his favour; and supposing him to be pleased, like themselves, with praise and flattery, there is no eulogy or exaggeration, which will be spared in their addresses to him. In proportion as men's fears or distresses become more urgent, they still invent new strains of adulation; and even he who outdoes his predecessor in swelling up the titles of his divinity, is sure to be outdone by his successor in newer and more pompous epithets of praise. Thus they proceed; till at last they arrive at infinity itself, beyond which there is no farther progress: And it is well, if, in striving to get farther, and to represent a magnificent simplicity, they run not into inexplicable mystery, and destroy the intelligent nature of their deity, on which alone any rational worship or adoration can be founded. While they confine themselves to the notion of a perfect being, the creator of the world, they coincide, by chance, with the principles of reason and true philosophy; though they are guided to that notion, not by reason, of which they are in a great measure incapable, but by the adulation and fears of the most vulgar superstition.

We often find, amongst barbarous nations, and even sometimes amongst civilized, that, when every strain of flattery has been exhausted towards arbitrary princes, when every human quality has been applauded to the utmost; their servile courtiers represent them, at last, as real divinities and point them out to the people as objects of adoration.[66] How much more natural, therefore, is it, that a limited deity, who at first supposed only the immediate author of the particular goods and ills in life, should in the end be represented as sovereign maker and modifier of the universe?

[66] By all Hume's educated contempories this would have been recognized at once as an allusion to the practice of deifying Roman emperors.

Even where this notion of a supreme deity is already established; though it ought naturally to lessen every other worship, and abase every object of reverence, yet if a nation has entertained the opinion of a subordinate tutelar divinity, saint, or angel; their addresses to that being gradually rise upon them, and encroach on the adoration due to their supreme deity. The Virgin Mary, ere checked by the reformation, had proceeded, from being merely a good woman, to usurp many attributes of the Almighty: God and ST NICHOLAS go hand in hand, in all the prayers and petitions of the MUSCOVITES.[67]

Thus the deity, who, from love, converted himself into a bull, in order to carry off EUROPA; and who, from ambition, dethroned his father, SATURN, became the OPTIMUS MAXIMUS of the heathens. Thus the deity, whom the vulgar Jews conceived of only as the God of ABRAHAM, ISAAC, and JACOB, became their JEHOVAH and Creator of the world.

The JACOBINS,[68] who denied the immaculate conception, have ever been very unhappy in their doctrine, even though political reasons have kept the ROMISH church from condemning it. The CORDELIERS have run away with all the popularity. But in the fifteenth century, as we learn from BOULAIN-VILLIERS, an ITALIAN *Cordelier* maintained, that, during the three days, when CHRIST was interred, the hypostatic union was dissolved, and that his human nature was not a proper object of adoration, during that period.[69] Without the art of

[67] In Hume's day the Russian empire was known as the empire of Muscovy, the province of Moscow.

[68] 'Jacobin' was a name originally given in France to Dominican Friars. (The Jacobins "who denied the immaculate conception" are not to be confused with the Jacobins of the great 1789 French Revolution; described by Lenin in a 1917 article in *Pravda* as "the first Bolsheviks".) "Their doctrine" was in fact later implicitly condemned by what has now to be called the First Vatican Council of 1870–71.

[69] 'Cordelier' was a name sometimes given in France to the Franciscan Observatines, an order deriving its inspiration from the Spiritual Franciscans. Presumably Hume is referring to the *Abrège chronologique de l'histoire de France* [Chronological Summary of the History of France] (Paris, 1733) by the Count Henri de Boulainvilliers.

divination, one might foretell, that so gross and impious a blasphemy would not fail to be anathematized by the people. It was the occasion of great insults on the part of the JACOBINS; who now got some recompense for their misfortunes in the war about the immaculate conception.

Rather than relinquish this propensity to adulation, religionists, in all ages, have involved themselves in the greatest absurdities and contradictions.

HOMER, in one passage, calls OCEANUS and TETHYS the original parents of all things, conformably to the established mythology and tradition of the GREEKS: Yet, in other passages, he could not forbear complimenting JUPITER, the reigning deity, with that magnificent appellation; and accordingly denominates him the father of gods and men.[70] He forgets, that every temple, every street was full of the ancestors, uncles, brothers, and sisters of this JUPITER; who was in reality nothing but an upstart parricide and usurper. A like contradiction is observable in HESIOD; and is so much the less excusable, as his professed intention was to deliver a true genealogy of the gods.[71]

Were there a religion (and we may suspect Mahometanism of this inconsistence) which sometimes painted the Deity in the most sublime colours, as the creator of heaven and earth; sometimes degraded him so far to a level with human creatures as to represent him wrestling with a man, walking in the cool of the evening, showing his back parts, and descending from heaven to inform himself of what passes on earth; while at the same time it ascribed to him suitable infirmities, passions, and partialities, of the moral kind: That religion, after it was extinct, would also be cited as an instance of those contradictions, which arise from the gross,

[70] *The Iliad,* XIV 200–04; and compare XV 12. Writing in Greek both Homer and Hesiod spoke not of Jupiter but Zeus.

[71] *Theogony,* 47 and 116; and compare 176ff.

[72] Characteristically Hume wants to suggest that it is Christianity rather than Islam which is in fact guilty of "this inconsistence". The examples are all taken from the Christian Bible: God walking in the cool of the evening from Genesis 3:8, God wrestling with Jacob from Genesis 32:24–29, and so on.

vulgar, natural conceptions of mankind, opposed to their continual propensity towards flattery and exaggeration. Nothing indeed would prove more strongly the divine origin of any religion, than to find (and happily this is the case with Christianity) that it is free from a contradiction, so incident to human nature.

VII — CONFIRMATION OF THIS DOCTRINE

It appears certain, that, though the original notions of the vulgar represent the Divinity as a limited being, and consider him only as the particular cause of health or sickness; plenty or want; prosperity or adversity; yet when more magnificent ideas are urged upon them, they esteem it dangerous to refuse their assent. Will you say that your deity is finite and bounded in his perfections; may be overcome by a greater force; is subject to human passions, pains, and infirmities; has a beginning, and may have an end? This they dare not affirm; but thinking it safest to comply with the higher encomiums, they endeavour, by an affected ravishment and devotion, to ingratiate themselves with him. As a confirmation of this, we may observe, that the assent of the vulgar is, in this case, merely verbal, and that they are incapable of conceiving those sublime qualities, which they seemingly attribute to the Deity. Their real idea of him, notwithstanding their pompous language, is still as poor and frivolous as ever.

That original intelligence, say the MAGIANS, who is the first principle of all things, discovers himself *immediately* to the mind and understanding alone; but has placed the sun as his image in the visible universe; and when that bright luminary diffuses its beams over the earth and the firmament, it is a faint copy of the glory, which resides in the higher heavens. If you would escape the displeasure of this divine being, you must be careful never to set your bare foot upon the ground, nor spit into a fire, nor throw any water upon it, even though it were consuming a whole city.[73] Who can express the perfections of the Almighty? say the Mahometans. Even the noblest of his works, if compared to him, are but dust and rubbish. How much more must human conception fall short of his infinite perfections? His smile and favour renders men for ever happy; and to obtain it for your children, the best method is to cut off from them, while infants, a little bit of skin, about half the breadth of a farthing.[74] Take two bits of cloth, say the

[73] Thomas Hyde, *Historia religionis veterum Persarum, earumque Magorum; Zoroastris vita, etc.* (Oxford, 1700) [History of the ancient Persian religion, and also of the Magian; life of Zoroaster, etc.].

[74] The reference is, of course, to the practice of male circumcision.

Roman Catholics, about an inch or an inch and a half square, join them by the corners with two strings or pieces of tape about sixteen inches long, throw this over your head, and make one of the bits of cloth lie upon your breast, and the other upon your back, keeping them next your skin: There is not a better secret for recommending yourself to that infinite Being, who exists from eternity to eternity.[75]

The GETES, commonly called immortal, from their steady belief of the soul's immortality, were genuine theists and unitarians. They affirmed ZAMOLXIS, their deity, to be the only true god; and asserted the worship of all other nations to be addressed to mere fictions and chimeras. But were their religious principles any more refined, on account of these magnificent pretensions? Every fifth year they sacrificed a human victim, whom they sent as a messenger to their deity, in order to inform him of their wants and necessities. And when it thundered, they were so provoked, that, in order to return the defiance, they let fly arrows at him, and declined not the combat as unequal. Such at least is the account, which HERODOTUS gives of the theism of the immortal GETES.[76]

[75] The reference is to the scapular or scapulary, a short shoulder cloak prescribed by the Rule of St. Benedict for monks engaged in manual labour; later adopted by other orders.

[76] *Op. Cit.,* IV 94.

VIII—FLUX AND REFLUX OF POLYTHEISM AND THEISM

It is remarkable that the principles of religion have a kind of flux and reflux in the human mind, and that men have a natural tendency to rise from idolatry to theism, and to sink again from theism into idolatry. The vulgar, that is, indeed, all mankind, a few excepted, being ignorant and uninstructed, never elevate their contemplation to the heavens, or penetrate by their disquisitions into the secret structure of vegetable or animal bodies; so far as to discover a supreme mind or original providence, which bestowed order on every part of nature. They consider these admirable works in a more confined and selfish view; and finding their own happiness and misery to depend on the secret influence and unforeseen concurrence of external objects, they regard, with perpetual attention, the *unknown causes,* which govern all these natural events, and distribute pleasure and pain, good and ill, by their powerful, but silent, operation. The unknown causes are still appealed to on every emergence;[77] and in this general appearance or confused image, are the perpetual objects of human hopes and fears, wishes and apprehensions. By degrees, the active imagination of men, uneasy in this abstract conception of objects, about which it is incessantly employed, begins to render them more particular, and to clothe them in shapes more suitable to its natural comprehension. It represents them to be sensible, intelligent beings, like mankind; actuated by love and hatred, and flexible by gifts and entreaties, by prayers and sacrifices. Hence the origin of religion: And hence the origin of idolatry or polytheism.

But the same anxious concern for happiness, which begets the idea of these invisible, intelligent powers, allows not mankind to remain long in the first simple conception of them; as powerful, but limited beings; masters of human fate, but slaves to destiny and the course of nature. Men's exaggerated praises and compliments still swell their idea upon them; and elevating their deities to the utmost bounds of perfection, at last beget the attributes of unity and infinity, simplicity and

[77] The older form of the word 'emergency', suggesting a not necessarily critical emerging.

spirituality. Such refined ideas, being somewhat dispro-
portioned to vulgar comprehension, remain not long in their
original purity; but require to be supported by the notion of
inferior mediators or subordinate agents, which interpose
between mankind and their supreme deity. These demi-gods
or middle beings, partaking more of human nature, and being
more familiar to us, become the chief objects of devotion, and
gradually recall that idolatry, which had been formerly ban-
ished by the ardent prayers and panegyrics of timorous and
indigent mortals. But as these idolatrous religions fall every
day into grosser and more vulgar conceptions, they at last
destroy themselves, and by the vile representations, which
they form of their deities, make the tide turn again towards
theism. But so great is the propensity, in this alternating
revolution of human sentiments, to return back to idolatry,
that the utmost precaution is not able effectually to prevent it.
And of this, some theists, particularly the JEWS and MAHOM-
ETANS, have been sensible; as appears by their banishing all
the arts of statuary and painting, and not allowing the
representations, even of human figures, to be taken by marble
or colours; lest the common infirmity of mankind should
thence produce idolatry. The feeble apprehensions of men
cannot be satisfied with conceiving their deity as a pure spirit
and perfect intelligence; and yet their natural terrors keep
them from imputing to him the least shadow of limitation and
imperfection. They fluctuate between these opposite senti-
ments. The same infirmity still drags them downwards, from
an omnipotent and spiritual deity, to a limited and corporeal
one, and from a corporeal and limited deity to a statue or
visible representation. The same endeavour at elevation still
pushes them upwards, from the statue or material image to
the invisible power; and from the invisible power to an
infinitely perfect deity, the creator and sovereign of the uni-
verse.

IX — COMPARISON OF THESE RELIGIONS, WITH REGARD TO PERSECUTION AND TOLERATION

Polytheism or idolatrous worship, being founded entirely in vulgar traditions, is liable to this great inconvenience, that any practice or opinion, however barbarous or corrupted, may be authorized by it; and full scope is given, for knavery to impose on credulity, till morals and humanity be expelled from the religious systems of mankind. At the same time, idolatry is attended with this evident advantage, that, by limiting the powers and functions of its deities, it naturally admits the gods of other sects and nations to a share of divinity, and renders all the various deities, as well as rites, ceremonies, or traditions, compatible with each other.[78]

VERRIUS FLACCUS affirmed, that it was usual for the ROMANS before they laid siege to any town, to invocate the tutelar deity of the place, and by promising him greater honours than those he at present enjoyed, bribe him to betray his old friends and votaries. The name of the tutelar deity of ROME was for this reason kept a most religious mystery; lest the enemies of the republic should be able, in the same manner, to draw him over to their service. For without the name, they thought, nothing of that kind could be practised. PLINY says, that the common form of invocation was preserved to his time in the ritual of the pontiffs. And MACROBIUS has transmitted a copy of it from the secret things of SAMMONICUS SERENUS.[79]

Theism is opposite both in its advantages and disadvantages. As that system supposes one sole deity, the perfection of reason and goodness, it should, if justly prosecuted, banish every thing frivolous, unreasonable, or inhuman from religious worship, and set before men the most illustrious example, as well as the most commanding motives, of justice and benevolence. These mighty advantages are not indeed over-balanced (for that is not possible), but somewhat diminished, by inconveniences, which arise from the vices and prejudices of man-

[78] Cited in Pliny, *Natural History*, XXVIII (iv) 18–19.

[79] Macrobius, *The Saturnalia*, III 9. Hume printed this paragraph as a note to its predecessor.

kind. While one sole object of devotion is acknowledged, the worship of other deities is regarded as absurd and impious. Nay, this unity of object seems naturally to require the unity of faith and ceremonies, and furnishes designing men with a pretence for representing their adversaries as profane, and the objects of divine as well as human vengeance. For as each sect is positive that its own faith and worship are entirely acceptable to the deity, and as no one can conceive that the same being should be pleased with different and opposite rites and principles, the several sects fall naturally into animosity, and mutually discharge on each other that sacred zeal and rancour, the most furious and implacable of all human passions.

The tolerating spirit of idolaters, both in ancient and modern times, is very obvious to any one, who is the least conversant in the writings of historians or travellers. When the oracle of DELPHI was asked, what rites or worship was most acceptable to the gods? Those which are legally established in each city, replied the oracle.[80] Even priests, in those ages, could, it seems, allow salvation to those of the different communion. The ROMANS commonly adopted the gods of the conquered people; and never disputed the attributes of those local and national deities, in whose territories they resided. The religious wars and persecutions of the EGYPTIAN idolaters are indeed an exception to this rule; but are accounted for by ancient authors from reasons singular and remarkable. Different species of animals were the deities of the different sects among the EGYPTIANS; and the deities being in continual war, engaged their votaries in the same contention. The worshippers of dogs could not long remain in peace with the adorers of cats or wolves.[81] But where that reason took not place, the EGYPTIAN superstition was not so incompatible as is commonly imagined; since we learn from HERODOTUS,[82] that very large contributions were given by AMASIS towards rebuilding the temple of DELPHI.

The intolerance of almost all religions, which have maintained the unity of God, is as remarkable as the contrary

[80] Xenophon, *Memorabilia,* I (iii) 1.

[81] Plutarch, *Isis and Osiris,* Chapter 72.

[82] *Op. Cit.,* II:180.

principle of polytheists. The implacable narrow spirit of the JEWS is well known. MAHOMETANISM set out with still more bloody principles; and even to this day, deals out damnation, though not fire and faggot, to all other sects. And if, among CHRISTIANS, the ENGLISH and DUTCH have embraced the principles of toleration, this singularity has proceeded from the steady resolution of the civil magistrate, in opposition to the continued efforts of priests and bigots.

The disciples of ZOROASTER shut the doors of heaven against all but the MAGIANS.[83] Nothing could more obstruct the progress of the PERSIAN conquests, than the furious zeal of that nation against the temples and images of the GREEKS. And after the overthrow of that empire we find ALEXANDER, as a polytheist, immediately re-establishing the worship of the BABYLONIANS, which their former princes, as monotheists, had carefully abolished.[84] Even the blind and devoted attachment of that conqueror to the GREEK superstition hindered not but he himself sacrificed according to the BABYLONISH rites and ceremonies.[85]

So social is polytheism, that the utmost fierceness and antipathy, which it meets with in an opposite religion, is scarcely able to disgust it, and keep it at a distance. AUGUSTUS praised extremely the reserve of his grandson, CAIUS CÆSAR, when this latter prince, passing by JERUSALEM, deigned not to sacrifice according to the JEWISH law. But for what reason did AUGUSTUS so much approve of this conduct? Only, because that religion was by the PAGANS esteemed ignoble and barbarous.[86]

I may venture to affirm, that few corruptions of idolatry and polytheism are more pernicious to society than this corruption of theism,[87] when carried to the utmost height. The human sacrifices of the CARTHAGINIANS, MEXICANS, and many barbarous nations, scarcely exceed the inquisition and

[83] Hyde, *Op. Cit.*

[84] Arrian, *Anabasis of Alexander,* III, (xvi) 3–5.

[85] *Ibid.,* VII (xvii).

[86] Suetonius, *Life of Augustus,* Chapter 93.

[87] Hume adds a note consisting of the Latin for 'the corruption of the best is the worst'.

persecutions of ROME and MADRID. For besides, that the effusion of blood may not be so great in the former case as in the latter; besides this, I say, the human victims, being chosen by lot, or by some exterior signs, affect not, in so considerable a degree, the rest of the society. Whereas virtue, knowledge, love of liberty, are the qualities, that call down the fatal vengeance of inquisitors; and when expelled, leave the society in the most shameful ignorance, corruption, and bondage. The illegal murder of one man by a tyrant is more pernicious than the death of a thousand by pestilence, famine, or any undistinguishing calamity.

Most nations have fallen into this guilt of human sacrifices; though, perhaps, this impious superstition has never prevailed very much in any civilized nation, unless we except the CARTHAGINIANS. For the TYRIANS soon abolished it.[88] A sacrifice is conceived as a present; and any present is delivered to their deity by destroying it and rendering it useless to men; by burning what is solid, pouring out the liquid, and killing the animate. For want of a better way of doing him service, we do ourselves an injury; and fancy that we thereby express, at least, the heartiness of our good-will and adoration. Thus our mercenary devotion deceives ourselves, and imagines it deceives the deity.[89]

In the temple of DIANA at ARICIA near ROME, whoever murdered the present priest, was legally entitled to be installed his successor.[90] A very singular institution! For, however barbarous and bloody the common superstitions often are to the laity, they usually turn to the advantage of the holy order.

[88] Carthaginians: people of Carthage, a city on the north African coast. Carthage was a troublesome rival of Rome until completely destroyed by Rome in 146 BCE. Tyrians: people of Tyre, on the coast of Syria.

[89] Hume printed this paragraph as a footnote to the second sentence of its immediate predecessor.

[90] Strabo, *Op. Cit.*, V 239; and compare Suetonius *Gaius Caligula*, 35 (3).

X — WITH REGARD TO COURAGE OR ABASEMENT

From the comparison of theism and idolatry, we may form some other observations, which will also confirm the vulgar observation that the corruption of the best things gives rise to the worst.

Where the deity is represented as infinitely superior to mankind, this belief, though altogether just, is apt, when joined with superstitious terrors, to sink the human mind into the lowest submission and abasement, and to represent the monkish virtues of mortification, penance, humility, and passive suffering, as the only qualities which are acceptable to him. But where the gods are conceived to be only a little superior to mankind, and to have been, many of them, advanced from that inferior rank, we are more at our ease, in our addresses to them, and may even, without profaneness, aspire sometimes to a rivalship and emulation of them. Hence activity, spirit, courage, magnanimity, love of liberty, and all the virtues which aggrandize a people.

The heroes in paganism correspond exactly to the saints in popery, and holy dervises[91] in MAHOMETANISM. The place of HERCULES, THESEUS, HECTOR, ROMULUS, is now supplied by DOMINIC, FRANCIS, ANTHONY, and BENEDICT. Instead of the destruction of monsters, the subduing of tyrants, the defence of our native country; whippings and fastings, cowardice and humility, abject submission and slavish obedience, are become the means of obtaining celestial honours among mankind.

One great incitement to the pious ALEXANDER in his warlike expeditions was his rivalship of HERCULES and BACCHUS, whom he justly pretended to have excelled.[92] BRASIDAS, that generous and noble SPARTAN, after falling in battle, had heroic honours paid him by the inhabitants of AMPHIPOLIS, whose defence he had embraced.[93] And in general, all founders of states and colonies among the GREEKS were raised to this

[91] Dervishes.

[92] Arrian, *Anabasis of Alexander,* passim; but especially IV (x) 5–7. Alexander the Great or Alexander of Macedon is here, unusually, and mischievously, "the pious Alexander". In Hume's time 'pretend' meant 'claim'. Hence there is no contradiction in "justly pretended".

[93] Thucydides, *History,* V ii.

inferior rank of divinity, by those who reaped the benefit of their labours.

This gave rise to the observation of MACHIAVEL,[94] that the doctrines of the CHRISTIAN religion (meaning the catholic; for he knew no other) which recommended only passive courage and suffering, had subdued the spirit of mankind, and had fitted them for slavery and subjection. An observation, which would certainly be just, were there not many other circumstances in human society which control the genius and character of a religion.

BRASIDAS seized a mouse, and being bit by it, let it go. *There is nothing so contemptible,* said he, *but what may be safe, if it has but courage to defend itself.*[95] BELLARMINE patiently and humbly allowed the fleas and other odious vermin to prey upon him. *We shall have heaven,* said he, *to reward us for our sufferings: But these poor creatures have nothing but the enjoyment of the present life.*[96] Such difference is there between the maxims of a GREEK hero and a CATHOLIC saint.

[94] Niccolo Machiavelli (1469–1527) Florentine statesman and author of *The Prince, The History of Florence,* and *Discourses.* The reference is to Book II (xx) 6–7 in the last of these.

[95] Thucydides, *Op. Cit.,* V ii.

[96] Hume's reference is to the article 'Bellarmine' in Bayle's *Dictionnaire historique et critique* [Critical and Historical Dictionary]. It was Cardinal, eventually Saint, Bellarmine who urged Galileo to divert the wrath of orthodoxy by giving an eirenically phenomenalist rather than a boldly realist account of his findings.

XI — WITH REGARD TO REASON OR ABSURDITY

Here is another observation to the same purpose, and a new proof that the corruption of the best things begets the worst. If we examine, without prejudice, the ancient heathen mythology, as contained in the poets, we shall not discover in it any such monstrous absurdity, as we may at first be apt to apprehend. Where is the difficulty in conceiving, that the same powers or principles, whatever they were, which formed this visible world, men and animals, produced also a species of intelligent creatures, of more refined substance and greater authority than the rest?[97] That these creatures may be capricious, revengeful, passionate, voluptuous, is easily conceived; nor is any circumstance more apt, among ourselves, to engender such vices, than the licence of absolute authority. And in short, the whole mythological system is so natural, that, in the vast variety of planets and worlds, contained in this universe, it seems more than probable, that, somewhere or other, it is really carried into execution.

The chief objection to it with regard to this planet, is, that it is not ascertained by any just reason or authority. The ancient tradition, insisted on by heathen priests and theologers, is but a weak foundation; and transmitted also such a number of contradictory reports, supported, all of them, by equal authority, that it became absolutely impossible to fix a preference amongst them. A few volumes, therefore, must contain all the polemical writings of pagan priests: And their whole theology must consist more of traditional stories and superstitious practices than of philosophical argument and controversy.

But where theism forms the fundamental principle of any popular religion, that tenet is so conformable to sound reason, that philosophy is apt to incorporate itself with such a system of theology. And if the other dogmas of that system be

[97] By Epicurus this suggestion was not merely entertained as a possibility but asserted as an actuality; although his gods, unlike either the Olympians or the God of Mosaic theism, were neither interested nor active in human affairs. This is one of many matters about which Hume has some significant sympathy with the Epicureans.

contained in a sacred book, such as the Alcoran,[98] or be
determined by any visible authority, like that of the ROMAN
pontiff, speculative reasoners naturally carry on their assent,
and embrace a theory, which has been instilled into them by
their earliest education, and which also possesses some degree
of consistence[99] and uniformity. But as these appearances are
sure, all of them, to prove deceitful, philosophy will soon find
herself very unequally yoked with her new associate; and
instead of regulating each principle, as they advance together,
she is at every turn perverted to serve the purposes of
superstition. For besides the unavoidable incoherences, which
must be reconciled and adjusted; one may safely affirm, that
all popular theology, especially the scholastic, has a kind of
appetite for absurdity and contradiction.[100] If that theology
went not beyond reason and common sense, her doctrines
would appear too easy and familiar. Amazement must of
necessity be raised: Mystery affected: Darkness and obscurity
sought after: And a foundation of merit afforded to the devout
votaries, who desire an opportunity of subduing their rebel-
lious reason, by the belief of the most unintelligible sophisms.

Ecclesiastical history sufficiently confirms these reflec-
tions. When a controversy is started, some people always
pretend with certainty to foretell the issue. Whichever opin-
ion, say they, is most contrary to plain sense is sure to prevail;
even where the general interest of the system requires not that
decision. Though the reproach of heresy may, for some time, be
bandied about among the disputants, it always rests at last on
the side of reason. Any one, it is pretended, that has but
learning enough of this kind to know the definition of ARIAN,
PELAGIAN, ERASTIAN, SOCINIAN, SABELLIAN, EUTYCHIAN, NES-
TORIAN, MONOTHELITE, &c. not to mention PROTESTANT, whose
fate is yet uncertain, will be convinced of the truth of this
observation. It is thus a system becomes more absurd in the

[98] *Al Koran* [The Koran].

[99] Consistency.

[100] Whatever other charges might reasonably be brought against
Scholasticism—as represented, for instance, by the *Summa Theologiae* of
St. Thomas Aquinas (c. 1225–74)—it is very hard to believe that anyone
who had read at all deeply in such works would want to dismiss them as
"popular theology".

end, merely from its being reasonable and philosophical in the beginning.

To oppose the torrent of scholastic religion by such feeble maxims as these, that *it is impossible for the same thing to be and not to be,* that *the whole is greater than a part,* that *two and three make five;* is pretending to stop the ocean with a bullrush. Will you set up profane reason against sacred mystery? No punishment is great enough for your impiety. And the same fires, which were kindled for heretics, will serve also for the destruction of philosophers.

XII—WITH REGARD TO DOUBT OR CONVICTION

We meet every day with people so sceptical with regard to history, that they assert it impossible for any nation ever to believe such absurd principles as those of GREEK and EGYPTIAN paganism; and at the same time so dogmatical with regard to religion, that they think the same absurdities are to be found in no other communion. CAMBYSES entertained like prejudices; and very impiously ridiculed, and even wounded, APIS, the great god of the EGYPTIANS, who appeared to his profane senses nothing but a large spotted bull. But HERODOTUS judiciously ascribes this sally of passion to a real madness or disorder of the brain: Otherwise, says the historian, he never would have openly affronted any established worship. For on that head, continues he, every nation are best satisfied with their own, and think they have the advantage over every other nation.[101]

It must be allowed, that the ROMAN CATHOLICS are a very learned sect; and that no one communion, but that of the church of ENGLAND, can dispute their being the most learned of all the Christian churches: Yet AVERROES, the famous ARABIAN, who, no doubt, had heard of the EGYPTIAN superstitions, declares, that, of all religions, the most absurd and nonsensical is that, whose votaries eat, after having created, their deity.[102]

I believe, indeed, that there is no tenet in all paganism, which would give so fair a scope to ridicule as this of the *real presence:* For it is so absurd, that it eludes the force of all argument.[103] There are even some pleasant stories of that kind, which, though somewhat profane, are commonly told by

[101] *Op. Cit.,* III 38.

[102] Averroes (1126–98) an Arab, who spent most of his life serving as a judge in Seville and Cordoba, wrote comprehensive commentaries on the works of Aristotle.

[103] Also known as Transubstantiation, this is the doctrine that in the Mass the substance of the bread and the wine is transformed into the substance of the body and blood of Jesus bar Joseph; all the 'appearances' (all physical and chemical properties) remaining unchanged. Calvin held that the communion service is purely symbolic, and this view became accepted by most Protestants.

the Catholics themselves. One day, a priest, it is said, gave inadvertently, instead of the sacrament, a counter, which had by accident fallen among the holy wafers. The communicant waited patiently for some time, expecting it would dissolve on his tongue: But finding that it still remained entire, he took it off. *I wish,* cried he to the priest, *you have not committed some mistake: I wish you have not given me God the Father: He is so hard and tough there is no swallowing him.*

A famous general, at that time in the MUSCOVITE service, having come to PARIS for the recovery of his wounds, brought along with him a young TURK, whom he had taken prisoner. Some of the doctors of the SORBONNE (who are altogether as positive as the dervishes of CONSTANTINOPLE) thinking it a pity, that the poor TURK should be damned for want of instruction, solicited MUSTAPHA very hard to turn Christian, and promised him, for his encouragement, plenty of good wine in this world, and paradise in the next.[104] These allurements were too powerful to be resisted; and therefore, having been well instructed and catechized, he at last agreed to receive the sacraments of baptism and the Lord's supper. The priest, however, to make every thing sure and solid, still continued his instructions, and began the next day with the usual question, *How many Gods are there? None at all,* replies BENEDICT; for that was his new name. *How! None at all!* cries the priest. *To be sure,* said the honest proselyte. *You have told me all along that there is but one God: And yesterday I eat him.*

Such are the doctrines of our brethren the Catholics. But to these doctrines we are so accustomed, that we never wonder at them: Though in a future age, it will probably become difficult to persuade some nations, that any human, two-legged creature could ever embrace such principles. And it is a

[104] The Sorbonne is the great university in Paris. Constantinople, also known as Byzantium, was the capital of the Eastern Roman empire. It was captured by the Turks in 1453, and became Istanbul. Muslims are not permitted to drink alcoholic beverages, whereas Catholics are. In relating these crude stories, which scarcely do justice to Catholic doctrine, Hume is using the fact that Catholics and Muslims were fair game for ridicule to convey the notion that, viewed objectively, there is something preposterous about a great many religious beliefs normally accepted out of familiarity.

thousand to one, but these nations themselves shall have something full as absurd in their own creed, to which they will give a most implicit and most religious assent.

I lodged once at PARIS in the same *hotel* with an ambassador from TUNIS, who, having passed some years at LONDON, was returning home that way. One day I observed his MOORISH excellency diverting himself under the porch, with surveying the splendid equipages that drove along; when there chanced to pass that way some *Capucin* friars,[105] who had never seen a TURK; as he, on his part, though accustomed to the EUROPEAN dresses, had never seen the grotesque figure of a *Capucin:* And there is no expressing the mutual admiration, with which they inspired each other. Had the chaplain of the embassy entered into a dispute with these FRANCISCANS, their reciprocal surprize had been of the same nature. Thus all mankind stand staring at one another; and there is no beating it into their heads, that the turban of the AFRICAN is not just as good or as bad a fashion as the cowl of the EUROPEAN. *He is a very honest man,* said the prince of SALLEE, speaking of DE RUYTER. *It is a pity he were a Christian.*[106]

How can you worship leeks and onions? we shall suppose a SORBONNIST to say to a priest of SAIS. If we worship them, replies the latter; at least, we do not, at the same time, eat them. But what strange objects of adoration are cats and monkeys? says the learned doctor. They are at least as good as the relics or rotten bones of martyrs, answers his no less learned antagonist. Are you not mad, insists the Catholic, to cut one another's throat about the preference of a cabbage or a cucumber? Yes, says the pagan; I allow it, if you will confess, that those are still madder, who fight about the preference among volumes of sophistry, ten thousand of which are not equal in value to one cabbage or cucumber.

It is strange that the EGYPTIAN religion, though so absurd,

[105] Capucins or Capuchins, a familiar term for Franciscan monks, who wear white capes. Hence, more recently, 'cappuccino', an espresso coffee topped with frothy white milk.

[106] Hume's source for this tale was, presumably, Geerart Brandt's *Life of Admiral de Ruyter,* originally published in Dutch in Amsterdam in 1687, but from 1698 also available in a French translation.

should yet have borne so great a resemblance to the JEWISH
that ancient writers, even of the greatest genius were not able
to observe any difference between them. For it is very remark-
able that both TACITUS and SUETONIUS, when they mention
that decree of the senate, under TIBERIUS, by which the
EGYPTIAN and JEWISH proselytes were banished from Rome,
expressly treat these religions as the same; and it appears,
that even the decree itself was founded on that supposition:
"Another debate dealt with the proscription of the Egyptian
and Jewish rites, and a senatorial edict directed that four
thousand descendants of enfranchised slaves, tainted with
that superstition and suitable in point of age, were to be
shipped to Sardinia and there employed in suppressing brig-
andage: if they succumbed to the pestilential climate, it was a
cheap loss. The rest had orders to leave Italy, unless they had
renounced their impious ceremonial by a given date." and "He
abolished foreign cults, especially the Egyptian and the Jew-
ish rites, compelling all who were addicted to such supersti-
tions to burn their religious vestments and all their
paraphernalia."[107] These wise heathens, observing something
in the general air, and genius, and spirit of the two religions to
be the same, esteemed the difference of their dogmas too
frivolous to deserve any attention.

Every bystander will easily judge (but unfortunately the
bystanders are few) that, if nothing were requisite to establish
any popular system, but exposing the absurdities of other
systems, every devotee of every superstition could give a
sufficient reason for his blind and bigotted attachment to the
principles in which he has been educated. But without so
extensive a knowledge, on which to ground this assurance (and
perhaps, better without it), there is not wanting a sufficient
stock of religious zeal and faith among mankind. DIODORUS
SICULUS[108] gives a remarkable instance to this purpose, of
which he was himself an eye-witness. While EGYPT lay under
the greatest terror of the ROMAN name, a legionary soldier
having inadvertently been guilty of the sacrilegious impiety of

[107] Tacitus, *Annals* II, 517; Suetonius, *Tiberius* 36. In Hume's origi-
nal, this passage was a footnote, and the quotations were in Latin.

[108] *Op. Cit.*, I 83 (8–9).

killing a cat, the whole people rose upon him with the utmost fury; and all the efforts of the prince were not able to save him. The senate and people of ROME, I am persuaded, would not, then, have been so delicate with regard to their national deities. They very frankly, a little after that time, voted AUGUSTUS a place in the celestial mansions; and would have dethroned every god in heaven, for his sake, had he seemed to desire it. *Presens divus habebitur,* says HORACE.[109] That is a very important point: And in other nations and other ages, the same circumstance has not been deemed altogether indifferent. When LOUIS the XIVth took on himself the protection of the Jesuit's College of CLERMONT, the society ordered the king's arms to be put up over the gate, and took down the cross in order to make way for it: Which gave occasion to the following epigram:

> Those who downed the cross of Christ, and upped the
> arms of Louis:
> A wicked folk they surely are who can't tell God from hooey.[110]

Notwithstanding the sanctity of our holy religion, says TULLY,[111] no crime is more common with us than sacrilege: But was it ever heard of, that an EGYPTIAN violated the temple of a cat, an ibis, or a crocodile? There is no torture, an EGYPTIAN would not undergo, says the same author in another place,[112] rather than injure an ibis, an aspic, a cat, a dog, or a crocodile. Thus it is strictly true, what DRYDEN observes,

> Of whatsoe'er descent their godhead be,
> Stock, stone, or other homely pedigree,
> In his defence his servants are as bold
> As if he had been born of beaten gold.
> *Absalom and Achitophel* (lines 100-03)

[109] 'Here Augustus shall be held divine': *Odes,* III (v) 3.

[110] Hume printed his anecdote about Louis XIV as a footnote, giving the epigram in the original Latin. The rather free but high-spirited translation was contributed by A. Wayne Colver.

[111] 'Tully' was in Hume's day the universally accepted nickname for Marcus Tullius Cicero (106–43 BCE). The reference is to his then very widely read and respected *De Natura Deorum* [On the Nature of the Gods], I (xxix) 81–82.

[112] *Tusculan Disputations* V (xxvii) 78.

Nay, the baser the materials are, of which the divinity is composed, the greater devotion is he likely to excite in the breasts of his deluded votaries. They exult in their shame and make a merit with their deity, in braving, for his sake, all the ridicule and contumely of his enemies. Ten thousand Crusaders inlist themselves under the holy banners; and even openly triumph in those parts of their religion which their adversaries regard as the most reproachful.

There occurs, I own, a difficulty in the EGYPTIAN system of theology; as indeed, few systems of that kind are entirely free from difficulties. It is evident, from their method of propagation, that a couple of cats, in fifty years, would stock a whole kingdom; and if that religious veneration were still paid them, it would, in twenty more, not only be easier in EGYPT to find a god than a man, which PETRONIUS says was the case in some parts of Italy; but the gods must at last entirely starve the men, and leave themselves neither priests nor votaries remaining. It is probable, therefore, that this wise nation, the most celebrated in antiquity for prudence and sound policy, foreseeing such dangerous consequences, reserved all their worship for the full-grown divinities, and used the freedom to drown the holy spawn or little sucking gods, without any scruple or remorse. And thus the practice of warping the tenets of religion, in order to serve temporal interests, is not, by any means, to be regarded as an invention of these later ages.

The learned, philosophical VARRO, discoursing of religion, pretends not to deliver any thing beyond probabilities and appearances: Such was his good sense and moderation! But the passionate, the zealous AUGUSTIN, insults the noble ROMAN on his scepticism and reserve, and professes the most thorough belief and assurance.[113] A heathen poet, however, contemporary with the saint, absurdly esteems the religious system of the latter so false, that even the credulity of children, he says, could not engage to believe it.[114]

It is strange, when mistakes are so common, to find every one positive and dogmatical? And that the zeal often rises in

[113] Varro, *On the Latin Language,* V (x) 57–74. Augustin is St. Augustine of Hippo (354–430); Hume's reference is to *The City of God,* III 17.

[114] Claudius Rutilius Namatianus, *A Voyage Home to Gaul,* I 391–94.

proportion to the error? *Moverunt,* says SPARTIAN, *& ca tempestate, Judœi bellum quod vetabantur mutilare genitalia.*[115]

If ever there was a nation or a time, in which the public religion lost all authority over mankind, we might expect, that infidelity in ROME, during the CICERONIAN age, would openly have erected its throne, and that CICERO himself, in every speech and action, would have been its most declared abettor. But it appears, that, whatever sceptical liberties that great man might take, in his writings or in philosophical conversation; he yet avoided, in the common conduct of life, the imputation of deism and profaneness. Even in his own family, and to his wife TERENTIA, whom he highly trusted, he was willing to appear a devout religionist; and there remains a letter, addressed to her, in which he seriously desires her to offer sacrifice to APOLLO and ÆSCULAPIUS, in gratitude for the recovery of his health.[116]

POMPEY's devotion was much more sincere: In all his conduct, during the civil wars, he paid a great regard to auguries, dreams, and prophesies.[117] AUGUSTUS was tainted with superstition of every kind. As it is reported of MILTON, that his poetical genius never flowed with ease and abundance in the spring; so AUGUSTUS observed, that his own genius for dreaming never was so perfect during that season, nor was so much to be relied on, as during the rest of the year. That great and able emperor was also extremely uneasy, when he happened to change his shoes, and put the right foot shoe on the left foot.[118] In short it cannot be doubted, but the votaries of the established superstition of antiquity were as numerous in every state, as those of the modern religion are at present. Its influence was as universal; though it was not so great. As

[115] This sentence, referring to a Jewish rebellion against Rome, is derived from Aelius Spartianus, *The Life of Hadrian,* XIV 2. "The Jews started their movement at that time because they were forbidden to mutilate their genitals."

[116] Cicero, *Letters,* XIV 7.

[117] Cicero, *De Divinatione* [On Divination], II 24.

[118] Suetonius, *Augustus,* 90–92; and compare Pliny *Natural History,* II (v) 24.

many people gave their assent to it; though that assent was not seemingly so strong, precise, and affirmative.

We may observe, that, notwithstanding the dogmatical, imperious style of all superstition, the conviction of the religionists, in all ages, is more affected than real, and scarcely ever approaches, in any degree, to that solid belief and persuasion, which governs us in the common affairs of life. Men dare not avow, even to their own hearts, the doubts which they entertain on such subjects: They make a merit of implicit faith; and disguise to themselves their real infidelity, by the strongest asseverations and most positive bigotry. But nature is too hard for all their endeavours, and suffers not the obscure, glimmering light, afforded in those shadowy regions, to equal the strong impressions, made by common sense and by experience. The usual course of men's conduct belies their words, and shows, that their assent in these matters is some unaccountable operation of the mind between disbelief and conviction, but approaching much nearer to the former than to the latter.

Since, therefore, the mind of man appears of so loose and unsteady a texture, that, even at present, when so many persons find an interest in continually employing on it the chissel and the hammer, yet are they not able to engrave theological tenets with any lasting impression; how much more must this have been the case in ancient times, when the retainers to the holy function were so much fewer in comparison? No wonder, that the appearances were then very inconsistent, and that men, on some occasions, might seem determined infidels, and enemies to the established religion, without being so in reality; or at least, without knowing their own minds in that particular.

Another cause, which rendered the ancient religion much looser than the modern, is, that the former were *traditional* and the latter are *scriptural,* and the tradition in the former was complex, contradictory, and, on many occasions, doubtful; so that it could not possibly be reduced to any standard and canon, or afford any determinate articles of faith. The stories of the gods were numberless like the popish legends; and though every one, almost, believed a part of these stories, yet no one could believe or know the whole: While, at the same time, all must have acknowledged, that no one part stood on a better foundation than the rest. The traditions of different

cities and nations were also, on many occasions, directly opposite; and no reason could be assigned for preferring one to the other. And as there was an infinite number of stories, with regard to which tradition was nowise positive; the gradation was insensible, from the most fundamental articles of faith, to those loose and precarious fictions. The pagan religion, therefore, seemed to vanish like a cloud, whenever one approached to it, and examined it piecemeal. It could never be ascertained by any fixed dogmas and principles. And though this did not convert the generality of mankind from so absurd a faith; for when will the people be reasonable? yet it made them falter and hesitate more in maintaining their principles, and was even apt to produce, in certain dispositions of mind, some practices and opinions, which had the appearance of determined infidelity.

To which we may add, that the fables of the pagan religion were, of themselves, light, easy, and familiar; without devils, or seas of brimstone, or any object that could much terrify the imagination. Who could forbear smiling, when he thought of the loves of MARS and VENUS, or the amorous frolics of JUPITER and PAN? In this respect, it was a true poetical religion; if it had not rather too much levity for the graver kinds of poetry. We find that it has been adopted by modern bards; nor have these talked with greater freedom and irreverence of the gods, whom they regarded as fictions, than the ancients did of the real objects of their devotion.

The inference is by no means just, that, because a system of religion has made no deep impression on the minds of a people, it must therefore have been positively rejected by all men of common sense, and that opposite principles, in spite of the prejudices of education, were generally established by argument and reasoning. I know not, but a contrary inference may be more probable. The less importunate and assuming any species of superstition appears, the less will it provoke men's spleen and indignation, or engage them into enquiries concerning its foundation and origin. This in the mean time is obvious, that the empire of all religious faith over the understanding is wavering and uncertain, subject to every variety of humour, and dependent on the present incidents, which strike the imagination. The difference is only in the degrees. An ancient will place a stroke of impiety and one of superstition

alternately, throughout a whole discourse; A modern often thinks in the same way, though he may be more guarded in his expression.

Witness this remarkable passage of TACITUS: "Besides the manifold misfortunes that befell mankind, there were prodigies in the sky and on the earth, warnings given by thunderbolts, and prophecies of the future, both joyful and gloomy, uncertain and clear. For never was it more fully proved by awful disasters of the Roman people or by indubitable signs that the gods care not for our safety, but for our punishment." AUGUSTUS's quarrel with NEPTUNE is an instance of the same kind. Had not the emperor believed NEPTUNE to be a real being, and to have dominion over the sea, where had been the foundation of his anger? And if he believed it, what madness to provoke still farther that deity? The same observation may be made upon QUINTILIAN's exclamation, on account of the death of his children.[119]

LUCIAN tells us expressly,[120] that whoever believed not the most ridiculous fables of paganism was deemed by the people profane and impious. To what purpose, indeed, would that agreeable author have employed the whole force of his wit and satire against the national religion, had not that religion been generally believed by his countrymen and contemporaries?

LIVY[121] acknowledges as frankly as any divine would at present the common incredulity of his age; but then he condemns it as severely. And who can imagine, that a national superstition, which could delude so ingenious a man, would not also impose on the generality of the people?

The STOICS bestowed many magnificent and even impious epithets on their sage; that he alone was rich, free, a king, and equal to the immortal gods. They forgot to add, that he was not inferior in prudence and understanding to an old woman. For surely nothing can be more pitiful than the sentiments, which

[119] The present paragraph was printed by Hume as a footnote, with the quotation from Tacitus, *Histories,* I, 3 left in the original Latin. Quintilian's exclamation is in his *Institutio Oratoria* [Education of an Orator], Preface to Book V.

[120] *Philopseudes* [The Lover of Lies], 3.

[121] *History,* X 40.

that sect entertain with regard to religious matters; while they seriously agree with the common augurs, that, when a raven croaks from the left, it is a good omen; but a bad one, when a rook makes a noise from the same quarter. PANÆTIUS was the only STOIC, among the GREEKS, who so much as doubted with regard to auguries and divination.[122] MARCUS AURELIUS[123] tells us, that he himself had received many admonitions from the gods in his sleep. It is true, EPICTETUS[124] forbids us to regard the language of rooks and ravens; but it is not, that they do not speak truth: It is only because they can fortell nothing but the breaking of our neck or the forfeiture of our estate; which are circumstances, says he, that nowise concern us. Thus the STOICS join a philosophical enthusiasm to a religious superstition. The force of their mind, being all turned to the side of morals, unbent itself in that of religion. The Stoics, I own, were not quite orthodox in the established religion; but one may see from these instances that they went a great way: And the people undoubtedly went every length.[125]

PLATO introduces SOCRATES affirming that the accusation of impiety raised against him was owing entirely to his rejecting such fables, as those of SATURN's castrating his father URANUS, and JUPITER's dethroning SATURN:[126] Yet in a subsequent dialogue,[127] SOCRATES confesses, that the doctrine

[122] Cicero, *On Divination* 3 and 7.

[123] *Meditations,* I 17.

[124] *Encheiridion,* 18. Epictetus (c. 55–135) was a freed slave whose teaching of Stoic philosophy as a religion greatly influenced, among others, the emperor Marcus Aurelius.

[125] Hume printed this sentence as a footnote.

[126] *Euthyphro,* 6 A–B. It is perhaps significant that Plato's Socrates here proceeds to discuss the question whether moral words can be defined in terms of the divine will; a question to which Hume's own answer would, of course, be an emphatic 'No!'.

[127] *Phaedo,* 68 D. Hume appears to have misinterpreted this passage, in which a sophisticated young man is represented as astonished that a most respected senior should be an immortalist. For surely Glaucon, here the interlocutor of Plato's Socrates, had assumed that this was one of those utterly discredited beliefs long since abandoned, not by the vulgar but by everyone with any pretentions to enlightenment. Compare, for instance, Antony Flew, *The Logic of Mortality* (Oxford: Blackwell, 1987), Chapter 3.

of the mortality of the soul was the received opinion of the people. Is there here any contradiction? Yes, surely: But the contradiction is not in PLATO; it is in the people, whose religious principles in general are always composed of the most discordant parts; especially in an age, when superstition sate so easy and light upon them.[128]

XENOPHON's conduct, as related by himself, is, at once, an incontestable proof of the general credulity of mankind in those ages, and the incoherencies, in all ages, of men's opinions in religious matters. That great captain and philosopher, the disciple of SOCRATES, and one who has delivered some of the most refined sentiments with regard to a deity, gave all the following marks of vulgar, pagan superstition. By SOCRATES's advice, he consulted the oracle of DELPHI, before he would engage in the expedition of CYRUS. He sees a dream the night after the generals were seized; which he pays great regard to, but thinks ambiguous. He and the whole army regard sneezing as a very lucky omen. He has another dream, when he comes to the river CENTRITES, which his fellow-general, CHIROSPHUS, also pays great regard to. The GREEKS, suffering from a cold north wind, sacrifice to it; and the historian observes, that it immediately abated. XENOPHON consults the sacrifices in secret, before he would form any resolution with himself about settling a colony. He was himself a very skilful augur. He is determined by the victims to refuse the sole command of the army which was offered him. CLEANDER, the SPARTAN, though very desirous of it, refuses for the same reason. XENOPHON, mentions an old dream with the interpretation given him, when he first joined CYRUS. Mentions also the place of HERCULES's descent into hell as believing it, and says the marks of it are still remaining. Had almost starved the army, rather than lead

[128] The following long paragraph was printed by Hume as a footnote. Almost all its telegraphic sentences were followed by references to the works of Xenophon, mainly the *Anabasis,* his account of the adventures in Asia Minor of an army of 10,000 Greek mercenary soldiers hired by the Persian King Cyrus the Younger. "Exta" are the entrails of a sacrificial victim. It was the priestly reading of their condition which constituted the auspices; encouraging or discouraging devotees, and hence determining their conduct.

them to the field against the auspices. His friend, EUCLIDES, the augur, would not believe that he had brought no money from the expedition; till he (EUCLIDES) sacrificed, and then he saw the matter clearly in the Exta. The same philosopher, proposing a project of mines for the encrease of the ATHENIAN revenues, advises them first to consult the oracle. That all this devotion was not a farce, in order to serve a political purpose, appears both from the facts themselves, and from the genius of that age, when little or nothing could be gained by hypocrisy. Besides, XENOPHON, as appears from his Memorabilia, was a kind of heretic in those times, which no political devotee ever is. It is for the same reason, I maintain, that NEWTON, LOCKE, CLARKE, &c. being *Arians* or *Socinians,* were very sincere in the creed they professed: And I always oppose this argument to some libertines, who will needs have it, that it was impossible but that these philosophers must have been hypocrites.[129]

The same CICERO, who affected, in his own family, to appear a devout religionist, makes no scruple, in a public court of judicature, of treating the doctrine of a future state as a ridiculous fable, to which no body could give any attention.[130] SALLUST[131] represents CÆSAR as speaking the same language in the open senate.

CICERO[132] and SENECA,[133] as also JUVENAL,[134] maintain that there is no boy or old woman so ridiculous as to believe

[129] Sir Isaac Newton (1642–1727), mathematician and physicist, was a professorial fellow of Trinity College, Cambridge; and has, under suspicion of this heresy, sometimes been described as 'the great Unitarian of Trinity'. John Locke (1632–1704) is the author of *An Essay concerning Human Understanding.* Samuel Clarke (1675–1729) was the philosophical theologian who acted as Newton's spokesman in the *Leibniz-Clarke Correspondence.* Whether Hume really did oppose the attribution of heresy to these respected figures, he here succeeds in putting into the reader's mind the delicate insinuation that established authors who make professions of orthodoxy may have done so to save their careers or necks.

[130] *Pro Cluentio* [In Defence of Cluentius], 61 (171).

[131] *The Catiline War,* 51 (16–20).

[132] *Tusculan Disputations,* I 5–6. Hume printed the present paragraph as a footnote.

[133] Letter 24.

[134] Satire 2.

the poets in their accounts of a future state. Why then does LUCRETIUS so highly exalt his master for freeing us from these terrors? Perhaps the generality of mankind were then in the disposition of CEPHALUS in PLATO who while he was young and healthful could ridicule these stories; but as soon as he became old and infirm, began to entertain apprehensions of their truth.[135] This we may observe not to be unusual even at present.

But that all these freedoms implied not a total and universal infidelity and scepticism amongst the people, is too apparent to be denied. Though some parts of the national religion hung loose upon the minds of men, other parts adhered more closely to them: And it was the chief business of the sceptical philosophers to show, that there was no more foundation for one than for the other. This is the artifice of COTTA in the dialogues concerning the *nature of the gods*.[136] He refutes the whole system of mythology by leading the orthodox gradually, from the more momentous stories, which were believed, to the more frivolous, which every one ridiculed: From the gods to the goddesses; from the goddesses to the nymphs; from the nymphs to the fawns and satyrs. His master, CARNEADES, had employed the same method of reasoning.[137]

Upon the whole, the greatest and most observable differences between a *traditional, mythological* religion, and a *systematical, scholastic* one are two: The former is often more reasonable, as consisting only of a multitude of stories, which, however groundless, imply no express absurdity and demonstrative contradiction; and sits also so easy and light on men's minds, that, though it may be as universally received, it happily makes no such deep impression on the affections and understanding.

[135] *Republic,* I 330D–331A.

[136] Cotta is the character in Cicero's *De Natura Deorum* who defends Academics as opposed to Stoics and Epicureans.

[137] See Sextus Empiricus, *Adversus Mathematicos* [Against the Professors], I 182–190.

XIII—IMPIOUS CONCEPTIONS OF THE DIVINE NATURE IN POPULAR RELIGIONS OF BOTH KINDS

The primary religion of mankind arises chiefly from an anxious fear of future events; and what ideas will naturally be entertained of invisible, unknown powers, while men lie under dismal apprehensions of any kind, may easily be conceived. Every image of vengeance, severity, cruelty, and malice must occur, and must augment the ghastliness and horror, which oppresses the amazed religionist. A panic having once seized the mind, the active fancy still farther multiplies the objects of terror; while that profound darkness, or, what is worse, that glimmering light, with which we are environed, represents the spectres of divinity under the most dreadful appearances imaginable. And no idea of perverse wickedness can be framed, which those terrified devotees do not readily, without scruple, apply to their deity.

This appears the natural state of religion, when surveyed in one light. But if we consider, on the other hand, that spirit of praise and eulogy, which necessarily has place in all religions, and which is the consequence of these very terrors, we must expect a quite contrary system of theology to prevail. Every virtue, every excellence, must be ascribed to the divinity, and no exaggeration will be deemed sufficient to reach those perfections, with which he is endowed. Whatever strains of panegyric can be invented, are immediately embraced, without consulting any arguments of phænomena: It is esteemed a sufficient confirmation of them, that they give us more magnificent ideas of the divine objects of our worship and adoration.

Here therefore is a kind of contradiction between the different principles of human nature, which enter into religion. Our natural terrors present the notion of a devilish and malicious deity: Our propensity to adulation leads us to acknowledge an excellent and divine. And the influence of these opposite principles are various, according to the different situation of the human understanding.

In very barbarous and ignorant nations, such as the AFRICANS and INDIANS, nay even the JAPONESE, who can form no extensive ideas of power and knowledge, worship may be paid to a being, whom they confess to be wicked and detestable; though they may be cautious, perhaps, of pronouncing this

judgment of him in public, or in his temple, where he may be supposed to hear their reproaches.

Such rude, imperfect ideas of the Divinity adhere long to all idolaters; and it may safely be affirmed, that the GREEKS themselves never got entirely rid of them. It is remarked by XENOPHON,[138] in praise of SOCRATES, that this philosopher assented not to the vulgar opinion, which supposed the gods to know some things, and be ignorant of others: He maintained, that they knew every thing; what was done, said, or even thought. But as this was a train of philosophy much above the conception of his countrymen, we need not be surprised, if very frankly, in their books and conversation, they blamed the deities, whom they worshipped in their temples.

(It was considered among the ancients, as a very extraordinary, philosophical paradox, that the presence of the gods was not confined to the heavens, but was extended every where; as we learn from LUCIAN.[139]) HERODOTUS in particular scruples not, in many passages, to ascribe *envy* to the gods; a sentiment, of all others, the most suitable to a mean and devilish nature. The pagan hymns, however, sung in public worship, contained nothing but epithets of praise; even while the actions ascribed to the gods were the most barbarous and detestable. When TIMOTHEUS, the poet, recited a hymn to DIANA, in which he enumerated, with the greatest eulogies, all the actions and attributes of that cruel, capricious goddess: *May your daughter,* said one present, *become*[140] *such as the deity whom you celebrate.*

But as men farther exalt their idea of their divinity; it is their notion of his power and knowledge only, not of his goodness, which is improved. On the contrary, in proportion to the supposed extent of his science and authority, their terrors naturally augment; while they believe, that no secrecy can conceal them from his scrutiny, and that even the inmost recesses of their breast lie open before him. They must then be careful not to form expressly any sentiment of blame and disapprobation. All must be applause, ravishment, extasy. And

[138] *Memorabilia,* I.i.19.

[139] *Hermotimus,* 81. Hume printed this aside as a footnote.

[140] Plutarch, *De Superstitione* [On Superstition], X.170 A–B.

while their gloomy apprehensions make them ascribe to him measures of conduct, which, in human creatures, would be highly blamed, they must still affect to praise and admire that conduct in the object of their devotional addresses. Thus it may safely be affirmed, that popular religions are really, in the conception of their more vulgar votaries, a species of dæmonism; and the higher the deity is exalted in power and knowledge, the lower of course is he depressed in goodness and benevolence; whatever epithets of praise may be bestowed on him by his amazed adorers. Among idolaters, the words may be false, and belie the secret opinion: But among more exalted religionists, the opinion itself contracts a kind of falsehood, and belies the inward sentiment. The heart secretly detests such measures of cruel and implacable vengeance; but the judgment dares not but pronounce them perfect and adorable. And the additional misery of this inward struggle aggravates all the other terrors, by which these unhappy victims to superstition are for ever haunted.

LUCIAN observes that a young man, who reads the history of the gods in HOMER or HESIOD, and finds their factions, wars, injustice, incest, adultery, and other immoralities so highly celebrated, is much surprised afterwards, when he comes into the world, to observe that punishments are by law inflicted on the same actions, which he had been taught to ascribe to superior beings.[141] The contradiction is still perhaps stronger between the representations given us by some later religions and our natural ideas of generosity, lenity, impartiality, and justice; and in proportion to the multiplied terrors of these religions, the barbarous conceptions of the divinity are multiplied upon us.[142]

Bacchus, a divine being, is represented by the heathen mythology as the inventor of dancing and the theatre. Plays were anciently even a part of public worship on the most solemn occasions, and often employed in times of pestilence, to appease the offended deities. But they have been zealously

[141] *Menippus,* 3.

[142] Hume printed the four following paragraphs as a monster footnote. In order to increase the chances that they will actually be read they have here, as usual, been promoted into the body of the text.

proscribed by the godly in later ages; and the playhouse, according to a learned divine, is the porch of hell.

But in order to show more evidently, that it is possible for a religion to represent the divinity in still a more immoral and unamiable light than he was pictured by the ancients, we shall cite a long passage from an author of taste and imagination, who was surely no enemy to Christianity. It is the Chevalier RAMSAY, a writer, who had so laudable an inclination to be orthodox, that his reason never found any difficulty, even in the doctrines which free-thinkers scruple the most, the trinity, incarnation, and satisfaction: His humanity alone, of which he seems to have had a great stock, rebelled against the doctrines of eternal reprobation and predestination. He expresses himself thus:[143]

'What strange ideas,' says he, 'would an Indian or a Chinese philosopher have of our holy religion, if they judged by the schemes given of it by our modern free-thinkers, and pharisaical doctors of all sects? According to the odious and too *vulgar* system of these incredulous scoffers and credulous scribblers, "The God of the Jews is a most cruel, unjust, partial, and fantastical being. He created, about 6,000 years ago, a man and a woman, and placed them in a fine garden of ASIA, of which there are no remains. This garden was furnished with all sorts of trees, fountains, and flowers. He allowed them the use of all the fruits of this beautiful garden, except one, that was planted in the midst thereof, and that had in it a secret virtue of preserving them in continual health and vigour of body and mind, of exalting their natural powers and making them wise. The devil entered into the body of a serpent, and solicited the first woman to eat of this forbidden fruit; she engaged her husband to do the same. To punish this slight curiosity and natural desire of life and knowledge, God not only threw our first parents out of paradise, but he condemned all their posterity to temporal misery, and the greatest part of them to eternal pains, though the souls of these innocent children have no more relation to that of ADAM

[143] Andrew Michael Ramsay (1686–1743), *The Philosophical Principles of Natural and Revealed Religion, Unfolded in a Geometrical Order*, Part II.

than to those of NERO and MAHOMET; since, according to the
scholastic drivellers, fabulists, and mythologists, all souls are
created pure, and infused immediately into mortal bodies, as
soon as the fœtus is formed. To accomplish the barbarous,
partial degree of predestination and reprobation, God aban-
doned all nations to darkness, idolatry, and superstition,
without any saving knowledge or salutary graces; unless it was
one particular nation, whom he chose as his peculiar people.
This chosen nation was, however, the most stupid, ungrateful,
rebellious and perfidious of all nations. After God had thus
kept the far greater part of all the human species, during near
4,000 years, in a reprobate state, he changed all of a sudden,
and took a fancy for other nations besides the JEWS. Then he
sent his only begotten Son to the world, under a human form,
to appease his wrath, satisfy his vindictive justice, and die for
the pardon of sin. Very few nations, however, have heard of this
gospel; and all the rest, though left in invincible ignorance, are
damned without exception, or any possibility of remission. The
greatest part of those who have heard of it, have changed only
some speculative notions about God, and some external forms
in worship: For, in other respects, the bulk of Christians have
continued as corrupt as the rest of mankind in their morals;
yea, so much the more perverse and criminal, that their lights
were greater. Unless it be a very small select number, all other
Christians, like the pagans, will be for ever damned; the great
sacrifice offered up for them will become void and of no effect;
God will take delight for ever, in their torments and blasphe-
mies; and though he can, by one *fiat* change their hearts, yet
they will remain, for ever unconverted and unconvertible,
because he will be for ever unappeasable and irreconcileable. It
is true that all this makes God odious, a hater of souls, rather
than a lover of them; a cruel, vindictive tyrant, an impotent or
a wrathful dæmon, rather than an all-powerful, beneficient
father of spirits: Yet all this is a mystery. He has secret reasons
for his conduct, that are impenetrable; and though he appears
unjust and barbarous, yet we must believe the contrary,
because what is injustice, crime, cruelty, and the blackest
malice in us, is in him justice, mercy, and sovereign goodness."
Thus the incredulous free-thinkers, the judaizing Christians,
and the fatalistic doctors have disfigured and dishonoured the
sublime mysteries of our holy faith; thus they have confounded

the nature of good and evil; transformed the most monstrous passions into divine attributes, and surpassed the pagans in blasphemy, by ascribing to the eternal nature, as perfections, what makes the most horrid crimes amongst men. The grosser pagans contented themselves with divinizing lust, incest, and adultery; but the predestinarian doctors have divinized cruelty, wrath, fury, vengeance and all the blackest vices.'

The same author asserts, in other places, that the *Arminian* and *Molinist* schemes serve very little to mend the matter: And having thus thrown himself out of all received sects of Christianity, he is obliged to advance a system of his own, which is a kind of *Origenism*,[144] and supposes the pre-existence of the souls both of men and beasts, and the eternal salvation and conversion of all men, beasts, and devils. But this notion, being quite peculiar to himself, we need not treat of. I thought the opinions of this ingenious author very curious; but I pretend not to warrant the justice of them.

Nothing can preserve untainted the genuine principles of

[144] Two related problems which have repeatedly exercised Christian thinkers are: 1. whether (as the *Epistle to the Romans* seems to maintain, and the doctrine of God's omniscience seems to require) God decided in advance who would be saved and who damned (who would eventually reside in Heaven and who in Hell), and if so, how the outcome can be held to be just; and 2. whether it is permissible to believe, or to hope, that every human, and even the demons and Lucifer himself, may eventually be saved. Since the sixteenth century, Protestantism has been riven by the dispute between Calvinists (followers of John Calvin, 1509–1564) and Arminians (or Remonstrants, followers of Jacobus Arminius, 1559–1609), usually understood as a conflict between 'predestination' and 'freewill'. (The actual issue is more complex. Arminius, for example, accepted that God knew "from eternity" which individuals would be saved and which damned.) The Molinists were Catholic followers of Luis de Molina (1535–1600), who combatted their fellow-Catholic Jansenists in seventeenth- and early eighteenth-century France. Jansenists followed Cornelius Jansen (1585–1638), bishop of Ypres in Flanders. Similarities between Jansenism and Calvinism have often been noted. Roughly, the Molinists were more inclined to 'freewill' and the Jansenists to 'predestination'. Origen (c. 185–253), the first systematic Christian theologian, was denounced as a heretic and his works burned in the sixth century CE—but by this time his indirect influence was so enormous that it is inextricable from all subsequent Christianity. Among Origen's teachings which have *not* been widely embraced, he believed in the eventual salvation of every creature, not excepting the Devil.

morals in our judgment of human conduct, but the absolute
necessity of these principles to the existence of society. If
common conception can indulge princes in a system of ethics,
somewhat different from that which should regulate private
persons; how much more those superior beings, whose attri-
butes, views, and nature are so totally unknown to us? *Sunt
superis sua jura.*[145] The gods have maxims of justice peculiar to
themselves.

[145] The Latin phrase, which Hume proceeds forthwith to translate,
comes in Ovid, *Metamorphoses,* X 500.

XIV — BAD INFLUENCE OF POPULAR RELIGIONS ON MORALITY

Here I cannot forbear observing a fact, which may be worth the attention of such as make human nature the object of their enquiry. It is certain, that, in every religion, however sublime the verbal definition which it gives of its divinity, many of the votaries, perhaps the greatest number, will still seek the divine favour, not by virtue and good morals, which alone can be acceptable to a perfect being, but either by frivolous observances, by intemperate zeal, by rapturous extasies, or by the belief of mysterious and absurd opinions. The least part of the *Sadder,* as well as of the *Pentateuch,*[146] consists in precepts of morality; and we may also be assured, that that part was always the least observed and regarded. When the old ROMANS were attacked with a pestilence, they never ascribed their sufferings to their vices, or dreamed of repentance and amendment. They never thought that they were the general robbers of the world, whose ambition and avarice made desolate the earth, and reduced opulent nations to want and beggary. They only created a dictator,[147] in order to drive a nail into a door; and by that means, they thought that they had sufficiently appeased their incensed deity.

In ÆGINA, one faction forming a conspiracy, barbarously and treacherously assassinated seven hundred of their fellow-citizens; and carried their fury so far, that, one miserable fugitive having fled to the temple, they cut off his hands, by which he clung to the gates, and carrying him out of holy ground, immediately murdered him. *By this impiety,* says HERODOTUS, (not by the other many cruel assassinations) *they offended the gods, and contracted an inexpiable*[148] *guilt.*

Nay, if we should suppose, what never happens, that a popular religion were found, in which it was expressly declared, that nothing but morality could gain the divine favour;

[146] The *Sadder,* normally *Siddur,* is the Jewish prayer book. 'Pentateuch' is the collective name for the first five books of *The Bible.*

[147] Hume refers to Livy, *History,* VII 3; where it is reported that the Roman senate decided to do this, believing that it had worked once in the past.

[148] *History,* VI 91.

if an order of priests were instituted to inculcate this opinion, in daily sermons, and with all the arts of persuasion; yet so inveterate are the people's prejudices, that, for want of some other superstition, they would make the very attendance on these sermons the essentials of religion, rather than place them in virtue and good morals. The sublime prologue of ZALEUCUS's laws[149] inspired not the LOCRIANS, so far as we can learn, with any sounder notions of the measures of acceptance with the deity, than were familiar to the other GREEKS.

This observation, then, holds universally: But still one may be at some loss to account for it. It is not sufficient to observe, that the people, every where, degrade their deities into a similitude with themselves, and consider them merely as a species of human creatures, somewhat more potent and intelligent. This will not remove the difficulty. For there is no *man* so stupid, as that, judging by his natural reason, he would not esteem virtue and honesty the most valuable qualities, which any person could possess. Why not ascribe the same sentiment to his deity? Why not make all religion, or the chief part of it, to consist in these attainments?

Nor is it satisfactory to say, that the practice of morality is more difficult than that of superstition; and is therefore rejected. For, not to mention the excessive penances of the *Brahmans* and *Talapoins*,[150] it is certain, that the *Ramadan* of the TURKS, during which the poor wretches, for many days, often in the hottest months of the year, and in some of the hottest climates of the world, remain without eating or drinking from the rising to the setting sun; this *Ramadan*, I say, must be more severe than the practice of any moral duty, even to the most vicious and depraved of mankind. The four lents of the MUSCOVITES, and the austerities of some ROMAN CATHO-LICS, appear more disagreeable than meekness and benevolence.[151] In short, all virtue, when men are reconciled to it by

[149] Diodorus Siculus, *Op. Cit.*, XII, 20–21.

[150] A now-obsolete word for Buddhist monks or priests; originally only those of Pegu but later extended to embrace all others.

[151] A. Wayne Colver suggests that Hume may have drawn this from Richard Chancelor's 'Booke of the great and mighty Emperor of Russia . . . etc.' in Hakluyt's *Principall Navigations, Voiages and Discoveries of the English Nation* (London, 1589).

ever so little practice, is agreeable: All superstition is for ever odious and burdensome.

Perhaps, the following account may be received as a true solution of the difficulty. The duties, which a man performs as a friend or parent, seem merely owing to his benefactor or children; nor can he be wanting to these duties, without breaking through all the ties of nature and morality. A strong inclination may prompt him to the performance: A sentiment of order and moral obligation joins its force to these natural ties: And the whole man, if truly virtuous, is drawn to his duty, without any effort or endeavour. Even with regard to the virtues, which are more austere, and more founded on reflection, such as public spirit, filial duty, temperance, or integrity; the moral obligation, in our apprehension, removes all pretension to religious merit; and the virtuous conduct is deemed no more than what we owe to society and to ourselves. In all this, a superstitious man finds nothing, which he has properly performed for the sake of his deity, or which can peculiarly recommend him to the divine favour and protection. He considers not, that the most genuine method of serving the divinity is by promoting the happiness of his creatures. He still looks out for some more immediate service of the supreme Being, in order to allay those terrors, with which he is haunted. And any practice, recommended to him, which either serves to no purpose in life, or offers the strongest violence to his natural inclinations; that practice he will the more readily embrace, on account of those very circumstances which should make him absolutely reject it. It seems the more purely religious, because it proceeds from no mixture of any other motive or consideration. And if, for its sake, he sacrifices much of his ease and quiet, his claim of merit appears still to rise upon him, in proportion to the zeal and devotion which he discovers. In restoring a loan, or paying a debt, his divinity is nowise beholden to him; because these acts of justice are what he was bound to perform, and what many would have performed, were there no god in the universe. But if he fast a day, or give himself a sound whipping; this has a direct reference, in his opinion, to the service of God. No other motive could engage him to such austerities. By these distinguished marks of devotion, he has now acquired the divine favour; and may expect, in recompense, protection and safety in this world, and eternal happiness in the next.

Hence the greatest crimes have been found, in many instances, compatible with a superstitious piety and devotion; Hence, it is justly regarded as unsafe to draw any certain inference in favour of a man's morals, from the fervour or strictness of his religious exercises, even though he himself believe them sincere. Nay, it has been observed, that enormities of the blackest dye have been rather apt to produce superstitious terrors, and encrease the religious passion. BOMILCAR, having formed a conspiracy for assassinating at once the whole senate of CARTHAGE, and invading the liberties of his country, lost the opportunity, from a continual regard to omens and prophecies. *Those who undertake the most criminal and most dangerous enterprizes are commonly the most superstitious;* as an ancient historian remarks on this occasion.[152] Their devotion and spiritual faith rise with their fears. CATILINE was not contented with the established deities and received rites of the national religion: His anxious terrors made him seek new inventions of this kind; which he never probably had dreamed of, had he remained a good citizen, and obedient to the laws of his country.[153]

To which we may add, that, after the commission of crimes, there arise remorses and secret horrors, which give no rest to the mind, but make it have recourse to religious rites and ceremonies, as expiations of its offences. Whatever weakens or disorders the internal frame promotes the interests of superstition: And nothing is more destructive to them than a manly, steady virtue, which either preserves us from disastrous, melancholy accidents, or teaches us to bear them. During such calm sunshine of the mind, these spectres of false divinity never make their appearance. On the other hand, while we abandon ourselves to the natural undisciplined suggestions of our timid and anxious hearts, every kind of barbarity is ascribed to the supreme Being, from the terrors with which we are agitated; and every kind of caprice, from the methods which we embrace in order to appease him. *Barbarity, caprice;* these qualities, however nominally disguised, we may universally observe, form the ruling character of the deity in popular

[152] Diodorus Siculus, *Op. Cit.,* XX 43.

[153] Cicero, *Against Catiline,* II 6; and Sallust, *The Catiline War,* 22.

religions. Even priests, instead of correcting these depraved ideas of mankind, have often been found ready to foster and encourage them. The more tremendous the divinity is represented, the more tame and submissive do men become his ministers: And the more unaccountable the measures of acceptance required by him, the more necessary does it become to abandon our natural reason, and yield to their ghostly guidance and direction. Thus it may be allowed that the artifices of men aggravate our natural infirmities and follies of this kind, but never originally beget them. Their root strikes deeper into the mind, and springs from the essential and universal properties of human nature.

XV — GENERAL COROLLARY

Though the stupidity of men, barbarous and uninstructed, be so great, that they may not see a sovereign author in the more obvious works of nature, to which they are so much familiarized; yet it scarcely seems possible, that any one of good understanding should reject that idea, when once it is suggested to him. A purpose, an intention, a design is evident in every thing; and when our comprehension is so far enlarged as to contemplate the first rise of this visible system, we must adopt, with the strongest conviction, the idea of some intelligent cause or author. The uniform maxims, too, which prevail throughout the whole frame of the universe, naturally, if not necessarily, lead us to conceive this intelligence as single and undivided, where the prejudices of education oppose not so reasonable a theory. Even the contrarieties of nature, by discovering themselves every where, become proofs of some consistent plan, and establish one single purpose or intention, however inexplicable and incomprehensible.

Good and ill are universally intermingled and confounded; happiness and misery, wisdom and folly, virtue and vice. Nothing is pure and entirely of a piece. All advantages are attended with disadvantages. An universal compensation prevails in all conditions of being and existence. And it is not possible for us, by our most chimerical wishes, to form the idea of a station or situation altogether desirable. The draughts of life, according to the poet's fiction, are always mixed from the vessels on each hand of JUPITER: Or if any cup be presented altogether pure, it is drawn only, as the same poet tells us, from the left-handed vessel.

The more exquisite any good is, of which a small specimen is afforded us, the sharper is the evil, allied to it; and few exceptions are found to this uniform law of nature. The most sprightly wit borders on madness; the highest effusions of joy produce the deepest melancholy; the most ravishing pleasures are attended with the most cruel lassitude and disgust; the most flattering hopes make way for the severest disappointments. And, in general, no course of life has such safety (for happiness is not to be dreamed of) as the temperate and moderate, which maintain, as far as possible, a mediocrity, and a kind of insensibility, in every thing.

As the good, the great, the sublime, the ravishing are

found eminently in the genuine principles of theism; it may be expected, from the analogy of nature, that the base, the absurd, the mean, the terrifying will be equally discovered in religious fictions and chimeras.

The universal propensity to believe in invisible, intelligent power, if not an original instinct, being at least a general attendant of human nature, may be considered as a kind of mark or stamp, which the divine workman has set upon his work; and nothing surely can more dignify mankind, than to be thus selected from all other parts of the creation, and to bear the image or impression of the universal Creator. But consult this image, as it appears in the popular religions of the world. How is the deity disfigured in our representations of him! How much is he degraded even below the character, which we should naturally, in common life, ascribe to a man of sense and virtue!

What a noble privilege is it of human reason to attain the knowledge of the supreme Being; and, from the visible works of nature, be enabled to infer so sublime a principle as its supreme Creator? But turn the reverse of the medal. Survey most nations and most ages. Examine the religious principles, which have, in fact, prevailed in the world. You will scarcely be persuaded, that they are any thing but sick men's dreams: Or perhaps will regard them more as the playsome whimsies of monkeys in human shape, than the serious, positive, dogmatical asseverations of a being who dignifies himself with the name of rational.

Hear the verbal protestations of all men: Nothing so certain as their religious tenets. Examine their lives: You will scarcely think that they repose the smallest confidence in them.

The greatest and truest zeal gives us no security against hypocrisy: The most open impiety is attended with a secret dread and compunction.

No theological absurdities so glaring that they have not, sometimes, been embraced by men of the greatest and most cultivated understanding. No religious precepts so rigorous that they have not been adopted by the most voluptuous and most abandoned of men.

Ignorance is the mother of Devotion: A maxim that is proverbial, and confirmed by general experience. Look out for a

people, entirely destitute of religion: If you find them at all, be assured, that they are but a few degrees removed from brutes.

What so pure as some of the morals, included in some theological systems? What so corrupt as some of the practices to which these systems give rise?

The comfortable views, exhibited by the belief of futurity, are ravishing and delightful. But how quickly vanish on the appearance of its terrors, which keep a more firm and durable possession of the human mind?

The whole is a riddle, an enigma, an inexplicable mystery. Doubt, uncertainty, suspence of judgment appear the only result of our most accurate scrutiny, concerning this subject. But such is the frailty of human reason, and such the irresistible contagion of opinion, that even this deliberate doubt could scarcely be upheld; did we not enlarge our view, and opposing one species of superstition to another, set them a quarrelling; while we ourselves, during their fury and contention, happily make our escape into the calm, though obscure, regions of philosophy.

PART VI

Dialogues concerning Natural Religion

5. Dialogues concerning Natural Religion

Pamphilus to Hermippus

Pamphilus: It has been remarked, my Hermippus, that, though the ancient philosophers conveyed most of their instruction in the form of dialogue, this method of composition has been little practised in later ages, and has seldom succeeded in the hands of those who have attempted it. Accurate and regular argument, indeed, such as is now expected of philosophical enquirers, naturally throws a man into the methodical and didactic manner; where he can immediately, without preparation, explain the point at which he aims; and thence proceed, without interruption, to deduce the proofs on which it is established. To deliver a SYSTEM in conversation scarcely appears natural; and while the dialogue-writer desires, by departing from the direct style of composition, to give a freer air to his performance, and avoid the appearance of *Author* and *Reader,* he is apt to run into a worse inconvenience, and convey the image of *Pedagogue* and *Pupil.* Or if he carries on the dispute in the natural spirit of good company, by throwing in a variety of topics, and preserving a proper balance among the speakers; he often loses so much time in preparations and transitions, that the reader will scarcely think himself compensated, by all the graces of dialogue, for the order, brevity, and precision, which are sacrificed to them.

There are some subjects, however, to which dialogue-writing is peculiarly adapted, and where it is still preferable to the direct and simple method of composition.

Any point of doctrine, which is so *obvious* that it scarcely admits of dispute, but at the same time so *important* that it cannot be too often inculcated, seems to require some such method of handling it; where the novelty of the manner may

compensate the triteness of the subject, where the vivacity of
conversation may enforce the precept, and where the variety of
lights, presented by various personages and characters, may
appear neither tedious nor redundant.

Any question of philosophy, on the other hand, which is so
obscure and *uncertain,* that human reason can reach no fixed
determination with regard to it; if it should be treated at all;
seems to lead us naturally into the style of dialogue and
conversation. Reasonable men may be allowed to differ, where
no one can reasonably be positive: Opposite sentiments, even
without any decision, afford an agreeable amusement: and if
the subject be curious and interesting, the book carries us, in a
manner, into company; and unites the two greatest and purest
pleasures of human life, study and society.

Happily, these circumstances are all to be found in the
subject of NATURAL RELIGION. What truth so obvious, so
certain, as the BEING of a God, which the most ignorant ages
have acknowledged, for which the most refined geniuses have
ambitiously striven to produce new proofs and arguments?
What truth so important as this, which is the ground of all our
hopes, the surest foundation of morality, the firmest support of
society, and the only principle, which ought never to be a
moment absent from our thoughts and meditations? But in
treating of this obvious and important truth; what obscure
questions occur, concerning the NATURE of that divine being;
his attributes, his decrees, his plan of providence? These have
been always subjected to the disputations of men: Concerning
these, human reason has not reached any certain determina-
tion:[1] But these are topics so interesting, that we cannot
restrain our restless enquiry with regard to them; though
nothing but doubt, uncertainty and contradiction, have, as yet,
been the result of our most accurate researches.

This I had lately occasion to observe, while I passed, as
usual, part of the summer season with CLEANTHES, and was
present at those conversations of his with PHILO and DEMEA,
of which I gave you lately some imperfect account. Your
curiosity, you then told me, was so excited, that I must of
necessity enter into a more exact detail of their reasonings,

[1] Decided result.

and display those various systems, which they advanced with regard to so delicate a subject as that of Natural Religion. The remarkable contrast in their characters still farther raised your expectations; while you opposed the accurate philosophical turn of CLEANTHES to the careless scepticism of PHILO, or compared either of their dispositions with the rigid inflexible orthodoxy of DEMEA. My youth rendered me a mere auditor of their disputes; and that curiosity, natural to the early season of life, has so deeply imprinted in my memory the whole chain and connection of their arguments, that, I hope, I shall not omit or confound any considerable part of them in the recital.

PART I

Pamphilus: After I joined the company, whom I found sitting in CLEANTHES's library, DEMEA paid CLEANTHES some compliments, on the great care which he took of my education, and on his unwearied perseverance and constancy in all his friendships. The father of PAMPHILUS, said he, was your intimate friend: The son is your pupil, and may indeed be regarded as your adopted son; were we to judge by the pains which you bestow in conveying to him every useful branch of literature and science. You are no more wanting,[2] I am persuaded, in prudence than in industry. I shall, therefore, communicate to you a maxim, which I have observed with regard to my own children, that I may learn how far it agrees with your practice. The method I follow in their education is founded on the saying of an ancient, 'That students of philosophy ought first to learn Logics, then Ethics, next Physics, last of all, the Nature of the Gods.'[3] This science of Natural Theology, according to him, being the most profound and abstruse of any, required the maturest judgment in its students; and none but a mind, enriched with all the other sciences, can safely be entrusted with it.

Philo: Are you so late, says PHILO, in teaching your children the principles of religion? Is there no danger of their neglecting or rejecting altogether those opinions, of which they have heard so little, during the whole course of their education?

Demea: It is only as a science, replied DEMEA, subjected to human reasoning and disputation, that I postpone the study of Natural Theology. To season their minds with early piety is my chief care; and by continual precept and instruction, and I hope too, by example, I imprint deeply on their tender minds an habitual reverence for all the principles of religion. While they pass through every other science, I still remark the

[2] Lacking.

[3] The quotation is from the account of the philosophy of Chrysippus in Plutarch's *De Stoicorum Repugnantiis* [On the Contradictions of the Stoics], part of his *Moralia*. Ancients are people who lived in the Classical world of Greece and Rome. The contrast is normally with modernity, subsequent to the Middle Ages.

uncertainty of each part, the eternal disputations of men, the obscurity of all philosophy, and the strange, ridiculous conclusions, which some of the greatest geniuses have derived from the principles of mere human reason. Having thus tamed their mind to a proper submission and self-diffidence,[4] I have no longer any scruple of opening to them the greatest mysteries of religion, nor apprehend any danger from that assuming arrogance of philosophy, which may lead them to reject the most established doctrines and opinions.

Philo: Your precaution, says PHILO, of seasoning your children's minds with early piety, is certainly very reasonable; and no more than is requisite, in this profane and irreligious age. But what I chiefly admire in your plan of education, is your method of drawing advantage from the very principles of philosophy and learning, which, by inspiring pride and self-sufficiency, have commonly, in all ages, been found so destructive to the principles of religion. The vulgar, indeed, we may remark, who are unacquainted with science and profound enquiry, observing the endless disputes of the learned, have commonly a thorough contempt for Philosophy; and rivet themselves the faster, by that means, in the great points of Theology, which have been taught them. Those, who enter a little into study and enquiry, finding many appearances of evidence in doctrines the newest and most extraordinary, think nothing too difficult for human reason; and presumptuously breaking through all fences, profane the inmost sanctuaries of the temple. But CLEANTHES will, I hope, agree with me, that, after we have abandoned ignorance, the surest remedy, there is still one expedient left to prevent this profane liberty. Let DEMEA's principles be improved and cultivated: Let us become thoroughly sensible of the weakness, blindness, and narrow limits of human reason: Let us duly consider its uncertainty and endless contrarieties, even in subjects of common life and practice: Let the errors and deceits of our very senses be set before us; the insuperable difficulties, which attend first principles in all systems; the contradictions, which adhere to the very ideas of matter, cause and effect, extension, space, time, motion; and in a word, quantity of all kinds, the

[4] Lack of self-confidence.

object of the only science, that can fairly pretend to any certainty or evidence. When these topics are displayed in their full light, as they are by some philosophers and almost all divines;[5] who can retain such confidence in this frail faculty of reason as to pay any regard to its determinations in points so sublime, so abstruse, so remote from common life and experience? When the coherence of the parts of a stone, or even that composition of parts, which renders it extended; when these familiar objects, I say, are so inexplicable, and contain circumstances so repugnant and contradictory; with what assurance can we decide concerning the origin of worlds, or trace their history from eternity to eternity?

Pamphilus: While PHILO pronounced these words, I could observe a smile in the countenance both of DEMEA and CLEANTHES. That of DEMEA seemed to imply an unreserved satisfaction in the doctrines delivered: But in CLEANTHES's features, I could distinguish an air of finesse; as if he perceived some raillery or artificial malice in the reasonings of PHILO.

Cleanthes: You propose then, PHILO, said CLEANTHES, to erect religious faith on philosophical scepticism; and you think, that if certainty or evidence be expelled from every other subject of enquiry, it will all retire to these theological doctrines, and there acquire a superior force and authority. Whether your scepticism be as absolute and sincere as you pretend, we shall learn by and by, when the company breaks up: We shall then see, whether you go out at the door or the window; and whether you really doubt, if your body has gravity, or can be injured by its fall; according to popular opinion, derived from our fallacious senses and more fallacious experience. And this consideration, DEMEA, may, I think, fairly serve to abate our ill-will to this humorous[6] sect of the sceptics. If they be thoroughly in earnest, they will not long trouble the world with their doubts, cavils, and disputes: If they be only in jest, they are, perhaps, bad ralliers, but can

[5] Learned clergymen.

[6] 'Humours' were the bodily fluids believed to cause moods. "Humorous" does not necessarily mean 'comical', but could suggest emotional instability or capriciousness.

never be very dangerous, either to the state, to philosophy, or to religion.

In reality, PHILO, continued he, it seems certain, that though a man, in a flush of humour,[7] after intense reflection on the many contradictions and imperfections of human reason, may entirely renounce all belief and opinion; it is impossible for him to persevere in this total scepticism, or make it appear in his conduct for a few hours. External objects press in upon him: Passions solicit him: His philosophical melancholy dissipates; and even the utmost violence upon his own temper will not be able, during any time, to preserve the poor appearance of scepticism. And for what reason impose on himself such a violence? This is a point, in which it will be impossible for him ever to satisfy himself, consistently with his sceptical principles: So that upon the whole nothing could be more ridiculous than the principles of the ancient PYRRHONIANS;[8] if in reality they endeavoured, as is pretended, to extend throughout, the same scepticism, which they had learned from the declamations of their schools, and which they ought to have confined to them.

In this view, there appears a great resemblance between the sects of the STOICS[9] and PYRRHONIANS, though perpetual antagonists: and both of them seem founded on this erroneous maxim, That what a man can perform sometimes, and in some dispositions, he can perform always, and in every disposition.

[7] A fleeting mood.

[8] Followers of Pyrrho of Elis, (c. 365–c. 275 BCE), generally regarded as the first systematic and would-be-total Sceptic. In modern times the influence of Pyrrhonism dates from the publication, in 1569, in a Latin translation, of the complete works of Sextus Empiricus (second century CE). The translator, Gentian Hervet, was himself one of those Catholics who exploited this publication to develop and deploy a new 'machine of war' for the Counter-Reformation. Their tactic was to use sceptical arguments to demoralize dissent, and then to present fideist faith as offering the only escape from insecurity and despair. (Fideism is the thesis that truth in religion in accessible only to faith.)

[9] Stoicism was a philosophical school founded by Zeno of Citium around 300 BCE, and named after the Stoa Poikile, the place where Zeno taught. His immediate successor was a Cleanthes, who was in turn succeeded by the Chrysippus mentioned above.

When the mind, by Stoical reflections, is elevated into a sublime enthusiasm of virtue, and strongly smitten with any *species* of honour or public good, the utmost bodily pain and suffering will not prevail over such a high sense of duty; and 'tis possible, perhaps, by its means, even to smile and exult in the midst of tortures. If this sometimes may be the case in fact and reality, much more may a philosopher, in his school, or even in his closet, work himself up to such an enthusiasm, and support in imagination the acutest pain or most calamitous event, which he can possibly conceive. But how shall he support this enthusiasm itself? The bent of his mind relaxes, and cannot be recalled at pleasure: Avocations lead him astray: Misfortunes attack him unawares: and the *philosopher* sinks by degrees into the *plebeian*.[10]

Philo: I allow of your comparison between the STOICS and SCEPTICS, replied PHILO. But you may observe, at the same time, that though the mind cannot, in Stoicism, support the highest flights of philosophy, yet even when it sinks lower, it still retains somewhat of its former disposition; and the effects of the Stoic's reasoning will appear in his conduct in common life, and through the whole tenor of his actions. The ancient schools, particularly that of ZENO, produced examples of virtue and constancy which seem astonishing to present times.

> *Vain Wisdom all and false Philosophy.*
> *Yet with a pleasing sorcery could charm*
> *Pain, for a while, or anguish, and excite*
> *Fallacious Hope, or arm the obdurate breast*
> *With stubborn Patience, as with triple steel.*[11]

In like manner, if a man has accustomed himself to sceptical considerations on the uncertainty and narrow limits of reason, he will not entirely forget them when he turns his reflection on other subjects; but in all his philosophical principles and reasoning, I dare not say, in his common conduct, he will be found different from those, who either never formed any

[10] The traditional Roman class division was into patricians and ple-beians. Hence a plebeian is one of the vulgar, the unenlightened.

[11] These lines are from *Paradise Lost* (II 565–69) by John Milton (1608–1674).

opinions in the case, or have entertained sentiments more favourable to human reason.

To whatever length any one may push his speculative principles of scepticism, he must act, I own, and live, and converse like other men; and for this conduct he is not obliged to give any other reason, than the absolute necessity he lies under of so doing. If he ever carries his speculations farther than this necessity constrains him, and philosophises, either on natural or moral subjects, he is allured by a certain pleasure and satisfaction, which he finds in employing himself after that manner. He considers besides, that every one, even in common life, is constrained to have more or less of this philosophy; that from our earliest infancy we make continual advances in forming more general principles of conduct and reasoning; that the larger experience we acquire, and the stronger reason we are endued with, we always render our principles the more general and comprehensive; and that what we call *philosophy* is nothing but a more regular and methodical operation of the same kind. To philosophise on such subjects is nothing essentially different from reasoning on common life; and we may only expect greater stability, if not greater truth, from our philosophy, on account of its exacter and more scrupulous method of proceeding.

But when we look beyond human affairs and the properties of the surrounding bodies: When we carry our speculations into the two eternities, before and after the present state of things; into the creation and formation of the universe; the existence and properties of spirits; the powers and operations of one universal spirit, existing without beginning and without end; omnipotent, omniscient, immutable, infinite, and incomprehensible: We must be far removed from the smallest tendency to scepticism not to be apprehensive, that we have here got quite beyond the reach of our faculties. So long as we confine our speculations to trade, or morals, or politics, or criticism, we make appeals, every moment, to common sense and experience, which strengthen our philosophical conclusions, and remove (at least, in part) the suspicion, which we so justly entertain with regard to every reasoning, that is very subtile and refined. But in theological reasonings, we have not this advantage; while at the same time we are employed upon objects, which, we must be sensible, are too large for our grasp,

and of all others, require most to be familiarised to our apprehension. We are like foreigners in a strange country, to whom every thing must seem suspicious, and who are in danger every moment of transgressing against the laws and customs of the people, with whom they live and converse. We know not how far we ought to trust our vulgar methods of reasoning in such a subject; since, even in common life and in that province, which is peculiarly appropriated to them, we cannot account for them, and are entirely guided by a kind of instinct or necessity in employing them.

All sceptics pretend, that, if reason be considered in an abstract view, it furnishes invincible arguments against itself, and that we could never retain any conviction or assurance, on any subject, were not the sceptical reasonings so refined and subtile, that they are not able to counterpoise the more solid and more natural arguments, derived from the senses and experience. But it is evident, whenever our arguments lose this advantage, and run wide of common life, that the most refined scepticism comes to be upon a footing with them, and is able to oppose and counterbalance them. The one has no more weight than the other. The mind must remain in suspense between them; and it is that very suspense or balance, which is the triumph of scepticism.

Cleanthes: But I observe, says CLEANTHES, with regard to you, PHILO, and all speculative sceptics, that your doctrine and practice are as much at variance in the most abstruse points of theory as in the conduct of common life. Wherever evidence discovers itself, you adhere to it, notwithstanding your pretended scepticism; and I can observe too some of your sect to be as decisive as those, who make greater professions of certainty and assurance. In reality, would not a man be ridiculous, who pretended to reject NEWTON's[12] explication of the wonderful phenomenon of the rainbow, because that explication gives a minute anatomy of the rays of light; a subject, forsooth, too

[12] The *Opticks* of Sir Isaac Newton (1642–1727) appeared in 1704. It was far easier to understand than his *Philosophiae Naturalis Principia Mathematica* [Mathematical Principles of Natural Philosophy] of 1687, and much more widely read.

refined for human comprehension? And what would you say to one, who having nothing particular to object to the arguments of COPERNICUS[13] and GALILÆO[14] for the motion of the earth, should withhold his assent, on that general principle, That these subjects were too magnificent and remote to be explained by the narrow and fallacious reason of mankind?

There is indeed a kind of brutish and ignorant scepticism, as you well observed, which gives the vulgar a general prejudice against what they do not easily understand, and makes them reject every principle, which requires elaborate reasoning to prove and establish it. This species of scepticism is fatal to knowledge, not to religion; since we find, that those who make greatest profession of it, give often their assent, not only to the great truths of Theism, and natural theology, but even to the most absurd tenets, which a traditional superstition has recommended to them. They firmly believe in witches; though they will not believe nor attend to the most simple proposition of Euclid.[15] But the refined and philosophical sceptics fall into an inconsistence of an opposite nature. They push their researches into the most abstruse corners of science; and their assent attends them in every step, proportioned to the evidence which they meet with. They are even obliged to acknowledge that the most abstruse and remote objects are those, which are best explained by philosophy. Light is in reality anatomized: The true system of the heavenly bodies is discovered and ascertained. But the nourishment of bodies by food is still an inexplicable mystery: The

[13] Nicolaus Copernicus (1473–1543) was a Polish astronomer who developed a system of heliocentric (Sun-centered) planetary motion, in opposition to the long-established system developed by Ptolemy (second century CE) a Greek working in Alexandria, Egypt.

[14] Galileo Galilei (1566–1642) was the Italian mathematician, astronomer and physicist who founded modern mechanics and argued for a Copernican theory of planetary motion.

[15] Euclid, who flourished around 300 BCE, founded a school of mathematics in Alexandria, Egypt. His systematic treatise *The Elements of Geometry* was for over 2,000 years the pre-eminent textbook. Hume may be alluding here to Joseph Glanvill (1636–1680), who publicly adopted a position of scepticism, while also arguing at length for the reality of witchcraft.

cohesion of the parts of matter is still incomprehensible. These sceptics, therefore, are obliged, in every question, to consider each particular evidence apart, and proportion their assent to the precise degree of evidence, which occurs. This is their practice in all natural, mathematical, moral, and political science. And why not the same, I ask, in the theological and religious? Why must conclusions of this nature be alone rejected on the general presumption of the insufficiency of human reason, without any particular discussion of the evidence? Is not such an unequal conduct a plain proof of prejudice and passion?

Our senses, you say, are fallacious, our understanding erroneous, our ideas even of the most familiar objects, extension, duration, motion, full of absurdities and contradictions. You defy me to solve the difficulties, or reconcile the repugnancies,[16] which you discover in them. I have not capacity for so great an undertaking: I have not leisure for it: I perceive it to be superfluous. Your own conduct, in every circumstance, refutes your principles; and shows the firmest reliance on all the received maxims of science, morals, prudence, and behaviour.

I shall never assent to so harsh an opinion as that of a celebrated writer,[17] who says, that the sceptics are not a sect of philosophers: They are only a sect of liars. I may, however, affirm, (I hope without offence) that they are a sect of jesters or ralliers. But for my part, whenever I find myself disposed to mirth and amusement, I shall certainly chuse my entertainment of a less perplexing and abstruse nature. A comedy, a novel, or at most a history, seems a more natural recreation than such metaphysical subtlties and abstractions.

[16] Contradictions.

[17] Hume is referring to *La logique, ou l'art de penser* [Logic, or the Art of Thinking], more usually known nowadays as the *Port-Royal Logic*. It is credited to Antoine Arnauld (1612–94) and Pierre Nicole (1625–95), although Blaise Pascal (1623–62) also appears to have had some hand in the composition. (As well as being the founder of probability theory, Pascal is famous for his view that reason cannot stand alone, but requires the help of intuition.) The relevant sentence reads, in full: "So that Pyrrhonism is not a sect of people that are themselves convinced of what they teach, but a sect of liars."

In vain would the sceptic make a distinction between science and common life, or between one science and another. The arguments, employed in all, if just, are of a similar nature, and contain the same force and evidence. Or if there be any difference among them, the advantage lies entirely on the side of theology and natural religion. Many principles of mechanics are founded on very abstruse reasoning; yet no man, who has any pretensions to science, even no speculative sceptic, pretends to entertain the least doubt with regard to them. The COPERNICAN system contains the most surprising paradox, and the most contrary to our natural conceptions, to appearances, and to our very senses: yet even monks and inquisitors are now constrained to withdraw their opposition to it. And shall PHILO, a man of so liberal a genius, and extensive knowledge, entertain any general undistinguished scruples with regard to the religious hypothesis, which is founded on the simplest and most obvious arguments, and, unless it meets with artificial obstacles, has such easy access and admission into the mind of man?

And here we may observe, continued he, turning himself towards DEMEA, a pretty curious circumstance in the history of the sciences. After the union of philosophy with the popular religion, upon the first establishment of Christianity, nothing was more usual, among all religious teachers, than declamations against reason, against the senses, against every principle, derived merely from human research and enquiry. All the topics of the ancient Academics[18] were adopted by the Fathers;[19] and thence propagated for several ages in every school and pulpit throughout Christendom. The Reformers embraced the same principles of reasoning, or rather declamation; and all panegyrics on the excellency of faith were sure to be interlarded with some severe strokes of

[18] The Academy of Athens, in effect the first university, was established by Plato (c. 428–c. 348 BCE), in about 385 BCE. Hume here employs the term 'Academics' as a synonym for 'Sceptics', as he also does, for instance, in Section XII of his *Enquiry concerning Human Understanding*.

[19] The main Christian teachers and thinkers of the first centuries of our era. U.S. citizens might think of these men as Founding Fathers, not of their republic but of that religion.

satire against natural reason. A celebrated prelate too,[20] of the Romish communion, a man of the most extensive learning, who wrote a demonstration of Christianity, has also composed a treatise, which contains all the cavils of the boldest and most determined PYRRHONISM. LOCKE[21] seems to have been the first Christian, who ventured openly to assert, that *faith* was nothing but a species of *reason,* that religion was only a branch of philosophy, and that a chain of arguments, similar to that which established any truth in morals, politics, or physics, was always employed in discovering all the principles of theology, natural and revealed. The ill use, which BAYLE[22] and other libertines made of the philosophical scepticism of the fathers and first reformers, still farther propagated the judicious sentiment of MR. LOCKE: and it is now, in a manner, avowed, by all pretenders to reasoning and philosophy, that Atheist and Sceptic are almost synonymous. And as it is certain, that no man is in earnest, when he professes the latter principle; I would fain hope that there are as few, who seriously maintain the former.

Philo: Don't you remember, said PHILO, the excellent saying of LORD BACON[23] on this head?

Cleanthes: That a little philosophy, replied CLEANTHES, makes a man an Atheist: a great deal converts him to religion.

Philo: That is a very judicious remark too, said PHILO. But

[20] Pierre-Daniel Huet (1630–1721), Bishop of Afranches, who wrote *A Philosophical Treatise concerning the Weakness of Human Understanding* (1723), first published in English in 1725. This was itself an exercise of the 'machine of war' mentioned above.

[21] John Locke (1632–1704). This contention is to be found in *An Essay concerning Human Understanding,* IV. xvii.24; as well as, more fully developed, in *The Reasonableness of Christianity* (1695).

[22] Pierre Bayle (1647–1706) came from a French Protestant family, and so had to spend most of his working life in Dutch exile. His *Dictionnaire historique et critique* [Historical and Critical Dictionary], in some version, was in every gentleman's library throughout the eighteenth century. It is often credited with constituting the arsenal of the Enlightenment. The word 'libertines' here is a deliberately crude translation of the French 'libertins': those free of traditional religious belief will, it is suggested, be free of all moral inhibitions.

[23] Francis Bacon, first Lord Verulam (1561–1626), author of *Essays, The Advancement of Learning, Novum Organum,* and *New Atlantis.*

what I have in my eye is another passage, where, having mentioned DAVID's fool, who said in his heart there is no God, this great philosopher observes, that the Atheists nowadays have a double share of folly: for they are not contented to say in their hearts there is no God, but they also utter that impiety with their lips, and are thereby guilty of multiplied indiscretion and imprudence. Such people, though they were ever so much in earnest, cannot, methinks, be very formidable.

But though you should rank me in this class of fools, I cannot forbear communicating a remark, that occurs to me, from the history of the religious and irreligious scepticism, with which you have entertained us. It appears to me, that there are strong symptoms of priestcraft in the whole progress of this affair. During ignorant ages, such as those which followed the dissolution of the ancient schools, the priests perceived, that Atheism, Deism,[24] or heresy of any kind, could only proceed from the presumptuous questioning of received opinions, and from a belief, that human reason was equal to everything. Education had then a mighty influence over the minds of men, and was almost equal in force to those suggestions of the senses and common understanding, by which the most determined sceptic must allow himself to be governed. But at present, when the influence of education is much diminished, and men, from a more open commerce[25] of the world, have learned to compare the popular principles of different nations and ages, our sagacious divines have changed their whole system of philosophy, and talk the language of STOICS, PLATONISTS, and PERIPATETICS,[26] not that of

[24] The doctrine that belief in God can commend itself to the human mind by its own inherent reasonableness, without either being supported by appeals to alleged divine revelations or imposed by religious institutions. It is usually taken also to involve the belief that, after an original creation, God leaves the Universe to its own lawful devices, without any particular interventions. The most famous spokesperson was Voltaire (1694–1778).

[25] The sense of the word includes travel, communications, all kinds of dealings, not merely trade.

[26] Followers of Aristotle (384–322 BCE), who taught philosophy while walking about. The word means 'walking about' and is now most often used to mean 'itinerant'.

PYRRHONIANS and ACADEMICS. If we distrust human reason, we have now no other principle to lead us into religion. Thus, sceptics in one age, dogmatists in another; whichever system best suits the purpose of these reverend gentlemen, in giving them an ascendancy over mankind, they are sure to make it their favourite principle, and established tenet.

Cleanthes: It is very natural, said CLEANTHES, for men to embrace those principles, by which they find they can best defend their doctrines; nor need we have any recourse to priestcraft to account for so reasonable an expedient. And surely nothing can afford a stronger presumption, that any set of principles are true, and ought to be embraced, than to observe, that they tend to the confirmation of true religion, and serve to confound the cavils of Atheists, Libertines, and Freethinkers of all denominations.

PART II

Demea: I must own, CLEANTHES, said DEMEA, that nothing can more surprise me, than the light in which you have, all along, put this argument. By the whole tenor of your discourse, one would imagine that you were maintaining the Being of a God, against the cavils of Atheists and Infidels; and were necessitated to become a champion for that fundamental principle of all religion. But this, I hope, is not by any means a question among us. No man; no man, at least, of common sense, I am persuaded, ever entertained a serious doubt with regard to a truth, so certain and self-evident. The question is not concerning the BEING, but the NATURE of GOD. This, I affirm, from the infirmities of human understanding, to be altogether incomprehensible and unknown to us. The essence of that supreme mind, his attributes, the manner of his existence, the very nature of his duration; these and every particular, which regards so divine a Being, are mysterious to men. Finite, weak, and blind creatures, we ought to humble ourselves in his august presence, and, conscious of our frailties, adore in silence his infinite perfections, which eye hath not seen, ear hath not heard, neither hath it entered into the heart of man to conceive. They are covered in a deep cloud from human curiosity: It is profaneness to attempt penetrating through these sacred obscurities: And next to the impiety of denying his existence, is the temerity of prying into his nature and essence, decrees and attributes.

But lest you should think, that my *piety* has here got the better of my *philosophy,* I shall support my opinion, if it needs any support, by a very great authority. I might cite all the divines almost, from the foundation of Christianity, who have ever treated of this or any other theological subject: But I shall confine myself, at present, to one equally celebrated for piety and philosophy. It is Father MALEBRANCHE,[27] who, I remember, thus expresses himself. 'One ought not so much (says he) to call God a spirit, in order to express positively what he is, as in order to signify that he is not matter. He is a Being infinitely

[27] The Oratorian Father Nicolas Malebranche (1638–1715), author of *De la Recherche de la Vérité* (On The Search for Truth). The passage quoted occurs in Book III, Chapter 9.

perfect: Of this we cannot doubt. But in the same manner as
we ought not to imagine, even supposing him corporeal, that he
is clothed with a human body, as the ANTHROPOMORPHITES
asserted, under colour that that figure was the most perfect of
any;[28] so neither ought we to imagine, that the Spirit of God
has human ideas, or bears any resemblance to our spirit;
under colour that we know nothing more perfect than a human
mind. We ought rather to believe, that as he comprehends the
perfections of matter without being material he com-
prehends also the perfections of created spirits, without being
spirit, in the manner we conceive spirit: That his true name is,
He that is, or, in other words, Being without restriction, All
Being, the Being infinite and universal.'

Philo: After so great an authority, DEMEA, replied PHILO,
as that which you have produced, and a thousand more, which
you might produce, it would appear ridiculous in me to add my
sentiment, or express my approbation of your doctrine. But
surely, where reasonable men treat these subjects, the ques-
tion can never be concerning the *Being,* but only the *Nature* of
the Deity.[29] The former truth, as you well observe, is unques-
tionable and self-evident. Nothing exists without a cause; and
the original cause of this universe (whatever it be) we call GOD;
and piously ascribe to him every species of perfection. Whoever
scruples[30] this fundamental truth, deserves every punishment
which can be inflicted among philosophers, to wit, the greatest
ridicule, contempt and disapprobation. But as all perfection is

[28] 'Under colour that' means on the grounds that. The term
'anthropomorphite' is applied to members both of a sect which arose in
Egypt in the fourth century CE and of a party in the Christian Church in
the tenth.

[29] It is surely significant that Hume never scripts either Demea or
Cleanthes to object that, until and unless some intelligible
characteristics are stipulated to be essential to God, this universal
agreement is entirely empty of any substantial content. No one prepared
to apply the word 'God' to anything at all—whether principle, system,
substance, or whatever else—can properly be charged with the offence of
atheism; an offence often punished with penalties much more severe
than those which alone Hume allows to be licit "among philosophers".

[30] Has reservations about.

entirely relative, we ought never to imagine that we compre-
hend the attributes of this divine Being, or to suppose, that his
perfections have any analogy or likeness to the perfections of a
human creature. Wisdom, Thought, Design, Knowledge; these
we justly ascribe to him; because these words are honourable
among men, and we have no other language or other concep-
tions, by which we can express our adoration of him. But let us
beware, lest we think, that our ideas any wise correspond to
his perfections, or that his attributes have any resemblance to
these qualities among men. He is infinitely superior to our
limited view and comprehension; and is more the object of
worship in the temple, than of disputation in the schools.

In reality, CLEANTHES, continued he, there is no need of
having recourse to that affected scepticism, so displeasing to
you, in order to come at this determination. Our ideas reach no
farther than our experience: We have no experience of divine
attributes and operations: I need not conclude my syllogism:
You can draw the inference yourself. And it is a pleasure to me
(and I hope to you too) that just reasoning and sound piety
here concur in the same conclusion, and both of them establish
the adorably mysterious and incomprehensible nature of the
Supreme Being.

Cleanthes: Not to lose any time in circumlocutions, said
CLEANTHES, addressing himself to DEMEA, much less in reply-
ing to the pious declamations of PHILO; I shall briefly explain
how I conceive this matter. Look round the world: contemplate
the whole and every part of it: You will find it to be nothing but
one great machine, subdivided into an infinite number of
lesser machines, which again admit of subdivisions, to a
degree beyond what human senses and faculties can trace and
explain. All these various machines, and even their most
minute parts, are adjusted to each other with an accuracy,
which ravishes into admiration all men who have ever contem-
plated them. The curious adapting of means to ends, through-
out all nature, resembles exactly, though it much exceeds, the
productions of human contrivance; of human designs, thought,
wisdom, and intelligence. Since therefore the effects resemble
each other, we are led to infer, by all the rules of analogy, that
the causes also resemble; and that the Author of Nature is
somewhat similar to the mind of man; though possessed of

much larger faculties, proportioned to the grandeur of the work, which he has executed. By this argument *a posteriori*,[31] and by this argument alone, do we prove at once the existence of a Deity, and his similarity to human mind and intelligence.

Demea: I shall be so free, CLEANTHES, said DEMEA, as to tell you, that from the beginning, I could not approve of your conclusion concerning the similarity of the Deity to men; still less can I approve of the mediums,[32] by which you endeavour to establish it. What! No demonstration of the Being of a God! No abstract arguments! No proofs *a priori!* Are these, which have hitherto been so much insisted on by philosophers, all fallacy, all sophism? Can we reach no farther in this subject than experience and probability? I will not say, that this is betraying the cause of a Deity: But surely, by this affected candor, you give advantage to Atheists, which they never could obtain, by the mere dint of argument and reasoning.

Philo: What I chiefly scruple in this subject, said PHILO, is not so much that all religious arguments are by CLEANTHES reduced to experience, as that they appear not to be even the most certain and irrefragable[33] of that inferior kind. That a stone will fall, that fire will burn, that the earth has solidity, we have observed a thousand and a thousand times; and when any new instance of this nature is presented, we draw without hesitation the accustomed inference. The exact similarity of the cases gives us a perfect assurance of a similar event; and a stronger evidence is never desired nor sought after. But wherever you depart, in the least, from the similarity of the cases, you diminish the evidence proportionately; and may at last bring it to a very weak *analogy,* which is confessedly liable to error and uncertainty. After having experienced the circula-

[31] *A posteriori* and its opposite *a priori* are Latin for 'from afterwards' and 'from before'. An *a priori* proposition is one which can be known to be true, or false, without reference to experience, except in so far as experience is necessary for understanding its terms. An *a posteriori* proposition can be known to be true, or false, only by reference to how, as a matter of contingent fact, things have been, are, or will be.

[32] A medium here is the second proposition in a syllogistic argument. In the traditional example, 'All men are mortal, and Socrates is a man, therefore Socrates is mortal', the medium is 'Socrates is a man'.

[33] Indisputable.

tion of the blood in human creatures, we make no doubt that it takes place in Titius and Mœvius:[34] but from its circulation in frogs and fishes, it is only a presumption, though a strong one, from analogy, that it takes place in men and other animals. The analogical reasoning is much weaker, when we infer the circulation of the sap in vegetables from our experience, that the blood circulates in animals; and those, who hastily followed that imperfect analogy, are found, by more accurate experiments, to have been mistaken.

If we see a house, CLEANTHES, we conclude, with the greatest certainty, that it had an architect or builder; because this is precisely that species of effect, which we have experienced to proceed from that species of cause. But surely you will not affirm, that the universe bears such a resemblance to a house, that we can with the same certainty infer a similar cause, or that the analogy is here entire and perfect. The dissimilitude is so striking, that the utmost you can here pretend to is a guess, a conjecture, a presumption concerning a similar cause; and how that pretension will be received in the world, I leave you to consider.

Cleanthes: It would surely be very ill received, replied CLEANTHES; and I should be deservedly blamed and detested, did I allow, that the proofs of a Deity amounted to no more than a guess or conjecture. But is the whole adjustment of means to ends in a house and in the universe so slight a resemblance? The œconomy of final causes? The order, proportion, and arrangement of every part? Steps of a stair are plainly contrived, that human legs may use them in mounting; and this inference is certain and infallible. Human legs are also contrived for walking and mounting; and this inference, I allow, is not altogether so certain, because of the dissimilarity which you remark; but does it, therefore, deserve the name only of presumption or conjecture?

Demea: Good God! cried DEMEA, interrupting him, where are we? Zealous defenders of religion allow that the proofs of a Deity fall short of perfect evidence! And you, PHILO, on whose assistance I depended in proving the adorable mysteriousness

[34] Like 'John Doe and Richard Roe', names for imaginary representative persons.

of the Divine Nature, do you assent to all these extravagant opinions of CLEANTHES? For what other name can I give them? Or why spare my censure, when such principles are advanced, supported by such an authority, before so young a man as PAMPHILUS?

Philo: You seem not to apprehend, replied PHILO, that I argue with CLEANTHES in his own way; and by showing him the dangerous consequences of his tenets, hope at last to reduce him to our opinion. But what sticks most with you, I observe, is the representation which CLEANTHES has made of the argument *a posteriori;* and finding, that that argument is likely to escape your hold and vanish into air, you think it so disguised, that you can scarcely believe it to be set in its true light. Now, however much I may dissent, in other respects, from the dangerous principles of CLEANTHES, I must allow, that he has fairly represented that argument; and I shall endeavour so to state the matter to you, that you will entertain no farther scruples with regard to it.

Were a man to abstract from every thing which he knows or has seen, he would be altogether incapable, merely from his own ideas, to determine what kind of scene the universe must be, or to give the preference to one state or situation of things above another. For as nothing which he clearly conceives, could be esteemed impossible or implying a contradiction, every chimera of his fancy would be upon an equal footing; nor could he assign any just reason why he adheres to one idea or system, and rejects the others, which are equally possible.

Again; after he opens his eyes, and contemplates the world, as it really is, it would be impossible for him, at first, to assign the cause of any one event; much less, of the whole of things or of the universe. He might set his Fancy a rambling; and she might bring him in an infinite variety of reports and representations. These would all be possible; but being all equally possible, he would never, of himself, give a satisfactory account for his preferring one of them to the rest. Experience alone can point out to him the true cause of any phenomenon.

Now, according to this method of reasoning, DEMEA, it follows (and is, indeed, tacitly allowed by CLEANTHES himself) that order, arrangement, or the adjustment of final causes is not, of itself, any proof of design; but only so far as it has been experienced to proceed from that principle. For ought we can

know *a priori,* matter may contain the source or spring of order originally, within itself, as well as mind does; and there is no more difficulty in conceiving, that the several elements, from an internal unknown cause, may fall into the most exquisite arrangement, than to conceive that their ideas, in the great, universal mind, from a like internal, unknown cause, fall into that arrangement. The equal possibility of both these suppositions is allowed. But by experience we find, (according to CLEANTHES) that there is a difference between them. Throw several pieces of steel together, without shape or form; they will never arrange themselves so as to compose a watch: Stone, and mortar, and wood, without an architect, never erect a house. But the ideas in a human mind, we see, by an unknown, inexplicable œconomy, arrange themselves so as to form the plan of a watch or house. Experience, therefore, proves, that there is an original principle of order in mind, not in matter. From similar effects we infer similar causes. The adjustment of means to ends is alike in the universe, as in a machine of human contrivance. The causes, therefore, must be resembling.

I was from the beginning scandalised, I must own, with this resemblance, which is asserted, between the Deity and human creatures; and must conceive it to imply such a degradation of the Supreme Being as no sound Theist could endure. With your assistance, therefore, DEMEA, I shall endeavour to defend what you just called the adorable mysteriousness of the Divine Nature, and shall refute this reasoning of CLEANTHES, provided he allows that I have made a fair representation of it.

When CLEANTHES had assented, PHILO, after a short pause, proceeded in the following manner.

That all inferences, CLEANTHES, concerning fact, are founded on experience, and that all experimental reasonings are founded on the supposition, that similar causes prove similar effects, and similar effects similar causes; I shall not, at present, much dispute with you. But observe, I entreat you, with what extreme caution all just reasoners proceed in the transferring of experiments to similar cases. Unless the cases be exactly similar, they repose no perfect confidence in applying their past observation to any particular phenomenon. Every alteration of circumstances occasions a doubt concern-

ing the event; and it requires new experiments to prove certainly that the new circumstances are of no moment or importance. A change in bulk, situation, arrangement, age, disposition of the air, or surrounding bodies; any of these particulars may be attended with the most unexpected consequences: And unless the objects be quite familiar to us, it is the highest temerity to expect with assurance, after any of these changes, an event similar to that which before fell under our observation. The slow and deliberate steps of philosophers, here, if any where, are distinguished from the precipitate march of the vulgar, who, hurried on by the smallest similitudes, are incapable of all discernment or consideration.

But can you think, CLEANTHES, that your usual phlegm and philosophy have been preserved in so wide a step as you have taken, when you compared to the universe houses, ships, furniture, machines; and from their similarity in some circumstances inferred a similarity in their causes? Thought, design, intelligence, such as we discover in men and other animals, is no more than one of the springs and principles of the universe, as well as heat or cold, attraction or repulsion, and a hundred others, which fall under daily observation. It is an active cause, by which some particular parts of nature, we find, produce alterations on other parts. But can a conclusion, with any propriety, be transferred from parts to the whole? Does not the great disproportion bar all comparison and inference? From observing the growth of a hair, can we learn any thing concerning the generation of a man? Would the manner of a leaf's blowing, even though perfectly known, afford us any instruction concerning the vegetation of a tree?

But allowing that we were to take the *operations* of one part of nature upon another for the foundation of our judgement concerning the *origin* of the whole (which never can be admitted) yet why select so minute, so weak, so bounded a principle as the reason and design of animals is found to be upon this planet? What peculiar privilege has this little agitation of the brain which we call *thought,* that we must thus make it the model of the whole universe? Our partiality in our own favour does indeed present it on all occasions; but sound philosophy ought carefully to guard against so natural an illusion.

So far from admitting, continued PHILO, that the opera-

tions of a part can afford us any just conclusion concerning the origin of the whole, I will not allow any one part to form a rule for another part, if the latter be very remote from the former. Is there any reasonable ground to conclude, that the inhabitants of other planets possess thought, intelligence, reason, or any thing similar to these faculties in men? When Nature has so extremely diversified her manner of operation in this small globe; can we imagine, that she incessantly copies herself throughout so immense a universe? And if thought, as we may well suppose, be confined merely to this narrow corner, and has even there so limited a sphere of action; with what propriety can we assign it for the original cause of all things? The narrow views of a peasant, who makes his domestic œconomy the rule for the government of kingdoms, is in comparison a pardonable sophism.

But were we ever so much assured, that a thought and reason, resembling the human, were to be found throughout the whole universe, and were its activity elsewhere vastly greater and more commanding than it appears in this globe; yet I cannot see, why the operations of a world, constituted, arranged, adjusted, can with any propriety be extended to a world, which is in its embryo-state, and is advancing towards that constitution and arrangement. By observation, we know somewhat of the œconomy,[35] action, and nourishment of a finished animal; but we must transfer with great caution that observation to the growth of a fœtus in the womb, and still more, in the formation of an animalcule in the loins of its male parent. Nature, we find, even from our limited experience, possesses an infinite number of springs and principles, which incessantly discover themselves on every change of her position and situation. And what new and unknown principles would actuate her in so new and unknown a situation as that of the formation of a universe, we cannot, without the utmost temerity, pretend to determine.

A very small part of this great system, during a very short time, is very imperfectly discovered to us: and do we then pronounce decisively concerning the origin of the whole?

[35] Economy: This word, which etymologically means the management of a household, is here equivalent to 'organization'.

Admirable conclusion! Stone, wood, brick, iron, brass, have not, at this time, in this minute globe of earth, an order or arrangement without human art and contrivance: therefore the universe could not originally attain its order and arrangement, without something similar to human art. But is a part of nature a rule for another part very wide of the former? Is it a rule for the whole? Is a very small part a rule for the universe? Is nature in one situation a certain rule for nature in another situation, vastly different from the former?

And can you blame me, CLEANTHES, if I here imitate the prudent reserve of SIMONIDES,[36] who, according to the noted story, being asked by HIERO, *What God was?* desired a day to think of it, and then two days more; and after that manner continually prolonged the term, without ever bringing in his definition or description? Could you even blame me, if I had answered at first *that I did not know,* and was sensible that this subject lay vastly beyond the reach of my faculties? You might cry out sceptic and rallier as much as you pleased: but having found in so many other subjects much more familiar, the imperfections and even contradictions of human reason, I never should expect any success from its feeble conjectures in a subject so sublime and so remote from the sphere of our observation. When two *species* of objects have always been observed to be conjoined together, I can *infer,* by custom, the existence of one wherever I *see* the existence of the other: and this I call an argument from experience. But how this argument can have place, where the objects, as in the present case, are single, individual, without parallel, or specific resemblance, may be difficult to explain. And will any man tell me with a serious countenance, that an orderly universe must arise from some thought and art, like the human, because we have experience of it? To ascertain this reasoning, it were requisite, that we had experience of the origin of worlds; and it is not sufficient, surely, that we have seen ships and cities arise from human art and contrivance. . . .

Pamphilus: PHILO was proceeding in this vehement

[36] This story is drawn from Cicero's *De Natura Deorum* [On the Nature of the Gods] I.xxii. Simonides of Ceos (c. 556–488 BCE) was a lyric poet in residence at the court of Hiero, a non-hereditary despotic ruler of Syracuse.

manner, somewhat between jest and earnest, as it appeared to me, when he observed some signs of impatience in CLEANTHES, and then immediately stopped short.

Cleanthes: What I had to suggest, said CLEANTHES, is only that you would not abuse terms, or make use of popular expressions to subvert philosophical reasonings. You know that the vulgar often distinguish reason from experience, even where the question relates only to matter of fact and existence; though it is found, where that *reason* is properly analyzed, that it is nothing but a species of experience. To prove by experience the origin of the universe from mind is not more contrary to common speech than to prove the motion of the earth from the same principle. And a caviller might raise all the same objections to the COPERNICAN system, which you have urged against my reasonings. Have you other earths, might he say, which you have seen to move? Have. . . .

Philo: Yes! cried PHILO, interrupting him, we have other earths. Is not the moon another earth, which we see to turn round its centre? Is not Venus another earth, where we observe the same phenomenon? Are not the revolutions of the sun also a confirmation, from analogy, of the same theory? All the planets, are they not earths, which revolve about the sun? Are not the satellites moons, which move round Jupiter and Saturn, and along with these primary planets, round the sun? These analogies and resemblances, with others, which I have not mentioned, are the sole proofs of the COPERNICAN system: and to you it belongs to consider, whether you have any analogies of the same kind to support your theory.

In reality, CLEANTHES, continued he, the modern system of astronomy is now so much received by all enquirers, and has become so essential a part even of our earliest education, that we are not commonly very scrupulous in examining the reasons upon which it is founded. It is now become a matter of mere curiosity to study the first writers on that subject, who had the full force of prejudice to encounter, and were obliged to turn their arguments on every side, in order to render them popular and convincing. But if we peruse GALILÆO's famous Dialogues concerning the system of the world,[37] we shall find,

[37] *Dialogues concerning the Two Chief Systems of the World* (1632); these being the Ptolemaic and the Copernican.

that that great genius, one of the sublimest that ever existed, first bent all his endeavours to prove that there was no foundation for the distinction commonly made between elementary and celestial substances. The schools, proceeding from the illusions of sense, had carried this distinction very far; and had established the latter substances to be ingenerable, incorruptible, unalterable, impassible;[38] and had assigned all the opposite qualities to the former. But GALILÆO, beginning with the moon, proved its similarity in every particular to the earth; its convex figure, its natural darkness when not illuminated, its density, its distinction into solid and liquid, the variations of its phases, the mutual illuminations of the earth and moon, their mutual eclipses, the inequalities of the lunar surface, &c. After many instances of this kind, with regard to all the planets, men plainly saw, that these bodies became proper objects of experience; and that the similarity of their nature enabled us to extend the same arguments and phenomena from one to the other.

In this cautious proceeding of the astronomers, you may read your own condemnation, CLEANTHES; or rather may see, that the subject in which you are engaged exceeds all human reason and enquiry. Can you pretend to show any such similarity between the fabric of a house, and the generation of a universe? Have you ever seen nature in any such situation as resembles the first arrangement of the elements? Have worlds ever been formed under your eye? and have you had leisure to observe the whole progress of the phenomenon, from the first appearance of order to its final consummation? If you have, then cite your experience, and deliver your theory.

[38] Here equivalent to incorruptible, but elsewhere meaning immune to suffering.

PART III

Cleanthes: How the most absurd argument, replied CLEAN-
THES, in the hands of a man of ingenuity and invention, may
acquire an air of probability! Are you not aware, PHILO, that it
became necessary for COPERNICUS and his first disciples to
prove the similarity of the terrestrial and celestial matter;
because several philosophers, blinded by old systems, and
supported by some sensible appearances, had denied that
similarity? But that it is by no means necessary, that Theists
should prove the similarity of the works of Nature to those of
Art, because this similarity is self-evident and undeniable?
The same matter, a like form: what more is requisite to show
an analogy between their causes, and to ascertain the origin of
all things from a divine purpose and intention? Your objec-
tions, I must freely tell you, are no better than the abstruse
cavils of those philosophers who denied motion,[39] and ought to
be refuted in the same manner, by illustrations, examples, and
instances, rather than by serious argument and philosophy.

Suppose, therefore, that an articulate voice were heard in
the clouds, much louder and more melodious than any which
human art could ever reach: Suppose, that this voice were
extended in the same instant over all nations, and spoke to
each nation in its own language and dialect: Suppose, that the
words delivered not only contain a just sense and meaning, but
convey some instruction altogether worthy of a benevolent
being, superior to mankind: could you possibly hesitate a
moment concerning the cause of this voice? and must you not
instantly ascribe it to some design or purpose? Yet I cannot see
but all the same objections (if they merit that appellation)
which lie against the system of Theism, may also be produced
against this inference.

Might you not say, that all conclusions concerning fact
were founded on experience: that when we hear an articulate
voice in the dark, and thence infer a man, it is only the
resemblance of the effects, which leads us to conclude that
there is a like resemblance in the cause: but that this extraor-

[39] The paradoxes of Zeno of Elea (born 490 BCE) were presented as
reductions to absurdity of both plurality and motion, and deployed to
discredit opponents of Parmenides of Elea (born 510 BCE).

dinary voice, by its loudness, extent, and flexibility to all languages, bears so little analogy to any human voice, that we have no reason to suppose any analogy in their causes: and consequently, that a rational, wise, coherent speech proceeded, you know not whence, from some accidental whistling of the winds, not from any divine reason or intelligence? You see clearly your own objections in these cavils; and I hope too, you see clearly, that they cannot possibly have more force in the one case than in the other.

But to bring the case still nearer the present one of the universe, I shall make two suppositions, which imply not any absurdity or impossibility. Suppose, that there is a natural, universal, invariable language, common to every individual of human race, and that books are natural productions, which perpetuate themselves in the same manner with animals and vegetables, by descent and propagation. Several expressions of our passions contain a universal language: all brute animals have a natural speech, which, however, limited, is very intelligible to their own species. And as there are infinitely fewer parts and less contrivance in the finest composition of eloquence, than in the coarsest organized body, the propagation of an *Iliad* or *Æneid*[40] is an easier supposition than that of any plant or animal.

Suppose, therefore, that you enter into your library, thus peopled by natural volumes, containing the most refined reason and most exquisite beauty: could you possibly open one of them, and doubt, that its original cause bore the strongest analogy to mind and intelligence? When it reasons and discourses; when it expostulates, argues, and enforces its views and topics; when it applies sometimes to the pure intellect, sometimes to the affections; when it collects, disposes, and adorns every consideration suited to the subject: could you persist in asserting, that all this, at the bottom, had really no meaning, and that the first formation of this volume in the loins of its original parent proceeded not from thought and

[40] *The Iliad,* in Greek, is one of the two epic poems usually attributed to Homer, an otherwise unidentifiable individual; although everything about their composition is in fact, conjectural. *The Aeneid,* in Latin, is an epic poem written by Virgil (70–19 BCE).

design? Your obstinacy, I know, reaches not that degree of firmness: even your sceptical play and wantonness would be abashed at so glaring an absurdity.

But if there be any difference, PHILO, between this supposed case and the real one of the universe, it is all to the advantage of the latter. The anatomy of an animal affords many stronger instances of design than the perusal of LIVY or TACITUS:[41] and any objection which you start in the former case, by carrying me back to so unusual and extraordinary a scene as the first formation of worlds, the same objection has place on the supposition of our vegetating library. Choose, then, your party, PHILO, without ambiguity or evasion; assert either that a rational volume is no proof of a rational cause, or admit of a similar cause to all the works of nature.

Let me here observe too, continued CLEANTHES, that this religious argument, instead of being weakened by that scepticism, so much affected by you, rather acquires force from it, and becomes more firm and undisputed. To exclude all argument or reasoning of every kind is either affectation or madness. The declared profession of every reasonable sceptic is only to reject abstruse, remote, and refined arguments; to adhere to common sense and the plain instincts of nature; and to assent, wherever any reasons strike him with so full a force, that he cannot, without the greatest violence, prevent it. Now the arguments for Natural Religion are plainly of this kind; and nothing but the most perverse, obstinate metaphysics can reject them. Consider, anatomize the eye; survey its structure and contrivance; and tell me, from your own feeling, if the idea of a contriver does not immediately flow in upon you with a force like that of sensation. The most obvious conclusion surely is in favour of design; and it requires time, reflection, and study, to summon up those frivolous, though abstruse objections, which can support Infidelity. Who can behold the male and female of each species, the correspondence of their parts and instincts, their passions and whole course of life before and after generation, but must be sensible, that the

[41] Livy (Titus Livius 59 BCE–17 CE) and Tacitus (c. 55–c. 120 CE) were both Roman historians, writing in Latin.

propagation of the species is intended by Nature? Millions and millions of such instances present themselves through every part of the universe; and no language can convey a more intelligible, irresistible meaning, than the curious adjustment of final causes. To what degree, therefore, of blind dogmatism must one have attained, to reject such natural and such convincing arguments?

Some beauties in writing we may meet with, which seem contrary to rules, and which gain the affections, and animate the imagination, in opposition to all the precepts of criticism, and to the authority of the established masters of art. And if the argument for Theism be, as you pretend, contradictory to the principles of logic; its universal, its irresistible influence proves clearly, that there may be arguments of a like irregular nature. Whatever cavils may be urged; an orderly world, as well as a coherent, articulate speech, will still be received as an incontestable proof of design and intention.

It sometimes happens, I own, that the religious arguments have not their due influence on an ignorant savage and barbarian; not because they are obscure and difficult, but because he never asks himself any question with regard to them. Whence arises the curious structure of an animal? From the copulation of its parents. And these whence? From *their* parents? A few removes set the objects at such a distance, that to him they are lost in darkness and confusion; nor is he actuated by any curiosity to trace them farther. But this is neither dogmatism nor scepticism, but stupidity; a state of mind very different from your sifting, inquisitive disposition, my ingenious friend. You can trace causes from effects: You can compare the most distant and remote objects: and your greatest errors proceed not from barrenness of thought and invention, but from too luxuriant a fertility, which suppresses your natural good sense, by a profusion of unnecessary scruples and objections.

Pamphilus: Here I could observe, HERMIPPUS, that PHILO was a little embarrassed and confounded: But while he hesitated in delivering an answer, luckily for him, DEMEA broke in upon the discourse, and saved his countenance.

Demea: Your instance, CLEANTHES, said he, drawn from books and language, being familiar, has, I confess, so much more force on that account; but is there not some danger too in

this very circumstance; and may it not render us presumptu-
ous, by making us imagine we comprehend the Deity, and have
some adequate idea of his nature and attributes? When I read
a volume, I enter into the mind and intention of the author: I
become him, in a manner, for the instant; and have an
immediate feeling and conception of those ideas which re-
volved in his imagination while employed in that composition.
But so near an approach we never surely can make to the
Deity. His ways are not our ways. His attributes are perfect,
but incomprehensible. And this volume of Nature contains a
great and inexplicable riddle, more than any intelligible dis-
course or reasoning.

The ancient PLATONISTS, you know, were the most reli-
gious and devout of all the PAGAN philosophers: yet many of
them, particularly PLOTINUS,[42] expressly declare, that intellect
or understanding is not to be ascribed to the Deity, and that
our most perfect worship of him consists, not in acts of
veneration, reverence, gratitude or love; but in a certain
mysterious self-annihilation or total extinction of all our
faculties. These ideas are, perhaps, too far stretched; but still
it must be acknowledged, that, by representing the Deity as so
intelligible, and comprehensible, and so similar to a human
mind, we are guilty of the grossest and most narrow partiality,
and make ourselves the model of the whole universe.

All the *sentiments* of the human mind, gratitude, resent-
ment, love, friendship, approbation, blame, pity, emulation,
envy, have a plain reference to the state and situation of man,
and are calculated for preserving the existence, and promoting
the activity of such a being in such circumstances. It seems
therefore unreasonable to transfer such sentiments to a su-
preme existence, or to suppose him actuated by them; and the
phenomena, besides, of the universe will not support us in
such a theory. All our *ideas,* derived from the senses are
confusedly false and illusive; and cannot, therefore, be sup-
posed to have place in a supreme intelligence: And as the ideas
of internal sentiment, added to those of the external senses,

[42] Plotinus (c. 205–270 CE) was the founder of what came to be called
Neo-Platonism. His wide-ranging works were posthumously arranged by
his disciple Porphyry into six "sets of nine", the *Enneads.*

compose the whole furniture of human understanding, we may conclude, that none of the *materials* of thought are in any respect similar in the human and in the divine intelligence. Now, as to the *manner* of thinking; how can we make any comparison between them, or suppose them anywise resembling? Our thought is fluctuating, uncertain, fleeting, successive, and compounded; and were we to remove these circumstances, we absolutely annihilate its essence, and it would, in such a case, be an abuse of terms to apply to it the name of thought or reason. At least, if it appear more pious and respectful (as it really is) still to retain these terms, when we mention the Supreme Being, we ought to acknowledge, that their meaning, in that case, is totally incomprehensible; and that the infirmities of our nature do not permit us to reach any ideas, which in the least correspond to the ineffable sublimity of the divine attributes.

PART IV

Cleanthes: It seems strange to me, said CLEANTHES, that you, DEMEA, who are so sincere in the cause of religion, should still maintain the mysterious, incomprehensible nature of the Deity, and should insist so strenuously, that he has no manner of likeness or resemblance to human creatures. The Deity, I can readily allow, possesses many powers and attributes, of which we can have no comprehension: But if our ideas, so far as they go, be not just and adequate, and correspondent to his real nature, I know not what there is in this subject worth insisting on. Is the name, without any meaning, of such mighty importance? Or how do you MYSTICS, who maintain the absolute incomprehensibility of the Deity, differ from Sceptics or Atheists, who assert, that the first cause of all is unknown and unintelligible?[43] Their temerity must be very great, if, after rejecting the production by a mind; I mean, a mind, resembling the human (for I know of no other) they pretend to assign, with certainty, any other specific, intelligible cause: And their conscience must be very scrupulous indeed, if they refuse to call the universal, unknown cause a God or Deity; and to bestow on him as many sublime eulogies and unmeaning epithets, as you shall please to require of them.

Demea: Who could imagine, replied DEMEA, that CLEANTHES, the calm, philosophical CLEANTHES, would attempt to refute his antagonists, by affixing a nickname to them; and like the common bigots and inquisitors of the age, have recourse to invective and declamation, instead of reasoning? Or does he not perceive, that these topics are easily retorted, and that ANTHROPOMORPHITE[44] is an appellation as invidious, and implies as dangerous consequences, as the epithet of MYSTIC, with which he has honoured us? In reality, CLEANTHES, consider what it is you assert, when you represent the

[43] Theists often claim that God is beyond our poor human understanding. Hume is using Cleanthes to suggest that, if and to the extent that this is so, we simply lack knowledge of God. A "mystic" who argued that God was *entirely* beyond human understanding would thus be taking a position very like that of the "sceptic or atheist".

[44] Anthropomorphism is ascribing human qualities to something— usually mistakenly, as to a natural process, an animal, or God.

Deity as similar to a human mind and understanding. What is the soul of man? A composition of various faculties, passions, sentiments, ideas; united, indeed, into one self or person, but still distinct from each other. When it reasons, the ideas, which are the parts of its discourse, arrange themselves in a certain form or order; which is not preserved entire for a moment, but immediately gives place to another arrangement. New opinions, new passions, new affections, new feelings arise, which continually diversify the mental scene, and produce in it the greatest variety, and most rapid succession imaginable. How is this compatible, with that perfect immutability and simplicity, which all true Theists ascribe to the Deity? By the same act, say they, he sees past, present, and future: His love and His hatred, his mercy and his justice, are one individual operation: He is entire in every point of space, and complete in every instant of duration. No succession, no change, no acquisition, no diminution. What he is implies not in it any shadow of distinction or diversity. And what he is, this moment, he ever has been, and ever will be, without any new judgement, sentiment, or operation. He stands fixed in one simple, perfect state; nor can you ever say, with any propriety, that this act of his is different from that other, or that this judgement or idea has been lately formed, and will give place, by succession, to any different judgment or idea.

Cleanthes: I can readily allow, said CLEANTHES, that those who maintain the perfect simplicity of the Supreme Being, to the extent in which you have explained it, are complete MYSTICS, and chargeable with all the consequences which I have drawn from their opinion. They are, in a word, ATHEISTS, without knowing it. For though it be allowed that the Deity possesses attributes, of which we have no comprehension; yet ought we never to ascribe to him any attributes, which are absolutely incompatible with that intelligent nature, essential to him. A mind, whose acts and sentiments and ideas are not distinct and successive; one, that is wholly simple, and totally immutable; is a mind, which has no thought, no reason, no will, no sentiment, no love, no hatred; or in a word, is no mind at all. It is an abuse of terms to give it that appellation; and we may as well speak of limited extension without figure, or of number without composition.

Philo: Pray consider, said PHILO, whom you are at present

inveighing against. You are honouring with the appellation of *Atheist* all the sound, orthodox divines almost, who have treated of this subject; and you will, at last, be, yourself, found, according to your reckoning, the only sound Theist in the world. But if idolaters be Atheists, as, I think, may justly be asserted, and Christian Theologians the same; what becomes of the argument, so much celebrated, derived from the universal consent of mankind?

But because I know you are not much swayed by names and authorities, I shall endeavour to show you, a little more distinctly, the inconveniences of that Anthropomorphism, which you have embraced; and shall prove, that there is no ground to suppose a plan of the world to be formed in the divine mind, consisting of distinct ideas, differently arranged; in the same manner as an architect forms in his head the plan of a house which he intends to execute.

It is not easy, I own, to see what is gained by this supposition, whether we judge of the matter by *Reason* or by *Experience*. We are still obliged to mount higher, in order to find the cause of this cause, which you had assigned as satisfactory and conclusive.

If *Reason* (I mean abstract reason, derived from inquiries *a priori*) be not alike mute with regard to all questions concerning cause and effect; this sentence at least it will venture to pronounce, That a mental world, or universe of ideas, requires a cause as much as does a material world, or universe of objects; and if similar in its arrangement must require a similar cause. For what is there in this subject, which should occasion a different conclusion or inference? In an abstract view, they are entirely alike, and no difficulty attends the one supposition, which is not common to both of them.

Again, when we will needs force *Experience* to pronounce some sentence, even on these subjects, which lie beyond her sphere; neither can she perceive any material difference in this particular, between these two kinds of worlds, but finds them to be governed by similar principles, and to depend upon an equal variety of causes in their operations. We have specimens in miniature of both of them. Our own mind resembles the one: A vegetable or animal body the other. Let Experience, therefore, judge from these samples. Nothing seems more delicate with regard to its causes than thought; and as these causes

never operate in two persons after the same manner, so we never find two persons who think exactly alike. Nor indeed does the same person think exactly alike at any two different periods of time. A difference of age, of the disposition of his body, of weather, of food, of company, of books, of passions; any of these particulars, or others more minute, are sufficient to alter the curious machinery of thought, and communicate to it very different movements and operations. As far as we can judge, vegetables and animal bodies are not more delicate in their motions, nor depend upon a greater variety or more curious adjustment of springs and principles.

How therefore shall we satisfy ourselves concerning the cause of that Being, whom you suppose the Author of Nature, or, according to your system of Anthropomorphism, the ideal world, into which you trace the material? Have we not the same reason to trace that ideal world into another ideal world, or new intelligent principle? But if we stop, and go no farther, why go so far? Why not stop at the material world? How can we satisfy ourselves without going on *in infinitum?* And after all, what satisfaction is there in that infinite progression? Let us remember the story of the INDIAN philosopher and his elephant.[45] It was never more applicable than to the present subject. If the material world rests upon a similar ideal world, this ideal world must rest upon some other; and so on, without end. It were better, therefore, never to look beyond the present material world. By supposing it to contain the principle of its order within itself, we really assert it to be God; and the sooner we arrive at that divine Being, so much the better. When you go one step beyond the mundane system, you only excite an inquisitive humour, which it is impossible ever to satisfy.

To say that the different ideas, which compose the reason of the Supreme Being, fall into order of themselves and by their own nature, is really to talk without any precise meaning. If it has a meaning, I would fain know, why it is not as good sense to say, that the parts of the material world fall into

[45] Having conjectured that the World rests upon the back of a giant elephant, which in turn rests upon a giant tortoise, this legendary Indian philosopher was at a loss to explain what supports the tortoise.

order, of themselves, and by their own nature. Can the one opinion be intelligible, while the other is not so?

We have, indeed, experience of ideas, which fall into order, of themselves, and without any *known* cause: But, I am sure, we have a much larger experience of matter, which does the same; as, in all instances of generation and vegetation, where the accurate analysis of the cause exceeds all human comprehension. We have also experience of particular systems of thought and of matter, which have no order; of the first, in madness; of the second, in corruption. Why then should we think, that order is more essential to one than the other? And if it requires a cause in both, what do we gain by your system, in tracing the universe or objects into a similar universe of ideas? The first step which we make leads us on for ever. It were, therefore, wise in us, to limit all our enquiries to the present world, without looking farther. No satisfaction can ever be attained by these speculations, which so far exceed the narrow bounds of human understanding.

It was usual with the PERIPATETICS, you know, CLEANTHES, when the cause of any phenomenon was demanded, to have recourse to their *faculties* or *occult qualities*,[46] and to say, for instance, that bread nourished by its nutritive faculty, and senna purged by its purgative: But it has been discovered, that this subterfuge was nothing but the disguise of ignorance, and that these philosophers, though less ingenuous, really said the same thing with the sceptics or the vulgar, who fairly confessed, that they knew not the cause of these phenomena. In like manner, when it is asked, what cause produces order in the ideas of the Supreme Being, can any other reason be assigned by you, Anthropomorphites, than that it is a *rational* faculty, and that such is the nature of the Deity? But why a similar answer will not be equally satisfactory in accounting for the order of the world, without having recourse to any such intelligent creator, as you insist on, may be difficult to determine. It is only to say, that *such* is the nature of material

[46] It is this recourse which the French comic dramatist Molière famously satirized in *La Malade Imaginaire* [The Hypochondriac], presenting a chorus of doctors who attributed the efficacy of sleeping pills to their *virtus domitiva* [soporific quality].

objects, and that they are all originally possessed of a *faculty* of order and proportion. These are only more learned and elaborate ways of confessing our ignorance; nor has the one hypothesis any real advantage above the other, except in its greater conformity to vulgar prejudices.

Cleanthes: You have displayed this argument with great emphasis, replied CLEANTHES: You seem not sensible,[47] how easy it is to answer it. Even in common life, if I assign a cause for any event; is it any objection, PHILO, that I cannot assign the cause of that cause, and answer every new question, which may incessantly be started? And what philosophers could possibly submit to so rigid a rule? philosophers, who confess ultimate causes to be totally unknown, and are sensible that the most refined principles into which they trace the phenomena are still to them as inexplicable as these phenomena themselves are to the vulgar. The order and arrangement of nature, the curious adjustment of final causes, the plain use and intention of every part and organ; all these bespeak in the clearest language an intelligent cause or author. The heavens and the earth join in the same testimony: The whole chorus of Nature raises one hymn to the praises of its creator: You alone, or almost alone, disturb this general harmony. You start abstruse doubts, cavils, and objections: You ask me, what is the cause of this cause? I know not; I care not; that concerns not me. I have found a Deity; and here I stop my enquiry. Let those go farther, who are wiser or more enterprising.

Philo: I pretend to be neither, replied PHILO: and for that very reason, I should never perhaps have attempted to go so far; especially when I am sensible, that I must at last be contented to sit down with the same answer, which, without farther trouble, might have satisfied me from the beginning. If I am still to remain in utter ignorance of causes, and can absolutely give an explication of nothing, I shall never esteem it any advantage to shove off for a moment a difficulty which, you acknowledge, must immediately, in its full force, recur upon me. Naturalists indeed very justly explain particular effects by more general causes, though these general causes themselves should remain in the end totally inexplicable: but

[47] Aware.

they never surely thought it satisfactory to explain a particular effect by a particular cause, which was no more to be accounted for than the effect itself. An ideal system, arranged of itself, without a precedent design, is not a whit more explicable than a material one, which attains its order in a like manner; nor is there any more difficulty in the latter supposition than in the former.

PART V

Philo: But to show you still more inconveniences, continued PHILO, in your Anthropomorphism; please to take a new survey of your principles. *Like effects prove like causes.* This is the experimental argument; and this, you say too, is the sole theological argument. Now it is certain, that the liker the effects are, which are seen, and the liker the causes, which are inferred, the stronger is the argument. Every departure on either side diminishes the probability, and renders the experiment less conclusive. You cannot doubt of the principle: neither ought you to reject its consequences.

All the new discoveries in astronomy, which prove the immense grandeur and magnificence of the works of Nature, are so many additional arguments for a Deity, according to the true system of Theism: but according to your hypothesis of experimental Theism, they become so many objections, by removing the effect still farther from all resemblance to the effects of human art and contrivance. For if Lucretius,[48] even following the old system of the world, could exclaim,

> *Quis regere immensi summam, quis habere profundi*
> *Indu manu validas potis est moderanter habenas?*
> *Quis pariter cœlos omnes convertere? et omnes*
> *Ignibus ætheriis terras suffire feraces?*
> *Omnibus inque locis esse omni tempore præsto?*[49]

If Tully[50] esteemed this reasoning so natural, as to put it into the mouth of his EPICUREAN.

[48] Titus Lucretius Carus (c. 95–c. 55 BCE) was the author of the greatest of didactic poems, *De Rerum Natura* [On the Nature of Things], expounding the teachings of Epicurus (341–270 BCE).

[49] "Who is strong enough to rule the sum of the immeasurable, who to hold in hand and control the mighty bridle of the unfathomable deep? Who to turn about all the heavens at one time and warm the fruitful worlds with ethereal fires, or to be present in all places and at all times?" (*De Rerum Natura* [On the Nature of Things], Book II, lines 1096–99)

[50] 'Tully' was in Hume's day the universally employed nickname of Marcus Tullius Cicero (104–43 BCE), nowadays known always by his Latin *cognomen* 'Cicero'. A Roman politician and advocate, he was also an amateur of philosophy.

> Quibus enim oculis animi intueri potuit vester Plato
> fabricam illam tanti operis, qua construi a Des atque
> ædificari mundum facit? quæ molitio? quæ ferramenta?
> qui vectes? quæ machinæ? qui minstri tanti muneris
> fuerunt? quemadmodum autem obedire et parere
> voluntati architecti aer, ignis, aqua, terra potuerunt?[51]

If this argument, I say, had any force in former ages; how much greater must it have at present; when the bounds of Nature are so infinitely enlarged, and such a magnificent scene is opened to us? It is still more unreasonable to form our idea of so unlimited a cause from our experience of the narrow productions of human design and invention.

The discoveries by microscopes, as they open a new universe in miniature, are still objections, according to you; arguments, according to me. The farther we push our researches of this kind, we are still led to infer the universal cause of all to be vastly different from mankind, or from any object of human experience and observation.

And what say you to the discoveries in anatomy, chemistry, botany?..

Cleanthes: These surely are no objections, replied CLEAN-THES: they only discover new instances of art and contrivance. It is still the image of mind reflected on us from innumerable objects.

Philo: Add a mind *like the human,* said PHILO.

Cleanthes: I know of no other, replied CLEANTHES.

Philo: And the liker the better, insisted PHILO.

Cleanthes: To be sure, said CLEANTHES.

Philo: Now, CLEANTHES, said PHILO, with an air of alacrity and triumph, mark the consequences. *First,* By this method of reasoning, you renounce all claim to infinity in any of the attributes of the Deity. For as the cause ought only to be

[51] "What power of mental vision enabled your master Plato to descry the vast and elaborate architectural process which, as he makes out, the deity adopted in building the structure of the universe? What tools and levers and derricks? What agents carried out so vast an undertaking? And how were air, fire, water and earth enabled to obey and execute the will of the architect?" (*De Natura Deorum* [On the Nature of the Gods], Book I, viii, 19)

proportioned to the effect, and the effect, so far as it falls under our cognisance, is not infinite; what pretensions have we, upon your suppositions, to ascribe that attribute to the divine Being? You will still insist, that, by removing him so much from all similarity to human creatures, we give in to the most arbitrary hypothesis, and at the same time weaken all proofs of his existence.

Secondly, You have no reason, on your theory, for ascribing perfection to the Deity, even in his finite capacity; or for supposing him free from every error, mistake, or incoherence in his undertakings. There are many inexplicable difficulties in the works of Nature, which, if we allow a perfect author to be proved *a priori,* are easily solved, and become only seeming difficulties, from the narrow capacity of man, who cannot trace infinite relations. But according to your method of reasoning, these difficulties become all real; and perhaps will be insisted on, as new instances of likeness to human art and contrivance. At least, you must acknowledge that it is impossible for us to tell, from our limited views, whether this system contains any great faults, or deserves any considerable praise, if compared to other possible, and even real systems. Could a peasant, if the ÆNEID were read to him, pronounce that poem to be absolutely faultless, or even assign to it its proper rank among the productions of human wit; he, who had never seen any other production?

But were this world ever so perfect a production, it must still remain uncertain, whether all the excellences of the work can justly be ascribed to the workman. If we survey a ship, what an exalted idea must we form of the ingenuity of the carpenter, who framed so complicated, useful, and beautiful a machine? And what surprise must we feel, when we find him a stupid mechanic, who imitated others, and copied an art, which, through a long succession of ages, after multiplied trials, mistakes, corrections, deliberations, and controversies, had been gradually improving? Many worlds might have been botched and bungled, throughout an eternity, ere this system was struck out: much labour lost: many fruitless trials made: and a slow, but continued improvement carried on during infinite ages in the art of world-making. In such subjects, who can determine, where the truth; nay, who can conjecture where the probability, lies; amidst a great number of hypothe-

ses which may be proposed, and a still greater number which may be imagined?[52]

And what shadow of an argument, continued PHILO, can you produce, from your hypothesis, to prove the unity of the Deity? A great number of men join in building a house or ship, in rearing a city, in framing a commonwealth: why may not several deities combine in contriving and framing a world? By sharing the work among several, we may so much further limit the attributes of each, and get rid of that extensive power and knowledge, which must be supposed in one deity, and which, according to you, can only serve to weaken the proof of his existence. And if such foolish, such vicious creatures as man can yet often unite in framing and executing one plan; how much more those deities or dæmons, whom we may suppose several degrees more perfect?

To multiply causes, without necessity, is indeed contrary to true philosophy:[53] but this principle applies not to the present case. Were one deity antecedently proved by your theory, who were possessed of every attribute, requisite to the production of the universe; it would be needless, I own (though not absurd) to suppose any other deity existent. But while it is still a question, Whether all these attributes are united in one subject, or dispersed among several independent beings: by what phenomena in nature can we pretend to decide the controversy? Where we see a body raised in a scale, we are sure

[52] This paragraph is one of many passages in Hume's writings reveal-ing an awareness—shared with his younger friends Adam Smith, Adam Ferguson and others—that many social institutions and social products seeming to have been deliberately designed might or must have been produced as unintended consequences of intended actions. In the present particular case of naval architecture, while all the successive improve-ments were severally the work of conscious innovations; it is certainly not the case that they were simultaneous or co-ordinated by an individu-al or a team of naval architects. This Scottish thinking about apparent without actual design was later to influence and inspire Charles Darwin (1809–1882). See, for instance, Antony Flew, *Darwinian Evolution* (Lon-don: Granada Paladin, 1984), III 2.

[53] This is a reference to Ockham's Razor, which in its usual formula-tion reads: (not causes but) "Entities are not to be multiplied beyond necessity". William of Ockham (c. 1285–1349) was an English Francis-can, and one of the greatest Scholastic philosophers.

that there is in the opposite scale, however concealed from sight, some counterpoising weight equal to it: but it is still allowed to doubt, whether that weight be an aggregate of several distinct bodies, or one uniform united mass. And if the weight requisite very much exceeds any thing which we have ever seen conjoined in any single body, the former supposition becomes still more probable and natural. An intelligent being of such vast power and capacity, as is necessary to produce the universe, or, to speak in the language of ancient philosophy, so prodigious an animal, exceeds all analogy, and even comprehension.

But farther, CLEANTHES; men are mortal, and renew their species by generation; and this is common to all living creatures. The two great sexes of male and female, says MILTON, animate the world. Why must this circumstance, so universal, so essential, be excluded from those numerous and limited deities? Behold then the theogony of ancient times brought back upon us.

And why not become a perfect Anthropomorphite? Why not assert the deity or deities to be corporeal, and to have eyes, a nose, mouth, ears, &c.? EPICURUS maintained, that no man had ever seen reason but in a human figure; therefore the gods must have a human figure. And this argument, which is deservedly so much ridiculed by CICERO, becomes, according to you, solid and philosophical.

In a word, CLEANTHES, a man, who follows your hypothesis, is able, perhaps, to assert, or conjecture, that the universe, sometime, arose from something like design: but beyond that position he cannot ascertain one single circumstance, and is left afterwards to fix every point of his theology, by the utmost licence of fancy and hypothesis. This world, for aught he knows, is very faulty and imperfect, compared to a superior standard; and was only the first rude essay of some infant deity, who afterwards abandoned it, ashamed of his lame performance: it is the work only of some dependent, inferior deity; and is the object of derision to his superiors: it is the production of old age and dotage in some superannuated deity; and ever since his death, has run on at adventures, from the first impulse and active force, which it received from him. You justly give signs of horror, DEMEA, at these strange suppositions: but these, and a thousand more of the same kind, are

CLEANTHES's suppositions, not mine. From the moment the attributes of the Deity are supposed finite, all these have place. And I cannot, for my part, think, that so wild and unsettled a system of theology is, in any respect, preferable to none at all.

Cleanthes: These suppositions I absolutely disown, cried CLEANTHES: they strike me, however, with no horror; especially, when proposed in that rambling way in which they drop from you. On the contrary, they give me pleasure, when I see, that by the utmost indulgence of your imagination, you never get rid of the hypothesis of design in the universe; but are obliged, at every turn, to have recourse to it. To this concession I adhere steadily; and this I regard as a sufficient foundation for religion.

PART VI

Demea: It must be a slight fabric, indeed, said DEMEA, which can be erected on so tottering a foundation. While we are uncertain whether there is one deity or many; whether the deity or deities, to whom we owe our existence, be perfect or imperfect, subordinate or supreme, dead or alive; what trust or confidence can we repose in them? What devotion or worship address to them? What veneration or obedience pay them? To all the purposes of life, the theory of religion becomes altogether useless: and even with regard to speculative consequences, its uncertainty, according to you, must render it totally precarious and unsatisfactory.

Philo: To render it still more unsatisfactory, said PHILO, there occurs to me another hypothesis, which must acquire an air of probability from the method of reasoning so much insisted on by CLEANTHES. That like effects arise from like causes: this principle he supposes the foundation of all religion. But there is another principle of the same kind, no less certain, and derived from the same source of experience; That where several known circumstances are observed to be similar, the unknown will also be found similar. Thus, if we see the limbs of a human body, we conclude that it is also attended with a human head, though hid from us. Thus, if we see, through a chink in a wall, a small part of the sun, we conclude, that, were the wall removed, we should see the whole body. In short, this method of reasoning is so obvious and familiar, that no scruple can ever be made with regard to its solidity.

Now if we survey the universe, so far as it falls under our knowledge, it bears a great resemblance to an animal or organized body, and seems actuated with a like principle of life and motion. A continual circulation of matter in it produces no disorder: a continual waste in every part is incessantly repaired: the closest sympathy is perceived throughout the entire system: and each part or member, in performing its proper offices, operates both to its own preservation and to that of the whole. The world, therefore, I infer, is an animal, and the Deity is the SOUL of the world, actuating it, and actuated by it.

You have too much learning, CLEANTHES, to be at all surprised at this opinion, which, you know, was maintained by almost all the Theists of antiquity, and chiefly prevails in their

discourses and reasonings. For though sometimes the ancient philosophers reason from final causes,[54] as if they thought the world the workmanship of God; yet it appears rather their favourite notion to consider it as his body, whose organization renders it subservient to him. And it must be confessed, that as the universe resembles more a human body than it does the works of human art and contrivance; if our limited analogy could ever, with any propriety, be extended to the whole of nature, the inference seems juster in favour of the ancient than the modern theory.

There are many other advantages too, in the former theory, which recommend it to the ancient Theologians. Nothing more repugnant to all their notions, because nothing more repugnant to common experience than mind without body; a mere spiritual substance, which fell not under their senses nor comprehension, and of which they had not observed one single instance throughout all nature.[55] Mind and body they knew, because they felt both: an order, arrangement, organization, or internal machinery in both they likewise knew, after the same manner: and it could not but seem reasonable to transfer this experience to the universe, and to suppose the divine mind and body to be also coeval, and to have, both of them, order and arrangement naturally inherent in them, and inseparable from them.

[54] The distinctions between material, formal, efficient, and final causes are known collectively as Aristotle's doctrine of the four causes. The description is unfortunate, because in English the word 'cause' would, by anyone quite untouched by Aristotelian influences, be applied only to the third. Although it remains necessary to know the traditional labels, it is perhaps best to think of Aristotle as here distinguishing four fundamentally different sorts of questions and their corresponding answers. Aristotle himself explains the final cause as the purpose, "that for the sake of which something is done, as health is of walking around."

[55] It is noteworthy that here, as in the Essay 'Of the Immortality of the Soul', the argument is: that an incorporeal or disembodied mind or soul is something of which as a matter of fact we have no experience; rather than that we are here confronted with talk to which no clear and definite sense has been given. Notice too that the 'notions' which Philo is here by implication attributing to modern (Christian) theologians are essential to the justification of their doctrines of human immortality. Compare, for instance, Antony Flew, *The Logic of Mortality* (Oxford: Blackwell, 1987).

Here therefore is a new species of *Anthropomorphism,*
CLEANTHES, on which you may deliberate; and a theory which
seems not liable to any considerable difficulties. You are too
much superior surely to *systematical prejudices,* to find any
more difficulty in supposing an animal body to be, originally,
of itself, or from unknown causes, possessed of order and
organization, than in supposing a similar order to belong to
mind. But the *vulgar prejudice,* that body and mind ought
always to accompany each other, ought not, one should think,
to be entirely neglected; since it is founded on *vulgar experi-
ence,* the only guide which you profess to follow in all these
theological inquiries. And if you assert, that our limited
experience is an unequal standard, by which to judge of the
unlimited extent of nature; you entirely abandon your own
hypothesis, and must thenceforward adopt our Mysticism, as
you call it, and admit of the absolute incomprehensibility of the
Divine Nature.

Cleanthes: This theory, I own, replied CLEANTHES, has
never before occurred to me, though a pretty natural one; and I
cannot readily, upon so short an examination and reflection,
deliver any opinion with regard to it.

Philo: You are very scrupulous, indeed, said PHILO; were I
to examine any system of yours, I should not have acted with
half that caution and reserve, in starting objections and
difficulties to it. However, if anything occur to you, you will
oblige us by proposing it.

Cleanthes: Why then, replied CLEANTHES, it seems to me,
that, though the world does, in many circumstances, resemble
an animal body; yet is the analogy also defective in many
circumstances, the most material: no organs of sense; no seat
of thought or reason; no one precise origin of motion and
action. In short, it seems to bear a stronger resemblance to a
vegetable than to an animal, and your inference would be so
far inconclusive in favour of the soul of the world.

But, in the next place, your theory seems to imply the
eternity of the world; and that is a principle, which, I think,
can be refuted by the strongest reasons and probabilities. I
shall suggest an argument to this purpose, which, I believe,
has not been insisted on by any writer. Those who reason from
the late origin of arts and sciences, though their inference
wants not force, may perhaps be refuted by considerations,

derived from the nature of human society, which is in continual revolution between ignorance and knowledge, liberty and slavery, riches and poverty; so that it is impossible for us, from our limited experience, to foretell with assurance what events may or may not be expected. Ancient learning and history seem to have been in great danger of entirely perishing after the inundation of the barbarous nations; and had these convulsions continued a little longer, or been a little more violent, we should not probably have now known what passed in the world a few centuries before us. Nay, were it not for the superstition of the Popes, who preserved a little jargon of LATIN, in order to support the appearance of an ancient and universal church, that tongue must have been utterly lost: in which case, the Western world, being totally barbarous, would not have been in a fit disposition for receiving the GREEK language and learning, which was conveyed to them after the sacking of CONSTANTINOPLE.[56] When learning and books had been extinguished, even the mechanical arts would have fallen considerably to decay; and it is easily imagined that fable or tradition might ascribe to them a much later origin than the true one. This vulgar argument, therefore, against the eternity of the world, seems a little precarious.

But here appears to be the foundation of a better argument. LUCULLUS[57] was the first that brought cherry-trees from ASIA to EUROPE; though that tree thrives so well in many EUROPEAN climates, that it grows in the woods without any culture. Is it possible, that, throughout a whole eternity, no EUROPEAN had ever passed into ASIA, and thought of transplanting so delicious a fruit into his own country? Or if the tree was once transplanted and propagated, how could it ever afterwards perish? Empires may rise and fall; liberty and slavery succeed alternately; ignorance and knowledge give place to each other; but the cherry-tree will still remain in the

[56] Constantinople, formerly Byzantium and now Istanbul, was taken and sacked by the (Western Christian) Fourth Crusade in 1204, and taken but not sacked by the (Muslim) Ottoman Turks in 1453.

[57] Lucius Licinius Lucullus (c. 117–55 BCE), having amassed great wealth in a successful military career, devoted his retirement to luxurious living; for which his name became a household word.

woods of GREECE, SPAIN and ITALY, and will never be affected
by the revolutions of human society.

It is not two thousand years since vines were transplanted
into FRANCE; though there is no climate in the world more
favourable to them. It is not three centuries since horses, cows,
sheep, swine, dogs, corn, were known in AMERICA.[58] Is it
possible, that, during the revolutions of a whole eternity, there
never arose a COLUMBUS, who might open the communication
between EUROPE and that continent? We may as well imagine
that all men would wear stockings for ten thousand years, and
never have the sense to think of garters to tie them. All these
seem convincing proofs of the youth, or rather infancy of the
world; as being founded on the operation of principles more
constant and steady, than those by which human society is
governed and directed. Nothing less than a total convulsion of
the elements will ever destroy all the EUROPEAN animals and
vegetables, which are now to be found in the Western world.

Philo: And what argument have you against such convul-
sions? replied PHILO.[59] Strong and almost incontestable proofs
may be traced over the whole earth, that every part of this
globe has continued for many ages entirely covered with water.
And though order were supposed inseparable from matter, and
inherent in it; yet may matter be susceptible of many and great
revolutions, through the endless periods of eternal duration.
The incessant changes, to which every part of it is subject,
seem to intimate some such general transformations; though
at the same time, it is observable, that all the changes and
corruptions of which we have ever had experience are but
passages from one state of order to another; nor can matter
ever rest in total deformity and confusion. What we see in the
parts, we may infer in the whole; at least, that is the method of

[58] In the British dialect of English, 'corn' is a generic term for grains
like wheat, barley, and oats. So Hume does not here mean maize, a
native American plant. No doubt Philo and Hume would have been
delighted to learn that the horses introduced by the Spaniards to Ameri-
ca were the remote descendants of horses which lived in America for
millions of years before becoming extinct there, thousands of years be-
fore Columbus.

[59] Hume knew nothing of the Ice Ages which have periodically wiped
out much of the temperate-zone flora and fauna of Europe.

reasoning on which you rest your whole theory. And were I obliged to defend any particular system of this nature (which I never willingly should do) I esteem none more plausible than that which ascribes an eternal, inherent principle of order to the world; though attended with great and continual revolutions and alterations. This at once solves all difficulties; and if the solution, by being so general, is not entirely complete and satisfactory, it is, at least, a theory, that we must sooner or later have recourse to, whatever system we embrace. How could things have been as they are, were there not an original, inherent principle of order somewhere, in thought or in matter? And it is very indifferent to which of these we give the preference. Chance has no place, on any hypothesis, sceptical or religious. Everything is surely governed, by steady, inviolable laws. And were the inmost essence of things laid open to us, we should then discover a scene of which, at present, we can have no idea. Instead of admiring the order of natural beings, we should clearly see that it was absolutely impossible for them, in the smallest article, ever to admit of any other disposition.

Were any one inclined to revive the ancient Pagan Theology, which maintained, as we learn from Hesiod,[60] that this globe was governed by 30,000 deities, who arose from the unknown powers of nature: you would naturally object, CLEANTHES, that nothing is gained by this hypothesis; and that it is as easy to suppose all men and animals, beings more numerous, but less perfect, to have sprung immediately from a like origin. Push the same inference a step farther; and you will find a numerous society of deities as explicable as one universal deity, who possesses, within himself, the powers and perfections of the whole society. All these systems, then, of Scepticism, Polytheism, and Theism, you must allow, on your principles, to be on a like footing, and that no one of them has any advantage over the others. You may thence learn the fallacy of your principles.

[60] Hesiod, after Homer the earliest known Greek poet, probably lived around 700 BCE. His *Theogony* gives an account of the genealogy of the Olympian gods and of the uninhibited infighting leading to the hegemony of Zeus.

PART VII

Philo: But here, continued PHILO, in examining the ancient system of the soul of the world, there strikes me, all on a sudden, a new idea, which, if just, must go near to subvert all your reasoning, and destroy even your first inferences, on which you repose such confidence. If the universe bears a greater likeness to animal bodies and to vegetables, than to the works of human art, it is more probable, that its cause resembles the cause of the former than that of the latter, and its origin ought rather to be ascribed to generation or vegetation than to reason or design. Your conclusion, even according to your own principles, is therefore lame and defective.

Demea: Pray open up this argument a little farther, said DEMEA. For I do not rightly apprehend it, in that concise manner, in which you have expressed it.

Philo: Our friend CLEANTHES, replied PHILO, as you have heard, asserts that since no question of fact can be proved otherwise than by experience, the existence of a Deity admits not of proof from any other medium. The world, says he, resembles the works of human contrivance: Therefore its cause must also resemble that of the other. Here we may remark, that the operation of one very small part of nature, to wit man, upon another very small part, to wit that inanimate matter lying within his reach, is the rule by which CLEANTHES judges of the origin of the whole; and he measures objects, so widely disproportioned, by the same individual standard. But to waive all objections drawn from this topic; I affirm, that there are other parts of the universe (besides the machines of human invention) which bear still a greater resemblance to the fabric of the world, and which therefore afford a better conjecture concerning the universal origin of this system. These parts are animals and vegetables. The world plainly resembles more an animal or a vegetable, than it does a watch or a knitting-loom. Its cause, therefore, it is more probable, resembles the cause of the former. The cause of the former is generation or vegetation. The cause, therefore, of the world, we may infer to be something similar or analogous to generation or vegetation.

Demea: But how is it conceivable, said DEMEA, that the world can arise from any thing similar to vegetation or generation?

Philo: Very easily, replied PHILO. In like manner as a tree

sheds its seeds into the neighbouring fields, and produces other trees; so the great vegetable, the world, or this planetary system, produces within itself certain seeds, which, being scattered into the surrounding chaos, vegetate into new worlds. A comet, for instance, is the seed of a world; and after it has been fully ripened, by passing from sun to sun, and star to star, it is at last tossed into the unformed elements, which everywhere surround this universe, and immediately sprouts up into a new system.

Or if, for the sake of variety (for I see no other advantage) we should suppose this world to be an animal; a comet is the egg of this animal; and in like manner as an ostrich lays its egg in the sand, which, without any farther care, hatches the egg, and produces a new animal; so . . .

Demea: I understand you, says DEMEA: But what wild, arbitrary suppositions are these? What *data* have you for such extraordinary conclusions? And is the slight, imaginary resemblance of the world to a vegetable or an animal sufficient to establish the same inference with regard to both? Objects, which are in general so widely different; ought they to be a standard for each other?

Philo: Right, cries PHILO: This is the topic on which I have all along insisted. I have still asserted, that we have no *data* to establish any system of cosmogony. Our experience, so imperfect in itself, and so limited both in extent and duration, can afford us no probable conjecture concerning the whole of things. But if we must needs fix on some hypothesis; by what rule, pray, ought we to determine our choice? Is there any other rule than the greater similarity of the objects compared? And does not a plant or an animal, which springs from vegetation or generation, bear a stronger resemblance to the world, than does any artificial machine, which arises from reason and design?

Demea: But what is this vegetation and generation of which you talk? said DEMEA. Can you explain their operations, and anatomize that fine internal structure, on which they depend?

Philo: As much, at least, replied PHILO, as CLEANTHES can explain the operations of reason, or anatomize that internal structure, on which *it* depends. But without any such elaborate disquisitions, when I see an animal, I infer that it

sprang from generation; and that with as great certainty as you conclude a house to have been reared by design. These words, *generation, reason,* mark only certain powers and energies in nature, whose effects are known, but whose essence is incomprehensible; and one of these principles, more than the other, has no privilege for being made a standard to the whole of nature.

In reality, DEMEA, it may reasonably be expected, that the larger the views are which we take of things, the better will they conduct us in our conclusions concerning such extraordinary and such magnificent subjects. In this little corner of the world alone, there are four principles, *Reason, Instinct, Generation, Vegetation,* which are similar to each other, and are the causes of similar effects. What a number of other principles may we naturally suppose in the immense extent and variety of the universe, could we travel from planet to planet and from system to system, in order to examine each part of this mighty fabric? Any one of these four principles above mentioned (and a hundred others which lie open to our conjecture) may afford us a theory, by which to judge of the origin of the world; and it is a palpable and egregious partiality, to confine our view entirely to that principle by which our own minds operate. Were this principle more intelligent on that account, such a partiality might be somewhat excusable: But reason, in its internal fabric and structure, is really as little known to us as instinct or vegetation; and perhaps even that vague, undeterminate word, *Nature,* to which the vulgar refer everything, is not at the bottom more inexplicable. The effects of these principles are all known to us from experience: But the principles themselves, and their manner of operation are totally unknown: Nor is it less intelligible, or less conformable to experience to say, that the world arose by vegetation from a seed shed by another world, than to say that it arose from a divine reason or contrivance, according to the sense in which CLEANTHES understands it.

Demea: But methinks, said DEMEA, if the world had a vegetative quality, and could sow the seeds of new worlds into the infinite chaos, this power would be still an additional argument for design in its author. For whence could arise so wonderful a faculty but from design? Or how can order spring

from anything, which perceives not that order which it be-
stows?

Philo: You need only look around you, replied PHILO, to
satisfy yourself with regard to this question. A tree bestows
order and organization on that tree which springs from it,
without knowing the order: an animal, in the same manner, on
its offspring: a bird, on its nest: and instances of this kind are
even more frequent in the world, than those of order, which
arise from reason and contrivance. To say, that all this order in
animals and vegetables proceeds ultimately from design, is
begging the question; nor can that great point be ascertained
otherwise than by proving *a priori,* both that order is, from its
nature, inseparably attached to thought, and that it can never,
of itself, or from original unknown principles, belong to mat-
ter.

But farther, DEMEA; this objection, which you urge, can
never be made use of by CLEANTHES, without renouncing a
defence which he has already made against one of my objec-
tions. When I enquired concerning the cause of that supreme
reason and intelligence, into which he resolves everything, he
told me that the impossibility of satisfying such enquiries
could never be admitted as an objection in any species of
philosophy. *We must stop somewhere,* says he; *nor is it ever
within the reach of human capacity to explain ultimate causes,
or show the last connections of any objects.*[61] *It is sufficient, if
any steps, so far as we go, are supported by experience and
observation.* Now, that vegetation and generation, as well as

[61] A logically necessary principle is involved here, and not just one
more unfortunate weakness of our common humanity. For every explana-
tion why anything is as it is has to be in terms of some other principle or
principles which, at least at that stage, is not or are not explained. So,
however high or deep a hierarchial series of explanations is taken, there
always has to be something which is accepted as a necessarily inexplica-
ble brute fact.

Philo in this, surely, faithfully representing Hume himself is forever
pressing towards what Boyle taught him to call the "Stratonician athe-
ism". This is the view that the existence of the Universe itself, and the
subsistence of whatever are found to be the most general and most
fundamental laws of nature, just are themselves those necessarily inex-
plicable ultimates.

reason, are experienced to be principles of order in nature, is undeniable. If I rest my system of cosmogony on the former, preferably to the latter, 'tis at my choice. The matter seems entirely arbitrary. And when CLEANTHES asks me what is the cause of my great vegetative or generative faculty, I am equally entitled to ask him the cause of his great reasoning principle. These questions we have agreed to forbear on both sides; and it is chiefly his interest on the present occasion to stick to this agreement. Judging by our limited and imperfect experience, generation has some privileges above reason: For we see every day the latter arise from the former, never the former from the latter.

Compare, I beseech you, the consequences on both sides. The world, say I, resembles an animal, therefore it is an animal, therefore it arose from generation. The steps, I confess, are wide; yet there is some small appearance of analogy in each step. The world, says CLEANTHES, resembles a machine, therefore it is a machine, therefore it arose from design. The steps are here equally wide, and the analogy less striking. And if he pretends to carry on *my* hypothesis a step farther, and to infer design or reason from the great principle of generation, on which I insist; I may, with better authority, use the same freedom to push farther his hypothesis, and infer a divine generation or theogony from his principle of reason. I have at least some faint shadow of experience, which is the utmost that can ever be attained in the present subject. Reason, in innumerable instances, is observed to arise from the principle of generation, and never to arise from any other principle.

HESIOD, and all the ancient Mythologists, were so struck with this analogy, that they universally explained the origin of nature from an animal birth, and copulation. PLATO too, so far as he is intelligible, seems to have adopted some such notion in his TIMÆUS.

The BRAHMINS assert that the world arose from an infinite spider, who spun this whole complicated mass from his bowels, and annihilates afterwards the whole or any part of it, by absorbing it again, and resolving it into his own essence. Here is a species of cosmogony, which appears to us ridiculous; because a spider is a little contemptible animal whose operations we are never likely to take for a model of the

whole universe. But still here is a new species of analogy, even in our globe. And were there a planet wholly inhabited by spiders (which is very possible), this inference would there appear as natural and irrefragable as that which in our planet ascribes the origin of all things to design and intelligence, as explained by CLEANTHES. Why an orderly system may not be spun from the belly as well as from the brain, it will be difficult for him to give a satisfactory reason.

Cleanthes: I must confess, PHILO, replied CLEANTHES, that of all men living, the task which you have undertaken, of raising doubts and objections, suits you best, and seems, in a manner, natural and unavoidable to you. So great is your fertility of invention, that I am not ashamed to acknowledge myself unable, on a sudden, to solve regularly such out-of-the-way difficulties as you incessantly start upon me: though I clearly see, in general, their fallacy and error. And I question not, but you are yourself, at present, in the same case, and have not the solution so ready as the objection; while you must be sensible, that common sense and reason is entirely against you, and that such whimsies as you have delivered, may puzzle, but never can convince us.

PART VIII

Philo: What you ascribe to the fertility of my invention, replied PHILO, is entirely owing to the nature of the subject. In subjects adapted to the narrow compass of human reason, there is commonly but one determination, which carries probability or conviction with it; and to a man of sound judgement, all other suppositions, but that one, appear entirely absurd and chimerical. But in such questions, as the present, a hundred contradictory views may preserve a kind of imperfect analogy; and invention has here full scope to exert itself. Without any great effort of thought, I believe that I could, in an instant, propose other systems of cosmogony, which would have some faint appearance of truth; though it is a thousand, a million to one, if either yours or any one of mine be the true system.

For instance; what if I should revive the old EPICUREAN hypothesis? This is commonly, and I believe, justly, esteemed the most absurd system that has yet been proposed; yet, I know not, whether, with a few alterations, it might not be brought to bear a faint appearance of probability. Instead of supposing matter infinite, as EPICURUS did; let us suppose it finite. A finite number of particles is only susceptible of finite transpositions: and it must happen, in an eternal duration, that every possible order or position must be tried an infinite number of times. This world, therefore, with all its events, even the most minute, has before been produced and destroyed, and will again be produced and destroyed, without any bounds and limitations. No one, who has a conception of the powers of infinite, in comparison of finite, will ever scruple this determination.

Demea: But this supposes, said DEMEA, that matter can acquire motion, without any voluntary agent or first mover.

Philo: And where is the difficulty, replied PHILO, of that supposition? Every event, before experience, is equally difficult and incomprehensible; and every event, after experience, is equally easy and intelligible. Motion, in many instances, from gravity, from elasticity, from electricity, begins in matter, without any known voluntary agent; and to suppose always, in these cases, an unknown voluntary agent, is mere hypothesis; and hypothesis attended with no advantages. The beginning of

motion in matter itself is as conceivable *a priori* as its communication from mind and intelligence.

Besides; why may not motion have been propagated by impulse through all eternity, and the same stock of it, or nearly the same, be still upheld in the universe? As much is lost by the composition of motion, as much is gained by its resolution. And whatever the causes are, the fact is certain, that matter is, and always has been in continual agitation, as far as human experience or tradition reaches. There is not probably, at present, in the whole universe, one particle of matter at absolute rest.

And this very consideration too, continued PHILO, which we have stumbled on in the course of the argument, suggests a new hypothesis of cosmogony, that is not absolutely absurd and improbable. Is there a system, an order, an œconomy of things, by which matter can preserve that perpetual agitation, which seems essential to it, and yet maintain a constancy in the forms, which it produces? There certainly is such an œconomy: for this is actually the case with the present world. The continual motion of matter, therefore, in less than infinite transpositions, must produce this œconomy or order; and by its very nature, that order, when once established, supports itself, for many ages, if not to eternity. But wherever matter is so poised, arranged, and adjusted as to continue in perpetual motion, and yet preserve a constancy in the forms, its situation must, of necessity, have all the same appearance of art and contrivance which we observe at present. All the parts of each form must have a relation to each other, and to the whole: and the whole itself must have a relation to the other parts of the universe; to the element, in which the form subsists; to the materials, with which it repairs its waste and decay; and to every other form, which is hostile or friendly. A defect in any of these particulars destroys the form; and the matter, of which it is composed, is again set loose, and is thrown into irregular motions and fermentations, till it unite itself to some other regular form. If no such form be prepared to receive it, and if there be a great quantity of this corrupted matter in the universe, the universe itself is entirely disordered; whether it be the feeble embryo of a world in its first beginnings, that is thus destroyed, or the rotten carcass of one, languishing in old

age and infirmity. In either case, a chaos ensues; till finite, though innumerable revolutions produce at last some forms, whose parts and organs are so adjusted as to support the forms amidst a continued succession of matter.

Suppose, (for we shall endeavour to vary the expression) that matter were thrown into any position, by a blind, unguided force; it is evident that this first position must in all probability be the most confused and most disorderly imaginable, without any resemblance to those works of human contrivance, which, along with a symmetry of parts, discover an adjustment of means to ends and a tendency to self-preservation. If the actuating force cease after this operation, matter must remain for ever in disorder, and continue an immense chaos, without any proportion or activity. But suppose, that the actuating force, whatever it be, still continues in matter, this first position will immediately give place to a second, which will likewise in all probability be as disorderly as the first, and so on, through many successions of changes and revolutions. No particular order or position ever continues a moment unaltered. The original force, still remaining in activity, gives a perpetual restlessness to matter. Every possible situation is produced, and instantly destroyed. If a glimpse or dawn of order appears for a moment, it is instantly hurried away, and confounded, by that never-ceasing force, which actuates every part of matter.

Thus the universe goes on for many ages in a continued succession of chaos and disorder. But is it not possible that it may settle at last, so as not to lose its motion and active force (for that we have supposed inherent in it) yet so as to preserve an uniformity of appearance, amidst the continual motion and fluctuation of its parts? This we find to be the case with the universe at present. Every individual is perpetually changing, and every part of every individual, and yet the whole remains, in appearance, the same. May we not hope for such a position, or rather be assured of it, from the eternal revolutions of unguided matter, and may not this account for all the appearing wisdom and contrivance, which is in the universe? Let us contemplate the subject a little, and we shall find, that this adjustment, if attained by matter, of a seeming stability in the forms, with a real and perpetual revolution or motion of parts, affords a plausible, if not a true solution of the difficulty.

It is in vain, therefore, to insist upon the uses of the parts in animals or vegetables and their curious adjustment to each other. I would fain know how an animal could subsist, unless its parts were so adjusted? Do we not find, that it immediately perishes whenever this adjustment ceases, and that its matter corrupting tries some new form. It happens, indeed, that the parts of the world are so well adjusted, that some regular form immediately lays claim to this corrupted matter: and if it were not so, could the world subsist? Must it not dissolve as well as the animal, and pass through new positions and situations; till in a great, but finite succession, it falls at last into the present or some such order?

Cleanthes: It is well, replied CLEANTHES, you told us, that this hypothesis was suggested on a sudden, in the course of the argument. Had you had leisure to examine it, you would soon have perceived the insuperable objections to which it is exposed. No form, you say, can subsist, unless it possess those powers and organs, requisite for its subsistence: some new order or œconomy must be tried, and so on, without intermission, till at last some order, which can support and maintain itself, is fallen upon. But according to this hypothesis, whence arise the many conveniencies and advantages which men and all animals possess? Two eyes, two ears, are not absolutely necessary for the subsistence of the species. Human race might have been propagated and preserved, without horses, dogs, cows, sheep, and those innumerable fruits and products which serve to our satisfaction and enjoyment. If no camels had been created for the use of a man in the sandy deserts of AFRICA and ARABIA, would the world have been dissolved? If no loadstone[62] had been framed to give that wonderful and useful direction to the needle, would human society and the human kind have been immediately extinguished? Though the maxims of Nature be in general very frugal, yet instances of this kind are far from being rare; and any one of them is a sufficient proof of design, and of a benevolent design, which gave rise to the order and arrangement of the universe.

At least, you may safely infer, said PHILO, that the forego-

[62] A kind of naturally magnetic rock, from which the first magnetic compasses were constructed. Often spelled 'lodestone'.

ing hypothesis is so far incomplete and imperfect; which I shall not scruple to allow. But can we ever reasonably expect greater success in any attempts of this nature? Or can we ever hope to erect a system of cosmogony, that will be liable to no exceptions, and will contain no circumstance repugnant to our limited and imperfect experience of the analogy of Nature? Your theory itself cannot surely pretend to any such advantage; even though you have run into *Anthropomorphism,* the better to preserve a conformity to common experience. Let us once more put it to trial. In all instances which we have ever seen, ideas are copied from real objects, and are ectypal, not archetypal,[63] to express myself in learned terms. You reverse this order, and give thought the precedence. In all instances which we have ever seen, thought has no influence upon matter, except where that matter is so conjoined with it, as to have an equal reciprocal influence upon it. No animal can move immediately anything but the members of its own body; and indeed, the equality of action and re-action seems to be an universal law of Nature: But your theory implies a contradiction to this experience. These instances, with many more, which it were easy to collect (particularly the supposition of a mind or system of thought that is eternal, or in other words, an animal ingenerable and immortal), these instances, I say, may teach, all of us, sobriety in condemning each other; and let us see that as no system of this kind ought ever to be received from a slight analogy, so neither ought any to be rejected on account of a small incongruity. For that is an inconvenience from which we can justly pronounce no one to be exempted.

All religious systems, it is confessed, are subject to great and insuperable difficulties. Each disputant triumphs in his turn; while he carries on an offensive war, and exposes the absurdities, barbarities, and pernicious tenets of his antagonist. But all of them, on the whole, prepare a complete triumph for the *Sceptic;* who tells them that no system ought ever to be

[63] Ideas which are somehow derived from our experience of the universe around us, as Hume himself contended that all legitimate ideas must be, are ectypal. Plato's Forms or Ideas are archetypal: all particular instances of such and suchness must somehow derive their such and suchness from the immaterial and eternal Form or Idea of the Such and Such.

embraced with regard to such subjects: For this plain reason, that no absurdity ought ever to be assented to with regard to any subject. A total suspense of judgment is here our only reasonable resource. And if every attack, as is commonly observed, and no defence, among Theologians, is successful; how complete must be *his* victory, who remains always, with all mankind, on the offensive, and has himself no fixed station or abiding city, which he is ever, on any occasion, obliged to defend?[64]

[64] A disingenuous use of a seemingly pious plea, in behalf of scepticism or agnosticism. Argument is better at demolishing than at establishing theological positions, and the winner is Satan, who doesn't need to commit himself to one intellectual standpoint. Here "with all mankind" means 'in his dealings with all mankind'.

PART IX

Demea: But if so many difficulties attend the argument *a posteriori,* said DEMEA; had we not better adhere to that simple and sublime argument *a priori,* which, by offering to us infallible demonstration, cuts off at once all doubt and difficulty? By this argument, too, we may prove the INFINITY of the divine attributes, which, I am afraid, can never be ascertained with certainty from any other topic. For how can an effect, which either is finite, or, for aught we know, may be so; how can such an effect, I say, prove an infinite cause? The unity too of the Divine Nature, it is very difficult, if not absolutely impossible, to deduce merely from contemplating the works of nature; nor will the uniformity alone of the plan, even were it allowed, give us any assurance of that attribute. Whereas the argument *a priori* . . .

Cleanthes: You seem to reason, DEMEA, interposed CLE-ANTHES, as if those advantages and conveniencies in the abstract argument were fully proofs of its solidity. But it is first proper, in my opinion, to determine what argument of this nature you choose to insist on; and we shall afterwards, from itself, better than from its *useful* consequences, endeavour to determine what value we ought to put upon it.

Demea: The argument, replied DEMEA, which I would insist on is the common one. Whatever exists must have a cause or reason of its existence; it being absolutely impossible for any thing to produce itself, or be the cause of its own existence. In mounting up, therefore, from effects to causes, we must either go on in tracing an infinite succession, without any ultimate cause at all; or must at last have recourse to some ultimate cause, that is *necessarily* existent: Now that the first supposition is absurd may be thus proved. In the infinite chain or succession of causes and effects, each single effect is determined to exist by the power and efficacy of that cause, which immediately preceded; but the whole eternal chain or succession, taken together, is not determined or caused by anything: and yet it is evident that it requires a cause or reason, as much as any particular object, which begins to exist in time. The question is still reasonable, Why this particular succession of causes existed from eternity, and not any other succession, or no succession at all. If there be no necessarily-existent being, any supposition, which can be formed, is

equally possible; nor is there any more absurdity in Nothing's having existed from eternity, than there is in that succession of causes, which constitutes the universe. What was it then, which determined something to exist rather than nothing, and bestowed being on a particular possibility, exclusive of the rest? *External causes,* there are supposed to be none. *Chance* is a word without a meaning. Was it *Nothing?* But that can never produce any thing. We must, therefore, have recourse to a necessarily-existent Being, who carries the REASON of his existence in himself; and who cannot be supposed not to exist without an express contradiction. There is consequently such a Being, that is, there is a Deity.

Cleanthes: I shall not leave it to PHILO, said CLEANTHES, (though I know that the starting objections is his chief delight) to point out the weakness of this metaphysical reasoning. It seems to me so obviously ill-grounded, and at the same time of so little consequence to the cause of true piety and religion, that I shall myself venture to show the fallacy of it.

I shall begin with observing, that there is an evident absurdity in pretending to demonstrate a matter of fact, or to prove it by any arguments *a priori.* Nothing is demonstrable, unless the contrary implies a contradiction. Nothing that is distinctly conceivable implies a contradiction. Whatever we conceive as existent, we can also conceive as non-existent. There is no being, therefore, whose non-existence implies a contradiction. Consequently there is no being whose existence is demonstrable. I propose this argument as entirely decisive, and am willing to rest the whole controversy upon it.

It is pretended that the Deity is a necessarily-existent being; and this necessity of his existence is attempted to be explained by asserting, that, if we knew his whole essence or nature, we should perceive it to be as impossible for him not to exist as for twice two not to be four. But it is evident that this can never happen while our faculties remain the same as at present. It will still be possible for us, at any time, to conceive the non-existence of what we formerly conceived to exist; nor can the mind ever lie under a necessity of supposing any object to remain always in being; in the same manner as we lie under a necessity of always conceiving twice two to be four. The words, therefore, *necessary existence,* have no meaning; or, which is the same thing, none that is consistent.

But farther; why may not the material universe be the necessarily-existent Being, according to this pretended explication of necessity? We dare not affirm that we know all the qualities of matter; and for aught we can determine, it may contain some qualities, which, were they known, would make its non-existence appear as great a contradiction as that twice two is five. I find only one argument employed to prove, that the material world is not the necessarily-existent Being; and this argument is derived from the contingency both of the matter and the form of the world. 'Any particle of matter,' 'tis said, 'may be *conceived* to be annihilated; and any form may be *conceived* to be altered. Such an annihilation or alteration, therefore, is not impossible.'[65] But it seems a great partiality not to perceive, that the same argument extends equally to the Deity, so far as we have any conception of him; and that the mind can at least imagine him to be non-existent, or his attributes to be altered. It must be some unknown, inconceivable qualities which can make his non-existence appear impossible, or his attributes unalterable: And no reason can be assigned, why these qualities may not belong to matter. As they are altogether unknown and inconceivable, they can never be proved incompatible with it.

Add to this, that in tracing an eternal succession of objects, it seems absurd to inquire for a general cause or first author. How can anything, that exists from eternity, have a cause, since that relation implies a priority in time and a beginning of existence?

In such a chain too, or succession of objects, each part is caused by that which preceded it, and causes that which succeeds it. Where then is the difficulty? But the WHOLE, you say, wants a cause. I answer, that the uniting of these parts into a whole, like the uniting of several distinct counties into one kingdom, or several distinct members into one body, is

[65] Hume apparently attributes the passage embraced by quotation marks to Dr. Samuel Clarke (1675–1729), who acted as spokesman for Newton in the *Leibniz-Clarke Correspondence* (1717). (In so far as Demea is to be identified with any non-fiction individual he has to be Clarke). The sense can certainly be found in Clarke's *Discourse concerning the Being and Attributes of God* (1704–06). But there it is not expressed, even approximately, in these words.

performed merely by an arbitrary act of the mind, and has no influence on the nature of things. Did I show you the particular causes of each individual in a collection of twenty particles of matter, I should think it very unreasonable, should you afterwards ask me, what was the cause of the whole twenty. This is sufficiently explained in explaining the cause of the parts.

Philo: Though the reasonings, which you have urged, CLEANTHES, may well excuse me, said PHILO, from starting any farther difficulties; yet I cannot forbear insisting still upon another topic. 'Tis observed by arithmeticians, that the products of 9 compose always either 9 or some lesser product of 9; if you add together all the characters, of which any of the former products is composed. Thus, of 18, 27, 36, which are products of 9, you make 9 by adding 1 to 8, 2 to 7, 3 to 6. Thus 369 is a product also of 9; and if you add 3, 6, and 9, you make 18, a lesser product of 9.[66] To a superficial observer, so wonderful a regularity may be admired as the effect either of chance or design: but a skilful algebraist immediately concludes it to be the work of necessity, and demonstrates, that it must for ever result from the nature of these numbers. Is it not probable, I ask, that the whole œconomy of the universe is conducted by a like necessity, though no human algebra can furnish a key, which solves the difficulty? And instead of admiring the order of natural beings, may it not happen, that, could we penetrate into the intimate nature of bodies, we should clearly see why it was absolutely impossible they could ever admit of any other disposition? So dangerous is it to introduce this idea of necessity into the present question! And so naturally does it afford an inference directly opposite to the religious hypothesis!

But dropping all these abstractions, continued PHILO; and

[66] Here Hume gives the reference *"République des Lettres.* Août 1685." John Valdimir Price, who checked this reference, found that Hume should have written "Septembre" [September] rather than "Août" [August], one of the more modest scholarly advances, but an advance nonetheless! The full reference is *Nouvelles de la République des Lettres* [News of the Republic of Letters], September 1685, Article II, 944–45. The article was by Fontenelle. The journal was edited by Pierre Bayle and published in Amsterdam.

confining ourselves to more familiar topics; I shall venture to add an observation, that the argument *a priori* has seldom been found very convincing, except to people of a metaphysical head, who have accustomed themselves to abstract reasoning, and who finding from mathematics, that the understanding frequently leads to truth, through obscurity, and contrary to first appearances, have transferred the same habit of thinking to subjects, where it ought not to have place. Other people, even of good sense and the best inclined to religion, feel always some deficiency in such arguments, though they are not perhaps able to explain distinctly where it lies. A certain proof that men ever did and ever will derive their religion from other sources than from this species of reasoning.

PART X

Demea: It is my opinion, I own, replied DEMEA, that each man feels, in a manner, the truth of religion within his own breast; and from a consciousness of his imbecility[67] and misery, rather than from any reasoning, is led to seek protection from that Being, on whom he and all nature is dependent. So anxious or so tedious are even the best scenes of life, that futurity is still the object of all our hopes and fears. We incessantly look forward, and endeavour, by prayers, adoration, and sacrifice, to appease those unknown powers, whom we find, by experience, so able to afflict and oppress us. Wretched creatures that we are! what resource for us amidst the innumerable ills of life, did not Religion suggest some methods of atonement, and appease those terrors, with which we are incessantly agitated and tormented?

Philo: I am indeed persuaded, said PHILO, that the best and indeed the only method of bringing every one to a due sense of religion, is by just representations of the misery and wickedness of men. And for that purpose a talent of eloquence and strong imagery is more requisite than that of reasoning and argument. For is it necessary to prove, what every one feels within himself? 'Tis only necessary to make us feel it, if possible, more intimately and sensibly.

Demea: The people, indeed, replied DEMEA, are sufficiently convinced of this great and melancholy truth. The miseries of life, the unhappiness of man, the general corruptions of our nature, the unsatisfactory enjoyment of pleasures, riches, honours; these phrases have become almost proverbial in all languages. And who can doubt of what all men declare from their own immediate feeling and experience?

Philo: In this point, said PHILO, the learned are perfectly agreed with the vulgar; and in all letters, *sacred* and *profane,* the topic of human misery has been insisted on with the most pathetic eloquence that sorrow and melancholy could inspire. The poets, who speak from sentiment, without a system, and whose testimony has therefore the more authority, abound in

[67] Hume employs this word to indicate general, not particularly intellectual, feebleness.

images of this nature. From HOMER down to DR. YOUNG,[68] the
whole inspired tribe have ever been sensible, that no other
representation of things would suit the feeling and observation
of each individual.

Demea: As to authorities, replied DEMEA, you need not
seek them. Look round this library of CLEANTHES. I shall
venture to affirm, that, except authors of particular sciences,
such as chemistry or botany, who have no occasion to treat of
human life, there is scarce one of those innumerable writers,
from whom the sense of human misery has not, in some
passage or other, extorted a complaint and confession of it. At
least, the chance is entirely on that side; and no one author has
ever, so far as I can recollect, been so extravagant as to deny it.

Philo: There you must excuse me, said PHILO: LEIBNITZ
has denied it; and is perhaps the first, who ventured upon so
bold and paradoxical an opinion; at least, the first, who made it
essential to his philosophical system.[69]

[68] The prolific Edward Young (1683–1765). This surely most minor
poet has no doubt been the last resort of several graduate students
desperate to find acceptable topics for 'original research contributions' in
English Literature.

[69] "That sentiment had been maintained by Dr. King and some few
others before Leibnitz, though by none of so great fame as that German
philosopher" [Note by Hume]. In view of this note, it is difficult to
dissociate Hume from Philo's misrepresentation of Leibniz.

Gottfried Wilhelm Leibniz (1646–1716)—this spelling is now standard
—was one of the great philosophical rationalists. In his *Theodicy* he
argued that a Universe created by an omnipotent and perfect God must
necessarily be the best of all possible worlds. But Philo is wrong to
assert that Leibniz denied the reality of human misery, either in this
world or the next. On the contrary, notwithstanding that he also ac-
cepted the traditional Christian teaching that most of us are destined for
eternal torment, Leibniz strove to maintain a thesis which is surely a
necessary consequence of such claims about the goodness and power of
the Creator. Leibniz argued that despite the enormous amount of evil in
the Universe, and despite God's omnipotence, there would have to be
more evil in any other logically possible universe (or in the absence of a
universe).

William King (1650–1729), archbishop of Dublin, was author of *De
Origine Mali* (Dublin, 1702), published in an English translation by
Edmund Law: *An Essay on the Origin of Evil* (London, 1732). Like
Leibniz, King fully recognized the reality of misery and evil.

Demea: And by being the first, replied DEMEA, might he not have been sensible of his error? For is this a subject, in which philosophers can propose to make discoveries, especially in so late an age? And can any man hope by a simple denial (for the subject scarcely admits of reasoning) to bear down the united testimony of mankind, founded on sense and consciousness?

And why should man, added he, pretend to an exemption from the lot of all other animals? The whole earth, believe me, PHILO, is cursed and polluted. A perpetual war is kindled amongst all living creatures. Necessity, hunger, want, stimulate the strong and courageous: Fear, anxiety, terror, agitate the weak and infirm. The first entrance into life gives anguish to the new-born infant and to its wretched parent: Weakness, impotence, distress, attend each stage of that life: and 'tis at last finished in agony and horror.

Philo: Observe too, says PHILO, the curious artifices of Nature, in order to embitter the life of every living being. The stronger prey upon the weaker, and keep them in perpetual terror and anxiety. The weaker too, in their turn, often prey upon the stronger, and vex and molest them without relaxation. Consider that innumerable race of insects, which either are bred on the body of each animal, or flying about infix their stings in him. These insects have others still less than themselves, which torment them. And thus on each hand, before and behind, above and below, every animal is surrounded with enemies, which incessantly seek his misery and distruction.

Demea: Man alone, said DEMEA, seems to be, in part, an exception to this rule. For by combination in society, he can easily master lions, tigers, and bears, whose greater strength and agility naturally enable them to prey upon him.

Philo: On the contrary, it is here chiefly, cried PHILO, that the uniform and equal maxims of Nature are most apparent. Man, it is true, can, by combination, surmount all his *real* enemies, and become master of the whole animal creation: but does he not immediately raise up to himself *imaginary* enemies, the demons of his fancy, who haunt him with superstitious terrors, and blast every enjoyment of life? His pleasure, as he imagines, becomes, in their eyes, a crime: his food and repose give them umbrage and offence: his very sleep and dreams furnish new materials to anxious fear: and even death,

his refuge from every other ill, presents only the dread of endless and innumerable woes. Nor does the wolf molest more the timid flock, than superstition does the anxious breast of wretched mortals.

Besides, consider, DEMEA; this very society, by which we surmount those wild beasts, our natural enemies; what new enemies does it not raise to us? What woe and misery does it not occasion? Man is the greatest enemy of man. Oppression, injustice, contempt, contumely, violence, sedition, war, calumny, treachery, fraud; by these they mutually torment each other: and they would soon dissolve that society which they had formed, were it not for the dread of still greater ills, which must attend their separation.

But though these external insults, said DEMEA, from animals, from men, from all the elements, which assault us, form a frightful catalogue of woes, they are nothing in comparison of those, which arise within ourselves, from the distempered condition of our mind and body. How many lie under the lingering torment of diseases? Hear the pathetic enumeration of the great poet.

> Intestine stone and ulcer, colic-pangs,
> Demoniac frenzy, moping melancholy,
> And moon-struck madness, pining atrophy,
> Marasmus and wide-wasting pestilence.
> Dire was the tossing, deep the groans: DESPAIR
> Tended the sick, busiest from couch to couch.
> And over them triumphant DEATH his dart
> Shook, but delay'd to strike, tho' oft invok'd
> With vows, as their chief good and final hope.[70]

The disorders of the mind, continued DEMEA, though more secret, are not perhaps less dismal and vexatious. Remorse, shame, anguish, rage, disappointment, anxiety, fear, dejection, despair; who has ever passed through life without cruel inroads from these tormentors? How many have scarcely ever felt any better sensations? Labour and poverty, so abhorred by

[70] John Milton, *Paradise Lost*, XI 11. 485–493. Hume has omitted Line 488: "Dropsies, and asthmas, and joint-racking rheums."

every one, are the certain lot of the far greater number; and those few privileged persons, who enjoy ease and opulence, never reach contentment or true felicity. All the goods of life united would not make a very happy man: but all the ills united would make a wretch indeed; and any one of them almost (and who can be free from every one?) nay often the absence of one good (and who can possess all?) is sufficient to render life ineligible.

Were a stranger to drop, on a sudden, into this world, I would show him, as a specimen of its ills, an hospital full of diseases, a prison crowded with malefactors and debtors, a field of battle strewed with carcases, a fleet floundering in the ocean, a nation languishing under tyranny, famine, or pestilence. To turn the gay side of life to him, and give him a notion of its pleasures; whither should I conduct him? to a ball, to an opera, to court? He might justly think, that I was only showing him a diversity of distress and sorrow.

Philo: There is no evading such striking instances, said PHILO, but by apologies, which still farther aggravate the charge. Why have all men, I ask, in all ages, complained incessantly of the miseries of life?. . . . They have no just reason, says one: these complaints proceed only from their discontented, repining, anxious disposition.. . . . And can there possibly, I reply, be a more certain foundation of misery, than such a wretched temper?

But if they were really as unhappy as they pretend, says my antagonist, why do they remain in life?. . . .

Not satisfied with life, afraid of death.[71]

This is the secret chain, say I, that holds us. We are terrified, not bribed to the continuance of our existence.

It is only a false delicacy, he may insist, which a few refined spirits indulge, and which has spread these complaints among the whole race of mankind.. . . . And what is this delicacy, I ask, which you blame? Is it any thing but a greater sensibility to all the pleasures and pains of life? and if the man

[71] Price suggests that Hume is misquoting "Railing at life, and yet afraid of death . . .", Line 221 of Charles Churchill's *Gotham* (London, 1764).

of a delicate, refined temper, by being so much more alive than the rest of the world, is only so much more unhappy; what judgment must we form in general of human life?

Let men remain at rest, says our adversary; and they will be easy. They are willing artificers of their own misery.. . . . No! reply I; an anxious languor follows their repose: disappointment, vexation, trouble, their activity and ambition.

Cleanthes: I can observe something like what you mention in some others, replied CLEANTHES: but I confess, I feel little or nothing of it in myself, and hope that it is not so common as you represent it.

If you feel not human misery yourself, cried DEMEA, I congratulate you on so happy a singularity. Others, seemingly the most prosperous, have not been ashamed to vent their complaints in the most melancholy strains. Let us attend to the great, the fortunate Emperor, CHARLES V, when, tired with human grandeur, he resigned all his extensive dominions into the hands of his son.[72] In the last harangue, which he made on that memorable occasion, he publicly avowed *that the greatest prosperities which he had ever enjoyed, had been mixed with so many adversities that he might truly say he had never enjoyed any satisfaction or contentment.* But did the retired life, in which he sought for shelter, afford him any greater happiness? If we may credit his son's account, his repentance commenced the very day of his resignation.

CICERO's fortune, from small beginnings, rose to the greatest lustre and renown; yet what pathetic complaints of the ills of life do his familiar letters, as well as philosophical discourses, contain? And suitably to his own experience, he introduces CATO, the great, the fortunate CATO, protesting in his old age, that, had he a new life in his offer, he would reject the present.[73]

[72] This Charles V (1500–1558) was King of Spain and Holy Roman Emperor; his son was the Philip of Spain who married England's 'Bloody Queen Mary', immediate predecessor of Queen Elizabeth I. Charles gave up his thrones in 1556 and 1558.

[73] This is Cato the Censor (234–149 BCE), great grandfather of the Cato of Utica represented in Shakespeare's *Julius Caesar*. Cicero, in his *De Senectute* [On Old Age], quotes Cato as saying that he would strongly object to starting his life over again, because life is so much trouble.

Ask yourself, ask any of your acquaintance, whether they would live over again the last ten or twenty years of their lives. No! but the next twenty, they say, will be better:

And from the dregs of life, hope to receive
What the first sprightly running could not give.[74]

Thus at last they find (such is the greatness of human misery; it reconciles even contradictions) that they complain, at once, of the shortness of life, and of its vanity and sorrow.

Philo: And is it possible, CLEANTHES, said PHILO, that after all these reflections, and infinitely more, which might be suggested, you can still persevere in your Anthropomorphism, and assert the moral attributes of the Deity, his justice, benevolence, mercy, and rectitude, to be of the same nature with these virtues in human creatures? His power we allow infinite: whatever he wills is executed: but neither man nor any other animal are happy: therefore he does not will their happiness. His wisdom is infinite: he is never mistaken in choosing the means to any end: but the course of nature tends not to human or animal felicity: therefore it is not established for that purpose. Through the whole compass of human knowledge, there are no inferences more certain and infallible than these. In what respect, then, do his benevolence and mercy resemble the benevolence and mercy of men?

EPICURUS's old questions are yet unanswered.

Is he willing to prevent evil, but not able? Then is he impotent. Is he able, but not willing? Then is he malevolent. Is he both able and willing? Whence then is evil?

You ascribe, CLEANTHES, (and I believe justly) a purpose and intention to Nature. But what, I beseech you, is the object of that curious artifice and machinery, which she has displayed in all animals? The preservation alone of individuals and propagation of the species. It seems enough for her purpose, if such a rank be barely upheld in the universe, without any care or concern for the happiness of the members that compose it. No resource for this purpose: no machinery, in order merely to give pleasure or ease: no fund of pure joy and

[74] John Dryden, *Aureng-Zebe* (London, 1676) IV (i) 41–42. Hume writes "hope" instead of Dryden's "think".

contentment: no indulgence without some want or necessity accompanying it. At least, the few phenomena of this nature are overbalanced by opposite phenomena of still greater importance.

Our sense of music, harmony, and indeed beauty of all kinds gives satisfaction, without being absolutely necessary to the preservation and propagation of the species. But what racking pains, on the other hand, arise from gouts, gravels, megrims, toothaches, rheumatisms; where the injury to the animal-machinery is either small or incurable? Mirth, laughter, play, frolic, seem gratuitous satisfactions, which have no farther tendency: spleen, melancholy, discontent, superstition, are pains of the same nature. How then does the divine benevolence display itself, in the sense of you Anthropomorphites? None but we Mystics, as you were pleased to call us, can account for this strange mixture of phenomena, by deriving it from attributes, infinitely perfect, but incomprehensible.

Cleanthes: And have you at last, said CLEANTHES smiling, betrayed your intentions, PHILO? Your long agreement with DEMEA did indeed a little surprise me; but I find you were all the while erecting a concealed battery against me. And I must confess, that you have now fallen upon a subject, worthy of your noble spirit of opposition and controversy. If you can make out the present point, and prove mankind to be unhappy or corrupted, there is an end at once of all religion. For to what purpose establish the natural attributes of the Deity, while the moral are still doubtful and uncertain?

Demea: You take umbrage very easily, replied DEMEA, at opinions the most innocent, and the most generally received even amongst the religious and devout themselves: and nothing can be more surprising than to find a topic like this, concerning the wickedness and misery of man, charged with no less than Atheism and profaneness. Have not all pious divines and preachers, who have indulged their rhetoric on so fertile a subject; have they not easily, I say, given a solution of any difficulties, which may attend it? This world is but a point in comparison of the universe: this life but a moment in comparison of the universe: this life but a moment in comparison of eternity. The present evil phenomena, therefore, are rectified in other regions, and in some future period of existence. And the eyes of men, being then opened to larger views

of things, see the whole connection of general laws; and trace, with adoration, the benevolence and rectitude of the Deity, through all the mazes and intricacies of his providence.

Cleanthes: No! replied CLEANTHES, No! These arbitrary suppositions, can never be admitted, contrary to matters of fact, visible and uncontroverted. Whence can any cause be known but from its known effects? Whence can any hypothesis be proved but from the apparent phenomena? To establish one hypothesis upon another, is building entirely in the air; and the utmost we ever attain, by these conjectures and fictions, is to ascertain the bare possibility of our opinion; but never can we, upon such terms, establish its reality.

The only method of supporting divine benevolence (and it is what I willingly embrace) is to deny absolutely the misery and wickedness of man. Your representations are exaggerated: Your melancholy views mostly fictitious: Your inferences contrary to fact and experience. Health is more common than sickness: Pleasure than pain: Happiness than misery. And for one vexation, which we meet with, we attain, upon computation, a hundred enjoyments.

Philo: Admitting your position, replied PHILO, which yet is extremely doubtful, you must, at the same time, allow, that, if pain be less frequent than pleasure, it is infinitely more violent and durable. One hour of it is often able to outweigh a day, a week, a month of our common insipid enjoyments: And how many days, weeks, and months are passed by several in the most acute torments? Pleasure, scarcely in one instance, is ever able to reach ecstasy and rapture: And in no one instance can it continue for any time at its highest pitch and altitude. The spirits evaporate; the nerves relax; the fabric is disordered; and the enjoyment quickly degenerates into fatigue and uneasiness. But pain often, good God, how often! rises to torture and agony; and the longer it continues, it becomes still more genuine agony and torture. Patience is exhausted; courage languishes; melancholy seizes us; and nothing terminates our misery but the removal of its cause, or another event, which is the sole cure of all evil, but which, from our natural folly, we regard with still greater horror and consternation.

But not to insist upon these topics, continued PHILO, though most obvious, certain, and important; I must use the freedom to admonish you, CLEANTHES, that you have put the

controversy upon a most dangerous issue, and are unawares introducing a total Scepticism, into the most essential articles of natural and revealed theology. What! No method of fixing a just foundation for religion, unless we allow the happiness of human life, and maintain a continued existence even in this world, with all our present pains, infirmities, vexations, and follies, to be eligible and desirable! But this is contrary to everyone's feeling and experience: It is contrary to an authority so established as nothing can subvert: No decisive proofs can ever be produced against this authority; nor is it possible for you to compute, estimate, and compare all the pains and all the pleasures in the lives of all men and of all animals: And thus by your resting the whole system of religion on a point, which, from its very nature, must for ever be uncertain, you tacitly confess that that system is equally uncertain.

But allowing you, what never will be believed; at least, what you never possibly can prove, that animal, or at least, human happiness, in this life, exceeds its misery; you have yet done nothing: For this is not, by any means, what we expect from infinite power, infinite wisdom, and infinite goodness. Why is there any misery at all in the world? Not by chance surely. From some cause then. Is it from the intention of the Deity? But he is perfectly benevolent. Is it contrary to his intention? But he is almighty. Nothing can shake the solidity of this reasoning, so short, so clear, so decisive; except we assert, that these subjects exceed all human capacity, and that our common measures of truth and falsehood are not applicable to them; a topic, which I have all along insisted on, but which you have, from the beginning, rejected with scorn and indignation.

But I will be contented to retire still from this retrenchment: For I deny that you can ever force me in it: I will allow, that pain or misery in man is *compatible* with infinite power and goodness in the Deity, even in your sense of these attributes: What are you advanced by all these concessions? A mere possible compatibility is not sufficient. You must *prove* these pure, unmixed, and uncontrollable attributes from the present mixed and confused phenomena, and from these alone. A hopeful undertaking! Were the phenomena ever so pure and unmixed, yet being finite, they would be insufficient

for that purpose. How much more, where they are also so jarring and discordant!

Here, CLEANTHES, I find myself at ease in my argument. Here I triumph. Formerly, when we argued concerning the natural attributes of intelligence and design, I needed all my sceptical and metaphysical subtlety to elude your grasp. In many views of the universe, and of its parts, particularly the latter, the beauty and fitness of final causes strike us with such irresistible force, that all objections appear (what I believe they really are) mere cavils and sophisms; nor can we then imagine how it was ever possible for us to repose any weight on them. But there is no view of human life or of the condition of mankind, from which, without the greatest violence, we can infer the moral attributes, or learn that infinite benevolence, conjoined with infinite power and infinite wisdom, which we must discover by the eyes of faith alone. It is your turn now to tug the labouring oar, and to support your philosophical subtleties against the dictates of plain reason and experience.

PART XI

Cleanthes: I scruple not to allow, said CLEANTHES, that I have been apt to suspect the frequent repetition of the word, *infinite,* which we meet with in all theological writers, to savour more of panegyric than of philosophy, and that any purposes of reasoning, and even of religion, would be better served, were we to rest contented with more accurate and more moderate expressions. The terms, *admirable, excellent, super-latively great, wise,* and *holy;* these sufficiently fill the imaginations of men; and anything beyond, besides that it leads into absurdities, has no influence on the affections or sentiments. Thus, in the present subject, if we abandon all human analogy, as seems your intention, DEMEA, I am afraid we abandon all religion, and retain no conception of the great object of our adoration. If we preserve human analogy, we must for ever find it impossible to reconcile any mixture of evil in the universe with infinite attributes; much less can we ever prove the latter from the former. But supposing the Author of Nature to be finitely perfect, though far exceeding mankind; a satisfactory account may then be given of natural and moral evil, and every untoward phenomenon be explained and adjusted. A less evil may then be chosen, in order to avoid a greater; Inconveniencies be submitted to, in order to reach a desirable end: And in a word, benevolence, regulated by wisdom, and limited by necessity, may produce just such a world as the present. You, PHILO, who are so prompt at starting views, and reflections, and analogies, I would gladly hear, at length, without interruption, your opinion of this new theory; and if it deserve our attention, we may afterwards, at more leisure, reduce it into form.

Philo: My sentiments, replied PHILO, are not worth being made a mystery of; and therefore, without any ceremony, I shall deliver what occurs to me, with regard to the present subject. It must, I think, be allowed, that, if a very limited intelligence, whom we shall suppose utterly unacquainted with the universe, were assured, that it were the production of a very good, wise, and powerful being, however finite, he would, from his conjectures, form *beforehand* a different notion of it from what we find it to be by experience; nor would he ever imagine, merely from these attributes of the cause, of which he is informed, that the effect could be so full of vice and misery and disorder, as it appears in this life. Supposing now that this

person were brought into the world, still assured that it was the workmanship of such a sublime and benevolent Being; he might, perhaps, be surprised at the disappointment; but would never retract his former belief, if founded on any very solid argument; since such a limited intelligence must be sensible of his own blindness and ignorance, and must allow, that there may be many solutions of those phenomena, which will for ever escape his comprehension. But supposing, which is the real case with regard to man, that this creature is not antecedently convinced of a supreme intelligence, benevolent, and powerful, but is left to gather such a belief from the appearances of things; this entirely alters the case, nor will he ever find any reason for such a conclusion. He may be fully convinced of the narrow limits of his understanding; but this will not help him in forming an inference concerning the goodness of superior powers, since he must form that inference from what he knows, not from what he is ignorant of. The more you exaggerate his weakness and ignorance, the more diffident you render him, and give him the greater suspicion, that such subjects are beyond the reach of his faculties. You are obliged, therefore, to reason with him merely from the known phenomena, and to drop every arbitrary supposition or conjecture.

Did I show you a house or palace, where there was not one apartment convenient or agreeable; where the windows, doors, fires, passages, stairs, and the whole œconomy of the building were the source of noise, confusion, fatigue, darkness, and the extremes of heat and cold; you would certainly blame the contrivance, without any farther examination. The architect would in vain display his subtlety, and prove to you, that if this door or that window were altered, greater ills would ensue. What he says may be strictly true: The alteration of one particular, while the other parts of the building remain, may only augment the inconveniences. But still you would assert in general that, if the architect had had skill and good intentions, he might have formed such a plan of the whole, and might have adjusted the parts in such a manner, as would have remedied all or most of these inconveniencies. His ignorance, or even your own ignorance of such a plan, will never convince you of the impossibility of it. If you find any inconveniencies and deformities in the building, you will always, without entering into any detail, condemn the architect.

In short, I repeat the question: Is the world, considered in general, and as it appears to us in this life, different from what a man or such a limited Being would, *beforehand,* expect from a very powerful, wise, and benevolent Deity? It must be strange prejudice to assert the contrary. And from thence I conclude that, however consistent the world may be, allowing certain suppositions and conjectures, with the idea of such a Deity, it can never afford us an inference concerning his existence. The consistence[75] is not absolutely denied, only the inference. Conjectures, especially where infinity is excluded from the Divine attributes, may perhaps be sufficient to prove a consistence; but can never be foundations for any inference.

There seem to be *four* circumstances, on which depend all, or the greatest part, of the ills that molest sensible creatures; and it is not impossible but all these circumstances may be necessary and unavoidable. We know so little beyond common life, or even of common life, that, with regard to the œconomy of a universe, there is no conjecture, however wild, which may not be just; nor any one, however plausible, which may not be erroneous. All that belongs to human understanding, in this deep ignorance and obscurity, is to be sceptical, or at least cautious; and not to admit of any hypothesis, whatever; much less of any which is supported by no appearance of probability. Now this I assert to be the case with regard to all the causes of evil, and the circumstances on which it depends. None of them appear to human reason, in the least degree, necessary or unavoidable; nor can we suppose them such, without the utmost license of imagination.

The *first* circumstance which introduces evil is that contrivance or œconomy of the animal creation by which pains, as well as pleasures, are employed to excite all creatures to action, and make them vigilant in the great work of self-preservation. Now pleasure alone, in its various degrees, seems to human understanding sufficient for this purpose. All animals might be constantly in a state of enjoyment; but when urged by any of the necessities of nature, such as thirst, hunger, weariness, instead of pain, they might feel a diminution of pleasure, by which they might be prompted to seek that object, which is necessary to their subsistence. Men pursue

[75] Consistency.

pleasure as eagerly as they avoid pain; at least, they might have been so constituted. It seems, therefore, plainly possible to carry on the business of life without any pain. Why then is any animal ever rendered susceptible of such a sensation? If animals can be free from it an hour, they might enjoy a perpetual exemption from it; and it required as particular a contrivance of their organs to produce that feeling, as to endow them with sight, hearing, or any of the senses. Shall we conjecture, that such a contrivance was necessary, without any appearance of reason? And shall we build on that conjecture as on the most certain truth?

But a capacity of pain would not alone produce pain, were it not for the *second* circumstance, *viz.* The conducting of the world by general laws; and this seems nowise necessary to a very perfect being. It is true; if every thing were conducted by particular volitions, the course of nature would be perpetually broken, and no man could employ his reason in the conduct of life. But might not other particular volitions remedy this inconvenience? In short, might not the Deity exterminate all ill, wherever it were to be found, and produce all good, without any preparation or long progress of causes and effects?

Besides, we must consider that, according to the present œconomy of the world, the course of Nature, though supposed exactly regular, yet to us appears not so, and many events are uncertain, and many disappoint our expectations. Health and sickness, calm and tempest, with an infinite number of other accidents, whose causes are unknown and variable, have a great influence both on the fortunes of particular persons and on the prosperity of public societies: and indeed all human life, in a manner, depends on such accidents. A being, therefore, who knows the secret springs of the universe, might easily, by particular volitions, turn all these accidents to the good of mankind, and render the whole world happy, without discovering himself in any operation. A fleet whose purposes were salutary to society might always meet with a fair wind: Good princes enjoy sound health and long life: Persons born to power and authority be framed with good tempers and virtuous dispositions. A few such events as these, regularly and wisely conducted, would change the face of the world, and yet would no more seem to disturb the course of Nature or confound human conduct, than the present œconomy of things, where the causes are secret, and variable, and compounded. Some

small touches, given to CALIGULA's[76] brain in his infancy, might have converted him into a TRAJAN:[77] one wave, a little higher than the rest, by burying CÆSAR and his fortune in the bottom of the ocean, might have restored liberty to a considerable part of mankind. There may, for aught we know, be good reasons why Providence interposes not in this manner; but they are unknown to us: and though the mere supposition that such reasons exist, may be sufficient to *save* the conclusion concerning the divine attributes, yet surely it can never be sufficient to *establish* that conclusion.

If everything in the universe be conducted by general laws, and if animals be rendered susceptible of pain, it scarcely seems possible but some ill must arise in the various shocks of matter, and the various concurrence and opposition of general laws: But this ill would be very rare, were it not for the *third* circumstance which I proposed to mention, *viz.* the great frugality, with which all powers and faculties are distributed to every particular being. So well adjusted are the organs and capacities of all animals, and so well fitted to their preservation, that, as far as history or tradition reaches, there appears not to be any single species which has yet been extinguished in the universe.[78] Every animal has the requisite endowments; but these endowments are bestowed with so scrupulous an œconomy that any considerable diminution must entirely destroy the creature. Wherever one power is increased, there is a proportional abatement in the others. Animals which excel

[76] The popular nickname for the Roman emperor Gaius, who ruled 37–41 CE. See either Robert Graves, *I Claudius* or Albert Camus, *Caligula* for colourful treatments of the horrors of his brief reign.

[77] Marcus Ulpius Trajanus, Roman emperor ruling 98–117 CE.

[78] Here Hume added a note in the margin, then crossed it out: "Caesar, speaking of the woods in Germany, mentions some animals as subsisting there, which are now utterly extinct. De bello Gall. Lib. 6. These, and some few more instances, may be exceptions to the propositions here delivered. Strabo [Lib. 4] quotes from Polybius an account of an animal about the Tyrol, which is not now to be found. If Polybius was not deceived, which is possible, the animal must have been then very rare, since Strabo cites but one authority and speaks doubtfully." The theory that no species had ever become extinct was widely believed in the eighteenth century. For the reasons why many thinkers were committed to that theory, see A.O. Lovejoy, *The Great Chain of Being* (New York: Harper, 1936), a masterpiece in the history of ideas.

in swiftness are commonly defective in force. Those which possess both are either imperfect in some of their senses, or are oppressed with the most craving wants. The human species, whose chief excellency is reason and sagacity, is of all others the most necessitous, and the most deficient in bodily advantages; without clothes, without arms, without food, without lodging, without any convenience of life, except what they owe to their own skill and industry. In short, Nature seems to have formed an exact calculation of the necessities of her creatures; and like a *rigid master,* has afforded them little more powers or endowments, than what are strictly sufficient to supply those necessities. An *indulgent parent* would have bestowed a large stock, in order to guard against accidents, and secure the happiness and welfare of the creature, in the most unfortunate concurrence of circumstances. Every course of life would not have been so surrounded with precipices, that the least departure from the true path, by mistake or necessity, must involve us in misery and ruin. Some reserve, some fund would have been provided to ensure happiness; nor would the powers and the necessities have been adjusted with so rigid an œconomy. The author of Nature is inconceivably powerful: his force is supposed great, if not altogether inexhaustible: nor is there any reason, as far as we can judge, to make him observe this strict frugality in his dealings with his creatures. It would have been better, were his power extremely limited, to have created fewer animals, and to have endowed these with more faculties for their happiness and preservation. A builder is never esteemed prudent who undertakes a plan beyond what his stock will enable him to finish.

In order to cure most of the ills of human life, I require not that man should have the wings of the eagle, the swiftness of the stag, the force of the ox, the arms of the lion, the scales of the crocodile or rhinoceros; much less do I demand the sagacity of an angel or cherubim. I am contented to take an increase in one single power or faculty of his soul. Let him be endowed with a greater propensity to industry and labour, a more vigorous spring and activity of mind, a more constant bent to business and application. Let the whole species possess naturally an equal diligence with that which many individuals are able to attain by habit and reflection; and the most beneficial consequences, without any allay of ill, is the immediate and necessary result of this endowment. Almost all the moral, as

well as natural evils of human life arise from idleness; and were our species, by the original constitution of their frame, exempt from this vice or infirmity, the perfect cultivation of land, the improvement of arts and manufactures, the exact execution of every office and duty, immediately follow; and men at once may fully reach that state of society, which is so imperfectly attained by the best-regulated government. But as industry is a power, and the most valuable of any, Nature seems determined, suitably to her usual maxims, to bestow it on men with a very sparing hand; and rather to punish him severely for his deficiency in it, than to reward him for his attainments. She has so contrived his frame, that nothing but the most violent necessity can oblige him to labour; and she employs all his other wants to overcome, at least in part, the want of diligence, and to endow him with some share of a faculty, of which she has thought fit naturally to bereave him. Here our demands may be allowed very humble, and therefore the more reasonable. If we required the endowments of superior penetration and judgment, of a more delicate taste of beauty, of a nicer sensibility to benevolence and friendship; we might be told that we impiously pretend to break the order of Nature, that we want to exalt ourselves into a higher rank of being, that the presents which we require, not being suitable to our state and condition, would only be pernicious to us. But it is hard; I dare to repeat it, it is hard, that being placed in a world so full of wants and necessities; where almost every being and element is either our foe or refuses its assistance . . . we should also have our own temper to struggle with, and should be deprived of that faculty which can alone fence against these multiplied evils.

The *fourth* circumstance, whence arises the misery and ill of the universe, is the inaccurate workmanship of all the springs and principles of the great machine of nature. It must be acknowledged, that there are few parts of the universe, which seem not to serve some purpose, and whose removal would not produce a visible defect and disorder in the whole. The parts hang all together, nor can one be touched without affecting the rest in a greater or less degree. But at the same time, it must be observed, that none of these parts or principles, however useful, are so accurately adjusted as to keep precisely within those bounds, in which their utility consists;

but they are, all of them, apt, on every occasion, to run into the one extreme or the other. One would imagine, that this grand production had not received the last hand of the maker; so little finished is every part, and so coarse are the strokes, with which it is executed. Thus, the winds are requisite to convey the vapours along the surface of the globe, and to assist men in navigation: but how oft, rising up to tempests and hurricanes, do they become pernicious? Rains are necessary to nourish all the plants and animals of the earth: but how often are they defective? how often excessive? Heat is requisite to all life and vegetation; but is not always found in the due proportion. On the mixture and secretion of the humours and juices of the body depend the health and prosperity of the animal: but the parts perform not regularly their proper function. What more useful than all the passions of the mind, ambition, vanity, love, anger? But how oft do they break their bounds, and cause the greatest convulsions in society? There is nothing so advantageous in the universe, but what frequently becomes pernicious, by its excess or defect; nor has Nature guarded, with the requisite accuracy, against all disorder or confusion. The irregularity is never, perhaps, so great as to destroy any species; but is often sufficient to involve the individuals in ruin and misery.

On the concurrence, then, of these *four* circumstances does all, or the greatest part of natural evil depend. Were all living creatures incapable of pain, or were the world administered by particular volitions, evil never could have found access into the universe: and were animals endowed with a large stock of powers and faculties, beyond what strict necessity requires; or were the several springs and principles of the universe so accurately framed as to preserve always the just temperament and medium, there must have been very little ill in comparison of what we feel at present. What then shall we pronounce on this occasion? Shall we say, that these circumstances are not necessary, and that they might easily have been altered in the contrivance of the universe? This decision seems too presumptuous for creatures, so blind and ignorant. Let us be more modest in our conclusions. Let us allow, that, if the goodness of the Deity (I mean a goodness like the human) could be established on any tolerable reasons *a priori*, these phenomena, however untoward, would not be sufficient to subvert that

principle, but might easily, in some unknown manner, be reconcilable to it. But let us still assert that as this goodness is not antecedently established, but must be inferred from the phenomena, there can be no grounds for such an inference, while there are so many ills in the universe, and while these ills might so easily have been remedied, as far as human understanding can be allowed to judge on such a subject. I am Sceptic enough to allow that the bad appearances, notwithstanding all my reasonings, may be compatible with such attributes as you suppose: But surely they can never prove these attributes. Such a conclusion cannot result from Scepticism; but must arise from the phenomena, and from our confidence in the reasonings, which we deduce from these phenomena.

Look round this universe. What an immense profusion of beings, animated and organized, sensible and active! You admire this prodigious variety and fecundity. But inspect a little more narrowly these living existences, the only beings worth regarding. How hostile and destructive to each other! How insufficient all of them for their own happiness! How contemptible or odious to the spectator! The whole presents nothing but the idea of a blind Nature, impregnated by a great vivifying principle, and pouring forth from her lap, without discernment or parental care, her maimed and abortive children!

Here the MANICHÆAN system occurs as a proper hypothesis to solve the difficulty: and no doubt, in some respects, it is very specious, and has more probability than the common hypothesis, by giving a plausible account of the strange mixture of good and ill, which appears in life.[79] But if we consider, on the other hand, the perfect uniformity and agreement of the parts of the universe, we shall not discover

[79] Manicheism is a form of Gnosticism deriving from the teachings of Manes (or Mani) in the third century CE. It holds that the Universe is controlled by two almost if not quite equally powerful principles, of Good and of Evil. Augustine of Hippo (354–430) was, before his conversion to Christianity, a Manichee. The word 'specious' first meant 'attractive', then (as here) 'attractive on the surface but perhaps deceptive', then 'attractive on the surface but (definitely) deceptive', and more recently has come to mean just 'deceptive' or 'unsound'.

in it any marks of the combat of a malevolent with a benevolent being. There is indeed an opposition of pains and pleasures in the feelings of sensible creatures: but are not all the operations of Nature carried on by an opposition of principles, of hot and cold, moist and dry, light and heavy? The true conclusion is that the original source of all things is entirely indifferent to all these principles, and has no more regard to good above ill than to heat above cold, or to drought above moisture, or to light above heavy.

There may *four* hypotheses be framed concerning the first causes of the universe; *that* they are endowed with perfect goodness, *that* they have perfect malice, *that* they are opposite and have both goodness and malice, *that* they have neither goodness nor malice. Mixed phenomena can never prove the two former unmixed principles. And the uniformity and steadiness of general laws seem to oppose the third. The fourth, therefore, seems by far the most probable.

What I have said concerning natural evil will apply to moral, with little or no variation; and we have no more reason to infer that the rectitude of the Supreme Being resembles human rectitude than that his benevolence resembles the human. Nay, it will be thought that we have still greater cause to exclude from him moral sentiments, such as we feel them, since moral evil, in the opinion of many, is much more predominant above moral good than natural evil above natural good.

But even though this should not be allowed, and though the virtue which is in mankind should be acknowledged much superior to the vice, yet so long as there is any vice at all in the universe, it will very much puzzle you Anthropomorphites how to account for it. You must assign a cause for it, without having recourse to the first cause. But as every effect must have a cause, and that cause another; you must either carry on the progression *in infinitum,* or rest on that original principle, who is the ultimate cause of all things . . .

Demea: Hold! hold! cried DEMEA: Whither does your imagination hurry you? I joined in alliance with you, in order to prove the incomprehensible nature of the Divine Being, and refute the principles of CLEANTHES, who would measure everything by a human rule and standard. But I now find you running into all the topics of the greatest libertines and

infidels, and betraying that holy cause which you seemingly espoused. Are you secretly, then, a more dangerous enemy than CLEANTHES himself?

Cleanthes: And are you so late in perceiving it? replied CLEANTHES. Believe me, DEMEA, your friend PHILO, from the beginning, has been amusing himself at both our expense; and it must be confessed that the injudicious reasoning of our vulgar theology has given him but too just a handle of ridicule. The total infirmity of human reason, the absolute incomprehensibility of the Divine Nature, the great and universal misery and still greater wickedness of men; these are strange topics surely to be so fondly cherished by orthodox divines and doctors. In ages of stupidity and ignorance, indeed, these principles may safely be espoused; and perhaps, no views of things are more proper to promote superstition, than such as encourage the blind amazement, the diffidence, and melancholy of mankind. But at present. . . .

Philo: Blame not so much, interposed PHILO, the ignorance of these reverend gentlemen. They know how to change their style with the times. Formerly it was a most popular theological topic to maintain that human life was vanity and misery, and to exaggerate all the ills and pains which are incident to men. But of late years, divines, we find, begin to retract this position, and maintain, though still with some hesitation, that there are more goods than evils, more pleasures than pains, even in this life. When religion stood entirely upon temper and education, it was thought proper to encourage melancholy; as indeed, mankind never have recourse to superior powers so readily as in that disposition. But as men have now learned to form principles, and to draw consequences, it is necessary to change the batteries, and to make use of such arguments as will endure, at least some scrutiny and examination. This variation is the same (and from the same causes) with that which I formerly remarked with regard to Scepticism.

Pamphilus: Thus PHILO continued to the last his spirit of opposition, and his censure of established opinions. But I could observe, that DEMEA did not at all relish the latter part of the discourse; and he took occasion soon after, on some pretence or other, to leave the company.

PART XII

Pamphilus: After DEMEA's departure, CLEANTHES and PHILO continued the conversation in the following manner. Our friend, I am afraid, said CLEANTHES, will have little inclination to revive this topic of discourse, while you are in company; and to tell truth, PHILO, I should rather wish to reason with either of you apart on a subject so sublime and interesting. Your spirit of controversy, joined to your abhorrence of vulgar superstition, carries you strange lengths, when engaged in an argument; and there is nothing so sacred and venerable, even in your own eyes, which you spare on that occasion.

Philo: I must confess, replied PHILO, that I am less cautious on the subject of Natural Religion than on any other; both because I know that I can never, on that head, corrupt the principles of any man of common sense, and because no one, I am confident, in whose eyes I appear a man of common sense, will ever mistake my intentions. You, in particular, CLEAN-THES, with whom I live in unreserved intimacy; you are sensible, that, notwithstanding the freedom of my conversation, and my love of singular arguments, no one has a deeper sense of religion impressed on his mind, or pays more profound adoration to the Divine Being, as he discovers[80] himself to reason, in the inexplicable contrivance and artifice of Nature. A purpose, an intention, a design strikes everywhere the most careless, the most stupid thinker; and no man can be so hardened in absurd systems, as at all times to reject-it. *That Nature does nothing in vain,*[81] is a maxim established in all the schools, merely from the contemplation of the works of Nature, without any religious purpose; and, from a firm conviction of its truth, an anatomist who had observed a new organ or canal would never be satisfied till he had also discovered its use and intention. One great foundation of the COPERNICAN system is the maxim, *That Nature acts by the simplest methods, and*

[80] Uncovers.

[81] Construed as a finding this is certainly false. For what about such vestigial organs as the vermiform appendix? It can instead be defended as a methodological maxim: biologists ought always to look very hard for the function before concluding that some 'new organ or canal' has in fact none.

chooses the most proper means to any end,[82] and astronomers often, without thinking of it, lay this strong foundation of piety and religion. The same thing is observable in other parts of philosophy: And thus all the sciences almost lead us insensibly to acknowledge a first intelligent Author; and their authority is often so much the greater, as they do not directly profess that intention.

It is with pleasure I hear GALEN reason concerning the structure of the human body.[83] The anatomy of a man, says he, discovers above 600 different muscles; and whoever duly considers these will find that in each of them Nature must have adjusted at least ten different circumstances, in order to attain the end which she proposed; proper figure, just magnitude, right disposition of the several ends, upper and lower position of the whole, the due insertion of the several nerves, veins, and arteries: So that in the muscles alone, above 6,000 several views and intentions must have been formed and executed. The bones he calculates to be 284: The distinct purposes, aimed at in the structure of each, above forty. What a prodigious display of artifice, even in these simple and homogeneous parts! But if we consider the skin, ligaments, vessels, glandules, humours, the several limbs and members of the body; how must our astonishment rise upon us, in proportion to the number and intricacy of the parts so artificially adjusted! The farther we advance in these researches, we discover new scenes of art and wisdom: But descry still, at a distance, farther scenes beyond our reach; in the fine internal structure of the parts, in the œconomy of the brain, in the fabric of the seminal vessels. All these artifices are repeated in every different species of animal, with wonderful variety, and

[82] This again should be reinterpreted as a methodological maxim; namely, Ockham's Razor. The Ptolemaic system could be made to fit the facts, but only at the price of introducing more and more complicating epicycles. The Copernican was therefore to be preferred as vastly simpler.

[83] Galen (129–199), personal physician to the emperor Marcus Aurelius, was the Greek doctor whose immensely influential writings dominated European medical teaching until the Renaissance. Hume is referring to his treatise *De Formatione Foetus* [On the Formation of the Foetus].

with exact propriety, suited to the different intentions of Nature in framing each species. And if the infidelity of GALEN, even when these natural sciences were still imperfect, could not withstand such striking appearances; to what pitch of pertinacious obstinacy must a philosopher in this age have attained, who can now doubt of a Supreme Intelligence?

Could I meet with one of this species (who, I thank God, are very rare) I would ask him: Supposing there were a God, who did not discover himself immediately to our senses; were it possible for him to give stronger proofs of his existence, than what appear on the whole face of Nature? What indeed could such a divine Being do, but copy the present œconomy of things; render many of his artifices so plain, that no stupidity could mistake them; afford glimpses of still greater artifices, which demonstrate his prodigious superiority above our narrow apprehensions; and conceal altogether a great many from such imperfect creatures? Now according to all rules of just reasoning, every fact must pass for undisputed, when it is supported by all the arguments which its nature admits of; even though these arguments be not, in themselves, very numerous or forcible: How much more, in the present case, where no human imagination can compute their number, and no understanding estimate their cogency!

Cleanthes: I shall farther add, said CLEANTHES, to what you have so well urged, that one great advantage of the principle of Theism is that it is the only system of cosmogony, which can be rendered intelligible and complete, and yet can throughout preserve a strong analogy to what we every day see and experience in the world. The comparison of the universe to a machine of human contrivance is so obvious and natural, and is justified by so many instances of order and design in Nature, that it must immediately strike all unprejudiced apprehensions, and procure universal approbation. Whoever attempts to weaken this theory cannot pretend to succeed by establishing in its place any other, that is precise and determinate: It is sufficient for him, if he start doubts and difficulties; and by remote and abstract views of things, reach that suspense of judgement, which is here the utmost boundary of his wishes. But besides, that this state of mind is in itself unsatisfactory, it can never be steadily maintained against such striking appearances, as continually engage us into the religious hypothe-

sis. A false, absurd system, human nature, from the force of
prejudice, is capable of adhering to, with obstinacy and perse-
verance: But no system at all, in opposition to theory, sup-
ported by strong and obvious reason, by natural propensity,
and by early education, I think it absolutely impossible to
maintain or defend.

Philo: So little, replied PHILO, do I esteem this suspense of
judgement in the present case to be possible, that I am apt to
suspect there enters somewhat of a dispute of words into this
controversy, more than is usually imagined. That the works of
Nature bear a great analogy to the productions of art is
evident: and according to all the rules of good reasoning, we
ought to infer, if we argue at all concerning them, that their
causes have a proportional analogy. But as there are also
considerable differences, we have reason to suppose a propor-
tional difference in the causes; and in particular ought to
attribute a much higher degree of power and energy to the
supreme cause than any we have ever observed in mankind.
Here then the existence of a DEITY is plainly ascertained by
reason; and if we make it a question, whether, on account of
these analogies, we can properly call him a *mind* or *intelli-
gence,* notwithstanding the vast difference, which may reason-
ably be supposed between him and human minds; what is this
but a mere verbal controversy? No man can deny the analogies
between the effects: To restrain ourselves from enquiring
concerning the causes is scarcely possible: From this enquiry,
the legitimate conclusion is, that the causes have also an
analogy: And if we are not contented with calling the first and
supreme cause a GOD or DEITY, but desire to vary the expres-
sion; what can we call him but MIND or THOUGHT, to which he
is justly supposed to bear a considerable resemblance?

All men of sound reason are disgusted with verbal dis-
putes, which abound so much in philosophical and theological
enquiries; and it is found that the only remedy for this abuse
must arise from clear definitions, from the precision of those
ideas which enter into any argument, and from the strict and
uniform use of those terms which are employed. But there is a
species of controversy which, from the very nature of language
and of human ideas, is involved in perpetual ambiguity, and
can never, by any precaution or any definitions, be able to
reach a reasonable certainty or precision. These are the
controversies concerning the degrees of any quality or circum-

stance. Men may argue to all eternity, whether HANNIBAL[84] be a great, or a very great, or a superlatively great man, what degree of beauty CLEOPATRA[85] possessed, what epithet of praise LIVY or THUCYDIDES[86] is entitled to, without bringing the controversy to any determination. The disputants may here agree in their sense, and differ in the terms, or *vice versa;* yet never be able to define their terms, so as to enter into each other's meaning: Because the degrees of these qualities are not, like quantity or number, susceptible of any exact mensuration, which may be the standard in the controversy. That the dispute concerning Theism is of this nature, and consequently is merely verbal, or perhaps, if possible, still more incurably ambiguous, will appear upon the slightest enquiry. I ask the Theist if he does not allow that there is a great and immeasurable, because incomprehensible, difference between the *human* and the *divine* mind: The more pious he is, the more readily will he assent to the affirmative, and the more will he be disposed to magnify the difference: He will even assert, that the difference is of a nature which cannot be too much magnified. I next turn to the Atheist, who, I assert, is only nominally so, and can never possibly be in earnest; and I ask him whether, from the coherence and apparent sympathy in all the parts of this world, there be not a certain degree of analogy among all the operations of Nature, in every situation and in every age; whether the rotting of a turnip, the generation of an animal, and the structure of human thought be not energies that probably bear some remote analogy to each other: It is impossible he can deny it: He will readily acknowledge it. Having obtained this concession, I push him still farther in his retreat; and I ask him, if it be not probable that

[84] Hannibal (247–183 BCE) was the Carthaginian commander in the First Punic War between Rome and Carthage. He is best remembered for having led his whole army, including battle elephants, over the Alps in Winter.

[85] Cleopatra (c. 70–30 BCE), Ptolemaic Queen of Egypt and mistress successively of Julius Caesar and Mark Antony. See Bernard Shaw's *Ceasar and Cleopatra* and Shakespeare's *Antony and Cleopatra.*

[86] Thucydides (c. 460–c. 400 BCE) wrote a *History of the Peloponnesian War.* This *History* was translated into English by Thomas Hobbes (1588–1679); a predecessor whom Hume certainly respected though, perhaps for reasons of prudence, scarcely ever mentioned.

the principle which first arranged and still maintains order in
this universe bears not also some remote inconceivable analo-
gy to the other operations of Nature, and among the rest to the
œconomy of human mind and thought. However reluctant, he
must give his assent. Where then, cry I to both these antago-
nists, is the subject of your dispute? The Theist allows, that
the original intelligence is very different from human reason:
The Atheist allows, that the original principle of order bears
some remote analogy to it. Will you quarrel, Gentlemen, about
the degrees, and enter into a controversy, which admits not of
any precise meaning, nor consequently of any determination?
If you should be so obstinate, I should not be surprised to find
you insensibly change sides; while the Theist on the one hand
exaggerates the dissimilarity between the Supreme Being, and
frail, imperfect, variable, fleeting, and mortal creatures; and
the Atheist on the other magnifies the analogy among all the
operations of Nature, in every period, every situation, and
every position. Consider then, where the real point of contro-
versy lies, and if you cannot lay aside your disputes, endeav-
our, at least, to cure yourselves of your animosity.

And here I must also acknowledge, CLEANTHES, that, as
the works of Nature have a much greater analogy to the effects
of *our* art and contrivance than to those of *our* benevolence and
justice; we have reason to infer that the natural attributes of
the Deity have a greater resemblance to those of man than his
moral have to human virtues. But what is the consequence?
Nothing but this, that the moral qualities of man are more
defective in their kind than his natural abilities. For, as the
Supreme Being is allowed to be absolutely and entirely perfect,
whatever differs most from him departs the farthest from the
supreme standard of rectitude and perfection.

It seems evident that the dispute between the Sceptics and
Dogmatists is entirely verbal, or at least regards only the
degrees of doubt and assurance which we ought to indulge with
regard to all reasoning: And such disputes are commonly, at
the bottom, verbal, and admit not of any precise determina-
tion. No philosophical Dogmatist denies that there are difficul-
ties both with regard to the senses and to all science; and that
these difficulties are in a regular, logical method, absolutely
insolveable. No Sceptic denies that we lie under an absolute
necessity, notwithstanding these difficulties, of thinking, and

believing, and reasoning with regard to all kind of subjects, and even of frequently assenting with confidence and security. The only difference, then, between these sects, if they merit that name, is, that the Sceptic, from habit, caprice, or inclination, insists most on the difficulties; the Dogmatist, for like reasons, on the necessity.[87]

These, CLEANTHES, are my unfeigned sentiments on this subject; and these sentiments, you know, I have ever cherished and maintained. But in proportion to my veneration for true religion, is my abhorrence of vulgar superstitions; and I indulge a peculiar pleasure, I confess, in pushing such principles, sometimes into absurdity, sometimes into impiety. And you are sensible, that all bigots, notwithstanding their great aversion to the latter above the former, are commonly equally guilty of both.

Cleanthes: My inclination, replied CLEANTHES, lies, I own, a contrary way. Religion, however corrupted, is still better than no religion at all. The doctrine of a future state is so strong and necessary a security to morals, that we never ought to abandon or neglect it. For if finite and temporary rewards and punishments have so great an effect, as we daily find; how much greater must be expected from such as are infinite and eternal?

Philo: How happens it then, said PHILO, if vulgar superstition be so salutary to society, that all history abounds so much with accounts of its pernicious consequences on public affairs? Factions, civil wars, persecutions, subversions of government, oppression, slavery; these are the dismal consequences which always attend its prevalency over the minds of men. If the religious spirit be ever mentioned in any historical narration, we are sure to meet afterwards with a detail of the miseries, which attend it. And no period of time can be happier or more prosperous than those in which it is never regarded or heard of.

Cleanthes: The reason of this observation, replied CLEANTHES, is obvious. The proper office of religion is to regulate the

[87] It has been disputed whether Hume intended this paragraph as a footnote or as part of the text. It can certainly be read as Philo's own elaboration of his position.

heart of men, humanize their conduct, infuse the spirit of temperance, order, and obedience; and as its operation is silent, and only enforces the motives of morality and justice, it is in danger of being overlooked, and confounded with these other motives. When it distinguishes itself, and acts as a separate principle over men, it has departed from its proper sphere, and has become only a cover to faction and ambition.

Philo: And so will all religion, said PHILO, except the philosophical and rational kind. Your reasonings are more easily eluded than my facts. The inference is not just, because finite and temporary rewards and punishments have so great influence, that therefore such as are infinite and eternal must have so much greater. Consider, I beseech you, the attachment which we have to present things, and the little concern which we discover for objects, so remote and uncertain. When divines are declaiming against the common behaviour and conduct of the world, they always represent this principle as the strongest imaginable (which indeed it is) and describe almost all human kind as lying under the influence of it, and sunk into the deepest lethargy and unconcern about their religious interests. Yet these same divines, when they refute their speculative antagonists, suppose the motives of religion to be so powerful, that, without them, it were impossible for civil society to subsist; nor are they ashamed of so palpable a contradiction. It is certain, from experience, that the smallest grain of natural honesty and benevolence has more effect on men's conduct, than the most pompous views suggested by theological theories and systems. A man's natural inclination works incessantly upon him; it is for ever present to the mind, and mingles itself with every view and consideration: whereas religious motives, where they act at all, operate only by starts and bounds; and it is scarcely possible for them to become altogether habitual to the mind. The force of the greatest gravity, say the philosophers, is infinitely small, in comparison of that of the least impulse; yet it is certain, that the smallest gravity will, in the end, prevail above a great impulse; because no strokes or blows can be repeated with such constancy as attraction and gravitation.

Another advantage of inclination: It engages on its side all the wit and ingenuity of the mind; and when set in opposition to religious principles, seeks every method and art of eluding

them: in which it is almost always successful. Who can explain the heart of man, or account for those strange salvos[88] and excuses, with which people satisfy themselves, when they follow their inclinations in opposition to their religious duty! This is well understood in the world; and none but fools ever repose less trust in a man, because they hear that from study and philosophy he has entertained some speculative doubts with regard to theological subjects. And when we have to do with a man who makes a great profession of religion and devotion, has this any other effect upon several, who pass for prudent, than to put them on their guard, lest they be cheated and deceived by him?

We must farther consider that philosophers, who cultivate reason and reflection, stand less in need of such motives to keep them under the restraint of morals; and that the vulgar, who alone may need them, are utterly incapable of so pure a religion, as represents the Deity to be pleased with nothing but virtue in human behaviour. The recommendations to the Divinity are generally supposed to be either frivolous observances, or rapturous ecstasies, or a bigotted credulity. We need not run back into antiquity, or wander into remote regions, to find instances of this degeneracy. Amongst ourselves, some have been guilty of that atrociousness, unknown to the EGYPTIAN and GRECIAN superstitions, of declaiming, in express terms, against morality, and representing it as a sure forfeiture of the Divine favour, if the least trust or reliance be laid upon it.

But even though superstition or enthusiasm should not put itself in direct opposition to morality; the very diverting of the attention, the raising up a new and frivolous species of merit, the preposterous distribution, which it makes of praise and blame; must have the most pernicious consequences, and weaken extremely men's attachment to the natural motives of justice and humanity.

Such a principle of action likewise, not being any of the familiar motives of human conduct, acts only by intervals on

[88] A saving clause or reservation. This 'salvo' is entirely different from the word meaning a discharge of guns, though ultimately from the same Latin root, 'salvus' (safe or well).

the temper, and must be roused by continual efforts, in order to render the pious zealot satisfied with his own conduct, and make him fulfil his devotional task. Many religious exercises are entered into with seeming fervour, where the heart, at the time, feels cold and languid: A habit of dissimulation is by degrees contracted: and fraud and falsehood become the predominant principle. Hence the reason of that vulgar observation that the highest zeal in religion and the deepest hypocrisy, so far from being inconsistent, are often or commonly united in the same individual character.

The bad effects of such habits, even in common life, are easily imagined: but where the interests of religion are concerned, no morality can be forcible enough to bind the enthusiastic zealot. The sacredness of the cause sanctifies every measure which can be made use of to promote it.

The steady attention alone to so important an interest as that of eternal salvation is apt to extinguish the benevolent affections, and beget a narrow, contracted selfishness. And when such a temper is encouraged, it easily eludes all the general precepts of charity and benevolence.

Thus the motives of vulgar superstition have no great influence on general conduct; nor is their operation favourable to morality, in the instances where they predominate.

Is there any maxim in politics more certain and infallible, than that both the number and authority of priests should be confined within very narrow limits, and that the civil magistrate ought, for ever, to keep his *fasces*[89] and *axes* from such dangerous hands? But if the spirit of popular religion were so salutary to society, a contrary maxim ought to prevail. The greater number of priests, and their greater authority and riches will always augment the religious spirit. And though the priests have the guidance of this spirit, why may we not expect a superior sanctity of life, and greater benevolence and moderation, from persons who are set apart for religion, who

[89] A fasces was the bundle of rods and an axe which used to be carried before magistrates of the Roman Republic; the rods being for the flogging and the axe for the decapitation of criminals. It was after World War I adopted as the totemic symbol of Benito Mussolini's Fascist Party in Italy.

are continually inculcating it upon others, and who must themselves imbibe a greater share of it? Whence comes it then, that in fact, the utmost a wise magistrate can propose with regard to popular religions, is, as far as possible, to make a saving game of it, and to prevent their pernicious consequences with regard to society? Every expedient which he tries for so humble a purpose is surrounded with inconveniencies. If he admits only one religion among his subjects, he must sacrifice, to an uncertain prospect of tranquillity, every consideration of public liberty, science, reason, industry, and even his own independency. If he gives indulgence to several sects, which is the wiser maxim, he must preserve a very philosophical indifference to all of them, and carefully restrain the pretensions of the prevailing sect; otherwise he can expect nothing but endless disputes, quarrels, factions, persecutions, and civil commotions.

True religion, I allow, has no such pernicious consequences: but we must treat of religion, as it has commonly been found in the world; nor have I anything to do with that speculative tenet of Theism, which, as it is a species of philosophy, must partake of the beneficial influence of that principle, and at the same time must lie under a like inconvenience, of being always confined to very few persons.

Oaths are requisite in all courts of judicature; but it is a question whether their authority arises from any popular religion. 'Tis the solemnity and importance of the occasion, the regard to reputation, and the reflecting on the general interests of society, which are the chief restraints upon mankind. Custom-house oaths and political oaths are but little regarded even by some who pretend to principles of honesty and religion: and a Quaker's asseveration is with us justly put upon the same footing with the oath of any other person. I know that POLYBIUS[90] ascribes the infamy of GREEK faith to the prevalency of the EPICUREAN philosophy; but I know also, that

[90] Polybius (c. 203–c. 120 BCE) was a Greek whose extant writings are mainly concerned with Rome. Hume's reference is to Polybius's *Histories*, Book VI, Chapter 54, though this seems to be a mistake. Hume may have been thinking of Chapter 56, sections 6–12, where Polybius blames new ideas for undermining religious belief, and therefore trustworthiness and social cohesion.

PUNIC[91] faith had as bad a reputation in ancient times, as IRISH evidence has in modern; though we cannot account for these vulgar observations by the same reason. Not to mention, that GREEK faith was infamous before the rise of the EPICUREAN philosophy; and EURIPIDES,[92] in a passage which I shall point out to you, has glanced a remarkable stroke of satire against his nation, with regard to this circumstance.

Cleanthes: Take care, PHILO, replied CLEANTHES, take care; push not matters too far: allow not your zeal against false religion to undermine your veneration for the true. Forfeit not this principle, the chief, the only great comfort in life; and our principal support amidst all the attacks of adverse fortune. The most agreeable reflection, which it is possible for human imagination to suggest, is that of genuine Theism, which represents us as the workmanship of a Being perfectly good, wise, and powerful; who created us for happiness, and who, having implanted in us immeasureable desires of good, will prolong our existence to all eternity, and will transfer us into an infinite variety of scenes, in order to satisfy those desires, and render our felicity complete and durable. Next to such a Being himself (if the comparison be allowed) the happiest lot which we can imagine, is that of being under his guardianship and protection.

Philo: These appearances, said PHILO, are most engaging and alluring; and with regard to the true philosopher, they are more than appearances. But it happens here, as in the former case, that, with regard to the greater part of mankind, the appearances are deceitful, and that the terrors of religion commonly prevail above its comforts.

[91] 'Punic' is an alternative word for Carthaginian, and Polybius wrote about what the Romans called their Punic Wars. Compare with such Roman talk of Punic faith the facts: that in England condoms used to be nicknamed 'French letters' whereas in France the phrase was 'chapeaux anglaises' (English hats); and that the French for 'to take French leave' is 'to take English leave' (filer à l'anglaise).

[92] Euripides (c. 480–406 BCE) was a Greek tragic dramatist. Hume's note gives only the title of the play, *Iphigeneia in Tauris*. Presumably the passage, which he does not in fact point out, is lines 1157–1233; full of dramatic irony, in which Iphigenia warns Thoas to beware of Greeks and their deception, while at the same time contriving the deception of Thoas.

It is allowed that men never have recourse to devotion so readily as when dejected with grief or depressed with sickness. Is not this a proof, that the religious spirit is not so nearly allied to joy as to sorrow?

Cleanthes: But men, when afflicted, find consolation in religion, replied CLEANTHES.

Philo: Sometimes, said PHILO: but it is natural to imagine, that they will form a notion of those unknown beings, suitably to the present gloom and melancholy of their temper, when they betake themselves to the contemplation of them. Accordingly, we find the tremendous[93] images to predominate in all religions; and we ourselves, after having employed the most exalted expressions in our description of the Deity, fall into the flattest contradiction, in affirming that the damned are infinitely superior in number to the elect.

I shall venture to affirm that there never was a popular religion which represented the state of departed souls in such a light as would render it eligible for human kind that there should be such a state. These fine models of religion are the mere product of philosophy. For as death lies between the eye and the prospect of futurity, that event is so shocking to Nature, that it must throw a gloom on all the regions which lie beyond it; and suggest to the generality of mankind the idea of CERBERUS[94] and FURIES;[95] devils, and torrents of fire and brimstone.

It is true: both fear and hope enter into religion, because both these passions, at different times, agitate the human mind, and each of them forms a species of divinity, suitable to itself. But when a man is in a cheerful disposition, he is fit for business or company or entertainment of any kind; and he naturally applies himself to these, and thinks not of religion. When melancholy, and dejected, he has nothing to do but brood upon the terrors of the invisible world, and to plunge

[93] In the eighteenth century, this word still meant 'causing trembling' or terrifying.

[94] A monstrous dog guarding the entrance to the Underworld. Hesiod gives him fifty heads, but by the Classical period this total had been diminished to a less extravagant three.

[95] The avenging female demons. See above all the great tragic trilogy, the *Oresteia* of Aeschylus (525/4–456 BCE).

himself still deeper in affliction. It may indeed happen that after he has, in this manner, engraved the religious opinions deep into his thought and imagination, there may arrive a change of health or circumstances which may restore his good humour, and raising chearful prospects of futurity, make him run into the other extreme of joy and triumph. But still it must be acknowledged that, as terror is the primary principle of religion, it is the passion which always predominates in it, and admits but of short intervals of pleasure.

Not to mention that these fits of excessive, enthusiastic joy, by exhausting the spirits, always prepare the way for equal fits of superstitious terror and dejection; nor is there any state of mind so happy as the calm and equable. But this state it is impossible to support where a man thinks, that he lies, in such profound darkness and uncertainty, between an eternity of happiness and an eternity of misery. No wonder, that such an opinion disjoints the ordinary frame of the mind, and throws it into the utmost confusion. And though that opinion is seldom so steady in its operation as to influence all the actions; yet it is apt to make a considerable breach in the temper, and to produce that gloom and melancholy so remarkable in all devout people.

It is contrary to common sense to entertain apprehensions or terrors, upon account of any opinion whatsoever, or to imagine that we run any risk hereafter, by the freest use of our reason. Such a sentiment implies both an *absurdity* and an *inconsistency*. It is an absurdity to believe that the Deity has human passions, and one of the lowest of human passions, a restless appetite for applause. It is an inconsistency to believe, that, since the Deity has this human passion, he has not others also; and, in particular, a disregard to the opinions of creatures, so much inferior.

To know God, says Seneca, *is to worship him.*[96] All other worship is indeed absurd, superstitious, and even impious. It

[96] Lucius Annaeus Seneca (c. 4 BCE–65 AD) was a philosophical Stoic who served for some years as an advisor to the Roman emperor Nero. In Number 95 of *Moral Letters* he in fact says something quite different: "The most important thing in divine worship is to believe in the gods . . ."

degrades him to the low condition of mankind, who are delighted with entreaty, solicitation, presents, and flattery. Yet is this impiety the smallest of which superstition is guilty. Commonly, it depresses the Deity far below the condition of mankind; and represents him as a capricious dæmon, who exercises his power without reason and without humanity! And were that divine Being disposed to be offended at the vices and follies of silly mortals who are his own workmanship, ill would it surely fare with the votaries of most popular superstitions. Nor would any of the human race merit his *favour,* save a very few, the philosophical Theists, who entertain, or rather indeed endeavour to entertain, suitable notions of his divine perfections: as the only persons, entitled to his *compassion* and *indulgence,* would be the philosophical Sceptics, a sect almost equally rare, who, from a natural diffidence of their own capacity, suspend or endeavour to suspend all judgement with regard to such sublime and such extraordinary subjects.

If the whole of Natural Theology, as some people seem to maintain, resolves itself into one simple, though somewhat ambiguous, at least undefined proposition, *That the cause or causes of order in the universe probably bear some remote analogy to human intelligence:* If this proposition be not capable of extension, variation, or more particular explication: If it affords no inference that affects human life, or can be the source of any action or forbearance: And if the analogy, imperfect as it is, can be carried no farther than to the human intelligence; and cannot be transferred, with any appearance of probability, to the qualities of the mind: If this really be the case, what can the most inquisitive, contemplative, and religious man do more than give a plain, philosophical assent to the proposition, as often as it occurs; and believe that the arguments, on which it is established, exceed the objections, which lie against it? Some astonishment indeed will naturally arise from the greatness of the object: Some melancholy from its obscurity: Some contempt of human reason, that it can give no solution more satisfactory with regard to so extraordinary and magnificent a question. But believe me, CLEANTHES, the most natural sentiment which a well-disposed mind will feel on this occasion, is a longing desire and expectation, that heaven would be pleased to dissipate, at least alleviate, this profound ignorance, by affording some particular revelation to

mankind, and making discoveries of the nature, attributes, and operations of the divine object of our faith. A person, seasoned with a just sense of the imperfections of natural reason, will fly to revealed truth with the greatest avidity: While the haughty Dogmatist, persuaded, that he can erect a complete system of Theology by the mere help of philosophy, disdains any farther aid, and rejects this adventitious instructor. To be a philosophical Sceptic is, in a man of letters, the first and most essential step towards being a sound, believing Christian; a proposition, which I would willingly recommend to the attention of PAMPHILUS: And I hope CLEANTHES will forgive me for interposing so far in the education and instruction of his pupil.

Pamphilus: CLEANTHES and PHILO pursued not this conversation much farther; and as nothing ever made greater impression on me than all the reasonings of that day, so I confess, that, upon a serious review of the whole, I cannot but think that PHILO's principles are more probable than DEMEA's, but that those of CLEANTHES approach still nearer to the truth.

BIBLIOGRAPHY

A. WORKS BY HUME

A Treatise of Human Nature (1739–1740)

An Abstract of a Treatise of Human Nature (1740)

Essays, Moral and Political (1741–1742)

Letter from a Gentleman to His Friend in Edinburgh (1745)

An Enquiry concerning Human Understanding (1748)

An Enquiry concerning the Principles of Morals (1751)

Political Discourses (1752)

The History of England (1754–1762)

Four Dissertations (1757) (including *The Dissertation on the Passions* and *The Natural History of Religion)*

A Concise and Genuine Account of the Dispute Between Mr. Hume and Mr. Rousseau (1766)

My Own Life (1777)

Two Essays ('Of Suicide' and 'Of the Immortality of the Soul') (1777)

Dialogues concerning Natural Religion (1779)

The Letters of David Hume, Edited by J.Y.T. Greig. 2 volumes. Oxford: Oxford University Press, 1932.

New Letters of David Hume, Edited by R. Klibansky and E.C. Mossner. Oxford: Clarendon, 1954.

For a complete Hume bibliography, see T.E. Jessop's *Bibliography of David Hume and of Scottish Philosophy from Francis Hutcheson to Lord Balfour,* and Roland Hall's *A Hume Bibliography, from 1930.* A supplement to the latter was printed in the *Philosophical Quarterly* for January 1976; and further supplements continue to appear in *Hume Studies.*

B. IMPORTANT WORKS ON HUME

Anderson, Robert F. *Hume's First Principles.* Lincoln: University of Nebraska Press, 1966.

Beauchamp, Tom L. and Alexander Rosenberg. *Hume and the Problem of Causation.* Oxford: Oxford University Press, 1981.

Bennett, Jonathan. *Locke, Berkeley, Hume: Central Themes.* Oxford: Clarendon, 1973.

Bricke, John. *Hume's Philosophy of Mind,* Edinburgh: Edinburgh University Press, 1980.

Capaldi, Nicholas. *David Hume: The Newtonian Philosopher.* Boston: Twayne, 1975.

Flew, Antony. *Hume's Philosophy of Belief.* London: Routledge, 1961.

Flew, Antony. *David Hume, Philosopher of Moral Science.* Oxford: Blackwell, 1986.

Fogelin, Robert J. *Hume's Skepticism in the Treatise of Human Nature.* London: Routledge, 1985.

Forbes, Duncan. *Hume's Philosophical Politics.* Cambridge: Cambridge University Press, 1975.

Gaskin, J.A.C. *Hume's Philosophy of Religion.* London: Macmillan, Second Edition, 1988.

Hendel, Charles W. *Studies in the Philosophy of David Hume.* Indianapolis & New York: Bobbs-Merrill, 1963.

Jones, Peter. *Hume's Sentiments.* Edinburgh: Edinburgh University Press, 1982.

Kemp Smith, Norman. *The Philosophy of David Hume.* London: Macmillan, 1941.

Laird, John. *Hume's Philosophy of Human Nature.* London: Methuen, 1932.

Livingston, Donald W. *Hume's Philosophy of Common Life.* Chicago: University of Chicago Press, 1984.

Mackie, J.L. *Hume's Moral Theory.* London: Routledge and Kegan Paul, 1980.

Macnabb, D.G.C. *David Hume: His Theory of Knowledge and Morality.* Hambden, Connecticut: Archon, 1966.

Mossner, E.C. *The Life of David Hume,* Oxford: Clarendon, 1980.

Norton, David Fate. *David Hume.* Princeton: Princeton University Press, 1982.

Noxon, James. *Hume's Philosophical Development*. Oxford: Clarendon, 1973.

Passmore, John A. *Hume's Intentions*. New York: Basic Books, 1968.

Penelhum, Terence. *Hume*. London: Macmillan, 1975.

Price, Henry H. *Hume's Theory of the External World*. Oxford: Clarendon Press, 1940.

Stove, D.C. *Probability and Hume's Inductive Skepticism*. Oxford: Clarendon, 1973.

Wright, John P. *The Sceptical Realism of David Hume*. Manchester: Manchester University Press, 1982.

C. COLLECTIONS OF ESSAYS ON HUME

Chappell, V.C., ed. *Hume*. South Bend, Indiana: University of Notre Dame, 1966.

Hearn, Thomas K., ed. *Hume's Philosophy of Religion*. Winston-Salem: Wake Forest University Press, 1986.

Livingston, Donald W. & James T. King, eds. *Hume: A Re-Evaluation*. New York: Fordham University Press, 1976.

Morice, George, ed. *David Hume: Bicentenary Papers*. Edinburgh: Edinburgh University Press, 1976.

Sesonske, A. & N. Fleming, eds. *Human Understanding: Studies in the Philosophy of David Hume*. Belmont, California: Wadsworth, 1965.

Todd, William B. *Hume and the Enlightenment*. Edinburgh: Edinburgh University Press, 1974.

A journal devoted entirely to research on Hume, *Hume Studies,* is published twice yearly by the University of Western Ontario Department of Philosophy. Subscription enquiries should be addressed to Hume Studies, University of Western Ontario, Department of Philosophy, London, Ontario, N6A 3K7, Canada.

INDEX